**RUDISILL, Richard. Mirror image; the influence of the daguerreo-
type on American society. New Mexico, 1971. 342p plates il
bibl 79-137880. 30.00**

The daguerreotype became an American phenomenon. Introduced to
New York in September 1839, three weeks after its publication by the
French government, this primitive form of photography spread rapidly
and in the 1840's "Daguerreian artists" were to be found practically
everywhere. Rudisill has studied this activity in depth. He examines
the American spirit and taste in the first half of the 19th century to
explain why Daguerre's invention was so popular in America. He finds
relationships between the philosophy of writers such as Hawthorne,
who chose a daguerreotypist as the hero of *The house of the seven gables*,
and the direct images made almost automatically by the camera and
light-sensitive silver plates. He points out the value of daguerreo-
types as documentation of the face of America. The superb collection
of more than 200 images are for the most part hitherto unpublished;
they include work by the masters: Albert Sands Southworth, Josiah
Johnson Hawes, Mathew B. Brady, and Marcus Aurelius Root. The
bibliography, carefully annotated, is admirable, and the index complete.

Continued

RUDISILL

The book complements the only other survey of the subject: B. New-
hall's *Daguerreotype in America* (rev. ed., 1968). Indispensable for all
libraries of the history of photography; recommended for collections
of American art.

DR. RICHARD RUDISILL is Assistant Professor
of Art and Photographic History at the University
of New Mexico. An earlier manuscript version of
this study won the McKnight Foundation Humani-
ties Award in American History in 1967.

MIRROR IMAGE

The democratic faith appeared in American culture as one of the principal forces making for what Whitman used to call adhesiveness. The ultimate appeal of the formula was to the feelings. If it were to have utility in the culture, it must be able to evoke an emotional response. To stir the sentiments of the people the faith must express itself in symbols.

Ralph Henry Gabriel—
The Course of American Democratic Thought

MIRROR IMAGE

The Influence of the Daguerreotype
on American Society

RICHARD RUDISILL

Albuquerque
UNIVERSITY OF NEW MEXICO PRESS

TO

MY PARENTS

D. C. AND MARGARET RUDISILL

and

to

DONALD ROSENBERG

and

RON LETNES

A manuscript version of this study, originally submitted as a doctoral dissertation in American Studies to the University of Minnesota, was given the 1967 McKnight Foundation Humanities Award in American History.

ACKNOWLEDGMENTS

The burdens of a project of this magnitude can never be carried alone. Success comes only because of the many persons whose time and ideas and whose aid are built into every line and image. Some stand large in their direct contributions; others are further removed, but to all I wish to express my deepest gratitude.

More than any other person, Professor Mary C. Turpie of the Program in American Studies of the University of Minnesota must be recognized for the patience, the endurance, and the cogently gentle advice which she has given for three years. Without her sensitivity to an unfamiliar medium and her vast insight into American culture, this work would have foundered. Similarly, the bridge between the medium of photography and the techniques of interdisciplinary scholarship is more solidly built because of the help of Professor Jerome Liebling of the Department of Art of the University of Minnesota. His incisive grasp of the relevance of one field to another produced the initial thought that has grown into the present study. As photographer, teacher, friend, and generous critic, he has given me irreplaceable aid throughout. To Professors Bernard Bowron, Allen Downs, Charles Foster, Rodney C. Loehr, Donald Torbert, and Melvin Waldfogel

of the University of Minnesota and to Professors Leo Marx of Amherst College and Alan Trachtenberg of Yale University, I give thanks for advice, criticism, and scholarly validation of ideas.

For great personal encouragement and tangible help, Beaumont Newhall, Director of the George Eastman House, Rochester, New York, must be singled out for especial thanks. His kind approval of digging by a faltering beginner in his own definitive field of photographic history has been deeply felt. I am also grateful for permission to quote from his writings.

For sharing the results of their work with me, I am indebted to Robert Bretz, of the Rochester Institute of Technology, Rochester, New York; Peter Bunnell of the Museum of Modern Art, New York; Josephine Cobb of the National Archives, Washington, D.C.; Caroline Dunn of the Indiana Historical Society, Indianapolis; Daniel Jones of the National Broadcasting Company, New York; Joan Kerr, Consulting Editor of *American Heritage,* New York; Bert Lund of the architectural firm of Ernst Born, San Francisco; Nathan Lyons, Director, Photographic Studies Workshop, Rochester, New York; Fr. Arthur D. Spearman, S. J., Archivist of Santa Clara University, California; John Szarkowski, Director of Photography of the Museum of Modern Art, New York; and Harris B. Tuttle, Sr., formerly Consultant in Law Enforcement Photography to the Eastman Kodak Company.

Since daguerreotype pictures themselves are the foundation of this work, it is first to those private collectors who have opened their collections and their homes with such courtesy to my camera and myself that I am indebted. These are the guardians of the vital stuff of historical research—their interest guarantees to the future what the past has valued. Particular thanks are due the late Frederick S. Baker, Berkeley, California; Mrs. Lee Brunson, trustee of the F. E. Seaton Collection, Minneapolis; Mrs. Theodora Kurrell and the late Mrs. Theodore J. Labhard, San Francisco; Fred Mazzulla, Denver; and Charles McInerney, San Francisco.

Similarly, I am indebted to numerous institutions for allowing me to reproduce pictures from their collections: these are gratefully cited in the captions. For close personal attention in various aspects of my research I owe particular appreciation to James de T. Abajian, formerly of the California Historical Society, San Francisco; Eugene Becker of the Minnesota Historical Society, St. Paul; the late Arthur Carlson of the New York Historical Society; Dr. Elliot Evans and Mrs. Helen Giffen of the Society of California Pioneers, San Francisco; Carroll D. Hall of the Sutter's Fort State Historical Monument, Sacramento, California; Dr. John W. Meaney, formerly Assistant Chancellor of the University of Texas, Austin; Mrs. Irene Simpson Neasham of the Wells Fargo Bank History Room, San Francisco; John Barr Tompkins of the Bancroft Library, Berkeley, California; and the late Mrs. Graham Wilcox of the Historical Room of the Public Library, Stockbridge, Massachusetts.

I wish also to thank the Graduate School of the University of Minnesota for tangible encouragement in the form of a basic research grant which made initial travel possible.

ACKNOWLEDGMENTS

This degree of confidence in the value of a novel project has been much appreciated.

To Delphine Swanson, for important clerical help and cheery smiles when they were much needed, and to Barbara Nelson, for incredible typing labors, many thanks. To Mark Steenerson, Director of the former Westbank Gallery, Minneapolis, I am grateful for his personally mounting a handsome exhibition of pictures relating to this study during the spring of 1967.

Finally, I wish at least to mention the gratitude that can never be adequately expressed to those friends whose kindness and love have enabled me to carry the burden of this project at all: Wendell Carroll, St. Paul, Minnesota; Dr. and Mrs. Morris Ditch, Charlton, Massachusetts; Mr. and Mrs. Fred Erisman, Fort Worth, Texas; Mr. and Mrs. Douglas George, Albuquerque, New Mexico; Edward Goldbarg, Minneapolis; Gerald Lang, University Park, Pennsylvania; Mr. and Mrs. Wayne R. Lazorik, Albuquerque, New Mexico; Ronald Letnes, St. Paul, Minnesota; Donald and Joan Paden, Minneapolis; Mr. and Mrs. Donald Rosenberg, Fairport, New York; Dr. and Mrs. Karl Schleunes, Chicago; Mr. and Mrs. Robert Wilcox, Mahtomedi, Minnesota; and Joseph B. Young, Alameda, California.

RICHARD RUDISILL

CONTENTS

MIRROR IMAGE

The illustrations which appear at the headings of the chapters are intended to give an additional sample of the world of the daguerreotype as seen within the trade. These pictures are reproduced from wood engravings published during the period.

Chapters 1 through 7 illustrate various operations in the manufacture of daguerreotype materials, as shown in an article on the great Anthony Factory at Daguerreville, New York, published in *The Photographic and Fine Art Journal* (July 1854). The specific operations illustrated are as follows:

Chapter 1—Cabinet Shop

Chapter 2—Machine Shop

Chapter 3—Apparatus Finishing Room

Chapter 4—Case Covering and Finishing Room

Chapter 5—Case Gilding Room

Chapter 6—Mat and Preserver Factory

Chapter 7—Metal Dipping Room

Chapter 8 illustrates the reception and exhibition salon of Ball's Great Daguerrian Gallery of the West, as shown in *Gleason's Pictorial Drawing-Room Companion* (April 1, 1854).

Chapter 9 presents the most frequent encounter between the daguerreotype and the public—that of sitting for a portrait—as taken from a newspaper announcement for the studio of A. G. Nye in Plymouth, Massachusetts, June 18, 1846.

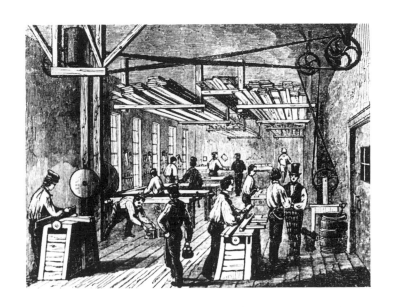

Chapter 1

THE CLIMATE OF NEED

URING THE FIRST HALF of the nineteenth century the society of the United States ceased to feel uncertain about its recent independence from Great Britain and became a burgeoning and loudly self-certain power in the world. Many of the transitions reflecting this change were actively sought by the public at large as well as by national men of the day; many were recorded in both words and visual images meant to reflect and to encourage a vitally "American" way of life. Swelling national pride in the showing made by America at the Crystal Palace Exposition in London in 1851 mirrored cultural nationalism in full array. The fact that ten years later the nation was engaged in seemingly tearing itself to pieces in the Civil War attests that the United States had achieved enough national certainty to demand that all parts of the country unify into one culture or to risk dismemberment should that national certainty be wrong.

Existing public and private records of the changing life of those decades are a treasure house from which scholars have often drawn to interpret American culture.

The writings of the period have frequently been examined by such historians of ideas as Vernon L. Parrington, Ralph Henry Gabriel, and Henry Nash Smith. The visual records have been considered less often than the writings, and when they have been used they have served primarily as illustrations. Art historians such as Virgil Barker, Oliver W. Larkin, and Marshall B. Davidson have searched out national elements in American painting, sculpture, and architecture, and collectors such as Abby Aldrich Rockefeller have prized folk art objects for their nationalistic aspects. Unfortunately very little attention has been given to the most public types of images from those years—those of photography. During the two decades before the Civil War the process of the daguerreotype, the first widely used form of photography, produced more visual images in America than almost any other medium, and yet the significance of the daguerreotype in American society has never been assessed.

In his *American Renaissance,* F. O. Matthiessen wrote with enthusiasm about the images of the daguerreotype, but he merely hints that something of importance resided there. John Kouwenhoven's *Made in America* touches on the similarity of visual impulses between photography and a stress on realism in American painting, but he confines most of his examples to artists after the Civil War. Anyone wishing to deal further with the question of American photography before 1860 is inevitably led back to Robert Taft, whose *Photography and the American Scene: A Social History, 1839-1889,* originally published in 1938 and reissued by Dover Publications in 1964, is at once the pioneering work and a continuing landmark in the field. While he called his book a social history, Taft actually stayed well within the bounds of photographic historiography and did not go far toward defining the overall impact of the medium on American society.

Beaumont Newhall, the leading modern historian of photography, has devoted an entire book to introducing the era of *The Daguerreotype in America* to modern eyes. He emphasizes the artistic value of the medium as well as introducing valuable indications of cultural interplay between nineteenth-century society and the daguerreotype. Since the book is an aspect of all his photographic writings, he primarily stresses how this interplay is significant to photography. To yield its greatest value as a cultural source, the book must be used along with Newhall's other writings—the result of steady research over the last thirty years. His four editions of *The History of Photography* and his countless articles and monographs, together with his directorship of the George Eastman House, reflect an unmatched scholarly concern with photography. This present examination of the daguerreotype owes much to his works and to his generous personal encouragement.

Foreign writers, such as Helmut Gernsheim, either treat generally of the daguerreotype or limit their consideration principally to Europe. Nineteenth-century writers on the contemporary view of the medium, such as Marcus Aurelius Root, are no longer in print, and many valuable sources from the period exist in very few surviving copies.

The daguerreotype exerted profound influences on American society between 1840 and 1860, the effects of which have never been examined. In its early period of use the photographic medium affected life in the United States in three essential ways. Ini-

4

tially the new medium directly encouraged cultural nationalism. Its pictures were clear affective images reflecting and reiterating many impulses toward the definition of an "American" character. At another level of consciousness, the invention of photography helped Americans adjust themselves intuitively to the transition from an agrarian to a technological society in that these images were produced with a reliable mechanical tool. Important as are both of these functions, however, it is at the level of the spirit that we must seek for the most essential operation of the daguerreotype in American life. It both reflected and activated national faith in spiritual insight and truth obtained from perceiving the works of God in nature.

Surviving daguerreotypes provide the next thing to immediate views of America as it was in the decades before 1860. They contain a directness of experience which gives us fresh information and new insights into the quality of the time. Used in parallel with written statements, these pictures allow us to approach nearer to American life before the Civil War than we can by any other means. To see that the time after 1839 was right for the daguerreotype to function significantly in America, we must examine some of the major concerns that produced the national climate.

Nationalistic enthusiasm is initially most evident in literary works produced by both major writers and the deservedly obscure. During the early period of the century some of the strongest insistence on a nativist culture came from leading literary men. Reviewing the novel *Redwood* in 1825, William Cullen Bryant commented that

> the writers of works of fiction, of which the scene is laid in familiar and domestic life, have a rich and varied field before them in the United States. Indeed, the opinion on this subject, which, till lately, prevailed pretty extensively among us, that works of this kind, descriptive of the manners of our countrymen, could not succeed, never seemed to us to rest on a very solid foundation.[1]

In successive decades many writers agreed with Bryant. In 1830 William Ellery Channing observed in his "Remarks on National Literature":

> The few standard works which we have produced, and which promise to live, can hardly be denominated a national literature. On this point, if marks and proofs of our real condition were needed, we should find them in the current apologies for our deficiencies. Our writers are accustomed to plead in our excuse our youth, the necessities of a newly settled country, and the direction of our best talents to practical life. Be the pleas sufficient or not, one thing they prove, and that is, our consciousness of having failed. . . . In an age of great intellectual activity, we rely chiefly for intellectual excitement and enjoyment on foreign minds; nor is our own mind felt abroad.[2]

Demands for a national literature finally became so intense that the degree of Americanism of a work was nearly its sole criterion of worth. Still the idea spread and intensified until by 1855 Walt Whitman was shouting the message:

> The Americans of all nations at any time upon the earth have probably the fullest poetical nature. The United States themselves are essentially the greatest poem. . . . Here at last

is something in the doings of man that corresponds with the broadcast doings of the day and night. . . . The American poets are to enclose old and new for America is the race of races. . . . Of all nations the United States with veins full of poetic stuff most need poets and will doubtless have the greatest and use them the greatest.[3]

The demand for native literature was answered consciously by writers such as Washington Irving and James Fenimore Cooper and less consciously by total amateurs such as Mrs. Clara Moreton Moore. While Irving's *Rip Van Winkle* or Cooper's *Leatherstocking Tales* are both American and worthy of serious literary attention, Mrs. Moore's "Niagara, Below the Cataract" is typical of countless efforts to produce indigenous literature in popular magazines:

> Within a temple's towering walls I stand!
> A temple vast! the heaven is its dome!
> No corniced crag was hewn by human hand,
> Nor by it wrought this tracery of foam.
> The inlaid floor of emerald and pearl
> Heaves at the hidden organ's thunderous peal;
> . . . It is a fitting place
> For solemn thought—for deep and earnest prayer;
> For here the finger of our God I trace,—
> Beneath, above, around me, everywhere;
> He hollowed out this grand and mighty nave;
> And robed his altar with the ocean wave.[4]

While this passage is not obviously national in its details, many others were explicit about their American locale:

> On thy wild banks, oh, lovely Genesee,
> I stand entranced! gazing with calm delight
> Upon thy leaping waters, foaming white
> Like wings of angels in their purity. . . .[5]

So strong did the tide of Americanism in literature become that other, qualitative elements were in danger of being totally obscured, and by 1849 James Russell Lowell sensed that stress on nationalism had overrun more important considerations. He felt compelled to protest while reviewing a new work by Longfellow. Remarking that, "If we only insist that our authors shall be good, we may cease to feel nervous about their being national,"[6] he gave an acid summation of our nationalistic literary outlook.

Lowell did not limit his criticism only to literary culture. Aware that much popular defense had been made of the power of the American landscape as a source of unique impulses to national cultural achievements, he demanded wryly that the landscape produce or face censure:

When anxious European friends inquire after our Art and our Literature, we have nothing to do but to refer them to Mount Washington or Lake Superior [as the ones responsi-

THE CLIMATE OF NEED

ble in those departments]. . . . Our geographers should . . . say, for example, that such a peak is six thousand three hundred feet high, and has never yet produced a poet; that the river so-and-so is a thousand miles long, and has wasted its energies in the manufacture of alligators and flatboatmen. On the other hand, they should remember to the credit of the Mississippi, that being the longest river in the world, it has very properly produced the longest painter, whose single work would overlap by a mile or two the pictures of all the old masters stitched together.[7]

Lowell's remark on the "longest painter" is a reference to John Banvard, who produced a panorama depicting the scenery along the entire length of the Mississippi River. Widely acclaimed in America and Europe, the panorama was painted on a canvas eight or ten feet high and several thousand yards long and was displayed to audiences by being unrolled before them on a stage while a lecturer narrated or appropriate music was played. Panorama exhibitions of this type were immensely popular in America during the 1840s and early 1850s; as many as half a dozen were to be seen in New York at one time at the crest of their appeal. Subject matter ranged from "Egypt and the Holy Land" and "The Antediluvian World" to "A Voyage to the Moon," but most often audiences were stirred by viewing a lavish portion of the American landscape, and they preferred details to be accurate in a way that first prefigured and later benefited from the accurate recording power of the daguerreotype.

At the same time as Lowell was poking fun, the painter Thomas Cole was strongly expressing nationalism of landscape in words as well as in pictures. Speaking at the Catskill Lyceum in 1841, Cole delivered a "Lecture on American Scenery," addressing himself to the topic:

> It is a subject that to every American ought to be of surpassing interest, for whether he beholds the Hudson mingling its waters with the Atlantic, explores the central wilds of this vast continent, or stands on the margin of the distant Pacific, he is still in the midst of American scenery—it is his own land; its beauty, its magnificence, its sublimity, all are his; and how undeserving of such a birthright if he can turn towards it an unobserving eye, an unaffected heart![8]

Not only did Cole feel that Americans should appreciate American scenery, but he called down scorn upon those who would appreciate it comparatively less than European landscape.

Because of the limits imposed by the Atlantic Ocean, Cole's painterly contemporaries were more often local products of America than were the nativist writers of the day. Some artists did contrive to emulate European styles, and the same sort of demand for American production and for the recognition of American work was made for painting as had been made for literature. In 1843 Horatio Greenough came very close to Channing's remarks of 1830 when he commented on the credit given Americans for practical matters rather than for production of art, but he was no more satisfied with such recognition than was Channing in his claim that such credit indicated a sense of failure in national culture. Greenough was decidedly irritated with Europe when he wrote:

Seeing us intently occupied, during several generations, in felling forests, in building towns, and constructing roads, she thence formed a theory that we are good for nothing except these pioneer efforts. She taunted us, because there were no statues or frescoes in our log-cabins; she pronounced us unmusical because we did not sit down in the swamp, with an Indian on one side and a rattlesnake on the other, to play the violin.[9]

As with requests for indigenous literature, the urgings of Greenough and others were met on several levels of competence. Most substantial painters approached the problem in one of two ways. Cole and his colleagues of the Hudson River School used the American landscape as specific subject matter while genre painters emphasized various local-color aspects of American life.

Cole led Asher B. Durand, John F. Kensett, and John W. Casilear toward rhapsodic but literally detailed representation of eastern river gorges and mountain ranges seen as panoramic vistas. Their tendency to work with such subject matter generally caused them to emphasize the wild and the spectacular, and they gave particular attention to the appearance of nature before civilization had overcome it. Asher B. Durand's *Kindred Spirits,* showing Cole and William Cullen Bryant in a setting of the Catskill wilds was typical in its lyrical treatment and its painstaking detail of the unspoiled landscape. At the height of his concern with the native wilderness, Cole grew fearful of the potential ruin of the American scene. His painting of a woodchopper, now in the Minneapolis Institute of Arts, for instance, shows a rough axeman in the center of the canvas attacking a tree while around him is a clearing he has hacked out of the forest. He used this same image of axe-destruction in his "Lecture on the American Landscape," when he lamented the loss of American woodland:

> I cannot but express my sorrow that much of the beauty of our landscape is quickly passing away: the ravages of the axe are daily increasing, and the most noble scenes are often laid desolate with a wantonness and barbarism scarcely credible in a people who call themselves civilized. The way-side is becoming shadeless, and another generation will behold spots now rife with beauty, bleak and bare. This is a *regret* rather than a complaint. I know, full well, that the forests must be felled for fuel and tillage, and that roads and canals must be constructed, but I contend that beauty should be of *some* value among us; that where it is not NECESSARY to destroy a tree or a grove, the hand of the woodman should be checked, and even the consideration, which, alas, weighs too heavily with us, of a few paltry dollars, should be held as nought in comparison with the pure and lasting pleasure that we enjoy, or ought to enjoy, in the objects which are among the most beautiful creations of the Almighty.[10]

Like Mrs. Moore at Niagara, Cole also found the hand of God in the beauty of the American landscape. Unlike her, however, he did not passively accept the worth of what he found; he struggled against the press of opposing national values—the benefit to be derived from wild nature and the demand of progress and prosperity—one needing to preserve the landscape as Cole sought to do while the other sought to destroy it for other benefits.

Along with this concern for preserving the wild, these painters reflected a vast public interest in the spectacular elements of the American landscape. Popular imagination singled out certain special wonders, like Niagara Falls, as epitomizing the handiwork of God expressly bestowed upon the North American continent. As we have seen, Mrs. Moore's "Niagara, Below the Cataract" indicated something of the character of popular literary efforts, but literature was by no means alone in the effort, as Carl Carmer, editor of the *Rivers of America* series, has noted:

> In this same period of the "Sublime Subject", painters, including those of the Hudson River School, joined their author-confreres in tributes to the Lord for having created Niagara Falls. Fortunately, however, their paintings were of a much more impressive quality than the essays, poems and songs of the same epoch.[11]

Carmer's judgment suggests a strength of response from visual artists not achieved by other craftsmen. The reason for this is implied in Thomas Cole's plea for saving the forests when he mentions "the pure and lasting pleasure that we enjoy . . . in the objects which are among the most beautiful creations of the Almighty." Cole felt that direct communication with "the objects" of nature was a vital spiritual experience; as a result, the formal concern in his work was to approach the directness of experience of "the objects" as closely as possible. Since a visual image, if accurately enough presented, could come closer to direct experience than could a verbal image which was by nature more abstract, intense responses to Niagara sought pictorial expression. Since the pictorial is a strongly affective medium, it is not strange that public favor should have encouraged substantial production by painters of Niagara.

The volume of surviving paintings of the Falls attests to their popularity. The Albright-Knox Art Gallery of Buffalo, New York, mounted a major exhibition in May 1964, *Three Centuries of Niagara Falls,* in which 91 of 154 works were from the period 1800-60. Most of the pictures produced in those years were more or less literal efforts to reduce the awesome magnitude of the Falls to a picture small enough to fit into a home. Edward Hicks, for example, produced a panel picture about 1830 as a fireplace board for his doctor's home where it could operate, as would a photograph in later generations, as a reminder of one's visit or as an inspiring suggestion of the sublime power he might never have seen.

During this period, Cole and his colleagues were achieving public recognition and sales accorded to no previous American painters and to few since. These picture makers captured for their generation a sense of communion with the American continent that evoked deep response in the public. It cannot be denied that this response was largely sentimental, yet we must not overlook the fact that these pictures were frequently such marvels of careful detailing that local botanists and geologists gainfully spent time examining them. Sentimental atmosphere was often combined with a literal exactitude derived from the keenest sort of descriptive observation, such as is obvious in John F. Kensett's *Niagara Falls,* painted about 1850. The picture is a meticulous study of jagged boulders far more than it is an impression of the distant Falls. A standard of accuracy

similar to that of John James Audubon in recording the birds of America came to be expected from nature painters generally—an observational accuracy which was nearly scientific. It was widely believed that a painted landscape should represent living details—whether the landscape was actual or imaginary. Although certain conventions of painting were not truly realistic—such as the English-Dutch stylization of leaves and foliage and the use of conventionalized brown tones for presenting many aspects of nature—it was still high praise for Frederick Church's 1857 painting of Niagara Falls that an influential photographer, inevitably concerned with accurate rendering, could remark in 1865:

> I fear the beauties of Niagara in natural colours can never be obtained in the camera; but what a glorious triumph for photography if they were. Mr. Church's picture, painted a few years ago, is the most faithful exponent of nature's gorgeous colouring of Niagara that has yet been produced. Indeed, the brilliant and harmonious colouring of this grand picture can scarcely be surpassed by the hand and skill of man.[12]

The feeling that a "living image" should be the cornerstone of painting was held by the artist as well as the layman. While he spoke for sensitive interpretation and unregimented imagination, Horatio Greenough flatly stated that the "great element of execution, whether in painting or in sculpture, is imitation. This is the language of art."[13] He expressed a prevailing attitude well oriented to welcome the precise rendering of photography. This was an age in which the major painter Samuel Morse could say of the first American sight of a daguerreotype that "the exquisite minuteness of the delineation cannot be conceived. No painting or engraving ever approached it."[14]

The genre painters advanced the other prong of the attack on the problem of nationalism in American painting. Such men as William Sidney Mount and George Caleb Bingham devoted themselves to recording human interest and local color in the American scene. These two painters in particular documented minutely exact anecdotes from the lives of country politicians, flatboatmen, folk musicians, and a host of other indigenous types of people and their activities. They were less often concerned with the city than with the rural or semi-pioneering aspects of American society, reflecting the earlier Jeffersonian ideal of an agrarian nation locally administered by enlightened people working their own ground and the Jacksonian emphasis on the worth of the American common man. In one after another of their widely distributed paintings they idealized the occupations of the common people. Mount's *Eel Spearing* and *Farmer Whetting his Scythe* are typical. The recreations or pastimes painted were often practical activities such as Bingham's *Shooting for the Beef*. In these pictures both artists reflected another deeply entrenched national attitude—the value of work. Throughout the 1830s, '40s, and '50s, visiting Europeans frequently remarked on the American national indulgence in work.

The German traveler Francis J. Grund spent several months exploring the United States in 1836 and was strongly impressed with the determination to industry he found everywhere:

There is, probably, no people on earth with whom business constitutes pleasure, and industry amusement, in an equal degree with the inhabitants of the United States of America. Active occupation is not only the principal source of their happiness, and the foundation of their national greatness, but they are absolutely wretched without it, and instead of the *"dolce far niente,"* know but the horrors of idleness. Business is the very soul of an American: he pursues it, not as a means of procuring for himself and his family the necessary comforts of life, but as the fountain of all human felicity; and shows as much enthusiastic ardor in his application to it as any crusader ever evinced for the conquest of the Holy Land, or the followers of Mohammed for the spreading of the Koran.[15]

After recognizing that work was an element of cultural nationalism, Grund stressed that this industrious commitment extended to every part of life. The passion was rural as well as urban, and it shot so urgently through the entire range of national interest that Grund summed up America in one dominating image:

Neither is this hurry of business confined to the large cities, or the method of travelling; it communicates itself to every village and hamlet, and extends to, and penetrates, the western forests. Town and country rival with each other in the eagerness of industrious pursuits. Machines are invented, new lines of communication established, and the depths of the sea explored to afford scope for the spirit of enterprise; and it is as if all America were but one gigantic workshop, over the entrance of which there is the blazing inscription *"No admission here, except on business."*[16]

Clearly work and occupations seemed to overcome disuniting elements operating in American life. Grund's statement that "town and country rival with each other" in industry, indicates a meeting ground for these traditionally opposed aspects of the nation. From the 1820s on, American cities were becoming influential factors for change in a nation almost totally agrarian.

The social views of Thomas Jefferson and Andrew Jackson summarized beliefs of a public committed to the values of agrarian society; actions such as Jackson's veto of the rechartering act for the United States Bank showed a deep suspicion of the rising power of urban concentration. At the same time, however, America was moving strenuously toward a burgeoning age of machine industry. The mills in Lowell, Massachusetts were frequent stops for foreign visitors curious about the social organization of democratic industry. *The Lowell Offering,* a magazine produced by the girls who lived and worked at the mills, projected the happy image of a moral industry uplifting and improving through work the lives of countless young women otherwise destined to waste in rural ignorance. Herman Melville's "Tartarus of Maids" revealed a dismally opposite view of mill culture when he portrayed a paper mill as an ultimate circle of Hell, blanking the faces and blighting the hopes of its young women while symbolically grinding up love in the machines.

Factories rose; machines spread; the electric telegraph captured the imagination of an age. Brook Farm and a hundred other experiments in social organization formed nuclei for criticism of current society and tried to reorient it to more traditionally rural

values. The cotton empire expanded with the machine and the labor of human slaves. Thoreau challenged the telegraph as being needless unless the parties connected had something worthwhile to say. But in all these instances, work formed a unifying concern whatever its goal. Thoreau attacked work as a destructive force for human or divine values, but he was far from reflecting a majority view—even his mentor Ralph Waldo Emerson observed that "though the wide universe is full of good, no kernel of nourishing corn can come to [a man] but through his toil bestowed on that plot of ground which is given to him to till."[17]

Because of these conditions and national pride, the genre painters found a ready audience for their pictures. With these painters, even more than with the landscapists, precise accounting of exact detail was a necessary object. Working men and artisans all over the country formed a keenly critical audience able to spot an inaccuracy or a distortion of what they knew from experience; in this kind of image recording, even more than with landscapes, Americans believed that a picture was "good" if it was "true." Perhaps more than any other form of visual record, the genre paintings illustrated a climate of interest that was favorable for the introduction of photography. Like the panoramas, these pictures prefigured a need for the recording accuracy of the daguerreotype.

Fascination with recording alone, however, cannot fully account for interest in pictured occupations. Since America was in a period of transition, she had to discover for herself as a nation the nationalistic implications underlying the surface rewards of labor. Why else would Grund have been able to remark that work was an American commitment equalled only by the spiritual zeal of the Crusaders and the Moslems? Why else should *The Lowell Offering* effusively point out the virtue of labor as being morally beneficial? Group social and religious ventures necessarily relied on community of labor and, in large part, succeeded or failed to the degree that members were willing to work for a goal beyond material benefits. As a result these groups all had in common a tendency to spiritualize labor. In 1855 Thomas Ewbank, formerly United States Commissioner of Patents, published *The World a Workshop*, dedicating it "to Working Men" as a "Testimony of Respect to the Dignity and Omnipotence of Enlightened Labor." Epitomizing the spiritual attributes of the impulse to work, he argued in his preface that "Material natures require something to *do* as well as to reflect on; this is indispensible to their being—the purpose of it. *Employment* is, therefore, an element of existence. . . ."[18] Nineteenth-century Americans had a spiritual involvement with work which needed to be put into a form that people could deal with effectively in their daily efforts to meet its implied demands. The public felt the need to work, as Grund has made clear, but in order for that need to be a useful item in forming a national consciousness, it had to be cast in more concrete form than Ewbank's pronouncement of it. As Ralph Waldo Emerson stated in 1844:

> We are symbols and inhabit symbols; workmen, work, and tools, words and things, birth and death, all are emblems; but we sympathize with the symbols, and being infatuated with the economical uses of things, we do not know that they are thoughts.[19]

In other words, it may be supposed that pictures of occupations and work were the visible symbolic forms needed by public response to a national impulse. Pictures of particular occupations or activities allowed people to objectify them and to use them to recognize national culture. To judge the "truth" to life of a Missouri political rally painted by Bingham was to participate in a symbolic process of defining regional and national character. The nearer its approach to living reality, the more significant would the symbolic function of the picture become, because the observer could better respond to the picture as if to reality itself. A more appropriate climate for a medium such as photography would be hard to imagine.

A similar process operated in another sort of picture making—that depicting great Americans. During the earlier nineteenth century, history was seen as the lengthened shadows of great men and was often written as biography. Certain public figures came to be regarded as symbols of national ideals of character. George Washington in particular epitomized the honor, the modesty, the democracy, and the loyal sense of duty that Americans saw as the cornerstones of their nation. Washington as a symbol was to be encountered everywhere in the public consciousness. Spiritualists of the 1840s often sought spirit messages from the great man; in folk legends he appeared as "King Washington," a mythological good spirit whose appearance on the scene could offset even the power of the devil; his appearance shocked the nation as a naked Caesar in a massive statue by Horatio Greenough which was widely scorned after its placement before the Capitol in 1843 even though it merely put into solid form a popular symbolic image of the heroic lawgiver-founder. Even after the Civil War, symbolic association of any political figure with the image of Washington was certain to increase his public stature. One of the stranger symbolic indications of the elevation of Abraham Lincoln to national sainthood occurs in a painterly photomontage of Washington welcoming the martyred president into Heaven with an embrace and a laurel wreath while angels look on (Plate 1). The picture was widely distributed in several versions as a photographic carte-de-visite and was common in parlor albums after 1865.

In a more direct sense Daniel Webster caught the imagination. His orations were national events, and his brooding "fallen Archangel" appearance (Plate 2) dominated the emotions of two generations. In a book of boyhood recollections Henry James suggests something of the overawing effect of Webster on his time:

> I passed my younger time, till within a year or two of the Civil War, with an absolute vagueness of impression as to how the political life of the country was carried on. The field was strictly covered, to my young eyes, I make out, by three classes, the busy, the tipsy, and Daniel Webster. This last great man must have represented for us a class in himself; as if to be "political" was just to *be* Daniel Webster in his proper person and with room left over for nobody else. That he should have filled the sky of public life from pole to pole, even to a childish consciousness not formed in New England and for which that strenuous section was but a name in the geography-book, is probably indeed a sign of how large, in the general air, he comparatively loomed.[20]

Conscious of the emotive power of leading men and believing that great men embodied the national character, Americans demanded images of public men. Portrait painters felt obligated to picture national leaders, and few major figures of the period escaped their efforts. As John Quincy Adams observed in April 1839:

> I gave my seventh and last sitting for my portrait to Mr. Charles, who told me that he was forming his style upon the model of Sir Joshua Reynolds, but that he was a young man. This is the thirty-fifth time that my likeness has been taken by artists for portrait, miniature, bust, or medal; and of the whole number, Parker's miniature, Copley's portrait in 1796, and Stuart's head in 1825, with Persico's bust, now in the library-room of Congress, are the only representatives of my face satisfactory to myself.[21]

Aside from the fact of Adams's limited satisfaction, it is noteworthy to find Mr. Charles guilty of pleading youth in his defense of imitating a foreign painting style in exactly the manner that had so exercised William Ellery Channing in his "Remarks on National Literature" nine years earlier (see p. 5).

Adams's dissatisfaction with his portraits points up a serious difficulty that besets even a competent artist's best efforts: the likeness may not be accurate. Flaws may be only a personal annoyance to the subject of a portrait, but when the subject is a man of symbolic importance to a nation seeking to define its character by personifying its ideals in its great men, inaccuracy can lead to distressing uncertainty or confusion of imagery. By 1840 numerous copies of representations of Washington as originally painted by Stuart and Sully had established a usable image for Americans despite obvious variations from pictures made in Washington's lifetime. The establishment of an affective symbolic image would have been easier and faster if there had been one penetrating photograph of Washington. It seems clear that some means of defining images of national identity as accurately as the daguerreotype could do it was urgently needed.

Considering the activity of the landscape painters, the genre painters, and the portraitists, it appears that a substantial amount of image making took place in the early half of the nineteenth century. For an image to elicit a national symbolic response, however, it not only had to be recorded, it had to be effectively distributed to the public. Some paintings were accessible to the public by direct sales and commission purchases. Others were on exhibit in a few museums such as Peale's early in the century or later, Barnum's. Magazines and gift books published engravings "after" works of popular painters, and some works were engraved for direct sale as prints. By 1850 engravings in metal or wood and chromolithographs hung in many parlors. The medium of engraving made national distribution of pictures possible. Using engravings in large numbers, the art unions came into being in many forms ranging from joint stock companies to outright lotteries.

Basically the art unions exhibited collections of paintings on which the public bought tickets or entitlement shares which gave the buyer an engraved copy of a selected work—often the leading item in a particular exhibition. After the sale the pictures were distributed either by a drawing or by the stating of preferences according to the num-

ber of shares the buyer held. The procedure was quickly accepted and sales competition ran high when popular artists were featured even though chance was a large factor in the likelihood of a patron's receiving his choice. Many leading artists of the period participated, including Bingham, Cole, and Doughty, and sale of American art has seldom reached the peak it did during the operation of art unions. A review of one typical exhibition in New York in October 1850, presumably by the American Art Union—the leading union of the many formed—noted a display of forty paintings of various degrees of quality. Subject matter ranged from a sentimental *First Love* by Peele through *Titian's Studio* and *Peasants of Cervarro* to *The Standard in Danger and the Standard Bearer* ("*after life's fitful fever, he sleeps well,*") by J. W. Glass. As one might expect in light of the nationalistic drive of the period, there were such indigenous items as *Boone's First View of Kentucky* by Ranney (classified as a bad picture), *On Otter Creek* by Church, *Near the Penobscot, with Cattle* and *Study from Nature* by Kensett, *Head of Cayuga Lake, Church of the Holy Innocents at West Point, On the Delaware at Cochocton* and *New-York Harbor.* Genre scenes were sparsely represented on this occasion but did include *Snowballing* and *Sleeping Child* by Rutherford, of which the reviewer remarked that it was a good foreshortened head of "a very homely child; we hope that it will not be our lot to draw it."[22]

A daguerreotype from the 1850s indicates that art unions catered to local interests in various areas of the country and that the art union idea had spread over the entire nation. Primarily made to document an office of Adams and Company's Express chain in an unidentified town, the daguerreotype records a poster for the California Art Union, which offered "costly works of art" at the bottom of a listing headed by "A $2000 ingot of GOLD" and "the largest diamond in the United States" and including "diamond work, watches, and shawls" (Plate 3). In art union distributions, Gold Rush California was as eager as New York, and it is likely that there were fewer dissatisfied patrons there.

Art unions were declared illegal by federal court action against gambling in the mid-1850s, but their operation had spread domestic and imported art works to homes in every part of the continent. The art historian Marshall B. Davidson has pointed out the major cumulative effect of their activity:

> At mid-century modern American art was probably more widely popular than it has been at any other time in our history. For a number of years, what was in effect a national lottery run by the American Art Union distributed thousands of paintings by Cole, Bingham, and hundreds of other artists, and scores of thousands of engraved copies of their work, to an eager public in all parts of the land. The nation was steeped in its own image. . . .[23]

A stockpile of images was thus developed from which Americans learned about national character. Again, these images were of greater symbolic significance as they were increasingly truthful in their representations. The character of the nation could best be defined from accurate information about the objects making it up. Whether the concern was landscape, scenes of American life, or the great men of the age, the public needed

accurate visual information before it could discern the underlying implications of American character. The writers and artists who stressed national style and subject matter brought about a demand for correct visual imagery which only a medium such as the daguerreotype could satisfy.

The middle period of the nineteenth century explored sight as a wonderful new source of information. American painters reveled in picturing their landscape, particularly when its moods were expressed in atmospheric effects of light, twilight, or morning haze. Subtle tonal gradations were basic to the Hudson River School and to its successors Doughty and Church. Whatever the mood, however, these painters sought to engage the eye of the viewer deeply enough to lead his vision beyond the basic subject matter. They hoped keen observation of the mists over the hills would lead the viewer beyond the physical limits of the hills. Characteristically, Mrs. Moore traced the hand of God in her poetic vision of Niagara Falls, and Thomas Cole felt that people should find pleasure in viewing the wilderness which was chief among the creations of God. Both indicated that seeing the landscape—the "objects" of nature—was a prelude to feeling the presence of God; physical seeing was the gateway to spiritual perception and truth.

Early in the century Ralph Waldo Emerson described Transcendentalism in terms of the spiritual response elicited by nature in its viewer. His essay "Nature," published in 1836, spoke of the physical eye as the means to spiritual perception. If one could see keenly enough, he could pass beyond the limit of surface appearance to the underlying truth of the universe; if one could observe the objects of nature sensitively, he could discern the unity of all life in the Oversoul. For the next decade Emerson's writings on many subjects repeatedly involved sight and insight. His thinking so pivoted on the evidence of his eyes that he tended to sum up most of the concerns of the age in ocular terms. His writings provide a philosophical basis for the subconscious operation of many visually oriented elements in American society. By examining several of his thoughts on sight, we can recognize concerns that were widely active in literature and in the arts and sciences.

Emerson valued sight both for the pleasure of direct experience and for its symbolic function as the means to spiritual perception. In operation both were part of the cultural nationalism of the period as much as were literary demands for native content and Cole's preference for American landscape. Although Emerson shared his philosophical ideas with writers in Germany and England, he developed them from American situations under the influence of local scenes. He relied upon a universal optical ability, but he looked at Massachusetts to see God:

> The charming landscape which I saw this morning is indubitably made up of some twenty or thirty farms. Miller owns this field, Locke that, and Manning the woodland beyond. But none of them owns the landscape. There is a property in the horizon which no man has but he whose eye can integrate all the parts. . . . The lover of nature is he whose inward and outward senses are still truly adjusted to each other. . . . In the woods, too, a man casts off his years, as the snake his slough, and at what period soever of life is always

a child. In the woods is perpetual youth. Within these plantations of God, a decorum and sanctity reign, a perennial festival is dressed, and the guest sees not how he should tire of them in a thousand years. In the woods, we return to reason and faith.[24]

By universalizing the objects of the American wilderness, Emerson reached the principle of the universe along a symbolic path also followed by Cole and Thoreau. The visitor to the woods responded ultimately to the abstract Oversoul, but he responded immediately to a pleasing view of the wilderness representing the Oversoul. To go from the immediate to the ultimate, he first had to apprehend what he saw in the pleasure of direct experience:

> Such is the constitution of all things, or such the plastic power of the human eye, that the primary forms, as the sky, the mountain, the tree, the animal, give us a delight *in and for themselves*; a pleasure arising from outline, color, motion, and grouping. This seems partly owing to the eye itself. The eye is the best of artists.[25]

The viewer of nature depends on his eyes for the pleasure of what is before him, but even in his direct appreciation Emerson stresses keenness of seeing when he refers to outline, color, or grouping in nature. These are terms of artistic analysis of what is being seen in nature by the viewer's active participation and his assisting the creative act through seeing with recognition. No function in the entire realm of human sensitivity is more nearly the basis of photography.

Emerson also took pleasure in the direct experience of nature by sight in a way that necessarily involved a time sense:

> To the attentive eye, each moment of the year has its own beauty, and in the same field, it beholds, every hour, a picture which was never seen before and which shall never be seen again.[26]

Emerson is also willing to enjoy the transitory nature of what he sees, but he recognizes that each moment of existence is unique if only its uniqueness is seen. The fact that he uses the word "picture" suggests that he is concerned with recognizing the moment as a complete and organized image which is another basic element of photography. The twentieth-century photographer Henri Cartier-Bresson has developed the term "the decisive moment" to indicate exactly this sort of picture which he produces at the point in time when the subject reaches that unique moment which is the fullest indication of its character and significance. While such moments may occur several times for a given subject, each will differ from the rest because the subject never remains exactly the same, and each moment will be a "picture which was never seen before and which shall never be seen again."

Henry David Thoreau felt that the benefits to be derived from the experience of seeing were even more demanding than did Emerson and advocated stern training in firsthand perception:

> No method nor discipline can supersede the necessity of being forever on the alert. What is a course of history, or philosophy, or poetry, no matter how well selected, or the best

society, or the most admirable routine of life, compared with the discipline of looking always at what is to be seen?[27]

Since this statement occurs in Thoreau's description of his experiment in wilderness living at Walden Pond, it is evident that his views are also a response to the regional landscape. The theme is once more American nationalism.

Emerson felt that viewing nature provided other types of benefits in addition to those of pure visual gratification. There was a therapeutic aspect to observing the woods:

> The tradesman, the attorney comes out of the din and craft of the street and sees the sky and the woods, and is a man again. In their eternal calm, he finds himself. The health of the eye seems to demand a horizon. We are never tired so long as we can see far enough.[28]

The same thought of nature making people better was echoed by Thoreau with the added strength that nature's benefit was not limited to present experience but continued beyond the moment of sight:

> The cars never pause to look at [the Pond]; yet I fancy that the engineers and firemen and brakemen, and those passengers who have a season ticket and see it often, are better men for the sight. The engineer does not forget at night, or his nature does not, that he has beheld this vision of serenity and purity once at least during the day. Though seen but once, it helps to wash out State Street and the engineer's soot.[29]

The visual experience in this case is notable for providing the viewer with an image which is retained and continues to affect him even though the actual sight is brief and passing. If the engineer, or his nature, continues to respond to a visual image retained after the immediate experience has faded, he is responding, more or less unconsciously, to a symbolic image. An affective retained image would have to be a strong impression to continue to operate in the way Thoreau states; yet how much more affective the operation of a retained image might be if the entire impression could be permanently retained as in the case of a photograph. A situation existed for Thoreau in which the stronger a symbolic image could be, the more affective it would presumably be.

Thoreau felt that the beneficent influences of nature were derived from sources within nature which were below the level of eyesight but which depended upon the senses to activate them:

> [At Walden] I experienced sometimes that the most sweet and tender, the most innocent and encouraging society may be found in any natural object, even for the poor misanthrope and most melancholy man. There can be no very black melancholy to him who lives in the midst of nature and has his senses still.[30]

In succinct form this passage is the transcendental experience of recognizing one's unity with the universe, the "innocent and encouraging society" of belonging to the Oversoul. He derives the experience from perception of the objects of nature by direct means of his senses, and by these means sight stands to become insight.

For both Thoreau and Emerson then, keen perception was definitive in directing their responses to nature. Even as Thoreau noted that melancholy cannot overcome "him who lives in the midst of nature and has his senses still," so did Emerson remark the "property in the horizon" belonging to no man but "he whose eye can integrate all the parts." Emerson placed great stress on this need for sight as the source of all the benefits of nature when he commented that in the woods "I feel that nothing can befall me in life—no disgrace, no calamity (leaving me my eyes), which nature cannot repair."[31] He expanded this thought into an ultimate means by which to achieve the transcendental experience:

> Standing on the bare ground—my head bathed by the blithe air and uplifted into infinite space—all mean egotism vanishes. I become a transparent eyeball; I am nothing; I see all; the currents of the Universal Being circulate through me; I am part or parcel of God.[32]

So the process of sight may become the achievement of insight, and the viewer may become a seer. To regard an entire human being as a perceptive device, Emerson's faith in the value of sight must have been total. Few metaphors could better express the intensity of his visual response to nature. Emerson's transcendental philosophy grew essentially from this idea in an American setting; and its characteristics of response to native scenery, its concern for accurate visual observation, and its spiritual impulse combined to form a single intellectual system which could underlie the major symbolic processes operating in America at the time. These aspects of Emerson's visually oriented thought were his version of widespread American efforts to define the abstract elements of national identity. He, Cole, and Mrs. Moore looked at the objects of the American landscape and discerned the universal spirit of God. He, Grund, and the genre painters observed the American concern for work and found that workshops, occupations, and toil reflected a basic American drive which was spiritual in origin.

Similarly the child Henry James and the portrait painters perceived that national men were symbolic manifestations of the ideals of American character and as such became spiritual beings. The visible objects of America were the symbolic representations of abstract principles distinguishing American society and life from any other. It is easier to discern and respond to a symbolic object than to an abstract principle, and the more accessible these objects became for Americans—through such popular agencies as the art unions—the easier became the subconscious process of defining abstract national principles. In addition to being accessible, pictures had to be representationally accurate to function effectively as symbols, and since we have seen the objections to paintings because they were inaccurate, it is clear that a more precise medium was necessary for the job of recording visually the objects of our national character. Had the daguerreotype not become available in 1839, it is likely that progress in the symbolic definition of America as a nation would have been retarded for at least a generation.

One additional advantage of pictures over the actual objects of nature was that pic-

tures were retained images which could continue to influence after direct observation was no longer possible. Since a permanent image showed this potential influence more than an ephemeral impression, the detailed thoroughness and the permanence of a daguerreotype seemed to make it an ideal means to collect affective images otherwise lost in the passage of time. Defeating time in this way promised an otherwise unattainable source of insight into events or objects too transitory to allow thorough perception. Rendering the ephemeral permanent also implied a possibility of greater control which could be exerted over the significance of fleeting aspects of life; permanence also opened the reverse possibility that the images themselves could exert greater affective influence on their viewers than could the actual subjects. Several intriguing new moral implications of sight and perception were thus opened for exploration, and writers of the day gave them considerable attention.

Nathaniel Hawthorne explored numerous ocular phenomena in his writings. He frequently relied on visual elements to point up the moral climaxes of his stories, and more than one critic has remarked on the number of mirror symbols in his work, while he developed other stories around artists, hallucinations, a diorama man, or various kinds of pictures. His short story "The Prophetic Pictures" brings several of these elements into play as he makes a statement of moral speculation about the power of art in human life. A pair of ideal young lovers, Elinor and Walter, decide to have their wedding portraits painted by a supernaturally gifted old artist of whom it is said that

> he paints not merely a man's features, but his mind and heart. He catches the secret sentiments and passions, and throws them upon the canvas, like sunshine—or perhaps, in the portraits of dark-souled men, like a gleam of infernal fire.[33]

The couple proceeds to arrange for their own likenesses although they have seen several portraits by the artist and found them disturbingly perceptive; and Walter has begun to wonder about a suggestion of sadness that steals over Elinor's face when she is unaware.

> "The old women of Boston affirm," continued he, "that after he has once got possession of a person's face and figure, he may paint him in any act or situation whatever—and the picture will be prophetic."[34]

The two portraits are prophetic in facial expression, and a third sketch shown only to Elinor is prophetic in that Walter tries to kill her but is prevented by the intervention of the painter, who is now seen as a fate figure. The implication remains after the story, however, that the painter not only was perceptive enough to foresee the inherent tragedy in his subjects but that he was actually controlling them by means of the power he exerted over their images. Hawthorne raises but does not resolve the issue of how moral it is for an artist to apply his keen discernment to human lives once that discernment becomes powerful enough to influence the direction of his subjects' lives. The idea is Hawthorne's repeated plea for the sanctity of the human soul, but here he uses a visual context for his tale to raise a moral issue.

In *Mosses from an Old Manse,* Hawthorne expanded the moral implications of visual imagery in the short story "Monsieur du Miroir" by making a character of his own reflection in the mirror. After discourse about Miroir's inescapable presence, his flattery of imitation, and the curious places in which he made his appearance—such as horse troughs and mud puddles—Hawthorne's narrator wondered

> Is it too wild a thought that my fate may have assumed this image of myself, and therefore haunts me with such inevitable pertinacity,—originating every act which it appears to imitate, while it deludes me by pretending to share the events of which it is merely the emblem and the prophecy?[35]

Hawthorne often raised the thought of directing a person's life from without by capturing the image of his actions or his soul because of a determining link of fate between a man and his image. He exploited this link most fully in his novel *The House of the Seven Gables* where the portrait of Colonel Pyncheon recurs as a determining image of moral flaw inescapably connected to successive generations of the family. But in his story of Monsieur du Miroir he abandoned the idea of fate as the moral point and concluded,

> I will be self-contemplative, as Nature bids me, and make him the picture or visible type of what I must muse upon, that my mind may not wander so vaguely as heretofore, chasing its own shadow. . . .[36]

In this story Hawthorne's character uses the visual image to gain self-understanding in a fashion somewhat like the way Thoreau and Emerson use heightened perception to gain insight into nature. While his concern is to grasp the truth of the human soul, nature is his guide and keen insight arising from keen sight his means.

Like *belles lettres,* popular literature was often concerned with matters of perception in the decades before the Civil War. The thoughts were seldom as profound as Emerson's or as laced with searching moral issues as Hawthorne's, but their contributions to the mood of the time reflected widespread visual interest. Magazines of a sentimental persuasion, such as *Godey's Lady's Book,* and the various gift books frequently had stories or sketches about magic pictures or mirrors used as moralizing devices and allegories of life. Other writings used mirrors allegorically. In 1840 in "The Magic Mirror: or The Way to Wealth," a glass served as the agency of a moral fable:

> One evening—'tis an Eastern story—
> The lily slept, the bat was flitting,
> The sun on clouds of crimson glory
> Was, like an ancient Sultan, sitting,
> The sky was dew, the air was balm,
> The camels by the tents were grazing,
> A pilgrim sat beneath a palm,
> Upon the Western splendor gazing.
>
> He plucked in careless reverie
> A bud beside him; was't a flame

That quivered on his startled eye?
　From earth the little lustre came;
He lisped a prayer, and half in terror,
　The night had just began [sic] to close him,
Dug up the turf and found a mirror,
　And hid the sparkler in his bosom.

Next morn ere Sol's first ray had shot,
　The Pilgrim gazed upon his treasure;
The edge with mystic shapes was wrought,
　Wreath'd in a dance of love and pleasure.
But in the centre was the wonder;
　His face with youth and beauty shone!
Old time had yielded up his plunder,
　By Allah! fifty years were gone!

His hour of precious gazing o'er,
　The Pilgrim strayed to Bagdad city;
Then sat him by a Kiosk door,
　And tuned his pipe, and sang his ditty;
But not a soul would stop to listen.
　At last an ancient dame pass'd by;
She saw, by chance, the mirror glisten,
　Stopped, gazed, and saw her wrinkles fly!

A dozen like herself soon gazed,
　And each beheld a blooming beauty;
The story through the city blazed,
　Their alms were but a Moslem's duty!
The men and maids by thousands gathered,
　Each visage won the rose's dye;
The Pilgrim's nest was quickly feathered.
　The mirror's name was FLATTERY![37]

While the poem's first concern is to make a didactic statement about the exploitation of flattery, the visual device used implies an underlying human wish to offset the personal inroads of time. A magic mirror that recreates the past was a wonderful thought to consider in lieu of somehow stopping time altogether. In "The Prophetic Pictures," Hawthorne tried to account for the wish to have one's portrait made and, in doing so, gave a direct statement of a mortal public concern:

Nothing, in the whole circle of human vanities, takes stronger hold of the imagination than this affair of having a portrait painted. Yet why should it be so? The looking-glass, the polished globes of the andirons, the mirror-like water, and all other reflecting surfaces continually present us with portraits, or rather ghosts, of ourselves, which we glance

at, and straightway forget them. But we forget them only because they vanish. It is the lack of duration—of earthly immortality—that gives such a mysterious interest to our own portraits.[38]

Mortality, particularly in its sentimental form, was another theme of popular literature during the first two-thirds of the nineteenth century in both America and England. Hardly an issue of *Godey's* or *Ballou's* or *The Opal* or *The Casket* passed without several poems or sketches devoted to death and its deprivations. "The Dying Poet," "The Dying Shepherd," "The Dying Painter," "The Dying Child," were repeated titles and topics. Even relatively scientific magazines fell under the shadow of exquisite musings over death. Between a descriptive article on the Indian pangolin and one on the cereopsis of New Holland, *The New Pictorial and Illustrated Magazine* was just as apt as any to include "The Last Look":

> The insatient tomb has robbed almost every one whom it has spared, of some being on whom his eye rested with pleasure, who softened for him the asperities of life's rough pathway, and into whose bosom he poured his own heart's rich treasures—feelings, confidence, and love. They have seen them droop and die gradually, perhaps. They have seen the rose fade, the flesh waste, the muscles relax . . . and the final triumph of death. They have paced the room where the poor body lay shrouded for the grave, and where Death almost seemed visibly present . . . where the grim tyrant seems to be watching and gloating over his victim, and the riot of decay is already beginning to be seen. All this has lacerated and crushed their hearts; but perhaps the bitterest pang of all came with the last look into the grave, when the coffin had been lowered, the loved object consigned to its long, dreamless rest, and the busy spade of the sexton was throwing back the senseless earth upon it, and hiding it for ever.[39]

In such a climate of emotion, it is not remarkable that Hawthorne should feel that the lack of earthly immortality gave "such a mysterious interest to our own portraits." It is not surprising that the artist who could strike off a good likeness should have been revered as the provider of some degree of immortality or of some degree of reliable memory. As Hawthorne's painter of "The Prophetic Pictures" summed it up,

> Oh, glorious Art! . . . Thou art the image of the Creator's own. The innumerable forms that wander in nothingness start into being at thy beck. The dead live again. Thou recallest them to their old scenes, and givest their gray shadows the luster of a better life, at once earthly and immortal. Thou snatchest back the fleeting moments of History. With thee, there is no Past; for at thy touch, all that is great becomes forever present; and illustrious men live through long ages, in the visible performance of the very deeds which made them what they are . . . thou bringest the faintly revealed Past to stand in that narrow strip of sunlight which we call Now. . . .[40]

Under a widespread feeling of sentimental concern with mortality and a desire to transcend it by means of art, people turned to a variety of types of pictures in an effort to find reliable likenesses which average citizens could afford. While the wealthy traditionally called on the painter, his services came dear for the middle and lower classes. Itinerant limners did a certain amount of trade throughout the Colonial period and dur-

ing the first quarter of the nineteenth century, often working on prepainted images into which they spliced the faces of particular sitters. Charming as were some of the paintings thus produced, they were of doubtful accuracy, and they still represented a relatively artificial approach to pictorial immortality at a popular level. Various kinds of drawings in chalk, crayon, pencil, or charcoal were made rather widely in the same decades and were more accessible than paintings since drawing was often regarded as part of a young lady's social training. The relative lack of skill of most amateurs, however, made some form of mechanical aid to accuracy increasingly desirable during the late eighteenth and early nineteenth centuries.

A variety of mechanical devices were contrived during this period in a widening search for a means to improve recording of visual images. It is noteworthy that the public offered little challenge to including machines among the tools of the artist in an era which accepted several other forms of mechanization only under protest. Occasionally an artist might be chided for allowing his use of mechanical aids to show too visibly in the finished work, but he was not likely to be criticized for actually using them. Protests against other types of machines stressed their dehumanization, but demand for more factual accuracy made mechanical aids welcome in art.

The desire for a degree of immortality particularly encouraged their use in portraiture and helped to guarantee a favorable climate for the daguerreotype to exert a profound influence on the nation. It brought not only matchless, permanent images, but also a new means of self-definition for Americans. Hawthorne's conclusion to "Monsieur du Miroir" expressed this function, as we have seen, when he chose to be "self-contemplative" by making his image in the mirror "the picture or visible type of what I must muse upon, that my mind may not wander so vaguely as heretofore chasing its own shadow." Ultimately mechanical aids to portraiture were all efforts to preserve a mirrorlike image that would provide a basis for self-contemplation. The various machines employed were all ancestors of the daguerreotype in this symbolic function, and they can be recognized as attempts to produce something like the daguerreotype in their operation. Consciously they were meant to produce correct likenesses; subconsciously they were to help produce spiritual truth about American character.

One popular method of making likenesses that was more or less reliable, charming, inexpensive, and amenable to mechanical production was the silhouette since tracing a cast shadow is all that is required to produce a convincing likeness. One well-known example of a strong portrait made by this method is a profile of George Washington made by his niece, Eleanor Parke Custis, in 1798, now in the collection of the Metropolitan Museum of Art in New York. Many amateurs also felt equal to the task of attempting to cut a silhouette likeness without the aid of a shadow, using only the concentration of one's eye, but the results were not always happy. Alice Van Leer Carrick, a twentieth-century collector of silhouettes, describes

a rather clumsy hollow-cut profile [of Washington] in the Pennsylvania Historical Society, somewhat larger than life size, I should say, and sewed against a backing of coarse

brown paper, which is attributed to Martha Washington's workmanship. (She did not see him beautifully; I hope she loved him more than this profile indicates.) [41]

Mrs. Carrick notes that she has traced the activities of more than forty makers of profiles in America prior to 1839. She comments on a number of mechanical devices used in the trade to produce accurate renderings or to make possible multiple reproductions by some form of engraving. She mentions such remarkably named tools as the *physionotrace,* invented by the Frenchman Gilles Louis Chretien in 1786 and used widely in America by Fevret de St.-Memin to make over 800 portraits including those of several founders of the Republic. The device operated by a series of gears to translate the tracing of a sitter's profile onto a copper plate for printing while the operator made the original drawing. Lumped with the *physionotrace,* under the title "Automatic Drawer," one also might have found several other devices, including the *pantograph* and the *prosopographus.* Despite the bland character of the profiles produced by these machines, their relative accuracy made them desirable to the average person. They were prized in their own time, and many have been preserved for generations as tokens of ancestral features. Some likenesses were so treasured that they were not only preserved but were copied photographically in later decades to further guarantee their preservation (Plate 4).

Mrs. Carrick speaks of remarkable numbers of silhouettes surviving even today from the production of those early image makers. She mentions an album of cuttings by a man named Todd, in the Boston Athenaeum, which contains nearly 2000 identified profiles. One advertisement she reproduces gives a general idea of the activity of these profile makers:

Wm. King
Taker of Profile Likenesses
Respectfully informs the Ladies and
Gentlemen of Hanover [New Hampshire]
and its vicinity, that he has taken a Room
at Mr. *James Wheelock's* where he intends to
stay one week to take
PROFILE LIKENESSES
with his Patent Delineating Pencil.

He takes the Profiles in six minutes, on a beautiful *wove paper,* with the greatest possible correctness which is well known, he having taken above twenty thousand in *Salem, Newburyport, Portsmouth, Portland,* and all their adjoining towns; and from them he has selected a few as specimens, which may be viewed at his Room.

His price for two Profiles of one person is Twenty-five Cents—and frames them in a handsome manner, with black glass, in elegant oval, round or square Frames, gilt or black—Price from *Fifty Cents* to *Two Dollars* each.

Mr. King respectfully solicits the early attendance of those Ladies and Gentlemen, who intend to have their Profiles taken, as he must leave town at the above named time. —Constant attendance from 8 in the morning till 10 in the evening.

March 24th, 1806.

N. B. Those who are not satisfied with their Profiles previous to their leaving his Room, may have their money returned.[42]

If King was a typical profilist, it appears that some substantial part of the desire for permanent images of loved ones or of oneself was being satisfied by this method. Men who produced from two to twenty thousand profiles single-handed account for a vast number when all the professionals and the countless amateurs are considered. Certainly King's prices and his money-back guarantee put the profile within reach of nearly every person desiring one. But it was not enough. A profile can produce a charming impression, potent in the absence of more lifelike imagery, but it is not a living likeness. Better methods were still wanted.

In 1807 the Englishman William Hyde Wollaston invented the *camera lucida*. This was an instrument using a prism with an eyepiece so that a draftsman looked directly at his subject and saw a virtual image of it on his paper at the same time, needing more or less only to trace the apparent image. It was popular with travelers because it aided rendering complex detail and perspective correctly and easily. Basil Hall used it to document his American travels, publishing in 1829, in Scotland, *Forty Etchings Made with the Camera Lucida in North America in 1827 and 1828.* In the preface he praised the instrument for liberating the amateur from "the triple misery of Perspective, Proportion and Form." He concluded by remarking that if Wollaston had not found the "Royal Road to Drawing," he had "at least succeeded in Macadamising the way already known."[43]

One other mechanical device was frequently used by more professional artists in the eighteenth and nineteenth centuries, though talented amateurs found it equally useful. This was the *camera obscura,* an old device as far as its idea was concerned; the idea of darkening a room and admitting light by a single small opening onto a white wall, there to project a living image of whatever was outside, was noted by Leonardo da Vinci and specifically encouraged for artistic use in Italy as early as the middle of the sixteenth century. With the growth in popularity of landscape painting, the labor of reproducing extensive detail made the instrument increasingly popular. By 1764 Count Francesco Algarotti noted that

> The best modern painters among the Italians have availed themselves greatly of this contrivance; nor is it possible they should have otherwise represented things so much to life.[44]

By the nineteenth century the *camera obscura* had diminished in size from a room and a sedan chair, to a portable box equipped with a lens for magnification and focus and an internal mirror to redirect the image onto a glass viewing screen on the top where the artist could trace his drawing. It was almost a drawing machine, and many artists remarked in delight on the charm and fascination of the little image on the ground glass. The narrator of the Great Moon Hoax of 1835 referred to this type of image as a standard for lifelike delineation when he wrote of the appearance of his blue-grey lunar unicorn:

This beautiful creature afforded us the most exquisite amusement. The mimicry of its movements upon our white painted canvas, was as faithful and luminous as that of animals within a few yards of a camera obscura, when pictured upon its tympan.[45]

Ralph Waldo Emerson found the images of the *camera obscura* entrancing. In his 1836 essay "Nature," he used the device to illustrate a point about how nature reveals new dimensions if seen from a new viewpoint:

The least change in our point of view gives the whole world a pictorial air. . . . Nay, the most wonted objects (make a very slight change in the point of vision), please us most. In a camera obscura, the butcher's cart, and the figure of one of our own family amuse us.[46]

Emerson's philosophical process of going from sight to insight could profit from mechanical aids as readily as could popular portraiture. He specifically pointed out the value of the machine for leading physical sight to inward perception:

In these cases [such as the use of the camera obscura to gain new viewpoints], by mechanical means, is suggested the difference between the observer and the spectacle—between man and nature. Hence arises a pleasure mixed with awe; I may say, a low degree of the sublime is felt. . . .[47]

Many an artist must have studied the image on the view screen of his *camera obscura* and wished it could record itself without intermediate effort. Anyone at the time who was aware of a book published at The Hague in 1760 by one Tiphaigne de la Roche must earnestly have wished for the actuality of a phenomenon the writer described:

Tiphaigne represents himself as transported into the palace of the elementary genii, the chief of whom speaks in this manner:
"You know that the rays of light reflected from different bodies, make a picture and paint those bodies on all polished surfaces: on the retina of the eye for example, on water, and on ice. The elementary spirits have sought to fix these transient images; they have composed a very subtle substance, very viscous, drying and hardening very rapidly, by means of which a picture is made in the twinkling of an eye. They harden with this substance a piece of cloth, and place it before the objects they wish to paint. The first effect of the cloth is that of a mirror, all the near and distant objects whose images can be brought to light, are visible; but what a glass cannot do, the cloth, by means of its viscous hardening does, it retains the shadow. The mirror gives you faithfully all objects but retains none, our cloth gives them, not less faithfully, but keeps them all. This impression of the images is the work of the first instant in which the cloth receives them. It is immediately taken away and placed in a dark place; an hour after, the coating is dry, and you have a picture, the more precious, since no art can imitate the truth of it, and time cannot injure it in any manner. We take, in their most pure source, from the body of light, the colors which painters draw from different materials, and which time never fails to injure. The precision of the drawing, the variety of expression, touches more or less heavy, the gradation of the shades, the rules of perspective, we abandon all this to nature, who with that sure step which is never mistaken, traces on our cloth images which impose on

27

the eye and cause reason to doubt whether they are realities, or only specious phantoms, deceiving the eyes, the ears, the touch—all the senses at once."[48]

Could such a medium have existed, Hawthorne's remarks on the "lack of duration —of earthly immortality" of our mirror images would have been idle. Thomas Cole could have preserved his vision of the American wilderness more perfectly than either his brush or his words could do. With such a process Cole could have held the image of the unspoiled landscape forever against the onset of civilization.

Through such a medium, technology itself could offset partially the loss of the wilderness to technological change. By 1850 America was in full transition from an agrarian, rural nation to one both industrial and urban despite any wish of the artist or the philosopher to restrict the damages sustained in the change. Not all spokesmen, however, felt wild nature was in fact important enough to preserve against the coming of an industrial nation. Some felt that nature was actually improved by being subdued and subjected to the influences of civilization and that images of the wilderness were sufficient as reminders of the past. As an unidentified writer asserted in the *North American Review:*

> All needful transformations of substance are but little lower than angelic. And, although it be a change to less external beauty, yet the higher human purpose served lends a higher beauty; so that an unsightly telegraph pole may be more noble than the tree from which it was formed, and a city may be grander than a forest.[49]

After claiming that "Nature never works so well in vegetation as when she unites with the industry of man,"[50] the writer continued by asserting that "Axes were foretold by trees, mills by cascades, railroads by levels and chasms, and steam-ships by oceans."[51] The writer went even so far as to assert that

> The small stone tower at Niagara Falls [(Plate 142) which people for generations regarded as an abomination on the face of nature] humanizes the shaggy, foaming creature; the bridge to Iris Island is a collar on the lion's neck, attesting the empire of man. All the artificial surroundings help the vastness of the cataract, by needed comparison; and it matters not what are the accessories of such a wonder; it is an immense revolving emerald set in the universe, not merely in its own narrow shores and cliffs. Wherever a tenement is desired, let it be built. Sooner may we upbraid the wasps for hanging their paper nests upon any tree . . . with no eye to the effect of scenery, with no respect to its proprieties. Man has claim to, and is a creature of, the earth, no less than birds and insects. We are placed here, not in the moon; are workers, not simply spectators of land and sea; are not all eye, but hands also. What if the Old World parks be sold for pence and given to the poor; their beauty will live in song and painting. What though every American solitude be overrun; its glory will remain in the lines of poets, the pages of novelists, the canvas of landscape artists.[52]

This was a view which, aside from sniping at Emerson's conceit of becoming a vast eyeball, the better to contemplate nature, applied the national impulse to work in an effort to reverse Thoreau's view that nature was a beneficent spiritual influence on man.

28

The anonymous writer, in stating this view which was generally put into practice though much at odds with that stated by Emerson and Thoreau in the early nineteenth century, responded to many of the same impulses as guided the views he opposed. His belief in the significance of Niagara Falls is as clear as his faith in the power of art to preserve the values of those natural scenes civilization must needs destroy. He also seemed to approve the popular demand for creative subjects drawn from the American scene. This was a view which came as a logical extension of the cultural nationalism of the early decades and culminated in the pride Americans felt in the nation's showing at the Crystal Palace —particularly in mechanical technology.

By the middle of the nineteenth century, the pattern of key impulses and ideas making up American cultural nationalism—nativism of the arts, emotive response to nature, idealization of labor, spiritual definition of the American scene, desire to offset mortality and time, and reliance upon machine technology as producing a higher spiritual state for humanity—was frequently rearranged, depending upon whose view was being expressed. Often similar basic concerns led thinkers to respond to their milieu in opposed ways, and a single writer might seem to hold contradictory views at different times according to which of the prevailing impulses of the time was affecting him most strongly at a given moment. It is not surprising, therefore, that this unidentified writer should stand at odds with Cole, Thoreau, or Emerson on the relative values of wild nature and technological progress while he shared much of their view about the preservative value of art for serving the needs of man in seeking the truth of nature. The difference in position arose from the writer's commitment to machine technology as the best way to achieve the spiritual purpose of the universe by bringing the affective insight of man to domination over the material world. Essentially, his desire to apply mechanical means to the process of intensifying sight in order to achieve insight was the same as it was for Emerson; the difference was that he began from a point in technological society while Emerson began in the natural woods. The distinction in view was more one of locale than of purpose and was indicative of the ambiguous nature of intellectual response to the transition from an agrarian America to a semi-urban nation. Even Emerson was able to include the technological view. His philosophy rested in part on the same sort of alert perception that prevailed in the physical sciences of the day. For him, as well as for the geologist or the botanist, descriptive evidence and keen observation were the foundation for discerning truth. As he noted in his second essay on nature in 1844,

> Things are so strictly related, that according to the skill of the eye, from any one object the parts and properties of any other may be predicted. If we had eyes to see it, a bit of stone from the city wall would certify us of the necessity that man must exist, as readily as the city.[53]

Emerson's archaeologically deductive use of observation was fully proper in method to the science of the day. It implied the type of analytical description and classification which was at the bottom of most studies in natural history. Mechanical aids to perception were as well received by scientific men as by painters. The telescope and the micro-

scope were primary tools in scientific popularity and in the public imagination. The Great Moon Hoax of 1835 depended for credibility on the fast pace of technological advances being made during the period, particularly in the fields of light and optics. It turned on a fanciful system for intensifying the magnified image of a huge telescope which made it possible to see details of life on the moon. Later in the period a fantasy by Fitz-James O'Brien capitalized on public imagination about the microscope. In his short story "The Diamond Lens," the narrator is visited by the spirit of van Leeuwenhoek, the inventor of the microscope, and told how to grind a perfect lens from a diamond. He does so and discovers humanoid life in a drop of water. The keen vision of science aided by a mechanical device falls into the category of nineteenth-century sentimental mortality, however, when the "animalcule" he finds proves to be a breathtakingly beautiful woman with whom he promptly falls in love. His heart is broken as he helplessly watches her waste away and die as the water drop dries up.

The unnamed author from the *North American Review* set down the view of a self-certain America when he wrote that in the life of the 1850s:

> Man is the engine, intuitions and rules the track, the life the steam; he must work away and play away, on or off the track. The proverbial American propensity to whittle is but an excess of irrepressible vitality, in conjunction with the temptation of a shingle architecture and the various necessities of a new country; it is not an accidental peculiarity.[54]

He recognized that the American impulse to be busy matched others in the American scene. He also sensed that these various impulses operated together to produce Amercian traits which defined national character. Continuing in this vein of cultural nationalism, he observed:

> We do not hesitate, in loose language, to call any artificial thing very natural in its circumstances; all that is human appears quite inevitable, to some moods of mind. The Mormon temple, absurd as it seemed, was but an aerolite thrown westward by the fiery superabundant energy of the nation. . . . The large American hotels, everywhere rising, are the splendid icebergs suddenly brought upon us by the currents of travel and migration, and sweeping down from the cold arctic of wealth to summer seas of common sympathy and use. Washington Monuments are the necessary craters for the volcano of national glory. Broadway, or Washington Street, or Chestnut Street, is a deep strait for a roaring gulf-stream of Cisatlantic life; vehicles are the drifted shells of many hues, silks the beautiful seaweed, and brick buildings the red, marble the white, ever-growing coral-rocks. Reaping-machines are patent whirlwinds. Bowie-knives are the long thorns put forth by the human crab apple tree, before it is reclaimed to sweetness by cultivation. All is life and growth in the universe,—forces seeking form.[55]

A view so certain as this could easily encompass the thought that progress must be inevitable, that those things needed in human affairs would inevitably follow upon the appearance of the need itself, that any good which needed to be produced would inevitably find an agency by which to bring itself into being:

> Books, statues, pictures, are well called children of the brain; they are unavoidable off-spring of it . . . for, by some inscrutable means, all needed books, pictures, and inventions find authors for themselves.[56]

This view provided adequate room for the machine as a potential source of answers to people's needs. The conjunction of pictorial requirements and the machine would in no wise strike false notes to the pattern of these thoughts. The artist might well expect the cloth of the "elementary genii" or his *camera obscura* to produce permanent images for him provided the need for some sort of self-registering picture machine became great enough for the invention to find an author for itself. As the anonymous writer summed up his thought in spiritual terms, "The time may come when men . . . will go to the picture and machine to meditate on the Infinite. . . ."[57]

The function of pictures as symbols representing national characteristics and spiritual impulses was better served with the help of machines than by human skill alone. As a result, the picture-making machine was easily invested by the public with symbolic and spiritual significance. Through succeeding decades of the century this unconsciously attributed significance increased as these machines became more effective and more nearly independent of human fallibility in their operation. Mechanical recording of images needing less and less human skill ultimately led the public into almost total reliance on images preserved with the aid of machines. By 1840 various indigenous needs demanded an ideal recording machine that could stop the passage of time and hold an accurate and complete image to which people could respond in terms of spiritual insight. Emerson's philosophical ideal of physical sight becoming spiritual insight by keen observation of nature became a practical activity once the medium of the daguerreotype became available for use in the definition of American society.

Americans were searching for ways in which to define themselves as cultural nationals. In their search they utilized the abstract means of language—as in nationally oriented literature or natively developed philosophical systems—but they needed objects, or, better, symbolic representations of objects, to respond to in order to be able to attain adequate insight for self-definition. The daguerreotype ideally answered their need.

Once it is evident that the daguerreotype was both needed and inevitable, four basic thoughts must guide our examination of the medium in American society. First, we must recognize that the daguerreotype provided a new way for people to see themselves. It was a way which became so popular in America as to constitute almost a universal experience as people saw and recorded and responded to their views of themselves and their age.

Second, we must recall that when people dealt with daguerreotypes they were responding to direct images. Each daguerreotype was unique. Efforts to publish daguerreotypes on any large scale were generally unsuccessful. Such a limitation meant that public response to daguerreotype pictures was immediate and at the personal level—the level most likely to have an emotional impact. Response to the daguerreotype remained primarily individual throughout the entire period of its use, although there were displays of pictures in most daguerreotypists' studios and a few public galleries of celebrity portraits

were opened. Portraits of public figures were copied for sale by the daguerreotype process itself—which produced identical copies—and some were multiplied in the 1850s by means of electroplating which produced perfect duplicates of a coppery appearance. The proportion of such copies to the total volume of pictures made, however, was relatively small.

Third, we must recognize that the greatest majority of the daguerreotypes produced were made deliberately. The relatively slow nature of the process usually meant that candid pictures were not possible. The pictures were deliberate in that they were produced by the conjunction of a knowing sitter and a purposeful cameraman. This conjunction usually guaranteed that whatever was recorded on the daguerreotype plate was there by design and by a choice which implied an attachment of some value to the subject. Well over ninety percent were single or group portraits made for commercial reasons in answer to customer request; the sitter or the daguerreotypist wanted the record made for some particular reason—perhaps not a fully conscious one, but the record reflected some attitude or feeling.

Finally, these three ideas combine to suggest a fourth: the basic assumption that the main function of the daguerreotype in American society was a symbolic one. Daguerreotypes were deliberately wrought images to which people responded at a level of personal feeling. At times they responded more directly to the images than to the subjects themselves, as in the case of a portrait of a person not present or no longer living. In these instances the value attached to the subject of a picture was often transferred to the picture itself in a way that allowed the picture not only to reflect attitudes or feelings but to affect them in terms of what people saw and how they saw it.

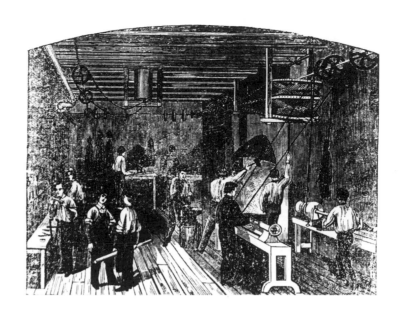

Chapter 2

ORIGINS AND INITIAL RECEPTION

HEN PHOTOGRAPHY, in the form of the daguerreotype, became available to the world in 1839, it was the culmination of many efforts to make nature record her own image by means of light. Legend has it that ancient cultures possessed various forms of magic mirrors which retained images reflected in them, and the late Middle Ages give accounts of small mirrors carried or worn by religious pilgrims in which images of holy places were symbolically or physically captured and carried home. The power of light to cause chemical and physical changes has been noted for centuries; the fading of dye colors variably exposed to light has been observed, and attention has been drawn to changes in plants and minerals caused by sunlight and shadow. Not until the eighteenth century, however, with its emphasis on reason and experimental science, are there substantial records of efforts to fix images by utilizing light-sensitive materials.

In 1727 Johann Schulze established the base point for nearly all subsequent photo-

graphic processes.* He defined the light sensitivity of silver nitrate and used it to record the shapes of letters by exposing the solution to light through a paper stencil. Following decades saw numerous experiments using Schulze's basic principle, though frequently these efforts were made without reference to each other or without knowledge of Schulze.

Numerous attempts at a photographic medium seem to have been made between 1780 and 1825, some of which appear to have been successful only to be hidden for one reason or another. Several publications in the 1860s reported circumstantial evidence indicating that in the 1790s Matthew Boulton had been connected with a secret fraternal group called the Lunar Society which was concerned with producing "sun-pictures" on plates of silvered copper.[1] Pictures of Boulton's house, reputedly made with a camera in 1790, were said to resemble daguerreotypes closely and were under investigation by the British Patent Office. The Lunar Society membership reputedly included such illustrious scientific men as Joseph Priestley, William Herschel, James Watt, and Josiah Wedgwood. It seems that in such company any attempt to make pictures with light should certainly have succeeded. During the Patent Office's historical research into Boulton's activities, a Miss Meteyard independently uncovered further "pictures on silver" while examining Josiah Wedgwood's library. At the same time she found a letter from James Watt to Wedgwood, dated 1799, in which he commented that he would try to make "silver-pictures" by a method Wedgwood had mentioned. Her description indicated that the pictures were positive images, although faded. If the images had survived seventy years and were still definable, it seems reasonable to suppose that some type of photographic image had been fixed by at least one of the various attempts made in the late eighteenth century.

More typical of efforts during this period, and better known in photographic history, were the experiments made around 1790 by Thomas Wedgwood, Josiah's son, and Sir Humphry Davy. Utilizing the light sensitivity of silver nitrate coated on white leather or paper, they succeeded in recording printed copies of paintings by contact exposure without a camera. These experiments were like most others in that they were made with paper and produced negative images which reversed the light and dark areas of the subject. The pictures were also typical in that they were disappointingly impermanent. They would not bear continued exposure to light without turning completely black, and Wedgwood was reduced to looking at them briefly by dim candlelight.

In 1816 the French lithographer Joseph Nicephore Niepce produced results similar to those of Wedgwood in their negative appearance, and he was also able to produce images from life with a camera. Without realizing that one further step would reverse the values to produce a positive image, he abandoned that line of experiment to seek a substance which light would bleach instead of darkening. His experiments had been undertaken because he wanted to produce direct positive images on stones or metal plates to be used for reproduction printing, and he had not initially thought of his recorded images

* The basic historical details of this chapter not otherwise documented are essentially from *The History of Photography* by Beaumont Newhall.

as end products. Turning away from silver compounds, he began testing oil soluble asphalts which became insoluble on exposure to light. With this means he was able to produce direct printing plates for the reproduction of engravings and drawings in line, thus devising the first photo-mechanical printing process to be more than an experiment. In 1826 Niepce set up a camera in the window of his workroom at Chalon-sur-Saone, France and made what is generally regarded as the world's first true photograph. Now in the Gernsheim Collection of the University of Texas,[2] this pewter plate with an image of bitumen of Judea (asphaltum) required an exposure of eight hours in bright sunlight to record a view of the buildings and the yard of Niepce's estate.

Niepce's success remained almost totally secret for over ten years and then was relatively lost in the commotion over publication of the daguerreotype. The problem of "sun painting" had still not been effectively solved.

Such experiments were not confined to Europe. Americans were also fascinated with the *camera obscura*, and some attempts were made to fix its images. Samuel F. B. Morse, the first American to see a daguerreotype, included in his letter about the medium a reminiscence of his own efforts to capture pictures with light-sensitive paper at about the same time as Niepce achieved success:

> I don't know if you recollect some experiments of mine in New Haven, many years ago, when I had my painting-room next to Professor Silliman's—experiments to ascertain if it were possible to fix the image of the *camera obscura*. I was able to produce different degrees of shade on paper, dipped into a solution of nitrate of silver, by means of different degrees of light; but, finding that light produced dark, and dark light, I presumed the production of a true image to be impracticable, and gave up the attempt.[3]

Morse's efforts suffered the same general fate as those of Thomas Wedgwood and the early attempts of Niepce. Morse produced negative images and abandoned the project without realizing that printing further pictures from the first would correct the tonal reversal.

Another report of an American effort to fix images by light reflects the climate of nativism and cultural nationalism which prevailed in the United States during the first half of the nineteenth century. In 1849 Henry Hunt Snelling wrote one of the first history books on photography; there he told of experiments by James M. Wattles at New Harmony, Indiana in 1828. Like others of the period, Wattles seems to have been charmed with the images produced by the *camera obscura* after he was employed to make landscape sketches with the device for instructors at the New Harmony School. In Snelling's account Wattles was sixteen years old and quite unversed in chemistry or physics; yet, despite ridicule from his parents and teachers, he persisted in trying to capture the engaging pictures he saw in his work. Snelling said of Wattles that

> his experiments and their results will, undoubtedly, be interesting to every American reader and although some of the profound philosophers of Europe may smile at his method of proceeding, it will in some measure show the innate genius of American minds, and prove that we are not far behind our trans-atlantic brethren in the arts and sciences.[4]

Making the best interpretation one can of vague chemical terms, it seems that Wattles followed essentially the same procedure as most other experimenters except that he gained enough sophistication to discover that less chemically active silver compounds were more sensitive to light than silver nitrate was. His own description of his work, quoted by Snelling, indicates that he was able to fix the images by removing the excess unexposed silver compound with a strong bath of sal soda. He admitted that the pictures he produced were blotchy, but he blamed the quality of his paper and noted that his overall results were

> enough to convince me that I had succeeded, and that at some future time, when I had the means and a more extensive knowledge of chemistry, I could apply myself to it again. I have done so since, at various times, with perfect success; but in every instance laboring under adverse conditions.[5]

If Mr. Wattles did actually succeed in such a process "with perfect success," it is a singular misfortune that his results were never made public. Whether his success was fully perfect or not, Snelling urged his readers to

> feel a national pride . . . that a mere yankee boy, surrounded by the deepest forests, hundreds of miles from the populous portion of our country, without the necessary materials, or resources for procuring them, should by the force of his natural genius make a discovery, and put it in practical use, to accomplish which, the most learned philosophers of Europe, with every requisite apparatus, and a profound knowledge of chemistry—spent years of toil to accomplish.[6]

Whatever the truth of the story of Mr. Wattles may be, Snelling's recounting of it to satisfy a nationalistic bias underlines the accompanying comment of Edward Anthony, the nation's leading photographic manufacturer of the time, that "when the age is fully ripe for any great discovery, it is rare that it does not occur to more than a single mind."[7]

The independent achievement of the Englishman William Henry Fox Talbot stands as a further illustration of Anthony's remark. Talbot devised the first practically effective permanent system of photography—a process based on paper made light sensitive with solutions of silver. Beginning in 1833, he worked for several years to record and fix the images thrown by a *camera obscura*. By 1835 he had worked out the problem of fixing the images with strong solutions of common salt and had realized that reprinting the negative pictures would give correct images in easily produced multiple numbers. With this printing method he established the negative-positive basis of photography still in use to day. For several years he further perfected his process without making it public, but with the French announcement of the daguerreotype on January 7, 1839 he became concerned for the primacy of his invention and published it, together with samples of pictures from as early as 1835, at a series of meetings of the Royal Academy in January and February of 1839.

After the announcements of both the daguerreotype and Talbot's system of "Photogenic Drawing," but before either process was made public, Sir John Herschel, son of the

great English astronomer, independently developed a photographic process similar to Talbot's but with an additional step. Herschel removed excess light-sensitive silver salts with "hyposulphite of soda," now known as *sodium thiosulfate,* the "hypo" of photographers everywhere. This chemical became the final necessary element in permanent silver-based photography, and it is still used today for the same purpose. The chemical was immediately adopted by Talbot and soon after by the inventor of the daguerreotype, so that 1839 was the year in which all the major essentials of subsequent systems of photography became available at once.

The daguerreotype process of 1839 was more or less exclusively the brainchild of the French illusionist painter Louis Jacques Mande Daguerre (1789-1851) who had labored over it for nearly twenty years. Widely known in France and England as a scene designer and operator of supremely convincing diorama presentations, Daguerre had devoted his life to the creation of realistic illusions. His painted diorama views of a storm in the Alps or of a midnight mass in a great cathedral were so effective that visitors from the provinces threw coins onstage to test the apparent spatial depth they thought they saw. By the use of transparent scrims and variable lighting, Daguerre was able to create the impression of movement and changes in time of day to convince audiences that they had actually seen the passage of a procession or the occurrence of living events. In his efforts to achieve realism of scenic effect, Daguerre often relied on the *camera obscura* for correct detail and perspective; like so many of his contemporaries he became entranced with the thought of capturing the images he watched on its view screen.

After he had experimented for some years with little success, Daguerre learned of Niepce through their common lensmaker. He initiated a haphazard correspondence with Niepce which lasted for several years without resulting in more than mutual suspicion. After Niepce had failed to have his photographic system of "Heliography" taken up by the British Royal Society, he sought closer acquaintance with Daguerre. The two signed a ten-year contract of partnership on December 4, 1829, but practically nothing fruitful had come of their joint efforts when Niepce died in 1833. Daguerre continued his explorations, sometimes alone, sometimes unofficially in company with men whom history has failed to record, such as William Archdall O'Dougherty with whom Daguerre worked in England.* By 1835 Daguerre had made sufficient progress to allow a premature announcement of his work, and by 1837 he had fully solved the problems of fixing the images of his *camera obscura* on silver-plated sheets of copper. Persuading Isidore Niepce, Nicephore's son, to renegotiate the partnership, Daguerre tried unsuccessfully to arrange a subscription to develop the refined process. Finally he reached the attention of the great scientist Francois Arago. Once Arago was convinced of the possibilities of the daguerreotype, the prehistory of photography was over.

Arago lectured on Daguerre's invention before the French Academy of Sciences on

* This information was communicated by Sister Gabriel, a descendant of O'Dougherty, to Rev. Arthur D. Spearman, S. J., Archivist of Santa Clara University, California, whose informative letters and whose loan of photographs have been greatly appreciated.

January 7, 1839, proposing that the discovery be investigated for possible purchase by the government to be published to the world. Coming from so reliable a source, the mere announcement of an effective photographic process set off vast excitement. The reaction of the London *Spectator* was somewhat restrained by comparison:

> An invention has recently been made public in Paris that seems more like some marvel of a fairy tale or delusion of necromancy than a practical reality: it amounts to nothing less than making light produce permanent pictures, and engrave them at the same time, in the course of a few minutes. The thing seems incredible, and, but for indisputable evidence, we should not at first hearing believe it; it is, however, a fact; the process and its results have been witnessed by M. Arago, who reported upon its merits to the Academie des Sciences. To think of Nature herself reflecting her own face, though but as "in a glass, darkly," and engraving it too, that we may have copies of it![8]

To appreciate fully the intensity of excitement such reactions implied, we must remember that at the time of Arago's report nothing of the kind was known to the world—Niepce and Talbot were unheard of and Herschel still had to devise his system.

Noting that the invention was "authenticated past the power of question, by the testimonies of such men as Biot, Von Humboldt, and the reporter (M. Arago)," the Paris correspondent of the London *Athenaeum* reported, "It is necessary to see the works produced by the newly-invented machine, which is to be called the Daguereotype [sic], fully to appreciate the curiosity of the invention."[9] Having interviewed Daguerre and examined some of his pictures, the correspondent observed that

> Some of his last works have the force of Rembrandt's etchings. He has taken them in all weathers—I may say at all hours—for he showed me a sketch of Notre Dame made in a pouring rain, (the time occupied by the process being lengthened under such unfavorable circumstances,) and a sketch procured under the moon's light, which required twenty minutes for its completion.[10]

Comparison with Rembrandt promptly because a general touchstone for discussing the monochromatic continuous-tone subtleties of light and dark which had never been seen before, and the medium's acuteness of rendering of atmospheric conditions was a constant marvel. The length of time needed for making an exposure created some limitations on public satisfaction:

> As might be suspected, the invention, comparatively speaking, fails where moving objects are concerned. "The foliage of trees,". . . to quote M. Arago, "from its always being more or less agitated by the air, is often but imperfectly represented. In one of the views a horse is faithfully given, save the head, which he never ceased moving—in another a *decrotteur* [bootblack], all but the arms, which were never still."[11]

Enthusiasm for the new medium was sufficient, however, that a fortunate use was predicted for even this limitation, though attention turned to a related criticism:

> The invention, it is obvious, will be chiefly applicable to still life—that is, to architectural subjects, &c. The reporter [Arago] . . . however, after pointing out the immense advan-

tage of such a process to travellers,—whom it enables under the most perilous circumstances of position or temperature, to obtain a fac-simile of any desired scene or monument of antiquity—objects to the invention, that there is still wanting to its results something to be given by the hand and eye of the artist. . . .[12]

Upon first consideration an objection to the new medium on ground of its being a mechanical approach to picture making seems strange coming from a scientific man like Arago. Further thought, however, suggests two facts basic to many reactions to the daguerreotype. Initially there was the fact that the medium was a supremely effective means of recording. Nothing approaching its accuracy had ever been seen. The pictures seemed more real and exacting in their truth to nature than did nature herself when viewed at firsthand. As the *Spectator* remarked,

> The precision and exactness of the effect of the pictures may be judged of from these facts: the same bas-relief in plaster and in marble are differently represented, so that you can perceive which is the image of the plaster and which of the marble; you may almost tell the time of day in the outdoor scenes. Three views of the Luxor Obelisk were taken, one in the morning, one at noon, and the other in the evening, and the effect of the morning light is distinctly discernible from that of the evening, though the sun's altitude, and consequently the length of the shadows, are the same in both.[13]

That Arago himself felt the effect of this degree of precision is certain from a report in the *Athenaeum:*

> As an additional proof of the delicacy of M. Daguerre's machine, M. Arago mentioned the fact, that in one view, a lightning conductor upon a house was correctly represented, but so minutely as only to be discerned through a magnifying glass.[14]

Such an extreme degree of acute recording reached so far beyond any known skill of man as to seem subtly inhuman and disturbing. The medium of the daguerreotype was more than once regarded with an uncomfortable, subconscious suspicion of being magic. Arago seems to have felt this aura of the strange when he was confronted with Daguerre's pictures.

The early pictures themselves intensified this mood by their eerie representation of Paris as a city complete to every brick yet totally devoid of life. Since even the most carefully detailed paintings of the age—such as those of David or Ingres—were still oriented to a central concern with humanity, people were used to thinking of pictures as centering on man. Since it was also the period of Romantic painting, pictures were expected to idealize the world by addition or suppression or interpretation. Now, suddenly, people in one of the most art-conscious cities of the world were confronted with pictures that were uncompromisingly acute in itemizing the details of the world but which simultaneously removed all trace of human life. The absence of color in such otherwise perfect representations further stressed this effect, as did the curious negative-positive character of the image on a perfect mirror surface that turned realistic scenes into ghostly negative images with the slightest change of viewing angle. All these elements combined with the sheer novelty of the medium to make a sensitive viewer's fascination carry a thin

edge of discomfort that was seldom adequately expressed except in statements wishing for the intervention of some visibly human artistic agency.

The second major factor underlying Arago's wish for the daguerreotype to be modified by the action of an artist was a matter of visual conditioning. No person of Arago's time had ever seen a photograph; consequently there was no rule for determining how a photograph should look. All one could do when confronted with the new pictorial medium was to measure it against standards he knew, such as those of painting. While painters of the time stressed realism, they operated under the traditional artist's license to alter reality at will as long as the final image seemed convincing. They also operated under conventions of how certain subjects should be represented. A machine, on the other hand, seemed to be lacking in human powers of selection and interpretation without which its products were under suspicion however perfect they were in realistic detail. The Romantic period generally regarded the creative human being as more valuable than his tools and felt that personal style was a key factor in defining the worth of a given picture. Unfortunately for the camera, attention usually fell on the machine alone without considering that the machine did have a human operator. Since the camera seemed to produce anonymous pictures, lacking characteristic styles of particular picture makers, there was doubt that camera pictures could be worth as much as those produced by a visibly individual human agency.

Daguerre was the one and only photographer visible in the world, and his pictures struck viewers so forcefully with their realistic total detail that nobody considered them in terms of a personal style. Daguerre's public reputation was already based on anonymous accuracy because he tried so completely to recreate reality in his dioramas. Since he had begun from that basis to invent the daguerreotype, the public expected to see superrealism in his pictures and tended to look no further; thus pictures were judged for accuracy alone. Since the few surviving daguerreotype plates from the period of his first work, 1837-39, are all static views of Paris or still life arrangements with statuary, it is easy to believe that he made his first pictures more to be taken as realistic images than as works of art.

As we have already noted, absence of life and lack of color also mitigated against complete public satisfaction with the first daguerreotypes when they were judged in the light of artistry. Again, such feelings were the result of conditioning about how a picture should appear. The nearest parallel most writers could offer was that of a Rembrandt etching, since that was at least a monochrome picture. Even then many people over looked the rich grey tonal scale in the daguerreotypes though they were impressed with the subtlety of detail which the tonal gradations made possible. Essentially, it would seem, Arago and other early spectators wanted an artist to intervene in the daguerreotype process because there had not yet been a demonstration that one could.

Even in this aspect of initial reaction to the medium, however, there were defenders. The reporter for the *Athenaeum* who mentioned Arago's feeling that the medium was wanting something of the artist continued his account by observing,

Of course this want exists: but the fault lies not with the machine, but with those who expect from it that which human taste and genius alone can accomplish.[15]

The reporter recognized, as Arago evidently did not, that the camera could be an artistic tool in the degree to which the photographer was able to be an artist in applying it.

Opinions on the new invention were as varied within the ranks of painters as they were in the general public. The French writer Gaston Tissandier described the intensity of some reactions:

> artists were seized with astonishment and admiration: Paul Delaroche sought out Daguerre, obtained a Daguerreotype plate from him and showed it everywhere, exclaiming—"Painting is dead from this day!"[16]

That Delaroche's probably apocryphal remark was effusive is indicated by the fact that he did not give up painting, yet just such a moment of panic probably did cross many an artist's mind when the daguerreotype first appeared. After consideration Delaroche offered testimony stressing the potential value of the invention and encouraging the French government to purchase the process. He stated clearly his view of the artistic worth of the medium:

> Mr. Daguerre's process completely satisfies art's every need, as the results prove. It carries some of its basic qualities to such perfection that it will become for even the most skillful painters a subject for observation and study. The drawings obtained by this means are at once remarkable for the perfection of details and for the richness and harmony of the whole. Nature is reproduced in them not only with truth, but with art. The correctness of line, the precision of form, is as complete as possible, and yet, at the same time, broad energetic modeling is to be found in them as well as a total impression equally rich in tone and in effect. The rules of aerial perspective are as scrupulously observed as those of linear perspective. Color is translated with so much truth that its absence is forgotten. The painter, therefore, will find this technique a rapid way of making collections of studies which he could otherwise obtain only with much time and trouble and, whatever his talents might be, in a far less perfect manner.[17]

That Delaroche believed nature to be represented with art as well as with truth indicates how little he agreed with Arago about the need for the hand of the artist in Daguerre's process. Still, he was clearly thinking under the same visual conditioning as to how a picture should be conceived of as was Arago—his standards and metaphors were those of painting and some of them did not exactly apply to photography. His conception of the new medium needed to be redefined along unfamiliar lines before he would be fully equipped to respond to photography on its own terms.

Despite his painterly description of photography, Delaroche was sensitive to the realism of Daguerre's pictures. His language makes clear that he conceived of the pictures as captured bits of reality. His comment that even skilled artists could benefit from "observation and study" of daguerreotypes reflects his awareness of daguerreotypes as substitutes for reality. Delaroche himself studied his subject matter carefully before

starting a painting. He examined the lighting so critically that he often set up staged re-creations of his subjects so as to certify the exactness of his representations. It is natural, therefore, that he appreciated the surrogate reality offered by the new process. Putting aside his representational concern for a moment, however, we can see his interest in realism in a different light. It is the interest of the artist in the inherent facts of his subject matter—his need for the fullest perception to the depths of his subject before he can grasp its nature completely enough to interpret it. It is the element of art which is concerned with the intensity of direct experience, and it is the artistic parallel of Emerson's transcendental belief that ultimate spiritual understanding derives from keen perception of the objects of reality.

Delaroche continued his testimony on the value of the daguerreotype for artists along the line of concern for exact rendering of reality:

> When this technique becomes known, the publication of inexact views will no longer be tolerated, for it will then be very easy to obtain in a few instants the most precise image of any place at all.[18]

While Delaroche did not state explicitly the idea that exact rendering was a substitute for actual subject matter, other writers indicated such a view. Jules Janin wrote that the daguerreotype

> is not a picture . . . it is the faithful memory of what man has built throughout the world and of landscapes everywhere. . . . You will write to Rome: Send me by post the dome of St. Peter's; and the dome of St. Peter's will come to you by return mail.[19]

Le Moniteur Universel stated the equation of picture and reality still more explicitly:

> this is Nature herself. We distinguish the smallest details: we count the paving stones, we see the dampness caused by the rain, we read the inscription of a shop sign.[20]

Since Arago's lecture on the daguerreotype had done no more than announce the invention and present a few specimens to public view, the strongest initial reaction to the medium centered in Paris. Interest ran high in other countries, as we have seen from the London press, but interest was inevitably more speculative as it was more distant from Paris. In America reprints from British periodicals and a few French papers brought the news, but little reaction was possible until firsthand observation had given a basis for response. Despite a complete lack of direct experience, however, the popular columnist N. P. Willis ventured to write an article on the two photographic systems of Daguerre and Talbot in the New York magazine *The Corsair* It appeared on April 13, 1839 before Morse's letter on the daguerreotype had arrived in New York to give the first direct American impressions of the new pictures. In his article, Willis speculated on some of the problems of such a medium with remarkably keen insight that reflected the rightness of the American climate for photography to become significant.

Willis opened his remarks with whimsical wonderment that the objects of nature were henceforth to stand for themselves in the new representative art:

> All nature shall paint herself—fields, rivers, trees, houses, plains, mountains, cities, shall all paint themselves at a bidding, and at a few moment's [sic] notice. Towns will no longer have any representative but themselves. Invention says it. It has found out the one thing new under the sun; that, by virtue of the sun's patent, all nature, animate and inanimate, shall be henceforth its own painter, engraver, printer, and publisher. Here is a revolution in art . . . to keep you all down, ye painters, engravers, and, alas! the harmless race, the sketchers. All ye, before whose unsteady hands towers have toppled down upon the paper, and the pagodas of the East have bowed, hide your heads in holes and corners, and wait there till you are called for. The "mountain in labor" will no more produce a mouse; it will produce itself, with all that is upon it.[21]

There is a sense here of the naturalness of a process by which nature shall render herself, and it differs in emphasis from the European reactions. The *Spectator* (cf. p. 38) had used the image of nature "reflecting herself" and "engraving" her image, but many French accounts seem to have discussed the pictures from the viewpoint of their being drawings or from the viewpoint of their being the anonymous products of a machine's action.

That Willis should conceive of nature as the operative agency in the process suggests a basically different orientation from his French contemporaries about what is the essential force in artistic creation. We have already examined in some detail the tendency in America to suppose that nature and its objects were formative elements in native art. Willis reflected that Americans conceived of new pictorial media along these same lines even as French reactions to new picture forms were governed by that nation's previous pictorial conditioning. He set up the same basic problem for artists that was raised in Europe—the duplication of detail which no human skill could match. His raising of the problem, however, did not seem to have the same sense of trouble about it that prevailed for Arago or that was implied by Delaroche's initial feeling that painting was dead. Willis reflected a national difference between American stress on nature and European stress on the creative individual as the key element in the production of art. He specifically asserted the dominant position of nature over the artist which he felt was newly stressed by the camera:

> Ye artists of all denominations that have so vilified nature as her journeymen, see how she rises up against you, and takes the staff into her own hands. Your mistress now, with a vengeance, she will show you what she really is. . . . Now, as to you, locality painters, with your towns and castles on the Rhine, you will not get the "ready rhino" for them now— and we have no pity for you. Bridges are far too arch now to put up with your false perspective. They will no longer be abridged of their true proportions by you; they will measure themselves and take their own toll. You will no longer be tolerated. You drawers of churches, Britton, Pugin, Mackenzie, beware lest you yourselves be drawn in. Every church will show itself to the world without your help. It will make its wants visible and known on paper; and, though vestry and church warden quash the church rates, every steeple will lift up its head and demand proper repair.[22]

Willis was widely popular in the first half of the nineteenth century as a humorist. In that role he often touched upon ideas of general interest. While he was functioning

humorously in this particular article, his emphasis on nature as an artistic impetus was strong enough to appear one of those responsive ideas. Despite his puns, he thought clearly about desiring precision and accuracy in works of art lest the displeasure of nature be aroused. When he commented on the churches making their wants known without the help of artists, he clearly espoused the same desire for direct experience as did Emerson and Thoreau. It is interesting, though, that he turned nature's artistic self-rendering into a record of necessary church repairs. For Willis the artistic consideration seemed to overlie a body of utilitarian concerns quite external to the realm of art. In this regard, he forecast a series of probable uses for the photographic inventions:

> What would you say to looking in a mirror and having the image fastened!! As one looks sometimes, it is really quite frightful to think of it; but such a thing is possible—nay, it is probable—no, it is certain. What will become of the poor thieves, when they shall see handed in as evidence against them their own portraits, taken by the room in which they stole, and in the very act of stealing! What wonderful discoveries is this wonderful discovery destined to discover! The telescope is rather an unfair tell-tale; but now every thing and every body may have to encounter his double every where, most inconveniently, and thus every one become his own caricaturist. Any one may walk about with his patent sketch-book—set it to work—and see in a few moments what is doing behind his back! . . . the weather must be its own almanack—the waters keep their own tide-tables.[23]

Portraiture was not yet believed possible because of the long exposures necessary for both Daguerre and Talbot to produce images, but Willis's whimsy accurately foreshadowed photographic utilities that were, in some cases, a century in the future, such as automatic cameras for banks and candid photography. Many insightful predictions were made for the photographic media as soon as they were announced, but the fact that Willis developed his speculations directly out of his discussion of the possible artistic impact of the inventions suggests that his primary concern with the media was utilitarian.

Willis turned again to artistic considerations later in his article, this time in a more serious tone, but even then he reiterated that the utilitarian function must loom very large. He designated two major branches of artistic activity: the imaginative and the imitative. He believed that the imaginative would be little benefited by the advent of photography and would probably be reduced in the number of its artists because the speed and detail of the camera's image would lead art students to neglect the years of patient sketching and drawing study they need to become masters. Respecting the other area of art, he stated that

> in the merely imitative walk, and that chiefly for scientific purposes, draughts of machinery and objects of natural history, the practice of art, as it now exists, will be nearly annihilated—it will be chiefly confined to the coloring [of] representations made by the new instruments. . . . Our mere painters of views . . . will be superseded; for who, that really values views, will not prefer the real representation to the less to be depended upon![24]

Despite a return at the end of his essay to a traditional view of placing value on hand work in art, Willis's remarks on the work of photography make clear that he saw imita-

tion as the aspect of art to derive greatest benefit. His stress on the "real" representations of the camera over the dubiously reliable products of hack painters and his recognition of the camera's utility in science and technology forecast a basic aspect of American response to the photographic media.

A week later, on April 20, 1839, the *New York Observer* published Morse's letter on the daguerreotype from Paris as the first direct American reaction to the medium. Part of Morse's reaction was much the same as that implied by Willis. Since Morse was a leading painter, it seems reasonable that his first interest should have been with the aesthetic attributes of the new pictures:

> They are produced on a metallic surface, the principal pieces, about seven inches by five, and they resemble aquatint engravings, for they are in simple *chiaro-oscuro* and not in colors. But the exquisite minuteness of the delineation cannot be conceived. No painting or engraving ever approached it. For example: in a view up the street a distant sign would be perceived, and the eye could just discern that there were lines of letters upon it, but so minute as not to be read with the naked eye. By the assistance of a powerful lens, which magnified fifty times, applied to the delineation, every letter was clearly and distinctly legible, and so also were the minutest breaks and lines in the walls of the buildings and the pavements of the street.[25]

Pronouncing the new pictorial medium "one of the most beautiful discoveries of the age,"[26] Morse used the same types of art terms to describe Daguerre's pictures as did most others fortunate enough to see them at firsthand. The language of engraving or of painting had to suffice until new terms came into being. However, his awareness of the minute rendering of detail led him to pass directly from artistic considerations to those of pragmatic utility:

> The impressions of interior views are Rembrandt perfected. One of Mr. D's plates is an impression of a spider. The spider was not bigger than the head of a large pin, but the image, magnified by the solar microscope to the size of the palm of the hand, having been impressed on the plate, and examined through a lens, was further magnified, and showed a minuteness of organization hitherto not seen to exist. You perceive how this discovery is, therefore, about to open a new field of research in the depths of microscopic Nature. We are soon to see if the minute has discoverable limits. The naturalist is to have a new kingdom to explore, as much beyond the microscope as the microscope is beyond the naked eye.[27]

Morse's double concern with the daguerreotype showed his immediate recognition that the acuteness of rendering of the new medium held promise for a variety of uses. His insight seems to have been typical of American response to the medium. Indeed, his insight may have directed American response somewhat, because his was the first widely read statement on the subject and his reputation was high as a leading artist and the president of the National Academy of Design. His lack of hesitance about the direct artistic worth of the medium seems to have indicated a greater openness of view than prevailed in Europe. His close linking of utilitarian to artistic functions particularly typified American reaction. After its introduction into America, the daguerreotype was not primarily

an artistic medium so much as a practical tool for performing many non-artistic functions in society.

Morse's report on the daguerreotype includes a section on Daguerre's sad loss:

> M. Daguerre appointed yesterday at noon to see my Telegraph. He came, and passed more than an hour with me, expressing himself highly gratified at its operation. But, while he was thus employed, the great building of the Diorama, with his own house, all his beautiful works, his valuable notes and papers, the labor of years of experiment, were, unknown to him, at that moment the prey of the flames. His secret indeed is still safe with him, but the steps of his progress in the discovery, and his valuable researches in science, are lost to the scientific world.[28]

Morse seems to have made a deep personal commitment to Daguerre's invention which led him to take active steps to try to help Daguerre in his misfortune. Arriving in New York on the same vessel that brought his letter to the *Observer*, Morse nominated Daguerre to honorary membership in the National Academy of Design. On May 20, 1839 he wrote to Daguerre:

> I have the honor to inclose you the note of the secretary of our Academy, informing you of your election, at our last annual meeting, into the body of honorary members of our National Academy of Design. When I proposed your name, it was received with wild enthusiasm, and the vote was *unanimous*. I hope, my dear sir, you will receive this as a testimonial, not merely of my personal esteem and deep sympathy in your late losses, but also as a proof that your genius is in some degree estimated on this side of the water.[29]

Considering that none of the members of the Academy but Morse had ever seen a daguerreotype, the "wild enthusiasm" of the body's response must have derived largely from the intensity of Morse's own presentation. Even so, this honor to Daguerre was the first such awarded to him. It is also notable that among his many honors this distinction was nearly unique in coming from a body of professional artists. The only similar artistic honor immediately visible is his nomination to the *Vienna Maler Akademie* in 1843.[30] Again, it would seem that America reacted in its own way to the new pictures; despite a degree of persuasion involved in the Academy's action, the body evidently reacted favorably to the idea of making pictures without direct hand work from the artist as long as they were accurate.

Morse continued his letter to Daguerre with a crusader's promise:

> Notwithstanding the efforts made in England to give to another [Talbot] the credit which is your due, I think I may with confidence assure you that throughout the United States your name alone will be associated with the brilliant discovery which justly bears your name.
>
> The letter I wrote from Paris, the day after your sad loss, has been published throughout this whole country in hundreds of journals, and has excited great interest. Should any attempts be made here to give to any other than yourself the honor of this discovery, my pen is ever ready in your defense.[31]

Morse was understandably sensitive about an inventor's honors and rewards since he was

starting a long series of patent fights over his telegraph, but his attitude was an accurate reflection of the situation in America. He foreshadowed the fact that Talbot's paper negative system never would do well in America, partly because of patent restrictions. The Langenheim firm of Philadelphia tried with little commercial success to introduce it formally and made a number of pictures now important as historical records. The talbotype system was included along with the daguerreotype on the Perry expedition to Japan, though hardly any mention has been made of the fact outside the government reports of the voyage, and a variant of it was rejected in favor of the daguerreotype for the Fremont expedition of 1853. Some amateurs employed the process as cheaper and less difficult than the daguerreotype, but popular appeal stayed with the finer detail and precision of Daguerre's method.

Daguerre's process was the favorite almost everywhere it was introduced. The talbotype and other processes were never seriously in competition with it because of the charm and the exquisite quality of its images. By comparison the talbotype seemed muddy and crude despite its greater ease of visibility and its multiple reproduction. In addition, it must be noted that the daguerreotype enjoyed more effective public promotion than did the other processes. Talbot zealously restricted use of his method by patents and crabby defenses, while Niepce and Herschel went unnoticed for lack of publicity. Against the popularity of Daguerre's reputation for his dioramas, the prestige of his support by the French Academy, and the flamboyant generosity of the French government in presenting the daguerreotype as a free gift to the world, Talbot carried no immediate weight. In most of Europe the consolidation of his success had to wait until the French refined his process and began to supplant their own national method with its greater utility. In America Talbot's process always ran a poor second against the daguerreotype on grounds of image quality alone—talbotypes could never outclass the appeal of perfect detail. Morse's support of the daguerreotype process aided its initial success, but once the process was known in the United States, its quality easily carried all before it.

Morse also offered to act as American agent for Daguerre in arranging to circulate an exhibition of pictures with which he intended that Daguerre might improve his economic situation after the burning of the Diorama. The plan was forestalled, however, by the fact that Arago's report on the worth of the daguerreotype was presented to the French Chamber of Deputies on July 3, and a bill was introduced for the purchase of the invention. The great chemist Joseph Louis Gay-Lussac delivered the sponsoring address for the bill in the Chamber of Peers on July 30; and the bill, authorizing lifetime pensions to Daguerre and Isidore Niepce, was passed.

The process of the daguerreotype was revealed freely to the world as a gift of the French government in an address to the Academies of Sciences and Fine Arts by Arago on August 19, 1839. It was not discovered until later that Daguerre had patented the invention in England where that restriction practically eliminated it from use. Everywhere else it was unrestricted, and publication of the process immediately caused a sellout of mercury and iodine in chemical supply shops all over Paris:

Everyone wanted to copy the view from his window, and very happy was he who at the first attempt obtained a silhouette of roofs against the sky: he was in ecstasies over the stove-pipes; he did not cease to count the tiles on the roofs and the bricks of the chimneys; he was astonished to see the cement between each brick; in a word, the poorest picture caused him unutterable joy.[32]

In a simplified statement, the original process of making a daguerreotype consisted of the following steps. A sheet of copper was plated with silver, highly polished for smoothness, and chemically cleaned of impurities. The plate was exposed to vapors of iodine crystals in a closed box. When the plate had become a golden yellow by formation of a surface of silver iodide, it was light sensitive. It was placed in a dark slide and set into the body of a *camera obscura* which had been previously focused on the subject to be reproduced. The cover of the dark slide was withdrawn and the lens uncapped for an exposure which averaged around fifteen minutes. The dark slide cover was then restored, to protect the still invisible but latent image, and the plate inserted into a closed box and exposed to the fumes of heated mercury. As the mercury settled on the portions of the plate's surface which had been affected by light, the image appeared. Ultimately the white areas were relatively pure mercury, the middle tones were mercury-silver amalgam, and the dark areas were relatively pure silver. The excess silver iodide was removed by rinsing the plate with Herschel's recommended hyposulphite of soda, and the delicate surface was dried and sealed under glass.

As initially publicized, the process was mercilessly complicated, calling for eight steps merely to clean and polish the plate. Even so, many Parisians set out to try this method for themselves. Marc-Antoine Gaudin's experience was typical. Rushing from the meeting of the Academy to buy iodine, he was unhappy at having to wait till the next morning for adequate light. He reported later;

As soon as day broke . . . my camera was ready. It consisted of an ordinary lens of three-inches focal length, fixed in a cardboard box. After having iodized the plate while holding it in my hand, I put it in my box whch I pointed out of my window, and bravely waited out the fifteen minutes that the exposure required; then I treated my plate . . . with mercury, heating the glue pot which contained it with a candle. The mystery was done at once: I had a Prussian blue sky, houses black as ink, but the window frame was perfect![33]

To explain the process in complete detail, Daguerre soon published a pamphlet, *Historique et description des procedes du Daguerreotype et du Diorama.* English, German, Italian, Spanish, and Swedish editions appeared in September, and thirty editions in nearly as many languages were published before the end of 1839. Although the text was detailed, popular demand forced Daguerre to give public demonstrations and to train agents who traveled and explained the procedure in various parts of the world. Daguerre's pamphlet reached America on September 20, 1839[34] and provided Morse and others with the essential facts of the eagerly awaited process.

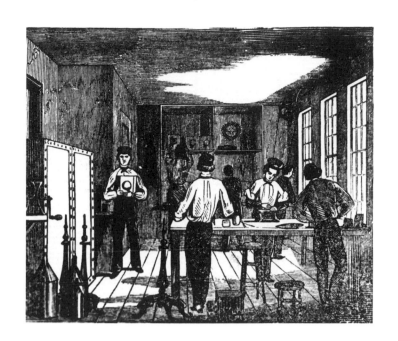

Chapter 3

NATURALIZATION INTO AMERICA

ENERALLY response to publication of Daguerre's process was rich in enthusiasm and honors as knowledge of the medium spread. Prince Metternich personally aided its introduction into Austria and led Emperor Ferdinand I to award Daguerre a medal and an imperial snuff box worth 1200 florins. Some years later Alexander von Humboldt persuaded the King of Prussia to award Daguerre the Order of Merit, seldom conferred on foreigners. Switzerland and Holland made and exhibited views with eagerness; Sweden gave particularly complete and detailed accounts of Daguerre's pictures and methods from January 1839 on through publication of the process at the end of the year. Pictures were soon being made in most European capitals and full-scale exhibitions were held within the year.[1]

Only in England and Germany was response less than fully enthusiastic. The English strongly affirmed the priority and significance of the work of Talbot, and they were highly piqued when Daguerre singled out England alone for restriction of his process by

patent. The medium never was widely used there except for commercial portraiture, and Americans and Frenchmen were leaders in even that aspect of its use.

In the 1830s Germany was still fractionated into nearly 400 small units, some of which seem to have been chauvinistically provincial in their opposition to non-German ideas. After the leading optics expert of Leipzig failed in trying to make a daguerreotype, the *Leipziger Anzeiger* denounced Daguerre's invention in ringing terms:

> Wanting to hold fast to transitory mirror-pictures is not only an impossibility, as has been shown by basic German research, but even the wish to do so is blasphemy. Man is created in the image of God, and God's image cannot be captured by any man-made machine. Only the supremely inspired artist may dare—when he is driven by Heavenly inspiration and in the highest command of his genius and without the help of a machine—to try to reproduce man's Godlike features. For man to contemplate bringing into being a machine to supplant such genius is comparable to considering bringing about an end to all creation. The man who begins such a thing must [arrogantly] consider himself even wiser than the Creator of the World.[2]

Continuing, the *Anzeiger* linked daguerreotypes with tools of the devil:

> God has, to be sure, tolerantly forborne the mirror in His creation as a vain toy of the Devil. Most likely, however, He is regretting this tolerance, especially because many women are using mirrors to look at themselves in all of their vanity and pride. But no mirror, neither of glass nor of quicksilver, has yet received permission from God to hold fast the image of the human face. God has never allowed the Devil's artistry, indwelling in mirrors, to go to such a high degree that the image of God or the image of man should come into his power.[3]

Pressing its attack, the paper simultaneously warned of vast, horrible consequences of Daguerre's "mirror-pictures" and dismissed his invention with contempt as beneath notice:

> Now: Should this same God, who for thousands of years has never allowed that mirror-pictures of men should be fadeless, should this same God suddenly become untrue to His eternal principles and allow that a Frenchman from Paris should set loose such a devilish invention into the World!!?? We must make clear, after all, how unChristian and Hellishly vain mankind would become if everyone could have his own mirror-picture made for filthy money and reproduced by the dozen. There would be such a mass epidemic of vanity that mankind would become godlessly superficial and godlessly vain. And if this "Mon-sewer" Daguerre in Paris maintains a hundred times that his human mirror-pictures can be held fast on silver plates, this must a hundred times be called an infamous lie, and it is not worthwhile that German masters of optics concern themselves with this impertinent claim.[4]

Aside from the speed with which the columnist could shift his polemic grounds, this article is curious in its emphasis on portraits because Daguerre and Arago both had clearly stated that portraiture, though desired immediately, was currently impractical owing to the length of exposure needed. Evidently the entire line of objection had little

to do with the medium itself but was an eruption of fearful xenophobia lingering from the period of Napoleon:

> The invention of the [French] Revolution and the idea of Napoleon to make all Europe an Empire of Equals—now M. Daguerre wants to trump all these puffed-up notions and outdo even the Creator of the World. If such things were at all possible, then long ago in ancient times men such as Archimedes or Moses would have done them before him. But if these brilliant men knew nothing of capturing mirror-pictures, then one must from the very outset consider the Frenchman Daguerre, who would aspire to such unheard-of things, as the fool of all fools, even as anyone in Germany who believes in such nonsensical inventions must be considered the ass of all asses.[5]

Clearly the time and the cultural climate in Leipzig were not right for the invention of the daguerreotype to be welcome; the *Anzeiger* account clarifies the considerable distinction between an adverse reaction and the type of response made to the medium by Americans. It has been difficult to find even a reservation stated in America about the wonder of the daguerreotype once it had been seen. One single account of suspicion is recorded by the leading daguerreotypist of Philadelphia, Marcus Aurelius Root.

> In 1839, and on the very day of the publication of Daguerre's discovery in the Philadelphia daily papers, Dr. Bird, then chemical professor in one of our medical schools, was asked, at a gathering of several scientific men, what he thought of this new method of copying objects with the sunbeam?
> The Doctor, in a lengthened reply, pronounced the whole report a fabrication—a new edition of the famed "moon-hoax"—such a performance being, in his view, an intrinsic improbability.[6]

While Root's account of Dr. Bird seems to reveal much the same attitude as that prevailing in Leipzig, Root is able to continue:

> Much to his credit, however, he soon after gave the subject a thorough investigation, and examining, with the requisite appliances, every new phase assumed by the art, he mastered each successive discovery and improvement as fast as they appeared, so that, at his decease in 1854, he was probably the ablest writer on sun-painting in the United States.[7]

Since even this isolated doubt of the new medium eventually turned favorable, we must conclude that American reaction was completely one of fascination and eager enthusiasm. Instead of attacking the daguerreotype as a Parisian swindle or a new moon hoax, the public was delighted. Response was warm toward the first American showing of pictures by Daguerre:

> We have seen the views taken in Paris by the "Daguerreotype," and have no hesitation in avowing, that they are the most remarkable objects of curiosity and admiration, in the arts, that we ever beheld. Their exquisite perfection almost transcends the bounds of sober belief. Let us endeavor to convey to the reader an impression of their character. Let him suppose himself standing in the middle of Broadway, with a looking-glass held perpendicularly in his hand, in which is reflected the street, with all that therein is, for two or three

miles, taking in the haziest distance. Then let him take the glass into the house, and find the impression of the entire view, in the softest light and shade, visibly retained upon its surface. This is the Daguerreotype![8]

The language of such initial reactions reflects a mood of wonderment, and it is the language of a visual orientation that can speculate with pleasure about capturing streets permanently in magic mirrors. Prevailing attitudes seem to have directed favorable responses to the new pictures from the outset.

The period between the arrival of Daguerre's process and the end of the year was a time of experiment and local activity. The operating method was widely made public:

> Working directions were reprinted from the translation of Daguerre's manual by J. S. Memes (London: Smith Elder and Co., 1839) in *The Observer* (New York), Nov. 3, 1839; *Amer. Repertory of Arts, Sciences and Manufactures*, I (Mar. 1840), 116-23; *The Family Magazine*, VII (1840), 415-23, and in Jacob Bigelow's *The Useful Arts* (Boston: T. Webb and Co., 1840), II, 350-67. A translation by J. F. Frazer appeared in *Jour. of the Franklin Inst.*, new ser. XXIV (Nov., 1839), 303-311. A condensation, by William E. A. Aikin, with facsimiles of the illustrations, was published in *Maryland Medical & Surgical Jour.*, I (April 1840); it was reprinted as a brochure.[9]

The gist of the process was summarized in a few paragraphs in newspapers in many parts of America, and it is certain that many efforts were made to produce pictures which have long been forgotten. Samuel Morse, Dr. John William Draper of New York University, Joseph Saxton of the Philadelphia Mint, and Robert Cornelius, a Philadelphia lamp maker and metalworker, were among the earliest Americans to make daguerreotypes after first success was achieved by D. W. Seager of New York. Unfortunately very little is known of Seager, and none of his pictures have been found.

One of the first critical reviews of a native photographic work appeared in the New York *Morning Herald* on September 30, 1839, describing one of Seager's pictures:

> We saw the other day, in Chilton's [chemical shop], in Broadway, a very curious specimen of the new mode, recently invented by Daguerre in Paris, of taking on copper the exact resemblances of scenes and living objects, through the medium of the sun's rays reflected in a *camera obscura*. The scene embraces a part of St. Paul's church, and the surrounding shrubbery and houses, with a corner of the Astor House. . . .[10]

Noting that Seager had pointed his camera at objects in bright sunlight "for eight or ten minutes," the paper immediately related the process to a nationalistic interest by commenting that "in Europe a longer exposure is required, because an American sun shines brighter than the European."[11] Even in this earliest response to the photographic medium there is visible a prevailing attitude that nature directed the production of the artist in America. The *Morning Herald* concluded with a statement recognizing the diminutive appeal of the mirrorlike picture as well as its primacy:

> The specimen at Chilton's is a most remarkable gem in its way. It looks like fairy work, and changes its color like a camelion [sic] according to the hue of the approximating ob-

jects. Ladies, if they are pretty, with small feet and delicate hands, fond of science, ought to call and see it. It is the first time that the rays of the sun were ever caught on this continent, and imprisoned, in all their glory and beauty, in a morocco case with golden clasps.[12]

It is clear from this account that the daguerreotype picture held not only a charm but an implicit value to be treated with respect. Use of words such as "gem" and mention of encasing the picture in morocco with golden clasps indicated awareness that the image was somehow precious. Use of tooled leather or embossed paper cases made to resemble leather and lined with satin or velvet remained a standard practice in America as opposed to the French and German practice of binding with bordered paper masks—as if Americans felt the images deserved a respect that did more than take their significance for granted.

To many viewers the realism of objects rendered by the daguerreotype was little short of magic. The process by which seemingly living representations were made appeared fanciful even while it seemed a typical stroke of modern technology. Philip Hone, onetime Mayor of New York, observed,

> It appears to me not less wonderful that light should be made an active operating power in this manner [than] that some such effect should be produced by sound; and who knows whether, in this age of invention and discoveries, we may not be called upon to marvel at the exhibition of a tree, a horse, or a ship produced by the human voice muttering over a metal plate, prepared in the same or some other manner, the words "tree," "horse," and "ship." How greatly ashamed of their ignorance the by-gone generations of mankind ought to be![13]

That the acuteness and accuracy of rendering of the new pictures had much influence on initial American reactions is often apparent in early writings. We have seen the *Knickerbocker's* fascination with capturing the entire detail of a street, and we have noted the *Morning Herald's* reference to "exact resemblances of scenes and living objects." It seems likely that some of the regard for the pictures indicated by morocco cases with golden clasps arose from this exactitude of detail. Hone's remarks reflect such an impression of the medium:

> Every object, however minute, is a perfect transcript of the thing itself; the hair of the human head, the gravel of the roadside, the texture of a silk curtain, or the shadow of the smaller leaf reflected upon the wall, are all imprinted as carefully as nature or art has created them in the objects transferred; and those things which are invisible to the naked eye are rendered apparent by the help of a magnifying glass.[14]

Hone's use of the phrase "the thing itself" is a milestone in recognition of the unique character of the photographic medium as distinct from other pictorial processes. In being aware of the fact of depicting total detail, Hone was not alone. We have seen that European descriptions of Daguerre's pictures often stressed their subtlety and detail. Hone typified American rather than European reaction, however, in that he was happy with such direct experience of visible objects whereas Europeans often wished to

interpose the hand of an artist. It is significant in terms of American attitudes that nearly a hundred years later Edward Weston, one of America's greatest photographers, used identical wording to state his aim in making pictures as being *"significant presentation of the thing itself—*without evasion in spirit or technique—with photographic beauty."[15] The phrase appears repeatedly in Weston's *Daybooks;* in 1930 he wrote,

> To see the *Thing Itself* is essential: the Quintessence revealed direct without the fog of impressionism. . . .
> This then: to photograph a rock, have it look like a rock, but be *more* than a rock.—Significant presentation—not interpretation.[16]

Considering Weston's statement in the light of Emerson's wish for spiritual insight reached through keen direct perception of the objects of nature, we can see that Weston's use of the medium of photography was in accord with Emerson. Nature had to guide the artist by means of intense direct experience for him as much as for Emerson or Thoreau. The picture-making process for Weston was inevitably one of acute realism meant to produce an insight which would ultimately be of a spiritually symbolic nature. If we can accept Weston and Emerson as two ends of a continuum, then Hone's phrase assumes great importance as a major step in defining the basic elements in common between the two. It is a first significant step in recognizing the distinct nature of photography.

That the daguerreotype also held symbolic connotations is evident from another contemporary statement:

> Its perfection is unapproachable by human hand, and its truth raises it high above all language, painting, or poetry. It is the first universal language, addressing itself to all who possess vision, and in characters alike understood in the courts of civilization and the hut of the savage. The pictorial language of Mexico, the hieroglyphics of Egypt are now superseded by reality.[17]

Such an observation is strongly transcendental in its concern for reaching insights beyond the power of language or extant arts for universal communication. It is equally transcendental in desiring that the communication of universal truth stem from direct experience of "reality," yet the description is of a *picture* rather than of actual reality and its implication is that reality will be perceived symbolically by means of the picture.

Edgar Allan Poe felt the same desire for truth derived from nature by means of the daguerreotype, rating it more accurate than other pictorial media. In 1840, he wrote,

> In truth the daguerreotype plate is infinitely more accurate than any painting by human hands. If we examine a work of ordinary art, by means of a powerful microscope, all traces of resemblance to nature will disappear—but the closest scrutiny of the photographic drawing discloses only a more absolute truth, more perfect identity of aspect with the thing represented.[18]

In a purely physical sense Poe's remark about seeing more accurate rendering of nature in the daguerreotype under a microscope is a pragmatic version of Emerson's seeing be-

yond the surface of nature by sharpening his sight. More significantly, however, Poe's desire for such mechanical accuracy is the same as that which led many American artists to rely on mechanical devices to produce accurate detail in their paintings.

Some of the painters were understandably concerned over the possibility that the comprehensive accuracy of the daguerreotype would damage their profession. In a letter to a friend, Thomas Cole raised this question and settled it for himself:

> I suppose you have read a great deal about the daguerreotype. If you believe everything the newspapers say (which, by-the-by, would require an enormous bump of marvelousness) you would be led to suppose that the poor craft of painting was knocked in the head by this new machinery for making Nature take her own likeness, and we nothing to do but give up the ghost. . . . This is the conclusion: that the art of painting is creative, as well as an imitative art, and is in no danger of being superseded by any mechanical contrivance.[19]

Cole saw the daguerreotype in much the same way as did European artists who objected to its mechanical aspect—he overlooked the fact that the machine did not operate itself. He evidently felt that the camera was inadequate to the task of selection and interpretation, which he held, in common with many other painters, to be the basis of art. His division of art into creative and imitative branches was much like that N. P. Willis made earlier. While both men recognized the remarkable recording capability of the camera, they felt its boundaries of application were not the same as those of painting.

Several years later the noted engraver John Sartain editorialized on a new vignetted style of daguerreotype portrait introduced to Philadelphia by Marcus Aurelius Root. In his favorable comments on Root's work he indicated a factor in daguerreotype picture making that seems to have underlain many painters' concern about the artistic quality of the medium. He remarked of the new daguerreotypes that they were to be preferred over previous ones because of

> the unity of effect in them as pictures, the absence of everything that can lead the eye away from that which is principal. In a good *daguerreotype* there is wonderful beauty in the lace, silks, satin, damask patterns on various kinds of drapery, and so forth, and we may dwell on the examination of these objects in delighted admiration, but the beauty of *parts* will not make a good *picture,* which as a whole must have portions subdued and kept down in subordination to others, and these others require to be expressed with all the emphasis and brilliancy possible.[20]

Sartain readily admits the appeal of visually rich detail which had charmed viewers all along, but his pointing out of the unselectivity of current daguerreotypes clearly reflects the basic concern of painters to interpret, select, and vary emphasis for pictorial effect according to human judgment and feelings. In terms of record and rendering of detail both Cole and Sartain admired the daguerreotype, and both men were daguerreotyped. Cole's portrait by Mathew Brady has been lost, but an engraving by Sartain of his own portrait by Root (Plate 5) reflects a sympathy to the medium as well as clearly indicating the influence of photographic tonal rendering on the contemporary practice of engraving.

Early in his career as a painter, the New England artist George Fuller became in-trigued with the economic possibilities of the daguerreotype. In a letter to his father from Boston in April 1840 he explored the idea of daguerreotypy in some detail:

> [Brother] Augustus and I went to see the specimens, and were much pleased; our ticket would entitle us to one of the lectures, but we were too late, as they had ceased delivering them. Now this can be applied to taking miniatures or portraits on the same principle that it takes landscapes. M. Gouraud [Daguerrs's American agent] is now fitting up an appara-tus for this purpose. If he can raise a class of ten or fifteen, he will give instruction or pri-vate lectures, making them perfectly acquainted with the art. . . . [Only] two minutes' time is required to leave a complete impression of a man's countenance, perfect as nature can make it. . . . We can afford to take a perfect likeness for $7.00; the plate and glass will cost $2.00, leaving $5.00. With custom enough fifty could be taken in one day.[21]

To start with, Fuller gave little consideration to the matter of artistry; instead he applied keen Yankee shrewdness and business acumen that took stock of American traits:

> This is a new invention, and consequently, a great novelty, of which every one has heard, and has a curiosity to see. It is just what the people in this country like, namely something new. I think any one would give $7.00 for their perfect likeness. We could clear ourselves of all expense in two weeks.[22]

Fuller actually purchased a daguerreotype outfit and took it home to Deerfield, Massachusetts where he used it once to record his old home. The following summer he and his deaf-mute half-brother Augustus began an itinerant period painting portraits and miniatures. In August he wrote home to have the daguerreotype apparatus brought to Waterloo, New York. In Newark, New York, in September, he wrote of having "taken" eight portraits, but whether he did them by painting or daguerreotype is uncertain. Ful-ler seems to have done little else with the daguerreotype medium except to paint por-traits from plates brought to him. In view of his first enthusiasm, Fuller seems to have grown cold very soon. An appraisal of his art by F. D. Millet, however, suggests that he may have felt an artistic dissatisfaction related to that of Cole and Sartain:

> Fuller doubtless often failed with his portraits to satisfy the requirements of ordinary por-traiture, because he could not be content with the superficial imitation of flesh, feature, or textures. What he attempted, and usually succeeded in doing, was to represent his sitters under the best aspect which his observation and imagination suggested. Of absolute real-ism in his portraits there is little; of accurate imitation of the details of form and color there is also little; but there is, what is very much better, a masterly generalization of the characteristic traits of the sitter.[23]

It is a fact that thousands of daguerreotype portraits were made that were accurate but quite lacking just the sort of "masterly generalization" of character attributed to Fuller. Very often daguerreotype portrait operators were not artistically trained; equally often they were not men of taste or discrimination, and their products were precisely detailed topographical representations without life. Years later, in 1864, Marcus Au-

relius Root observed ruefully that the field of photography—heliography, as he called it—suffered from this type of artistic lack:

> Is it not deplorable that, of existing portraits of men of eminence—especially those transferred from heliographs,—so very few display that intelligent, spirited, noble cast of countenance which we instinctively ascribe to the originals, and which properly signalizes true greatness? . . .
>
> . . . numbers of the heliographs of our eminent men, members of Congress, and others, taken by unthinking, machine-like operators, actually look as if the originals *contemned* the art, and had no faith in the ability of the individual to whom they had consented to give their time. . . .[24]

It appears that mechanical picture making had shortcomings that were a problem for genuine artists—both painters and daguerreotypists—throughout the entire period of the daguerreotype and persisted in subsequent forms of photography.

As president of the National Academy of Design and a leading artist of the period, Morse was inevitably concerned with the impact of the daguerreotype on painting and the question of whether the new medium would have an adverse effect. At the annual dinner of the Academy on April 24, 1840, Morse was asked to speak on the probable effects of the invention of Daguerre. Without hesitation he declared,

> The daguerreotype is undoubtedly destined to produce a great *revolution* in art, and we, as artists, should be aware of it and rightly understand its influence. This influence, both on ourselves and the public generally, will, I think, be in the highest degree *favorable* to the character of art.[25]

Continuing from this positive stand, Morse spelled out the benefits to be derived from the association of the painter with the daguerreotype:

> Its influence on the artist must be great. By a simple and easily portable apparatus, he can now furnish his studio with *fac-simile* sketches of nature, landscapes, buildings, groups of figures, &c., scenes selected in accordance with his own peculiarities of taste; but not, as heretofore, subjected to his imperfect, sketchy translations into crayon or Indian ink drawings, and occupying days, and even weeks, in their execution; but painted by Nature's self with a minuteness of detail, which the pencil of light in her hands alone can trace, and with a rapidity, too, which will enable him to enrich his collection with a superabundance of *materials* and not *copies;—they cannot be called copies of nature, but portions of nature herself.*[26]

Contrary to Cole or Sartain, Morse felt that the daguerreotype could function selectively for the artist according to his "own peculiarities of taste." The important fact for Morse was that selection could be made by the artist who chose to employ the camera. For him the camera was not automatic or self-operating, but a tool directed by the artist. The novel benefit in using the camera was that the process of selection became almost instantaneous. The artist could study the details of his selected objects with greater care than previously when he had to give more time to making choices. His apprehensions

would be more immediate. His perception and insight would be deeper and more nearly total, and his experiences would be direct. The concept was Emersonian in operation and yet symbolic in that the artist would respond to daguerreotype pictures which stood in place of actual "portions of nature." Over and over again, American reaction to the new picture-making medium treated it as a means of greater access to reality and assumed that more direct experience of nature by such an agency was beneficial.

Morse's observations on how the daguerreotype would affect public taste emphasized his assumption of such benefits:

> Can these lessons of *nature's art* . . . read every day by thousands charmed with their beauty, fail of producing a juster estimate of the artist's studies and labors, with a better and sounder criticism of his works? Will not the artist, who has been educated in Nature's school of truth, now stand forth pre-eminently, while he, who has sought his models of style among fleeting fashions and corrupted tastes, will be left to merited neglect?[27]

Like Thoreau's locomotive engineer who was a better man for glimpsing nature at Walden Pond, Morse's public would presumably improve in taste and discrimination, to say nothing of character, if its art experience were to be increasingly directed by nature. Nature, as we have seen previously, was regarded as the source and the guide for the artist in America, and for Morse the daguerreotype provided a more truthful means through which nature could operate. As Morse summed up the thought in his closing remarks, "Honor to Daguerre, who has first introduced Nature to us, in the character of *Painter*."[28]

It must not be supposed that attention to the daguerreotype was confined only to artists or to a few select Americans. We have seen that newspapers and periodicals in many areas gave space to the new process throughout the year 1839 and continued to do so in 1840. The average public reacted in much the same enthusiastic way as did Hone or Morse or the editors of the *Knickerbocker* and the *Morning Herald*. Beginning in late 1839, access to information and specimens of the daguerreotype was widened for greater numbers of people with the coming of Francois Gouraud from Paris as an agent of Daguerre. Arriving on November 23, 1839 to expedite arrangements for the sale of daguerreotype equipment made by the firm of Alphonse Giroux & Cie. under authority of Daguerre, Gouraud set quickly to work developing public interest. He gave private viewings of a collection of plates made in Paris by Daguerre and others to the editors of the New York *Observer* and other selected persons:

> We have been favored with the sight of a large number of pictures from a collection of the exquisitely beautiful results of this wonderful discovery, just arrived from Paris; several of them *taken by Daguerre himself*. . . .
> Our readers may suppose that, after reading the highly wrought descriptions of the new art, which we have transferred to our paper from European points, we were prepared to form something like an adequate conception of its power; but we can only say as the Queen of Sheba said after examining the exhibition of the glory of Solomon, "The half was not told us." We can find no language to express the charm of these pictures, painted by no

mortal hand. . . . We are told that the shop-windows in Paris, in which the photographic pictures are exhibited, are so beset by the crowd that the streets are impassable in their vicinity. . . .[29]

Noting that Gouraud was also sent as a traveling photographer to collect pictures around Havana for publication in Paris, the *Observer* ventured to "hope M. Gourraud [sic] will stay so long among us as to give us a few practical lectures, and also to furnish an opportunity for our citizens to see this collection of Nature's own paintings."[30]

On November 29, Gouraud sent a facsimile handwritten letter to the leading people of New York announcing a special showing of the collection. The nature painter Asher B. Durand (Plate 6) received a copy of the invitation, which was calculated to win friends:

> As the friend and pupil of Mr. Daguerre, I came from Paris by the British Queen, with the charge of introducing to the new world, the perfect knowledge of the marvellous process of drawing, which fame has already made known to you under the name of the Daguerreotype. Having the good fortune to possess a collection of the finest proofs which have yet been made either by the most talented pupils of Mr. Daguerre, or by that great artist himself, I have thought it my duty, before showing them to the public to give the most eminent men and distinguished artists of this City, the satisfaction of having the first view of perhaps the most interesting object which has ever been exposed to the curiosity of a man of taste, and therefore if agreeable to you, I shall have the honor of receiving you on Wednesday next the 4th Decr, from the hours of 11 to one o'clock inclusive at the Hotel Francais No. 57 Broadway, where this invitation will admit you.[31]

It was this exhibition of thirty plates by Daguerre and others, to which Gouraud added pictures he had made in New York, that elicited the enthusiasm of Philip Hone and the *Knickerbocker.*

The *Knickerbocker* printed an extended commentary on the exhibition, noting "the minute light and shade; the *perfect* clearness of every object; the extreme softness of the distance."[32] The subtlety and accuracy of depiction, even to capturing effects of atmosphere and weather, once more aroused wonder and admiration. The overall impression was summed up, as in other published statements, by remarking on the directness of experience the plates provided:

> Look, again, at the view of the Statue of Henry the Fourth and the Tuilleries, the Pont des Arts, Pont du Carousel, Pont Royal, and the Heights of Challot in the distance. There is not a shadow in the whole, that is not *nature itself;* there is not an object, even the most minute, embraced in that wide scope, which was not in the original; and it is impossible that one should have been omitted. Think of that! . . . The shade of a shadow is frequently reflected in the river, and the very trees are taken with the *shimmer* created by the breeze, imaged in the water! Look where you will, Paris itself is before you.[33]

Continuing, the *Knickerbocker* confirmed the fact that portraiture had been accomplished despite doubts about its possibility but suggested a compunction about portraits in this particular medium:

We have little room to speak of the "interior" views. We can only say, in passing, that they are *perfect*. Busts, statues, curtains, pictures, are copied to the very life; and portraits are included, without the *possibility* of an incorrect likeness. Indeed, the DAGUERREO-TYPE will never do for portrait painting. Its pictures are quite *too* natural, to please any other than very beautiful sitters.[34]

Despite its doubts about the satisfaction of the public with accurate portraiture, the *Knickerbocker* assumed that realism and artistic character were both inherent in the new pictures:

illness, with sea-voyage cures, must decline now; for who would throw up their business and their dinners, on a voyage to see Paris or London, when one can sit in an apartment in New-York, look at the streets, the architectural wonders, and the busy life of each crowded metropolis?. . . M. Gouraud, the accomplished and gentlemanly proprietor of the "DAGUERREOTYPE" and the only legitimate specimens of the art in this country, favored us with an examination of one or two views, which were accidentally injured in the process of being taken. But although imperfect, they were still wonderful in the general effect. The "darkness visible," the floods of light, the immensity of the space, and the far perspective, in their dim, obscure state, all reminded us of the English MARTIN.[35]

Throughout his stay in New York, Gouraud maintained a mood of hurry, probably calculated to encourage greater public attention. His announcements and advertisements were usually couched in terms of limited time before his departure, though he stayed in New York until March 1840. After the invitational premiere of his exhibition of plates from Paris, he opened the display to the public, charging admission of one dollar. The New York *Evening Post* of December 9, 1839 reported a substantial attendance and forecast the first course in photography to be taught in America:

We hear with pleasure, that Mr. Gouraud has yielded to the urgent requests of the numerous visitors that have been so much delighted in viewing the specimens of this most beautiful art, to stay for a short time with us, previous to his departure for Havana, and to give a public demonstration of the whole process, with practical examples. . . .[36]

Attendance, even at a dollar per person, must have been very good; on December 20, Gouraud announced that public request had led him to relocate the display more conveniently and to increase its time to include evening hours. He also lowered the admission fee to fifty cents.

While the exhibition had been reported by the *Knickerbocker* to contain portraits and Philip Hone had written of acute delineation of "the hair of the human head," portraiture was evidently still in a pioneering state to judge from an item reprinted in the *Evening Post* on December 23:

IMPROVEMENT IN THE DAGUERREOTYPE.—Amongst the numerous improvements proposed in the Daguerreotype is the following, by M. Jobard, of Brussels, for taking portraits *a l'heliographe:*—"Paint in dead white the face of the patient; powder his hair, and fix the back of his head between two or three planks solidly attached to the back

of an arm-chair, and wound up with screws! The color of the flesh, not reflecting sufficiently the rays of light, would require a powerful sun, whereas a whitened face will be reproduced as well as plaster figures by diffused light". . . .[37]

This process sounds more funerary than photographic, but it was substantially the method by which the first daguerreotype portraits were achieved, both in France and in America. Gouraud later wrote that

> Within fifteen days after the publication of the process of M. Daguerre, in Paris, people in every quarter were making portraits. At first they were all made with *the eyes shut.* M. Susse, of the *place de la Bourse,* was one of the first amateurs who succeeded in making them in the most satisfactory manner. The achromatic lens, recommended by M. Daguerre was naturally first made use of. But these amateurs soon perceived, that in using a glass of this kind, a very long time was required to make the drawing. Every one began to look about for some means of shortening, as much as possible, the period of from fifteen to twenty-five minutes, which M. Susse, who had the whole disposal of his time, had employed in making his pretty portraits—with the eyes shut. Almost at the same time . . . Mr. Abel Rendu, directed by the most simple optical principles, adopted an idea which seemed new to him, and produced . . . portraits of men and women, with the *eyes open,* executed in the most satisfactory manner.[38]

By means of a practice similar to that of M. Susse, Morse produced full-length portraits of his daughter and her friends with closed eyes after long periods in the sun on the roof of his workshop at New York University in late 1839. A crude woodcut, altered to show the eyes open, is the only surviving indication of his efforts (Plate 7) .

Other efforts were made in America before the end of 1839, notably by Henry Fitz, to produce portraits with the eyes closed.[39] American experimenters were nothing if not ambitious, however, and as early as October serious efforts were made to produce fully lifelike portraits. Evidently the first to succeed, in October 1839, was Alexander S. Wolcott, holder of the first American photographic patent—for a camera with a curved mirror instead of a lens that concentrated enough light to allow for very tiny portraits with the eyes open. On the basis of this advance, Wolcott and another man named Johnson opened the world's first commercial portrait studio in New York in March 1840. American effort thus gained precedence in this line of photography.

The noted scientist John William Draper, Professor of Chemistry at New York University and an associate of Morse, also made attempts to produce portraits at the same time as Wolcott and Morse. He was perhaps best equipped for such experiments with thorough chemical training and a backlog of experiments in chemical photo-sensitivity covering almost a decade. He had explored photographic methods like those of Wedgwood and Davy as early as 1837 before either the Talbot process or that of Daguerre had been made public, and he had immediately re-created Talbot's work after its publication and begun to suggest improvements. In early 1840 he suggested fixing daguerreotype pictures by means of immersion in salt water so as to decompose the excess silver iodide by touching the plate with a piece of zinc to make a voltaic cell. He pointed out

that this method, "which adds not a little to the magic of the whole operation,"[40] was cheaper than Herschel's method and gave a warmer tone to the finished pictures than the slate-blue metallic effect of the "hypo" process. Unfortunately, time proved the method somewhat unreliable and it was abandoned. According to Robert Taft, Draper wrote of having made his first successful portrait in December 1839.[41] Sometime before July 1840, Draper made the famous portrait of his sister Dorothy (Plate 8), which has often been reproduced under the erroneous title of the world's first portrait. Subsequent to his announcement of successful portraits from life in the issue of the *London, Edinburgh, and Dublin Philosophical Magazine* for June 1840, Draper sent this portrait to Sir John Herschel:

> We have heard in America that all attempts of the kind had been unsuccessful both in London and Paris, but whether or not it be a novelty with you, allow me to offer it to your acceptance as an acknowledgment of the pleasure with which I have read so many of your philosophical researches.
> This portrait, which is of one of my sister [sic], was obtained in a sitting of 65 seconds, the light being not very intense and the sky coated with a film of pale white cloud.[42]

Herschel's reply, in October 1840, indicated that portraiture was not altogether a novelty to him, but gave further ground to the nationalistic thought that in America even the sun was more favorable to the daguerreotype than in Europe. He wrote of the picture,

> I have no hesitation in declaring it by far the most satisfactory *portrait* which I have yet seen, so executed, and considering the shortness of the sitting, does equal credit to the brilliancy of your trans-Atlantic sunshine and to your own perfect mastery of the details of that most surprising process.[43]

Even allowing for English courtesy, Herschel's preeminent position in the photographic world meant that his praise for Draper's work was significant. His response to the quality of the portrait foreshadowed many subsequent international recognitions of American skill.

Draper's publication of articles on daguerreotypy in the *Philosophical Magazine* was another indication of the substance of American activity in the field almost from the beginning. It is worthy of note that the daguerreotype gave a branch of American scientific research a solid opportunity to gain recognition on the international scene. In the September 1840 issue of the magazine, Draper described some of the physical aspects of his initial portrait work in an account that resembled the early European efforts described by Jobard and Gouraud but yet superseded them:

> In the first experiments which I made for obtaining portraits from the life, the face of the sitter was dusted with a white powder, under the idea that otherwise no impression could be obtained. A very few trials showed the error of this; for even when the sun was only dimly shining, there was no difficulty in delineating the features. . . .
> . . . The chair in which the sitter is placed, has a staff at its back, terminating in an iron

ring, that supports the head, so arranged as to have motion in directions to suit any stature and any attitude. By simply resting the back or side of the head against this ring, it may be kept sufficiently still to allow the minutest marks on the face to be copied. The hands should never rest upon the chest, for the motion of respiration disturbs them so much, as to bring them out of a thick and clumsy appearance, destroying also the representation of the veins on the back, which, if they are held motionless, are copied with surprising beauty.[44]

While Draper's apparatus for immobilizing the sitter was awesome, it seemed less so than the "planks" of M. Jobard of Brussels. His cosmetic preparations also appeared less funerary than those employed by the Belgian. One is tempted to speculate about M. Jobard's delicately morbid aura in any case when confronted with his further "improvements" in the daguerreotype:

> M. Jobard, who forwarded to the exhibition the first view, taken in Belgium, with the Daguerreotype, has just exhibited the *first portrait* [he has] taken from the life. It represents a young female dressed in white, sleeping, under a canopy; the material and embroidery of the pillows on which she reclines are rendered with exquisite nicety, as well as the hand and the side of the face on which the *light* rests. This proves that small *tableaux de genre* in the style of Deverin, might be produced by the machine, which could not fail to possess some beauty.[45]

Aside from his sweet funereal mode, M. Jobard illustrates a distinction between Europe and America in approaching the basic problem of portraiture. Wolcott, Morse, Fitz, and Draper, as well as Cornelius and others, all attempted portraiture in America by a head-on approach to the sitter. They tried to maximize the light and the optimum preparation of the daguerreotype plate to take the sitter as he was, or they tried to immobilize the sitter for a long enough period to register him as he was without any more alteration than was necessary. Jobard, on the other hand, began immediately to turn the long exposure period necessary into a romantic posed tableau along the lines of standard paintings of the day. We are here confronted with a further reflection of the more ready American acceptance of the daguerreotype on its own unique terms. Jobard's attitude toward the "machine" seems distinctly patronizing by contrast and reiterates European desire for the performance of the traditional artist.

Draper's description of the physical arrangement of the situation for his portraits coincides relatively well with that recommended by Gouraud in his *Provisory Method of Taking Human Portraits* published earlier in the year. Gouraud began his theoretical description by designing a room to throw maximum light on the subject:

> In the first place you will begin by preparing a room exposed to the sun, the southeast, if possible. You will give to this room the form of a truncated pyramid, lying down, of which the base will be the whole breadth of the window—which window you will make as large as possible, and extending from the floor to the ceiling. The floor, the ceiling, and the two sides of the room, should be plastered with the whitest kind of lime plaster. Those who cannot dispose a room in this manner, can fix the sides of the room with sheets or other

cloth of perfect whiteness. The focus of the room must be covered with a tapestry of white cotton, with knotted or raised figures, which is designed to form the drapery. These are always agreeable to the eye, and should be shown in interior views.[46]

Gouraud's stress on what was "agreeable to the eye" was an element of European conditioning quite to be expected in a "gentleman of taste" of the period, and it is noteworthy that he introduced such an item of aesthetic concern even before portraiture was more than theoretical. The simplicity of his ideal room and its freedom from eye-catching artifacts not only betokened his concession to the practical need of concentrating all available light on the sitter, but it reflected a distinct artistic restraint that would center visual attention on the sitter without undue distraction. His stress on a pleasing but simple visual situation was a fortunate addition of French artistic taste to initial American activity. Since Gouraud taught many early daguerreotypists, and his theoretically ideal portrait studio formed a relative prototype for actual daguerrean parlors, his influence on later American practices would appear to have been substantial. While it is not certain that later studios were built to follow Gouraud's printed directions, the fact is that many did approximate them—knowingly or unknowingly—and American practice was generally to concentrate visual attention on the sitter and commonly exclude the use of props or fancy backgrounds.

The general custom of immobilizing the sitter which developed in American studios was as both Gouraud and Draper described it. The headrest was first described by Gouraud:

> Having covered your plate well with the coating of iodine, you will fix the sitter. His head should be placed on a semi-circle of iron, fitted to the back of the chair. His arms may be arranged at pleasure. He should fix his eyes on some well defined object in any direction which he may prefer. . . .[47]

The iron headrest became a standard fixture of portrait studios in America for the next fifty years, far outlasting the daguerreotype itself.

Important as were the lessons Gouraud taught Americans about the operations of the daguerreotype, he, in turn, was affected by American ways of thinking. From the time he arrived to teach Americans about the process, he was being taught that it could be improved. It was reported in January 1840 that Gouraud had

> scarcely arrived among us before he was in communication with two gentlemen who first endeavored in this country to give us an idea of the process and its extraordinary results.— they were surprised at the extreme beauty and purity of the materials upon which the designs were impressed, but were rather discouraged at the interminable catalogue of preparatory processes which were detailed. . . . One of them submitted to Mr. Gouraud, a substance for polishing, upon which his opinion was asked. On examining it, he was struck with its prominent characteristics as possessing the qualities which had long been sought for with anxiety by all interested in the new art. He made a preparatory experiment upon one of his plates, and in a few minutes obtained an extremely high and beautiful polish, thus saving eight or ten tedious operations.[48]

One of the two gentlemen was probably Morse; the other is uncertain but could have been either Seager, Chilton, or Draper, all of whom were acquainted and directly involved in the first uses of the daguerreotype in New York. Gouraud must have been impressed with American ingenuity and resources for simplifying and improving the process. It was further reported that the Daguerreolite—as the polishing substance was immediately named—

> is fortunately very abundant in this country,—a fact of which Mr. Gouraud assured himself by a geological excursion for the purpose. We may add, however, that all the localities where it is found, do not contain it of the same degree of purity and excellence. But the specimens sent to Mr. Daguerre and Mr. Arago, to be submitted to the French Institute are taken from a spot which appears to possess it in extreme purity and perfection. . . .
>
> . . . In justification of our expressions on this subject, we are happy in having the complete approbation of the pupil of Mr. Daguerre [Gouraud], and of the decided preference he gives to the new substance. And we would say to those who go to admire his rich collection,—examine the plates obtained by this new mode of polishing and judge for yourselves, if we have said too much of the Daguerreolite.[49]

It seems that American geology was as favorable to the daguerreotype as was American sunshine. The fact that the polishing compound was used within two months of publication of Daguerre's process in Paris indicates readiness to experiment with improvement of the new medium at once—a characteristic aspect of American mechanical ingenuity especially marked in the first half of the nineteenth century. A later squabble during which Gouraud claimed to have improved Morse's skills with the daguerreotype by his teaching would suggest that the Frenchman was eager to be recognized as the source of knowledge. His willingness, therefore, to adopt the Daguerreolite at once suggests his perception that America had a significant improvement to offer.

At about the same time as he moved his exhibition, December 20, 1839, Gouraud also began to prepare the public for his series of lecture-demonstrations on the daguerreotype process. In January he wrote a letter to the editor of the *Evening Post* to encourage interest:

> As I am in daily receipt of letters from different cities in the Union, requesting me to come and exhibit the proofs and mode of Mr. Daguerre's process, permit me to make use of your columns to reply to all, that I defer to their requests; and that after completing my practical lectures this week, I shall proceed to Philadelphia, Baltimore, Washington, and Charleston, to be in the spring in New Orleans, from whence I go to Havana, before returning to New York, to attend to the improvement of the numerous pupils I hope to leave behind me.[50]

In view of the fact that Gouraud remained in New York until the end of February, never reaching several of the cities on his schedule at all, it seems likely that this letter was intended to increase the "numerous pupils I hope to leave behind me." The public lectures apparently did not occur until February, though he was giving private lessons to Morse

and others. On January 31, the *Evening Post* carried a long advertisement announcing the opening of Gouraud's "central depot for all that concerns the Daguerreotype in the new world" at 281 Broadway. He offered "to suit every taste," cameras "imported (from Paris)" as well as "GENUINE APPARATUS *constructed in this country* UNDER HIS IMMEDIATE SUPERVISION." Cameras, priced at twenty dollars, were to be had in "mahogany, maple and white holly," and the entire set of equipment for making daguerreotypes was available for fifty-one dollars, packed with an instruction book; whole plates (silver-plated copper, 8½"x6½") were one dollar apiece. He listed the items necessary for the entire process "in order that those who should rely upon *other* advertisements, may know what they have to *claim* for their money."[51]

The lectures finally began on February 5. Gouraud announced that "whatever may be the state of the weather, (excepting fog,) the lecture will never be omitted," and noted his spacious room in the granite building on the corner of Chambers Street and Broadway where "views of the City Hall and of the American Institute, are those which serve to illustrate the process." Two lectures were given each day:

> Each lecture occupies about one hour, and is sufficient to be initiated in all the peculiarities of this beautiful and most valuable art. The lectures at two o'clock, on Tuesday and Friday, are delivered in the French language, and that of the same hour on Thursday, in the Spanish language. . . .[52]

All told, Gouraud would have given thirty-two lectures in New York, including six in French and three in Spanish, by the time he planned to end the series on February 20. At this rate it is likely that several hundred New Yorkers were given a working introduction to Daguerre's process. A substantial number of the viewers must have been ladies, if the direction of Gouraud's advertising is indicative, so that many visitors were less interested in taking up photography than in being entertained. It would appear that the lectures probably did more to prepare consumers than they did to produce daguerreotypists. This influence was basically significant, however, since the growth of the medium in America was almost immediately a commercial matter that needed a responsive public.

Gouraud moved on to Boston at the end of February. On March 6 he gave an invitational showing of pictures similar to the initial one in New York. The Boston *Daily Evening Transcript* observed, in high Brahmin fashion,

> The company was large and highly intelligent. The views presented to their examination were most beatuful [sic], and the unseen process by which they were produced truly astonishing. Not the half has been said of them, by the New Yorkers; and we incline to the opinion that their best qualities will be first discovered in Boston.[53]

Perhaps the *Transcript* was correct. Attendance was large and eager from the outset. The paper reported of the public opening of the exhibition on March 11 that

> The hall has been thronged all day with a crowd of ladies, and gentlemen in attendance,

and promises to be still more so when the gentlemen are most at leisure, that is in the evening. . . .[54]

On March 17 the exhibition was noted as "a constantly increasing attraction."[55] Gouraud set the first of his lectures for Friday, March 27, 1840, in the Masonic Temple. In preparation he "made some beautiful photogenic drawings of Faneuil Hall and Quincy Market, the first he has taken in this city, which are . . . fully equal to the best specimens executed at Paris."[56]

Boston reacted with intense enthusiasm to Gouraud's efforts:

> Mr. Gouraud's lecture at the Temple yesterday . . . gave the utmost satisfaction to an audience of five hundred ladies and gentlemen, the number of whom would have been twice or thrice increased if the lecturer had not judiciously limited the issue of tickets. . . .[57]

Gouraud gave only four lectures in Boston and then began to diversify his activities. His lectures

> were well attended, and the delight manifested at the first lecture, seemed not, in the slightest degree, to have abated. . . . the exhibition of the specimens of the art, at the Horticultural Rooms, will close on the Wednesday following [next Monday]. This arrangement is positive, as Mr. Gouraud's attention to his private classes will require all the time he has remaining, during his visit to Boston, if we are to except that portion of it which he proposes to devote to the taking of *portraits*. . . .[58]

Gouraud went so far with his portrait plans as to publish in the Boston papers his description of how to set up a studio and prepare a sitter. This material was reprinted in his pamphlet and published in March. The *Transcript* twice ran an advertisement on the subject:

> DAGUERREOTYPE PORTRAITS. MR. GOURAUD is fitting up an apparatus for taking portraits of any persons who may desire to have them delineated by the Daguerreotype process. For further information apply at Mr. Simpkin's bookstore, 21 Tremont Row.[59]

This notice appeared on April 14 and 16, 1840 without being repeated. It is tempting to speculate that he may have proceeded to actual portrait making, but there is currently no evidence to indicate that he completed his plans. His presence in Boston did however, bring into business a daguerreotype plate maker, one O. Rich of Court Avenue, whose advertisement ran daily in the *Transcript* from April 14 through May 5.

The noted theologian and author Edward Everett Hale reported in his later years that he had been one of Gouraud's pupils and gave some indication of the impression the Frenchman's photographic presentations made on Boston:

> Mr. Francis Colby Gray, a leader in affairs of art in Boston, one of the directors of Harvard College, interested himself greatly in Gouraud, and arranged for him a class which met in the sacred precincts of the Massachusetts Historical Society. To say this in the Bos-

ton of that day, was as if you said the class met in the queen's private apartments at Windsor.[60]

Evidence such as this indicates that the daguerreotype fascinated the leading people of the day quite as much as the average man on the street. Continuing his reminiscence, Hale recalled his own trials with the medium:

> M. Gouraud was impecunious, and I suspect that my father used to lend him money. I wish now that he had bought apparatus instead. Instead of that, we youngsters had to make our apparatus, and did. [My cousin] Mr. Durivage and I made at least two sets. . . . My first picture was of the church of which, queerly enough, I became a minister sixteen years after. . . . I prepared my plates. . . . I adjusted the camera, and then went on to the church and stood—eight minutes expired, I think—while my cousin took off the lens [cap] and put it on. . . . I am sorry that I have not this plate. But plates cost us two dollars each. I was impecunious . . . and after I had shown it to my friends, it took its turn under pumice stone and putty, and was ready for another picture.[61]

Hale noted in his journal at the time that this picture was not particularly successful, but he was vastly pleased with it because of its automatic correctness:

> I stood in the picture myself, getting Frank to open and close the camera at the right time. But this operation was rather a failure, for having stood mostly against a strong dark shade, nothing could be seen but my white shirt bosom and face and my two legs, which came against a light in the picture. It seemed really more wonderful than ever to think that I, who was the artist if any one was, was represented (and correctly) in the drawing.[62]

Hale soon tried to make a portrait, only to learn, as did other early amateurs, that portraiture was an elusive matter:

> Early in the business I sat with a mirror in my hands, in full sunshine. The mirror threw up the sun from below to abate the shadows. I sat in this light *five minutes*. The picture came out a captial portrait of my hair, ears, and *chin*. Alas! I had tipped my head too far back, and all that appeared were my projecting eyebrows and the orifices of both nostrils (no mouth, alas!) , and the chin from below taking its place.[63]

It was to be some time before the discomfort of staying for several minutes with both the sun and a mirror blazing in one's face abated enough for most people to care to sit for pictures. At about this time, however, a discovery was made that allowed portrait work to become a practical matter. This was the fact that additional exposure of the daguerreotype plate to other halogens after the iodine greatly increased its sensitivity to light. Initially bromine, and, later, various chlorine compounds, came to be used as "accelerators" or "quickstuffs," as the trade called them. Used in conjunction with superior lenses devised by Petzval and sold by the Voigtländer firm of Germany, these accelerators provided the basis for commercial application of the daguerreotype. Also in 1840, the French scientist Hippolyte Louis Fizeau introduced the practice of "gilding" the fixed picture with a solution of gold chloride which made the image more permanent, richer

in tone, and less subject to surface damage. By 1845 Fizeau's process was standard practice throughout the trade and has been a distinct factor in the preservation of pictures from the later years of the daguerreotype. Untreated pictures are less well defined in their tone than gilded ones and more prone to chemical deterioration.

Other pupils of Gouraud fared better as picture makers than did Hale. On April 15, 1840, the same day that Hale was making his picture at the church, Samuel Bemis, a dentist, purchased a complete apparatus from Gouraud along with twelve whole plates. The outfit has been preserved and may now be seen in the George Eastman House in Rochester, New York, together with the pictures Bemis made. Beaumont Newhall, Director of the George Eastman House, has observed of Bemis's first effort—a picture of the King's Chapel burying ground made April 19—that

> The picture which Dr. Bemis made on that April day in 1840 is an excellent record. Like all early daguerreotypes, it is a mirror image: the buildings are laterally reversed. The doctor photographed with an eye for detail, and yet the picture hangs together; miraculously we behold the very atmosphere of Boston over a hundred and twenty years ago.[64]

Bemis was the epitome of the early daguerreotypist as far as the concerns that went into his picture making. Fascinated with a new technical process that reproduced nature with the appearance of magical reality, he made pictures for the sake of trying out the process. It is unlikely that he considered whether he was making works of art—his concern was to record the actuality of what he saw before him. His vision was essentially untrained and direct in apprehending the facts of his subject. He recorded a view that somehow caught his interest. It is possible that he thought about preserving a moment for the future; certainly his pictures reveal to us today a moment of time suspended and denied its usual passage. Not only do we witness the "very atmosphere of Boston" in another Bemis picture (Plate 9), but we can observe the variations from one season to the next in the atmosphere. Dr. Bemis made other views of the King's Chapel burying ground after the initial one in April. In doing so, he recorded alterations in the surrounding buildings, and he reflected the snows of the winter of 1840-41 and the changing grey skies over Boston (Plates 10-11). His picture making was at least partly undeliberate; perhaps he was intrigued with recording the progress of the remodeling of a small building in the foreground; perhaps he merely found the view a convenient one for experiments—though small changes in his camera location indicate some degree of choice in how he approached the view.

That some elements of his picture making were deliberate is clear from examination of other plates Bemis made, notably in the summer of 1840, in the region around Crawford Notch, New Hampshire. The sequence of his pictures indicates a methodical approach to documenting the area. He daguerreotyped a group of buildings nearby, capturing such small details as a curtain drawn back in a window. Then he chose a new viewpoint and used buildings and a pipe-fed horse trough to frame a far vista of the Notch (Plate 12). Finally he moved up toward the mountainous cut of the Notch itself (Plate 13) to record a vague wagon road and skeletal trees like those which served Thomas Cole

so well in his noted painting of the same scene. Bemis was, thus, a true pioneer in American landscape photography by deliberately using the medium in direct response to nature.

Dr. Bemis seems to have felt the influence of nature quite strongly in making a picture of a single tree in a meadow with the homely bean poles and board fences of a farm around it (Plate 14). Centering his attention on the tree, in as direct and head-on a manner as possible, Bemis seems to have been intensely concerned with the fact and the nature of this particular tree as distinct from any other. Having made a selection which stemmed from some inner response to this particular scene, he recorded it so directly as to depict its essential nature inescapably for any viewer. It is "the thing itself," as Edward Weston put it a century later, "without evasion in spirit or technique." As a result of Bemis's directness of expression of his vision, the picture has Weston's "photographic beauty" despite technical shortcomings and the damage of time. At any moment one can go to this picture to renew an immediate apprehension of the facts and the nature of the subject—one can reflect upon their significance later as could Thoreau's locomotive driver after his brief glimpse of Walden Pond. While we can only speculate about the degree to which Bemis was conscious of what he was doing, we can recognize that he grasped the nature of the photographic medium and used it in its own unique way in such pictures. He relied on the comprehensive detail and the accuracy of the medium—applying them to his choice of subject—to report what he experienced. His expression is so immediate that his pictures carry the force of his personal discovery as strongly now as they undoubtedly did 130 years ago.

Once people such as Dr. Bemis began to bring out the inherent pictorial value of the daguerreotype, and others such as George Fuller recognized its commercial potential, the use of the medium began to spread rapidly through all levels of American society. Only nine years later daguerreotypists were so numerous that *Godey's Lady's Book* included an article on "The Daguerreotypist" as part of a continuing series on "American Characteristics," which otherwise included such elements of everyday culture as "The Sleigh Ride" and "The Village Horse Block." It was reported that

> In our great cities, a Daguerreotypist is to be found in almost every square; and there is scarcely a county in any state that has not one or more of these industrious individuals busy at work. . . . A few years ago it was not every man who could afford a likeness of himself, his wife or his children; these were luxuries known only to those who had money to spare; now it is hard to find the man who has not gone through the "operator's" hands from once to half-a-dozen times, or who has not the shadowy faces of his wife and children done up in purple morocco and velvet, together or singly, among his household treasures.[65]

If daguerreotypists had become as typical as the village horse block in nine years, they had achieved a very essential position in American life, and they had attained to such a status very quickly.

Selected examples of the spread of the word "daguerreotype" through American life provide a rough index by which to measure the diffusion of the medium through society.

From the outset, Americans had problems pronouncing the word. In 1840 Edgar Allan Poe campaigned for a properly French sound:

> this word is properly spelt Daguerreotype, and pronounced as if written Dagairraioteep. The inventor's name is Daguerre, but the French usage requires an accent on the second e, in the formation of the compound term.[66]

Even before Poe addressed himself to the question, however, native taste had adapted the word to domestic speech. The New York *Observer* discussed the problem in late 1839:

> THE DAGUERREOTYPE. We have been asked how this novel name is pronounced. Some truly mangle it most sadly. *Dog-gery-type,* says one,—*Dag-gery-type,* says another,—*Daygwerryotype* says a third. We have endeavored to procure the right pronunciation.
>
> *Daguerre* . . . spelt in our language, will be *Dargair;* the accent on the last syllable. If to this be added the latter part of the word, *o-type,* the word is easily pronounced, and might be spelt to conform to the sounds of our language *Dar-ger-row-type,* making *g* hard before *e,* and putting the accent on the second syllable.[67]

Through subsequent decades, this pronunciation has alternated with the five-syllable version which is similar but adds an unaccented *e* as a third syllable.

An exchange of letters between two California daguerreotypists in 1853 bears out the existence of parallel versions of the word. In opening negotiations with Isaac W. Baker, recently of Beverly, Massachusetts, accepting him as pupil and agent, the itinerant operator Perez M. Batchelder wrote, "We will learn you the Daguerrotype business during the first two months. . . ."[68] In sending another Batchelder letter to his wife back in Beverly, however, Baker added the note, "I think by next mail you may expect [a] Daguerreotype."[69] In the letter Baker sent on, Batchelder had, for whimsical good measure, produced an alternative version that was probably indicative of his current mood toward the work, "Winter is the season for Dogtyping."[70] Despite the presence of the two dominant forms of the word, still other versions were evidently widespread in the 1840s:

> Wide ignorance prevailed on even the elementary principles of photography, a situation displayed in no better manner than by the names given to the daguerreotype, which was variously called "dagaratype," "degyrotype," "daggertype," "dogertype," and even "dogtype". . . .[71]

In 1847 a new magazine was established in Boston and called *The Daguerreotype.* The periodical had nothing to do with the photographic medium and carried the subtitle, *A Magazine of Foreign Literature and Science; Compiled Chiefly from the Periodical Publications of England, France, and Germany.* In thus adapting the term from photography to a purely verbal medium, the publisher J. M. Whittemore sensed the unique characteristics of accuracy and detail as well as the recording facility of the daguerreotype. At the same time, however, he seemed to make no distinction between visual and

verbal "pictures," and the prospectus of the new magazine indicated this lack, stating that it was

> intended to supply, in its successive numbers, a series of striking pictures of the constantly varying aspect of public affairs, of the state of the public taste, and the bent of public opinion, in the most refined and intellectual countries of Europe; and is, therefore, not inaptly, called THE DAGUERREOTYPE.[72]

The name was chosen primarily because of the ability of daguerreotypes to capture and fix an instant out of life for study at leisure. The Introduction to volume I extended the conception of the title so as to indicate that the editor was, indeed, thinking in new literary ways which had been conditioned by his experiences with photography:

> THE DAGUERREOTYPE is, as the name imports, designed to reflect a faithful image of what is going on abroad in the great Republic of letters. . . .[73]

In one manner of speaking, such a concept partakes of the sense of realism that had been inherent when the *Knickerbocker* spoke of capturing the complex detail of the street permanently in a mirror and taking it into the house. The magazine, like the photographic plate, was to function as a sample faithfully enough made to indicate the whole nature of its subject. Careful scrutiny of a good sample would guarantee a full perception, as Emerson had suggested, if one could see sharply enough. The process was to be carried on by the magazine in as nearly pictorial terms as a verbal means would allow, inevitably by a symbolic procedure:

> it will be our aim to make the several parts of which it shall consist combine together, and produce one harmonious whole. . . . it will be our task to select from the heterogeneous mass whatever seems to be of greatest value, as indicating and portraying the mind and the manners, the tone of public opinion and the direction of the public taste . . . thus to present the American reader with a picture in which the characteristic features will all be reflected, and of which, though the lights and shades may at times be somewhat strongly marked, the general fidelity will be unquestionable.[74]

The ocular character of this approach to literary publication is striking. Given the mood of the time, however, it was not strange. It was a transfer of the painter's desire for accurate rendering to the needs of the publisher. Such an adaptation of a technical process for picture making to verbal uses reinforced the implication of the magazine's subtitle, *A Magazine of Foreign Literature and Science. . . .* Linking literature directly to science necessitated a reconsideration of traditional modes of literature. To such revised thinking the daguerreotype could supply impetus by the example of its separation from traditional modes of art. The new magazine was seen as incorporating technology into the field of literature in a way parallel to the way the daguerreotype introduced technology into pictorial art. Unyielding directness of perception was to be the hallmark of both. According to the editor,

in making our selections . . . our name implies that we must portray every important feature. No partial or sectarian views must govern our choice, and even opinions from which we dissent must (when not of irreligious or immoral tendency) often find a place in our pages. A painting may omit a blemish, or adapt a feature to the artist's fancy, but a reflected image must be faithful to its prototype.[75]

That technological considerations affected the thinking of the editor is evident from another part of the introduction.

The periodical literature of the present age is in fact one of its distinctive features; a feature belonging to the same class as railroads, and steamboats, and electric telegraphs. It is a mighty engine for the rapid diffusion of ideas among the masses of mankind, and so for the education of the people.[76]

Ultimately, it seems that the magazine was an effort to respond to a pattern of technology which was beginning to pervade the time and reach into many fields. It would have been possible for the publisher to put his efforts into sympathy with this pattern without mentioning the daguerreotype. That the daguerreotype became the specific metaphor of his efforts reflects the degree to which the medium had already become a part of public consciousness. Along with the railroad and the electric telegraph, it had taken hold of popular imagination as an example of technology. Distinct from the railroad and the telegraph, the daguerreotype had implications of symbolic insight which made it an ideal agency for such use. It seemed to epitomize new means of reaching truth in a form acceptable to everyone. As the editor put it,

The citizens of these States are frequently charged by foreign writers with national vanity; but there is one characteristic of vanity in which we are certainly wanting, namely, an unwillingness to learn.[77]

The potential function of the daguerreotype as a means of insight into human nature and character was also intuitively perceived very early. Before the end of 1843, Mrs. Francis S. Osgood, a sentimental writer of the day, had chosen the image of the daguerreotype as her organizing metaphor for a short story presented in the form of a series of character sketches. She did not use the daguerreotype directly or mention it in the story, but she relied on the title, "Daguerreotype Pictures,"[78] to indicate that she offered searching insights into the characters of her tale. The public had already found a mesmeric fascination in the lens of the daguerreotypist's camera and felt that the device somehow had the power to see inside a sitter's character. Nathaniel Hawthorne used this feeling as a central plot device in *The House of the Seven Gables* nearly a decade later, but Mrs. Osgood was influenced by such feelings before the medium was four years old.

A more sophisticated operation of the word "daguerreotype" on public consciousness is found in a letter on politics written by the popular author Joseph G. Baldwin, later noted for his sketches of southern life, *The Flush Times of Alabama and Mississippi,* published in 1853. Baldwin attended the Whig National Convention in Philadel-

phia in June 1848. Sympathetic to the candidacy of Zachary Taylor (Plate 15) over that of Winfield Scott, Baldwin observed in his letter,

> Somehow—*why* it is hard to say—Scott, although he has impressed the intellect, never has *daguerreotyped* himself, like Washington, Jackson Harrison & Taylor, upon the popular heart.[79]

Several levels of perception are involved in Baldwin's remark. Initially, there is the basic fact that the daguerreotype is a means of registering an impression on a sensitive surface; here that fact becomes a metaphor of the responsive nature of public affection. This particular metaphor also contains the element of political image making—presentation of a candidate as a popular symbolic figure identifiable with public sympathies. Bestowing affection on the part of the public, like the operation of light-sensitive materials, is a subconscious and automatic process that does not require intellect. Both, however, are processes which can be deliberately activated from without for the purpose of forming an affective symbolic image. There is still another level of perception in Baldwin's observation, that of recognizing the potential emotional power of a symbolic image registered on whichever of the two sensitive surfaces is being activated at a given time. That Baldwin should speak of Washington—who died in 1799, forty years before publication of the medium—as having "daguerreotyped himself upon the popular heart," indicates a conception of the daguerreotype as similar to the charismatic process. His mention of Washington in this context also indicates the vast symbolic presence of the first President and the need felt by political personalities to be associated with him in the popular mind.

During the daguerreotype period efforts were made to record as many of the leading figures of the day as possible, and all the men Baldwin mentioned were daguerreotyped in one way or another. Washington was shown in copies of paintings or sculptures —often as part of allegorical tableaux indicating the feeling of national homage that prevailed at the time (Plates 16, 149). Jackson was recorded as ravaged by age and pain shortly before he died in 1845 (Plate 17). It has long been felt that William Henry Harrison lived too briefly in the era of the daguerreotype to have been taken from life, having died in April 1841, before portraiture was much less than an ordeal. The Metropolitan Museum of Art's great collection of portraits by the Boston firm of Southworth and Hawes, however, includes a plate of Harrison (Plate 18) which is apparently from life and which evidently provided the painter Albert G. Hoyt with the source of his well-known portrait.

An amusing and rather impractical instance of use of the word "daguerreotype" in the late 1840s which relates to Baldwin's political use occurs in a whimsical poem on the wonders of the age, "Rhymes and Chimes,"

> Oh, the world ain't now as it used to was,
> The past is like a dream, sirs.
> Every thing's on the railroad plan,
> Though they don't all go by steam, sirs.

> Expresses now are all the rage,
> By steamboat and balloon, sirs,
> In a year or two we'll get the news
> Directly from the moon, sirs.
>
> The electric telegraphs are now
> Both time and distance mocking,
> But then, the news which they convey
> Is really very shocking. . . .
>
> Short hand is now quite out of use,
> For when the ministers preach, sirs,
> Or politicians rise to spout,
> They "Daguerreotype" the speech, sirs.[80]

A final example of the diffusion of the daguerreotype process through popular speech further illustrates the impression made by the medium as a memory device. The accuracy and permanency of the silver plates were of great importance to the general public after they became familiar, and these aspects of the medium have given it a historical significance for later generations. The leading historian Francis Parkman used the word "daguerreotype" in both these connotative senses of historical record and permanence of personal experience. In his *California and Oregon Trail,* published in 1849, he included an account of traveling with a group of Snake Indians to join a war encampment at La Bonte's Camp on the Platte River. At one point on the journey the party camped for some days at Laramie Creek to await other members. Their camp was in a small valley dominated by a great gnarled cottonwood tree around which Parkman's memories of the site were grouped as he recalled it:

> The weather-beaten old tree was in the centre; our rifles generally rested against its vast trunk, and our saddles were flung on the ground around it; its distorted roots were so twisted as to form one or two convenient armchairs, where we could sit in the shade and read or smoke. . . . An antelope or a deer usually swung from a stout bough, and haunches were suspended against the trunk. That camp is daguerreotyped on my memory; the old tree, the white tent with Shaw sleeping in the shadow of it, and Reynal's miserable lodge close by the bank of the stream. It was a wretched oven-shaped structure, made of begrimed and tattered buffalo-hides stretched over a frame of poles; one side was open, and at the side of the opening hung the powder-horn and bullet-pouch of the owner, together with his long red pipe, and a rich quiver of otter-skin, with a bow and arrows. . . .[81]

Parkman's image is centered on a single tree with a few essential details arranged around it in a manner quite like that of the daguerreotype of a tree made by Dr. Bemis of Boston in 1840 (Plate 14). His visual details are selected in the way they would have been chosen by a good daguerreotypist—one who was so concerned to be accurate about the essence of his subject that he imposed his selective will upon the unselective record-

ing ability of the camera. Parkman's conceptual application of the idea of the daguerreo-type is not mere acceptance of the powers of the medium which most people found impressive; it is a reasoned concept of the daguerreotype as a medium offering matchless accuracy that is most useful when it is under the direction of a discerning operator who sees keenly the essential nature of his subject. In his thinking, Parkman reflects deeper understanding of the particular character of the medium than prevailed generally in America nine years earlier. By the time Parkman conceived of the daguerreotype process as an ideal sort of historical recall, the medium had become definable as unique in the manner of its effect as well as in its operation. That Parkman's use of the term in this way was somewhat conscious is suggested by the Foreword to his book:

> Although in the chapters which relate to [the Indians], [the author] has only attempted to sketch those features of their wild and picturesque life which fell, in the present instance, under his own eye, yet in doing so he has constantly aimed to leave an impression of their character correct as far as it goes. In justifying his claim to accuracy on this point, it is hardly necessary to advert to the representations given by poets and novelists, which, for the most part, are mere creations of fancy.[82]

Like Emerson, Parkman felt that keen vision was the most reliable way to discern truth; what fell under his own eye was more to be trusted than the abstractions of writers at second hand. Direct experience had no substitute. A medium which could come as close as the daguerreotype to re-creating the full fact of direct experience in permanent form was the most nearly perfect tool a historian could ask. Still, as the artists felt that unselected detail did not produce truthful paintings, so Parkman recognized that selection of essential facts struck closer to truth than clutters of detail—hence his use of selection as part of his exercise of daguerrean ways of seeing. In facing this recognition, we cannot assert that Parkman was directly influenced by the daguerreotype, but we can note that his thinking was very similar to the operations of sensitive daguerreotypists active in the same period. His very use of the word indicates an acquaintance with the medium; his perceptiveness in using the idea indicates a good deal of sophistication in his understanding of the medium. His stated concern to present facts of history in terms of direct experience, if not fully daguerrean in mode, is undeniably part of the climate of the time which helped make the daguerreotype so acceptable to Americans.

The spread of the daguerreotype through American consciousness was remarkably fast, as these various examples of use of the word indicate. The medium was also remarkably well received in contrast to the adversity of its reception in Leipzig. The most significant aspect of the medium's reception, however, is the great variety of ways in which its function was conceptualized. The process was likened to the operation of political charisma as easily as it was to the searching recall of the historian. By providing new methods of insight, it seemed to be a manifestation of truth itself—with beauty—for the artist, for the editor, for the character writer, and, most necessarily, for the average American.

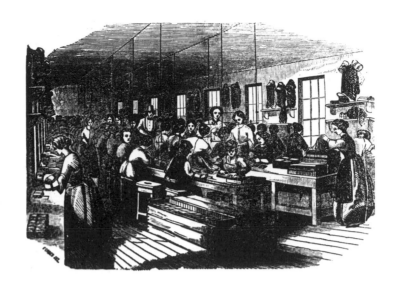

Chapter 4

THE MIRROR OF FACT

S THE DAGUERREOTYPE became a familiar item in American life, it was pressed into a great variety of uses. In addition to becoming an ideal agent for portraiture, which remained its dominant application throughout its existence, it also served the needs of the scientist, the statesman, and the explorer, as well as of the serious and the frivolous ordinary citizen with equal reward.

Scientific application of the daguerreotype process began with Daguerre himself. Morse's original letter to America on the wonder of the plates he saw in Paris included comment on a microscope study of a spider which was even more minutely detailed when examined under a lens. As he remarked,

> You perceive how this discovery is, therefore, about to open a new field of research in the depths of microscopic Nature. We are soon to see if the minute has discoverable limits. The naturalist is to have a new kingdom to explore, as much beyond the microscope as the microscope is beyond the naked eye.[1]

Along with his other experiments in the process of the daguerreotype, John William Draper also turned his attention to microscope images. By July 1840 he reported experiments with artificial light in this field:

> It has been known for many years, that chloride of silver would become dark, when exposed to the light emitted from incandescent lime before the oxy-hydrogen blow-pipe, or to galvanic discharge between charcoal points. The same effect takes place much more promptly with iodized silver. I arranged a gas microscope with a lime pea, and also with charcoal points; and procured an impression of part of a fly's wing without any difficulty. The same result was also obtained by means of a Drummond's light: a jet of oxygen passing through the flame of a spirit lamp and directed on a piece of lime.[2]

By the end of 1840, one of Draper's assistants at New York University reported,

> I have taken proofs of microscopic objects magnified six hundred times, by receiving the image from a solar microscope on the iodized surface. Perfect pictures of the wings of insects and other small objects were thus obtained.[3]

Draper did considerable work with microscope pictures, using them in teaching. In retrospect, he recalled,

> When giving courses of lectures on Physiology in the University of New York, I found it very desirable to have photographic representations of various microscopic objects. There are many such objects, costing much time and trouble in their preparation, which it is very difficult, if not impossible, to preserve. A photograph is their best substitute.[4]

Such scientific uses of the daguerreotype relied on the apparent realism of the images produced. What had seemed a wonderful illusion to the average viewer was turned to useful advantage in the laboratory and the classroom as a truthful substitute for reality. Concentrating a beam of sunlight to make his pictures, Draper found that

> Two difficulties were, however, to be provided for: 1st. If the condensing lens be large, the heat at its focal point may be so high as to injure or even destroy the object. 2d. It is not easy to find the chemical focus [that part of the light spectrum which most strongly activates the light sensitive surface], for it does not coincide with the visual one.[5]

He solved the problem by a means earlier suggested by Wolcott and others as a relief to the eyes of portrait sitters:

> But these difficulties may be completely overcome by causing the illuminating beam to pass through a solution of sulphate of copper and ammonia. This transmits all the radiations that affect a photographic surface, but absorbs all others. With the absorbed rays the heat so nearly disappears that the most delicate preparation may be left at the focal point for any length of time without risk.
>
> The solution of sulphate of copper and ammonia also enables us to ascertain the focal point with precision. On receiving the image on the ground glass of a camera, it is, of course, of a blue color, and when brought to a sharp focus its photograph will be equally sharp.[6]

Once these basic difficulties were overcome, Draper was able to regard daguerreotype with the microscope so nearly as child's play that he turned the making of microscope studies over to his thirteen-year-old son.[7] Many of the plates the boy made were reproduced as wood engravings a few years later in Draper's textbook *Human Physiology*. Draper noted years later, "Some of my old original daguerreotypes were exhibited in the Centennial Exposition at Philadelphia, as illustrations of the early history of the art."[8]

In a manner similar to magnifying the sub-visible world, Draper very early turned his concern to making the burden of the itinerant daguerreotypist easier by use of magnification. In offering his ideas, he became the first person to offer a process of photographic enlarging:

> There is no difficulty in making copies of Daguerreotype pictures of any size. The proof from which a duplicate is to be taken, should be placed in a full light, and in such a position as respects the incident light, that its lights and shadows may come out with the utmost clearness. During last winter [1839-40] I made many copies of my more fortunate proofs, with a view of ascertaining the possibility of diminishing the bulk of the traveller's Daguerreotype apparatus, on the principle of copying views on very minute plates, with a very minute camera; and then magnifying them subsequently to any required size, by means of a stationary apparatus. These arrangements will probably add great facilities to the practice of the art.[9]

Subsequent daguerreotypists made some use of a method such as Draper suggested. One of the best-known portraits of Andrew Jackson was evidently made in somewhat this way by Dan Adams, an operator sent to the Hermitage by Mathew Brady. The picture Adams made on April 15, 1845 is reproduced in *McClure's Magazine* for July 1897 (p. 803), with a caption indicating that it was enlarged from a plate $1\frac{1}{8}$ inch x $\frac{3}{4}$ inch on which the head was but one-quarter of an inch in diameter.

In the 1840s some thought was also given to reduction of photographic images for various reasons. The *Philadelphia Public Ledger* reported that

> A copy of the Boston Transcript has been daguerreotyped of the size of an inch by an inch and a half. The heading, capital letters, and pictorial figures are clear to the naked eye, and by the aid of a twelve-power microscope the letter press may be read with ease.[10]

Other reduced images seem to have been little used while the daguerreotype medium was ascendant, except in jewelry and badges. Tiny pictures were often made for lockets, brooches, or watch cases (Plate 19). While few, if any, have survived, campaign badges were supposedly made containing daguerreotypes. In 1944 a badge containing a small likeness of Daniel Webster suspended on a black ribbon was reproduced in the magazine *American Photography* as probably having been a funeral badge.[11]

A second important way in which science benefited from invention of the daguerreotype was the means it afforded for study of the spectrum. During Arago's presentation of Daguerre's process before the French Academies of Arts and Sciences in August 1839 he

Adverted to M. Daguerre's hopes of discovering some further method of fixing not merely the images of things, but also of their colours: a hope based upon the fact, that, in the experiments which have been made with the solar spectrum, blue colour has been seen to result from blue rays, orange colour from orange, and so on with the others.[12]

Color daguerreotypes remained an object of great desire throughout the entire period of the medium despite various efforts made—with varying degrees of success—to solve the problem. Spectroscopy, however, proved more accessible. Arago had, in his lecture, singled out this aspect of research for further comment:

He instanced some of the most complex phenomena exhibited by the solar spectrum. We know, for example, that the different coloured rays are separated by black tranversal [sic] lines [the Fraunhofer lines which indicate gaps in the spectrum owing to absorption of energy at given wave lengths by energy changes in atoms of some intervening substance such as the atmosphere in and around the sun], indicating the absence of these rays at certain parts; and the question arises whether there are also similar interruptions of the chemical rays?[13]

Arago had specifically directed attention to the new medium as the source of an answer by proposing,

as a simple solution of this question, to expose one of M. Daguerre's prepared plates to the action of the spectrum; an experiment which would prove whether the action of these rays is continuous or interrupted by blank spaces.[14]

In this area of research, as in so many relating to the origins of American photography, Draper was of major importance. Years later, he reported something of his early experiments with the chemical effects of light to Marcus Aurelius Root:

For years before either Daguerre or Talbot had published anything on the subject, I had habitually used "sensitive paper" for investigations of this kind. It was thus . . . that I had examined the impressions of chemical rays (i.e. their destroying of each other's effect); investigated the action of moonlight, and of flames, either common or colored, red or green; and also the effects of yellow and blue solutions and other absorbing media. . . . In these experiments I used the preparations of bromine, recently so much spoken of. The *then* difficulty was in *fixing* the impressions.[15]

Draper's articles on his work in these years were published on both sides of the Atlantic, in the *Journal of the Franklin Institute*, the *American Journal of Science*, and the *London and Edinburgh Philosophical Magazine*. Thus, as a scientist of international reputation whose experiments were published, Draper did much to secure a degree of recognition for American science at a time when many things American were in doubt in Europe and when Americans were urgently nationalistic. For our purposes, it is notable that many of his articles were derived from experiments related to photography.

Draper retained his interest in spectroscopic study for several years after his initial work. In further experiments and by means of the daguerreotype, he finally answered

Arago's question on chemical effects affirmatively. After withdrawing from portrait studio partnership with Morse in 1841 in order to devote himself to medical teaching and scientific work, Draper pursued the study of spectroscopy in 1842, 1843, and 1844, sometimes with the aid of Joseph Saxton of the Philadelphia Mint, another daguerreotype pioneer. On July 27, 1842 he made the first successful daguerreotype of the solar spectrum (Plate 20). Now in the Science Museum in London, the plate is encased along with Draper's meticulous key to interpretation and clearly shows the extension of the spectrum beyond visible light on both ends, as well as a strongly registered break (at Point D on the plate) at the point of the absorption frequency of sodium—indicating a break also in chemical effect at that wave length. On later plates the Fraunhofer lines in various parts of the spectrum were also visible. Donald Fleming, a modern scholar, has summed up the importance of Draper's work in this connection by noting that his daguerreotype experiments in this area

> took him to the edge of a whole universe of study: the mapping of the spectrum. Questions of priority are at least as difficult here as anywhere else in the history of science and technology. But it seems that Draper was the first to take with any precision a photograph in the infrared region, and the first to describe three great Fraunhofer lines there, which he called alpha, beta, and gamma. His discovery of these lines was subsequently confirmed by Foucault and Fizeau. He also photographed lines in the ultraviolet at about the same time as Edmond Becquerel. . . .

> Draper may fairly be described as one of the chief, if not the chief, of the pioneers in pushing with the techniques of photography beyond both extremes of the visible spectrum. In addition he secured some of the earliest photographs of Fraunhofer lines between these extremes—though here again he seems to have been just anticipated by Becquerel.[16]

If Draper was not always in the lead, at least he was using the new medium with a certainty and enthusiasm that allowed him to hold his ground with the leading scientists of Europe at a time when such matters were quite important to Americans.

Draper also pursued related experiments in photometry. As a further result of his demonstration in 1842 that the red rays of the visible spectrum will bleach undeveloped latent photographic images—an application of the so-called "Herschel effect"— Draper also provided a subsequent basis for infrared photography and the production of direct positive images.[17]

In addition to using the daguerreotype as a tool of pure research and as a source of illustrations to supplant real objects in teaching, Draper called on the chemistry of the daguerreotype process itself as a teaching device. Attributing the active chemical principle in light to something he called "Tithonic rays," Draper wrote his Lecture XXII on the daguerreotype in a basic chemistry textbook which was published in 1846. Despite the peculiar forms given to some of his ideas in photochemistry, the basic point of his lecture was sound, and it was something he had substantiated by his spectroscopic research with the daguerreotype:

When a beam from any shining source falls on a changeable medium, a portion of it is absorbed for the purpose of effecting the change, and the residue is either reflected or transmitted, and is perfectly inert as respects the medium itself.

No chemical effect can, therefore, be produced by such rays except they be absorbed... and absorption is absolutely necessary before chemical action can ensue.[18]

Proof of the energy-absorption basis of photochemistry by this means established a principle previously only a theory. The book was distributed fairly widely and sold several thousand copies, thus having at least the effect of exposing numerous students to his work with the daguerreotype.

Draper was not alone in using the daguerreotype for teaching. Robert Taft reports the inclusion in 1839 of a daguerreotype outfit in the purchase of technical equipment from Europe for the new medical school of Transylvania College of Lexington, Kentucky.[19] Similarly, in 1857, Santa Clara College in California listed "A complete Daguerreotyping Apparatus" among its various "machines" for instruction in the natural sciences.[20]

Early accounts of the daguerreotype included descriptions of plates made by Daguerre under the light of the moon, but he was not able to capture an actual image of the moon itself owing to the relative insensitivity of his materials. It fell to Draper to accomplish the first photographic image of the moon with any degree of success in March 1840. In *The American Repertory* for July of that year, Draper detailed the efforts he made in obtaining his picture.

The rays of the moon, reflected by the mirror of a heliostat, were made to pass through a lens four inches in diameter, and fifteen inches focus. The image, when received on an iodized plate, was about one-sixth of an inch in diameter. After an exposure of half an hour, the plate was mercurialized, and a very well marked result obtained. It appeared however to have been exposed to the light too long, as it had commenced to blacken.[21]

Draper was evidently somewhat ahead of Daguerre in the effectiveness of his materials if he was able to so overexpose his plate on his first attempt that it began to solarize—as the effect of a black or blue coloring of the plate in areas of excess exposure was called. By adding another lens to magnify the image, he reduced the light intensity for his next attempt:

The moon being about seventeen days old, by means of two lenses I obtained an image of her nearly an inch in its longest diameter; and to this, for three quarters of an hour, an iodized plate was exposed. The mercury bath evolved a chart, which was however deficient in sharpness; partly owing to defects in the optical arrangement, but chiefly on account of the difficulty of making the heliostat follow the course of the moon with accuracy. The position of the darker spots on the surface of the luminary was distinct.[22]

There seems to have been some variation in Draper's own accounts of the distinctness of

this image, since he reported the achievement to the *London and Edinburgh Philosophical Magazine* in September in less certain terms:

> There is no difficuty in procuring impressions of the moon by daguerreotype beyond that arising from her motion. . . . With another arrangement of lenses I obtained a stain of nearly an inch in diameter, and of the general figure of the moon, in which the places of the dark spots might be indistinctly traced.[23]

Despite such variations in his reports of capturing the moon photographically, Draper had made a first accomplishment in the field. Unfortunately the plate no longer exists, having been destroyed in a fire at the New York Lyceum of Natural History.[24]

Draper's relative success at daguerreotyping the moon seems not to have become widely known. For some years afterward, there remained doubt in scientific circles as to whether there was in moonlight the necessary actinism to make daguerreotype impressions. It was reported in the *Annual of Scientific Discovery* that a Dr. Robinson in Britain had been led by reports of the successful daguerreotyping of stars and nebulae at the Rome Observatory in 1843[25] to attempt without success to daguerreotype the moon. In an article on "Lunar Daguerreotypes," in 1850, the *Annual* noted that

> Dr. Robinson considered the experiment as conclusive in establishing the fact, that the chemically active principle known as actinism did not exist in lunar light. Results similar to those of Dr. Robinson, have been also arrived at by various philosophers in Europe and America. Dr. Draper, of New York, however, has stated that he has been able to detect the actinic element both in moonlight and in artificial light.[26]

Since this report was made seven to ten years after Draper's various publications of daguerreotype impressions of the moon and various types of artificial light, it appears that diffusion of knowledge of scientific experiments was not altogether thorough in the 1840s. While it is sometimes tempting to attribute great contemporary significance to activities connected with the daguerreotype, we must proceed cautiously under such evidence and content ourselves with the fact that the medium affected even single individuals in some fields. It might also be inferred from the limited publication of Draper's lunar photographic achievement, that the picture he obtained was really not very good. Draper never in his lifetime gave up reiterating the embattled claim to having made the first daguerreotype portrait from life—though he was not the first, even in America, as we have seen. Had his moon picture been as striking in quality as his portrait of his sister, it is likely that he would have made much more of it, particularly around 1850 when the first astronomically effective plates of the moon were made.

In September 1849 the moon sat for her portrait again, this time to Samuel Dwight Humphrey of Canandaigua, New York. In his own magazine, *The Daguerreian Journal*, which was founded in late 1850 as the world's first photographic magazine—another indication of the degree of American activity—Humphrey recounted the event:

> Our first experiment was performed by taking a Daguerreotype of the Moon, which was done on the first of September, at half past ten, P.M., 1849. We prepared two plates as

nearly alike as possible, and in the same manner as for taking a portrait; one of these was put in the Camera and exposed to the moon for two minutes and five seconds, then turning the regulating screw of the camera stand once around in order to allow space for another impression and exposing the plate one minute and one second; then regulating the camera as before. We obtained nine distinct impressions on the *same plate,* two as above, and seven as follows: the third exposure, fifteen seconds; the fourth, five; the fifth, four; sixth, three; the seventh, two; the eighth, one, and the ninth or last, instantaneous. Both plates were subject to the same operation, and like result produced: the impression given at the three second exposure was the most strongly marked and possessed a free development in light and shadow.[27] [Plate 21.]

Some of Humphrey's longer exposures gave images of the moon which were elongated or egg-shaped and blurred owing to the rotation of the earth, but his three-second exposure was described in the *Annual of Scientific Discovery* as strikingly clear and distinct:

> The figure was round, and the representation of the surface so perfect, that its appearance, when examined under the microscope, somewhat resembled the full moon seen through a telescope.[28]

Aside from being impressed with the realism and detail of the image, the editors of the *Annual* were pleased with Humphrey's pictures as conclusively showing

> that lunar light possesses the chemical principle or force, in a high degree, and it is to this source that we may reasonably attribute its supposed action in producing phosphorescence and other changes in animal or vegetable substances.[29]

Humphrey sent one of his plates of the moon to Jared Sparks, President of Harvard University, who responded with his "thanks for this very curious and ingenious specimen of art."[30] Sparks's use of the term "art" in this particular context reflects the tendency in America to equate art with realism and acute rendering. Considering Humphrey's description of the operation of making the moon pictures, it seems highly unlikely that he was moved by aesthetic considerations. Sparks further indicated such a view when he observed that future improvements in daguerreotypy might produce an image large enough for a lunar map. He noted that

> This would be a most desirable attainment; since a map of the moon's surface can now be made only by the detached images presented to the eye through a telescope, and then transcribed by the hand. Such a map must necessarily be imperfect, and no two will precisely agree in all the parts. A Daguerreotype map would exhibit every feature with perfect exactness.[31]

By setting his wish for precision of rendering so firmly against the hand of the artist, Sparks here reiterates the idea expressed by Nathaniel P. Willis in 1839 that the "imitative" branch of art would probably come wholly under the influence of the photographic media. In addition, however, he states a feeling that handwork by the artist is *necessarily*

imperfect as visual evidence of reality. His trust in a mechanical aid to visual reliability is measured in terms of two records being in agreement—as if Sparks had reached a viewpoint appropriate to his time that individual differences in artistic renderings indicate flaws in perception, at least for the recording arts.

Sparks was also moved by another aspect of the images Humphrey sent him:

> We here perceive the apparent motion of the Moon, or rather the actual motion of the Earth on its axis, distinctly measure[d] for half a minute's time, within the space of one-tenth of an inch. I have shown the impressions to several of our scientific men, who are much pleased with them. . . .[32]

President Sparks felt the same sort of thrill sensed by many who saw directly, for the first time, some aspect of the universe otherwise impossible to apprehend immediately—in this case visible evidence of the rotation of the earth. In such instances, the daguerreotype not only recorded reality acutely, but it added new dimensions to perceiving it. Human experience was thus deepened in a way to excite even the most learned of men.

At the time of Humphrey's venture into lunar photography, the Harvard Observatory had the largest telescope on earth. Thus ideally equipped, the Observatory began its own daguerreotype experiments aimed at the moon in 1848. Professor William C. Bond, Director of the Observatory, enlisted the aid of John Adams Whipple (Plate 22) , a leading Boston daguerreotypist, for this work. Whipple was a chemist before taking up daguerreotypy and had a good mechanical sense. He invented and patented the "crayon portrait" in 1849. This was made by interposing a circular mask between the sitter and the camera to produce a vignetted image.[33] He also devised the "crystalotype," a glass-negative process for making photographic prints.

Whipple's mechanical ingenuity manifested itself in operating his Boston studio almost completely by means of a steam engine—a wonderfully symbolic implication for the 1850s. Humphrey commented on the operation in his *Daguerreian Journal*:

> Friend Whipple we found going it *by steam*, in some respects, however, reversing the general application by making it to cool rather than heat his room. He has a large fan so arranged and worked by steam, that it keeps a cool and rather inviting breeze, and prepares the complexion of the subject for one of his best, even in the warmest weather; by steam he cleans his plates; by steam he polishes his plates, heats his mercury, distils water, and *steam like* sits his picture—hence we conclude that Mr. Whipple lives by steam.[34]

Whipple was quite proud of his steam-powered studio and wrote an article on it in 1852 for Henry Hunt Snelling's *Photographic Art-Journal*, the second photographic periodical published in America. He said of his engine that it

> is 3¼ in. diameter of cylinder, and 6 inches stroke, running about 150 revolutions per minute, and is rated at one horse power. The boiler is an upright tubular one somewhat resembling a large stove, eighteen inches diameter and five feet high.[35]

By use of the engine he was able, at a cost of twenty-five cents a day for coal, to perform all the operations of preparing plates more effectively and faster than was usual at the

time. He thus gained the advantage of a better product and shorter working time along with novelty which appealed to customers. He devised various other refinements to go with the basic power supply, such as compressed air cushioning for his buffing wheels, to control the degree of pressure of the plate for polishing, and standardized steam heat for his mercury box, to control the technical processing of his pictures more completely. Not without a slight whimsy, by steam he operated a revolving weather vane on the roof as an advertisement, and he used a cut of his steam engine to signalize his gallery in the city directory.

Joining forces at Harvard with Professor Bond, Whipple made his first daguerreotype of the moon on December 18, 1849 by removing the eyepiece and using the entire body of the great telescope as his camera.[36] In a letter to Snelling, Whipple gave an account of some of the difficulties he had to overcome in this and successive attempts:

> Having obtained permission of Professor Bond to use the large Cambridge reflector for that purpose, I renewed my experiments with high hopes of success, but soon found it no easy matter to obtain a clear, well-defined, beautiful Daguerreotype of the moon. Nothing could be more interesting than its appearance through that *magnificent* instrument: but to transfer it to the silver plate, to make something tangible of it, was quite a different thing. The "governor," that regulates the motion of the telescope, although sufficiently accurate for observing purposes, was entirely unsuitable for Daguerreotyping. . . . The governor had a tendency to move the instrument a little too fast, then to fall slightly behind. By closely noticing its motion, and by exposing my plates those few seconds that it exactly followed between the accelerated and retarded motion, I might obtain one or two perfect proofs in the trial of a dozen plates, other things being right.[37]

It is indicative of the range of concern of a good daguerreotypist that Whipple was eager to produce a *beautiful* image at the same time as he was trying for acuteness and accuracy. A quest for beauty doubtless made his task harder, but it contained a distinct element of the "photographic beauty" we have noted in discussing Weston and Bemis, which arose from the unique sense a serious daguerreotypist had of direct perception of "the thing itself." It is also not without significance for Whipple's time that the beauty he sought was the beauty of a mechanically produced image, and it was beauty he saw initially by means of a telescope—a mechanical extension of normal human perception which allowed keener vision. In attempting both beauty and accuracy, Whipple had not only mechanical problems peculiar to his own craft, but he had also to contend with the very air itself, in the form of the "vibration" well known to astronomers:

> But a more serious obstacle to my success was the usual state of the atmosphere in the locality—the sea breeze, the hot and cold air commingling, although its effects were not visible to the eye; but when the moon was viewed through the telescope it had the same appearance as objects when seen through the heated air from a chimney, in a constant tremor, precluding the possibility of successful Daguerreotyping. This state of the atmosphere often continued week after week in a greater or less degree, so that an evening of perfect quiet was hailed with the greatest delight.[38]

The "greatest delight" Whipple felt on quiet evenings is an essential feeling for intensely committed men who deal in perceptional experience—such as photographers and astronomical observers—and to creative artists generally because such times signalize an ideal opportunity to employ skill and materials in making a tangible statement of response to experiences otherwise lost. This delight is the sensitive man's response of being aware of the transcendental moment of slipping beyond the limits of keen perception to spiritual insight. Whipple's expression of greatest delight implies recognition of an opportunity to achieve a mechanical record of Emerson's sort of keen perception restated in terms of aesthetic satisfaction.

In 1927, Edward Weston wrote of a like exhilaration during a moment of intense photographic application in trying to record objects acutely and accurately as well as beautifully. As he indicated, such a moment exceeds conscious awareness of method because perception becomes direct experience:

> I had no physical thoughts,—never have. I worked with clearer vision of sheer aesthetic form. I know what I was recording from within, my feeling for life as I never had before. Or better, when the negatives were actually developed, I realized what I had felt,—for when I worked, I was never more unconscious of what I was doing.[39]

In the midst of technical and scientific exigencies, Whipple responded to this same sort of creative anticipation of an ideal moment made fruitful by the medium of the daguerreotype. Because of its particular characteristics, the medium exerted itself at the level of the operator's feelings and influenced his reactions in ways as intense as they were new in method.

One of Whipple's plates made during this period (Plate 23) shows the softening effect of atmospheric vibration fairly evidently despite the rather good definition of some of the moon's features. A much sharper plate (Plate 24), made on a visibly better evening, however, reveals something of the fine quality and the beauty of the images Whipple was eager to secure. Unfortunately, no manner of reproduction can do justice to the beauty of image in a fine daguerreotype. This image of a quarter moon is very like one noted in Humphrey's *Daguerreian Journal* in August 1851:

> Mr. G. P. Bond [Professor Bond's son], recently presented to the members of the French Academy of Sciences, a Daguerreotype of the Moon. The impression was taken with the assistance of Mr. Whipple, of Boston. This picture surprised the members who acknowledged it to be the finest production ever brought before them. Those formerly exhibited have been mere whitish dots about the size of a pinhead, not marking in the least the well known rough and mountainous surface of that satellite. The copy presented by Mr. Bond, represented the moon in its first quarter, and possessing on the plate a diameter of about two and a half inches, representing full details and incidents of the face of the moon, as it appears when seen by a powerful telescope.[40]

Whipple was continuing in the tradition already established by Draper of commanding international respect for American skill and accomplishments with the daguerreo-

type. That the French Academy of Sciences, where the daguerreotype was born for the public, should designate Whipple's picture as "the finest production ever brought before them," is high recognition of the quality of American work. The *Photographic Art-Journal* reported similar praise in England:

> After encountering great difficulties, he finally succeeded in daguerreotyping the moon. . . . These daguerreotypes are exciting great interest in Europe. The Royal Academy of Arts and Sciences has highly complimented Mr. Whipple for his great skill shown in these wonderful productions. With a person of such indomitable energy of character—such perseverance and inate [sic] talent as Mr. Whipple, nothing is impossible which the mind of man is capable of attaining.[41]

Whipple's accomplishments and honors are presented in terms of character and hard work winning over difficulties which had been an American stereotype since the time of Benjamin Franklin. This treatment stemmed in part from the mood of the time and partly from the fact that the editor of the *Photographic Art-Journal* was the same Henry Hunt Snelling whose account of the photographic researches of James M. Wattles had been given in similar terms of resolute American determination. Nationalism claimed Whipple the daguerreotypist for its own because he had succeeded by the photographic medium. The daguerreotype at mid-century had not only become as characteristic of American life as the horse block, it had become an acceptable building block for American nationalism.

Whipple, however, had already surpassed even these honors, when a plate of the moon, made by him in March 1851, took a gold medal at the Crystal Palace Exposition in London as part of a total American sweep of the gold medals awarded in daguerreotypy. Horace Greeley summed up the national attitude in no uncertain terms when he commented upon the American triumph:

> there are many good things in the American department. In Daguerreotypes, it seems to be conceded that we beat the world, when excellence and cheapness are both considered —at all events, England is no where in comparison—and our Daguerreotypists make a great show here.[42]

Greeley's remarks betray a degree of nationalistic enthusiasm that is slightly absurd when he compares American success at the daguerreotype with British. It must be remembered that Britain was the one place in the world where the daguerreotype process was patented and restricted by license, with the result that Britain was never of real significance in the field, concentrating instead on development of the calotype and the wet-plate collodion processes. It is noteworthy, however, that in less than twenty years the daguerreotype medium had so permeated public consciousness that it could fit into a nationalistic effusion as well as any other American product. Ultimately, too, it must be admitted that Greeley was right. Considering Whipple's moon plates in particular, nothing produced anywhere else could equal American work in the medium.

The efforts of Whipple and Bond, with the aid of George P. Bond and Whipple's assistant William B. Jones, were not confined to the moon. On July 16, 1850 the star Alpha Lyrae was daguerreotyped. In the absence of confirmation of reports that both stars and nebulae were first photographed at the Rome Observatory in 1843, all available evidence indicates that this was the first such photograph in history. Professor Bond wrote of the importance of this accomplishment and its implications:

> The question will doubtless occur, To what good purpose can this discovery be applied? One of the first direct applications of it would be the measurement of angles of opposition and distance of double stars. It is interesting to be assured of the fact, that the light emanating from the stars possesses the requisite chemical properties to produce effects similar to certain of the solar rays, and that these properties retain their efficacy after traversing the vast distance which separates us from stellar regions. . . . the ray of light which made the first impression on our Daguerreotype plates took its departure from the star more than twenty years ago, long before Daguerre had conceived his invention.[43]

With his remarks about the similarity of chemical properties of stellar light to those of sunlight, Bond implied a most important symbolic function of the daguerreotype. The medium confirmed that the universe was uniformly alike, at least in some ways, no matter how far beyond the reach of humanity it might spread. Such a confirmation made it possible for some men to realize that everyday sunlight coming in their windows was no different from the light coming millions of miles across space. By so small a recognition it was possible for man to relate himself to the universe in a new way—his consciousness of his situation thus expanded while his sense of presence in the universe became one degree less that of a stranger governed by deterministic forces. Technology allowed man a greater grasp of information which, in turn, gave him slightly more control over his circumstances because he could make and interpret a daguerreotype picture.

A new view of man's place in the universe came about, for some people, with the daguerreotype or, more properly, with the national mood which made the daguerreotype so desirable for American uses. The ideas of Edward Hitchcock, D.D., LL.D., Professor of Geology and Natural (i.e., Scientific) Theology and President of Amherst College, reflect an awakening to new relationships in the universe that are to be understood through science and technological elements such as the telegraph and the daguerreotype. In a lecture which he delivered to college groups repeatedly throughout the 1840s, he derived a new cosmology from elemental facts of science. Initially he noted a biblical concept of inanimate objects standing in witness of human activities and then gave that idea technological form:

> The discoveries of modern science . . . show us that there is a literal sense in which the material creation receives an impression from all our words and actions that can never be effaced; and that nature, through all time, is ever ready to bear testimony of what we have said and done. Men fancy that a wave of oblivion passes over the greater part of their actions. But physical science shows us that those actions have been transfused into the

very texture of the universe, so that no waters can wash them out, and no erosions, comminution, or metamorphoses, can obliterate them.

The principle which I advance in its naked form is this: *Our words, our actions, and even our thoughts, make an indelible impression on the universe.* Thrown into a poetic form, this principle converts creation

> Into a vast sounding gallery;
> Into a vast picture gallery;
> And into a universal telegraph.[44]

Hitchcock used various types of "reactions" drawn from various sciences for his evidence. He cited the aerial vibrations caused by his speech, fossil footprints in rocks, and the reflections of images carried by bounced rays of light as examples. He pointed out that, like endlessly continuing vibrations in the air produced by sounds, there were subtle vibrations of light which keen enough perceptive powers could see or reclaim into images. He suggested that the whole universe was thus filled with pictures of the past, could one but discern them. Quoting an unknown writer of "The Stars and the Earth," Hitchcock posited the universe as a great pictorial transcript of history:

> the universe encloses the *pictures* of the past, like an indestructible and incorruptible record, containing the purest and the clearest truth . . . and although they become weaker and smaller, yet, in immeasurable distance, they still have color and form; and as everything possessing color and form is visible, so must these pictures also be said to be visible, however impossible it may be for the human eye to perceive it with the hitherto discovered optical instruments.[45]

He exemplified his thought by speculating on a Godlike being

> with powers of vision acute enough to take in all these pictures of our world's history, as they make the circuit of the numberless suns and planets that lie embosomed in boundless space[.] Suppose such a being at this moment upon a star of the twelfth magnitude, with an eye turned toward the earth. He might see the deluge of Noah, just sweeping over the surface. Advancing to a nearer star, he would see the patriarch Abraham going out, not knowing whither he went. Coming still nearer, the vision of the crucified redeemer would meet his gaze. Coming nearer still, he might alight upon worlds where all the revolutions and convulsions of modern times would fall upon his eye. Indeed, there are worlds enough and at the right distances, in the vast empyrean, to show him every event in human history.[46]

The essential difference between Hitchcock's image and Bond's description of the passage of light from Alpha Lyrae beginning before the daguerreotype was conceived is only in the direction of the movement of light.

For a further source of "reaction" in support of his thesis, Hitchcock turned to chemistry. He observed numerous "transmutations" in substances which were "modified by the agency of man; so that here is another channel through which human actions exert an influence upon the material universe. . . ."[47] In this context, it was logical that he should use the illustration of

photography, or the art of obtaining sketches of objects by means of the action of light. This is strictly a chemical process. In a beam of light, that comes to us from the sun, we find not only rays of light and heat, but chemical rays, which act upon some bodies to change their constitution. When these rays are reflected from a human countenance, and fall upon a silvered plate, that has been coated with iodine and bromine, they leave an impression, which is fixed and brought out as a portrait by the vapor of mercury and some other agents. Here the chemical changes produced by these rays are exceedingly perfect; but they produce effects upon many other surfaces, artificially or naturally prepared; such as paper, for instance, immersed in a solution of bichromate of potash, or upon vegetation. . . . Indeed, a large part of the changes in color in nature depend upon these invisible rays.[48]

From the nature of the daguerreotype process itself and from the action of the chemical principle in light which the daguerreotype verified, Hitchcock was able to conceive of the entire universe as a vast daguerreotype gallery:

It seems, then, that this photographic influence pervades all nature; nor can we say where it stops. We do not know but it may imprint upon the world around us our features, as they are modified by various passions, and thus fill nature with daguerreotype impressions of all our actions that are performed in daylight. It may be, too, that there are tests by which nature, more skilfully than any human photographist, can bring out and fix those portraits, so that acuter senses than ours shall see them, as on a great canvas, spread over the entire universe. Perhaps, too, they may never fade from that canvas, but become specimens in the great picture gallery of eternity.[49]

It is not without significance for Hitchcock's time that nature herself is the photographer who fills the gallery with records of the truth. Hitchcock also adduced another chemical principle to guarantee that actions in darkness would also be registered—a process also semi-photographic in nature.

While Hitchcock never diminishes the supremacy of God in his lecture, his use of a daguerreotype metaphor in this sense has the effect of placing the whole universe subject to the will of man. This subjection holds because of the mindless nature of the daguerreotype process which functions only under the direction of a human hand. Though man is, by Hitchcock's metaphor, uncompromisingly revealed in all his sins and actions, the universe functions entirely for the purpose of recording man. If the metaphor is as consistent as it appears to be, the universe is a tool to preserve the record of man for some keener power to appreciate.

Ultimately, Hitchcock's idea is related to Emerson's transcendental attainment of spiritual insight by means of intense perceptive experience. He climaxes his lecture on that note:

What new and astonishing avenues of knowledge does this subject show us! . . . I do not now speak of the new knowledge of the divine character which will [in eternity] astonish and delight the soul by direct intuition, but rather of those new channels that will be thrown open, through which a knowledge of other worlds and of other created beings,

can be conveyed to the soul almost illimitably. And just consider what a field that will be. At present we know nothing of the inhabitants of other worlds, and it is only by analogy that we make their existence probable. Nor, with our present senses, could we learn any thing respecting them but by an actual visit to each world. But . . . let our sensorium be so modified and spiritualized that every thought, word, and action in those worlds shall come to us through pulsations falling upon the organs of vision, or by an electric current through the nerve of sensation, or by some transmitted chemical change,—and on what vantage ground should we be placed! Every movement of matter around us, however infinitesimal, would be freighted with new knowledge, perhaps from distant spheres. Every ray of light that met our gaze from the broad heavens above us would print an image upon our visual organs of events transpiring in distant worlds, while every electrical flash might convey some ideas to our mind never before thought of . . . and then who can calculate what organic and mental influences might be transmitted to us? . . .[50]

It is necessary to be careful about attributing too much significance of cause and effect directly to the daguerreotype in so sweeping a set of ideas as this. Nevertheless, Hitchcock did organize his entire metaphoric structure of intercommunication in space—his "Telegraphic System of the Universe," as he called it—around the daguerreotype as the perfect example of the influence of images registered on a sensitive surface. Symbolically, he saw the process as exemplary of limitless enrichment of human experience. His methods were those of the scientist—verification of the chemical principle of the actinic portion of the spectrum and definition of the relationship between various portions of the universe registering their influences upon each other—along with the parallel process of turning physical and chemical influences into pictorial images. He turned the process into metaphysics by continuing its operation until the pictures became a source of moral and spiritual effects.

Professor Hitchcock did not stand alone in his cosmic response to pictures at the time. Nor did others confine similar imagery to the purpose of making extrapolations from science. About 1850, Walt Whitman began to collect notes for a "Poem of Pictures" which took much the same form as Hitchcock's daguerreotype gallery of the universe:

> In a little house pictures I keep,
> Many pictures hang suspended—
> It is not a fixed house,
> It is round—it is but a few inches from
> one side of it to the other side,
> But behold! it has room enough—In it
> hundreds and thousands, all the varieties;
> Here! do you know this? this is cicerone
> himself;
> And here, see you my own States—and here
> the world itself rolling through
> the air. . . .[51]

Whitman internalized his picture gallery within his own head and began its display with his own likeness, but its scope is as universal as the metaphor of Hitchcock. While he did not specifically mention the medium of the daguerreotype, Whitman did include an image which comes very close to the form of a daguerreotype, first being polished then magically given power to portray any aspect of experience at will:

> And that is a magical wondrous mirror—
> long it lay clouded, but the cloud
> has pass'd away,
>
> It is now a clean and bright mirror—it will
> show you all you can conceive of, all
> you wish to behold. . . .[52]

Whitman's catalog of the images in his picture gallery resembles Hitchcock's metaphor of stepping from one star to another to observe the stages of human history, even to some of the same significant images:

> There is represented the Day . . .
> And there the Night . . .
> There is a picture of Adam in Paradise . . .
> There is an old Egyptian temple—and
> again, a Greek temple, of white marble;
> There are Hebrew prophets . . . and there
> is Homer . . .
> Here is one singing canticles in an un-
> known tongue, before the Sanskrit it was,
> And here a Hindu sage, with his recita-
> tive in Sanskrit;
> And here the divine Christ expounds eter-
> nal truths—expounds the Soul,
> And here he appears en-route to Calvary,
> bearing the cross
> This again is a series after the great
> French revolution,
> This is the taking of the Bastile, the
> prison—this the execution of the king. . . .[53]

Whitman may have been influenced by other types of pictures than daguerreotypes, despite the implications of his magic mirror. However, his concern to pictorialize events in history to gain insight into the human condition is relevant to public feelings about the daguerreotype.

A similar fascination was aroused by the daguerreotype itself immediately after Francois Gouraud showed New York his pictures in 1839:

The Daguerreotype is destined to high purposes. It is one of the most brilliant discoveries the mind of man has ever conceived and compassed. That light should be its own historian and draftsman, is, indeed, a sublime conception. . . . What would we now give to see before us the realities of past history,—to see Jerusalem with its dazzling temple when it contained its nine millions of inhabitants,—to see encamped the hosts of Israel, or to behold the city of the Caesars, or the armies of Alexander!

What high and exalted impulses would then stimulate us when we beheld these assurances of what man had been, or had achieved! The theme possesses an inexhaustible mine of interest, and any thing connected with the art is of corresponding value.[54]

Almost exactly the same thought was converted into more locally American terms by the newspaperman George Alfred Townsend in 1891, well after the daguerreotype era. On the occasion of having interviewed the aged Mathew Brady, in 1851 the best-known daguerreotypist in America, Townsend observed,

Brady . . . had some people who began with the American institution. John Quincy Adams, for instance . . . living to 1849, Brady seized his image in the focus of the sun. Had he been thirteen years earlier he could have got John Adams and Jefferson, too; and he missed the living Madison and Monroe and Aaron Burr by only four or five years. For want of such art as his we worship the Jesus of the painters, not knowing the face of our Redeemer. . . .[55]

It seems apparent that by 1850 the daguerreotype had formalized widespread impulses to search for the meaning of man through history and science, as well as through metaphysics and theology. By the time Whipple and Bond daguerreotyped a star, the medium had assumed a symbolic function of cosmic proportions, and Bond's remarks on the significance of the achievement reflect the implications of the medium in all these ways.

Whipple and Bond continued their astronomical daguerreotyping in still other areas of the heavens. On March 22, 1851:

Several daguerreotype pictures of Jupiter were obtained on plates exposed at the focus of the great refractor. The belts were faintly indicated; but the most interesting fact in connection with the experiment, apart from its having been, as is believed, the first instance of a photographic impression obtained from a planet, was the shortness of the time of the exposure, which was nearly the same as for the moon, whereas, considering the relative distances of the two bodies from the sun, it was to have been expected that the light of the moon would have had twenty-seven times more intensity than that of Jupiter, supposing equal capacities for reflection.

The modern writer Daniel Norman has commented:

This observation . . . was of great importance as indicating quite different albedoes for Jupiter and the moon.[56]

Not all the efforts Whipple and Bond made were successful. Exposure times were very long when daguerreotyping stars, and mechanical problems created distortions. Some stars did not register owing to the relative insensitivity of the medium:

> it was found that Polaris, although from its small polar distance errors of the clock work [heliostat] motion of the telescope were scarcely sensible, gave no impression at all, however long the exposure was continued. There seemed to remain no other alternative than to wait for future developments in the science which might lead to more sensitive processes. Our progress in lunar photography was arrested at nearly the same time by the imperfections of the clock work machinery of the telescope.[57]

In daguerreotyping eclipses America came in rather late. In Milan in 1842, G. A. Majocchi accomplished a poor first picture of a solar eclipse. At Koenigsberg on July 28, 1851, Berkowski and Busch captured a total eclipse of the sun, showing the corona and prominences. Professor Secchi, at Rome, examined the same eclipse with both daguerreotype and silver chloride paper. Though the display was only partially visible in the United States, Whipple recorded it at Cambridge[58] (Plate 25).

In 1854, however, an annular eclipse of the sun found eight photographers ready in various parts of the United States. In Rochester, New York, John Kelsey daguerreotyped the stages of the eclipse; wood engravings of his plates were published in *Moore's Rural New Yorker*. John Campbell; C. Barnes in Mobile, Alabama; George E. Hale in Detroit; the Langenheim Brothers in Philadelphia; Marcus Aurelius Root in Philadelphia; and Professor William Holmes Chambers Bartlett of West Point all documented the sight with the daguerreotype, and Victor Prevost, recently from France, applied the calotype paper-negative process.[59] Since no previous eclipse had ever been so widely photographed, it is clear that both skill and interest in daguerreotyping solar events had become widespread enough for a variety of persons to participate. The idea of things in the universe relating to man had grown and, at the same time, had become somewhat more matter of fact because of the impulse of daguerreotypists to record such events as a part of their regular activities.

In lecturing on the usefulness of Daguerre's invention before the French Academy in 1839, Arago had noted its possible value in the field of archaeology:

> To copy the millions and millions of hieroglyphics, which entirely cover the exteriors of the great monuments at Thebes, Memphis, Carnac . . . would require scores of years and legions of artists. With the Daguerreotype, a single man would suffice to bring to a happy conclusion this vast labor. Arm the Egyptian Institute with two or three of Daguerre's instruments, and on several of the large engravings . . . vast assemblages of real hieroglyphics would replace fictitious or purely conventional characters. At the same time, these designs shall incomparably surpass, in fidelity and in truth of local color, the works of the ablest artists.[60]

Arago recognized the comprehensiveness and accuracy of the medium in rendering detail as valuable for study. He also noted that pictures drawn by artists were "fictitious"

or "conventional" as well as unreliable and time-consuming. Within six months of Arago's presentation, traveling daguerreotypists were at work in Egypt, in Rome, and in Greece, carrying out documentary projects on a large scale for picture publishers.

A few Americans turned their cameras toward the ruins of the past on their own continent, though such activity seems not to have been widespread in this country.

Dighton Rock, an inscription stone found at Taunton, Massachusetts, around 1690, was a subject for daguerreotypists more than once. Throughout its known history the source and meaning of the rock have been hotly disputed. In the *Transactions of the Colonial Society of Massachusetts,* there is mention of a daguerreotype of the rock made as early as 1840.[61] An account is also given of pictures made in 1853 by the artist Seth Eastman and a "professed daguerreotypist" of Taunton. Henry R. Schoolcraft, the historian of the Indians of North America, commented that these plates revealed discrepancies in earlier drawings of the rock. He believed that the discrepancies were clarified enough by the daguerreotypes for him to determine that the pictographs were entirely of Indian origin. He commented on the daguerreotype method of reaching his conclusion:

> By this process of transferring the original inscription from the rock, it is shown to be a uniform piece of Indian pictography. A professed daguerreotypist from Taunton attended the artist (Capt. E.) on this occasion. . . . The lines were traced with chalk, with great care and labor, preserving their original width. On applying the instrument to the surface, the impression herewith presented was given. (Previously depicted resemblances to Roman letters disappear; moreover) no trace appears, or could be found by the several searchers, of the assumed Runic letter Thor, which holds a place on former copies. . . .

> At least two daguerreotypes were made on this occasion. One of them came into possession of . . . the Massachusetts Historical Society. The picture is of course mirror-wise reversed. It shows a man, probably Captain Eastman, coatless and wearing a tall hat, reclining on the rock, and therein differs from the one reproduced in Schoolcraft's plate. The former was evidently taken first, then a few unimportant lines were added to the chalking, the camera was moved a little further upstream, Captain Eastman assumed a different position on the rock, and the second exposure was made.[62]

Even though subsequent studies of Dighton Rock deny Schoolcraft the final word on the subject, his reliance on the daguerreotype for accurate recording is indicative of the kind of assistance the medium was able to render and how willingly it was accepted.

In 1842, John Lloyd Stephens and Frederick Catherwood sought with only relative success to employ the daguerreotype archaeologically in Yucatan. Leaving New York in October 1841, the Stephens expedition, including the later noted surgeon and ornithologist Dr. Samuel Cabot, took two daguerreotype outfits along.[63] They were meant to simplify the problem of accurately recording the ruins observed so that Catherwood could develop architectural studies of them. Various problems beset the group, as Stephens later recorded.

The next day the rain continued, and the *mayordomo* left us, taking with him nearly all the Indians. This put an end to the clearing [of the site], Mr. Catherwood had a recurrence of fever and in the intervals of sunshine Dr. Cabot and myself worked with the Daguerreotype.[64]

The basic concern of Catherwood and Stephens was to be accurate in reporting the facts of the buildings they surveyed. The daguerreotype was obviously chosen for that reason. Unfortunately the results were not altogether satisfactory, forcing Catherwood to rely on his own skill at drawing while still driving him to exertions of acute observation aided with a mechanical device:

Mr. Catherwood . . . made all his drawings with the camera lucida, for the purpose of obtaining the utmost accuracy of proportion and detail. Besides which, we had with us a Daguerreotype apparatus, the best that could be procured in New York, with which, immediately on our arrival at Uxmal, Mr. Catherwood began taking views; but the results were not sufficiently perfect to suit his ideas. At times the projecting cornices and ornaments threw parts of the subject in shade, while others were in broad sunshine; so that while parts were brought out well, other parts required pencil drawings to supply their defects. They gave a general idea of the character of the buildings, but would not do to put into the hands of the engraver without copying the views on paper and introducing the defective parts, which would require more labor than that of making at once complete original drawings. He therefore completed everything with his pencil and camera lucida, while Doctor Cabot and myself took up the Daguerreotype. . . .[65]

It is significant that after this account of dissatisfaction with the details in their daguerreotype pictures, Stephens should still close his remarks by reiterating the accuracy of the medium:

in order to insure the utmost accuracy, the Daguerreotype views were placed with the drawings in the hands of the engravers for their guidance.[66]

Even defective daguerreotype pictures were considered a reliable check on the fallibility of the artist.

In view of the vast bulk of enthusiastic comment about the perfection of daguerreotypes for recording detail in all sorts of situations, one wonders what went wrong in Uxmal. Three possibilities may be advanced. Initially, there is the fact that the range of light intensity in Mexico is very great—as photographers have repeatedly discovered to their disappointment, particularly when photographing architecture. The extreme contrast of bright light and deep shadow may simply have been too great for a single plate's latitude of sensitivity. Daguerreotypes frequently seem to have been fairly effective in resolving extreme lighting conditions, however. In addition, the medium was still quite new in the western hemisphere—Stephens gives several accounts of the natives and the residents of Merida as never having seen a daguerreotype—and not all the technical refinements which marked its later years had yet been developed.

Gilding by Fizeau's process was still relatively new in America, and images were not

as good as they were a few years later. However, both of these factors must be considered in the light of the fine work done by several European daguerreotypists under equally difficult conditions. Before the end of 1840, daguerreotypists had spread over the whole Mediterranean area to record the monuments of history. Many produced splendid pictures despite the blazing Egyptian sun and the brilliant light-dark extremes of Greece. In his book *Creative Photography: Aesthetic Trends 1839-1960,* the historian Helmut Gernsheim reproduces a well-detailed study of the facade of the Metropolitan Church in Athens in 1842 made by J. P. Girault de Prangey (his Plate 9). The picture was obviously made under brilliant sunlight which projected dark shadows, yet all the detail is fully visible because the daguerreotypist has chosen his time for best revelation of the subject—a choice denied the Stephens expedition by rain, quality of sunlight, and the number of pictures required. De Prangey was also a thoroughly skilled daguerreotypist able to overcome the extremes of light and dark.

The daguerreotype process was relatively simple to learn, and it would produce good results in most ordinary situations. But like any photographic process, its results tended to decline under adverse conditions, especially when the process was applied by those not well trained in its use. It is unlikely that any of the three men on the Stephens expedition was a technical expert. Cabot, as a medical doctor, would have had some knowledge of chemistry. The training of Catherwood, an architect and a draftsman, or of Stephens is purely speculative. They were probably given instruction when their daguerreotype apparatus was purchased. Stephens also reported that before going to Uxmal, he and his colleagues had "made trials upon ourselves until we had tired of the subjects," and had concluded that "with satisfactory results, we considered ourselves sufficiently advanced to begin."[67] It would appear that the problems of photographic rendering they encountered stemmed from several sources but principally from the fact that the men were not adequately trained. It is still something of a tribute to the recording ability of the medium, however, that so great a reliance was placed on its evidence anyway. The engravers were referred to the plates for definitive guidance, and the published account of the expedition appeared in 1843 with an introduction stressing that the accuracy of its illustrations derived in part from daguerreotypes.

At least one other daguerreotype picture exists that has archaeological implications. The New-York Historical Society has a plate made by Gabriel Harrison for the gallery of Martin Lawrence of the Stone Tower at Newport, Rhode Island (Plate 26). Like Dighton Rock, the tower is another widely disputed relic which has been known since the seventeenth century. It has been regarded as the ruin of a Norse church from the thirteenth century by some and by others as part of a windmill built around 1675. Whatever may by the facts of its origin, Harrison's picture faithfully indicates its condition in the 1850s and reflects that it was of sufficient interest for someone to want to have a picture made of it.

In addition to the Stephens party, a number of other expeditions used the daguerreotype as a recording tool for various purposes during the two decades before the Civil

War. Primarily exploring groups, these expeditions generally had other motives as well, such as seeking railroad routes across the continent or expanding American influence abroad. Since these parties were often official, acting in behalf of the federal government, their application of the daguerreotype reflects very early acceptance of the photographic medium by the government. Initially, this acceptance was more tacit than active, but by the time of the Perry expedition to Japan in 1852-54, somewhat official sanction was given and archives established.

In 1840, President William Henry Harrison and Secretary of State Daniel Webster took steps to seek a final settlement of the vexatious question of the Northeast Boundary. The exact line demarcating Canada from Maine had been festeringly uncertain ever since the Treaty of 1783, and both Britain and the United States deemed it time to settle the matter. Queen Victoria appointed a special Minister Plenipotentiary, Lord Ashburton, to negotiate directly with Secretary Webster, and the next two years were devoted to examining the entire boundary from the Saint Croix River east to the sea. To resolve discrepancies existing from previous surveys, Webster asked for a comprehensive new study of the area, and President Harrison appointed a survey commission under the chairmanship of the noted architect and engineer Professor James Renwick of Columbia University. Renwick divided the survey into three parts, each commissioner to employ "the methods and course of action most appropriate, in his opinion, to the successful fulfilment of his appointed task. . . ."[68] Since Renwick's own section, the Maine boundary, had the presence or absence of certain highlands as its basis of dispute, Renwick was particularly concerned with obtaining indisputable evidence. He not only relied on standard surveyors' tools, but he also stressed visual evidence as far as possible. He chose Edward Anthony, one of his former engineering students, to become his assistant for the purpose of making daguerreotypes in the disputed areas. Anthony, later one of the most noted daguerreotypists and photographic manufacturers in America, had studied daguerreotypy in his spare time with Samuel Morse, and was, therefore, well qualified for the unplanned post of first photographic surveyor to the government of the United States.

Very little has been discovered about the activities of the survey party with respect to the making of daguerreotypes. Anthony participated especially in the initial stage of the survey from August to November 1840. A letter from Renwick to Webster, on August 29, reports the arrival of the party at Bangor, Maine and notes the appointment of Anthony as second assistant at a rate of two dollars a day. An account of disbursements in the archives of the Boundary Survey notes a payment to Anthony on August 23. The file also notes the "Return of instruments used on the Survey of the Northeast Boundary . . . 1 Daguerreotype apparatus . . . Feb. 22, 1843."[69] The fact that the instruments returned included daguerreotype equipment seems to indicate that the equipment belonged directly to the government. If this were the case, it represents a very early commitment by an agency of the national government to the photographic medium. Such a commitment reflects the great faith that was placed in the daguerreotype because of its

recording excellence and its indisputably factual nature. Considering that the Boundary negotiations were delicate and urgent matters of diplomacy for America, such a willingness of the government to extend this degree of faith suggests something of the strength with which the medium made an impression on its time.

Renwick's report to the Secretary of State, which was submitted in turn to President John Tyler and to Congress, contains several indications of the depth of his commitment to definitive visual evidence. He twice cites use of the camera lucida for making drawings intended to be unassailably accurate. In one case, the area north of the military road from Houlton, Maine to Woodstock, New Brunswick was under particular attention:

> A sketch of this view from Park's hill is annexed to the report; and, lest any doubt be entertained of its accuracy, it is proper to state that the unassisted vision was not relied upon, but that the outlines were carefully delineated by means of the "camera lucida."[70]

When it is recalled that Renwick's major fame rests on his stature as an architect, it is plain that this statement is a very strong one. It is a complete acceptance of the fallibility of the unaided eye and hand of the artist, which are not to be relied on alone or even with the support of surveyors' descriptions. The most reliable facts must derive from visual experience intensified by mechancial means as far as possible.

In another instance Renwick demonstrates his strong faith in visual evidence by stacking his observational methods three-deep. Having turned to the western boundary of Maine, he took up the question of the highlands of St. Andre which divide the waters of the river Fourchee from those of the St. Francis. Observing from a height east of the river Du Loup, he notes,

> The nearest and more conspicuous of these highlands . . . are on the river Fourchee. . . . A similar view of the same panorama of highlands is obtained from Hare Island in the St. Lawrence, an outline of which, taken with the camera lucida, is likewise submitted.[71]

Relocating to another viewing site, Renwick continues:

> The entire panorama from the latter point, taken with the camera lucida, along with copies of some daguerreotypes made at the same place are herewith submitted.[72]

Having established by direct observation and by two mechanical aids that the disputed highlands were where the United States claimed they were, Renwick drove the fact home with a pointed visual argument:

> Of the part of the line which extends to the northeast . . . a view may be almost constantly seen from the citadel of Quebec, and from the tops of the houses in that city. One still more satisfactory may be obtained from the road between Quebec and the Falls of Montmorenci, in the vicinity of the village of Belport. The latter views are in particular referred to, as they are within the reach of numerous civil and military officers of the British Government, who must assent to the evidence of their own senses. . . .[73]

In thus proclaiming national territorial interests, Renwick might as well have quoted Emerson's essay on nature to the effect that "There is a property in the horizon which no man has but he whose eye can integrate all the parts. . . ."[74] There is something almost transcendental in Renwick's manner as he asserts that the truth is to be obtained by vision, if one will but rely on vision. In this instance, the daguerreotype was evidently considered more as a clinching argument than as a primary experience alone. But its power to record reality convincingly is unquestioned in Renwick's application of it.

What became of these daguerreotypes no one presently can say. Renwick may have given them to Webster for use in his deliberations before the conclusion of the Webster-Ashburton Treaty, but no reliable record of such use has survived. Renwick's report mentions "copies of daguerreotypes" only, and the archive file on the Boundary Survey contains four drawings marked "Daguerreotype views."[75] There is some evidence that Anthony's activities were considerably more extensive than these few facts would indicate. The records of the Fifth Auditor of the Treasury relative to the Boundary Survey include four separate entries of compensation to Edward Anthony covering various periods between April 25, 1841 and March 31, 1842. Payments are also noted for daguerreotype materials, including a bill of $39.92 paid to G. W. Prosch, an important early lens and equipment maker for unspecified "daguerreotype apparatus," and a bill of $27.50 paid to S. F. B. Morse for "100 daguerreotype plates."[76] If Anthony was using plates in such number, it seems reasonable to believe that a substantial body of pictures must have been made. What became of them is one of the great unanswered questions of American photographic history.

The daguerreotype was not restricted to territorial expeditions in this period. In his book *Cosmos*, published in 1853, the leading scientist Alexander von Humboldt urged the application of photographic media to scientific exploration. Eleven years earlier, in 1842, the first American to make a specific effort in this direction was John C. Fremont (Plate 27), on his first western expedition. Unfortunately, his effort was a failure —so thoroughly, indeed, that only the recently discovered German diaries of his cartographer have recorded the fact at all. Charles Preuss kept a sneering record of Fremont through three of his five expeditions and delighted in noting any personal failures of his commander. In the instance of Fremont's effort to make daguerreotypes, Preuss's sarcasm obscured the fact that Fremont was quite advanced in even considering the medium. Preuss not only failed to appreciate Fremont's scientific concern for trying the daguerreotype, but he attributed failure to American national character. On August 1, 1842 the party had camped at Independence Rock on the way to the Wind River Mountains in what is now Wyoming. The next day Preuss recorded,

> Yesterday afternoon and this morning Fremont set up his daguerreotype to photograph the rocks; he spoiled five plates that way. Not a thing was to be seen on them. That's the way it often is with these Americans. They know everything, they can do everything, and when they are put to a test, they fail miserably.[77]

On August 5, the party was in the Wind River Mountains on the way to Fort Platte; and Preuss explicitly scorned Fremont's scientific interests, remarking acidly on his obvious lack of skill with the daguerreotype:

> Fremont is roaming through the mountains collecting rocks and keeping us waiting for lunch. I am as hungry as a wolf. That fellow knows nothing about mineralogy or botany. Yet he collects every trifle in order to have it interpreted later in Washington and to brag about it in his report. Let him collect as much as he wants—if he would only not make us wait for our meal.
>
> Today he said the air up here is too thin; that is the reason his daguerreotype was a failure. Old boy, you don't understand the thing, that is it.[78]

Clearly Fremont did not know what he was doing, but his willingness to try the medium in conjunction with his efforts to collect specimens shows him to be a man of his age. He was fascinated with science and with the recording power of the daguerreotype as much as were Whipple and Bond in Cambridge capturing the moon or Stephens and Catherwood in Yucatan restoring prehistory to the world. Men such as these felt that the daguerreotype was a means of extending their senses so as to gather more telling information about the world. Even Preuss was occasionally able to feel the fascination of recording a sublime aspect of nature:

> Today Fremont again wanted to take pictures. But the same as before, nothing was produced. This time it was really too bad, because the view was magnificent.[79]

That Preuss should relent, after having been so completely scornful about daguerreotyping or abstracting parts of nature in any other way, is indicative of the power of the landscape itself. His comment, written later in the day, suggests that, like Thoreau's locomotive engineer, he could be made a better man by a memory image of his vision of nature. Preuss's response here is to the thought of keeping a permanent image of the splendor of nature as much as it is to a direct experience of nature itself.

Fremont did not renew his interest in using photography again until his last expedition. On reading Humboldt's *Cosmos* in 1853, he again became persuaded of the potential value of photographs for catching "the truth in representing nature."[80] Fremont invited Solomon N. Carvalho, an established painter and daguerreotypist, to join the company of his fifth expedition into the Rockies. By 1853 the daguerreotype was beginning to face competition from various negative-positive processes, and Fremont was uncertain which method to use. At his departure camp near Westport, Kansas he called a competition between Carvalho and a Mr. Bomar, a "photographist" who used the waxed-paper process for making negatives. Carvalho recorded the event in his account of the expedition:

> The preparations not being entirely completed [for the waxed-paper process], a picture could not be made that day; but on the next, when we were all in camp, Col. Fremont requested that daguerreotypes and photographs should be made. In half an hour from the time the word was given, my daguerreotype was made; but the photograph could not be

seen until next day, as it had to remain in water all night, which was absolutely necessary to develope it. . . . Col. Fremont finding that he could not see immediate impressions, concluded not to incur the trouble and expense of transporting the apparatus, left it at Westport, together with the photographer.[81]

Fremont seems to have made a sound choice. If Carvalho did not exaggerate, Bomar evidently did not understand his process well, since no such length of processing time was standard for any photographic medium in use at the time. Occasional purists washed final prints for up to twelve hours, but developing was a brief matter.

On the first morning of the expedition, Carvalho was overcome by the sublime aspect of nature as he confronted the Great Plains for the first time:

> My heart beat with fervent anxiety, and whilst I felt happy, and free from the usual care and trouble, I still could not master the nervous debility which seized me while surveying the grand and majestic works of nature. Was it fear? no; it was the conviction of my own insignificance, in the midst of the stupendous creation; the undulating grass seemed to carry my thoughts on its rolling surface, into an impenetrable future;—glorious in inconceivable beauty, extended over me, the ethereal tent of heaven, my eye losing its power of distant vision, seemed to reach down only to the verdant sea before me.[82]

The language Carvalho uses to describe his sensations in facing nature suggests the transcendental experience of Emerson in a form appropriate to great distances which defeat the keenness of sight. His sense of the wonder of the landscape is of a part with Thomas Cole's enthusiasm and the spiritualizing impulses Mrs. Clara Moreton Moore derived from contemplating Niagara Falls. As Emerson wrote of becoming a vast transparent eyeball, ultimately fusing part and parcel with God, so Carvalho experienced a commitment to the overriding spirit of nature, yielding himself up to it completely in trust:

> A deep sigh of longing for the society of man wrested itself from my breast. Shall I return, and not accomplish the object of my journey? No. I cannot; does not the grass, glittering in the morning dew in the unbroken rays of the sun, beckon me a pleasant welcome over its untrodden surface. I will onward, and trust to the Great Spirit, who lives in every tree and lonely flower, for my safe arrival at the dwelling of my fellow-men, far beyond the invisible mountains. . . .[83]

Such feelings are in themselves not uncommon in the frontiering period when Carvalho wrote. What is significant is that he wrote this exalted description three years later, after repeatedly facing death from freezing, hunger, exhaustion, and deterioration in the face of the Rocky Mountain winter. This emotional statement is not merely a pleasant recollection, it is the spiritual experience of Thoreau's locomotive driver once more—though it carries more expansive feelings. It is reactivation of the type of visual encounter with nature from whence derived the power of the American landscape felt generally by artists and poets in the early nineteenth century. Such feelings assume importance for our examination of the daguerreotype in American life when Carvalho joins his spiritual responses toward nature to the making of daguerreotype pictures. Months

later, near the end of December, 1853, after the expedition had crossed the Continental Divide in the vicinity of Cochotope Pass, Carvalho made the fusion explicit:

> Near by our camp, a rugged mountain, barren of trees, and thickly covered with snow, reared its lofty head high in the blue vault above us. The approach to it was inaccessible by even our surefooted mules. From its summit, the surrounding country could be seen for hundreds of miles. Col. Fremont . . . told me that if I was determined to go he would accompany me; this was an unusual thing for him and it proved to me, that he considered the ascent difficult and dangerous. . . .
>
> After three hours' hard toil we reached the summit and beheld a panorama of unspeakable sublimity spread out before us; continuous chains of mountains reared their snowy peaks far away in the distance, while the Grand River plunging along in awful sublimity through its rocky bed, was seen for the first time. Above us the cerulean heaven, without a single cloud to mar its beauty, was sublime in its calmness.
>
> Standing as it were in this vestibule of God's holy Temple, I forgot I was of this mundane sphere; the divine part of man elevated itself, undisturbed by the influences of this world. I looked from nature, up to nature's God, more chastened and purified than I ever felt before.
>
> Plunged up to my middle in snow, I made a panorama of the continuous ranges of mountains around us.[84]

In this instance, Carvalho's act of making his panorama of daguerreotypes comes as the necessary completion of the experience. The pictures render the experience permanent and verifiable. They are the remaining token of the exalted spiritual event, to preserve visually the intensity of the direct experience for contemplation later.

Significant and intense as such experiences with the daguerreotype and nature were, they were not the common occurrence of the expedition. Carvalho more often found the duties of his assignment quite miserable:

> To make daguerreotypes in the open air, in a temperature varying from freezing point to thirty degrees below zero, requires different manipulation from the processes by which pictures are made in a warm room. My professional friends were all of the opinion that the elements would be against my success. Buffing and coating plates, and mercurializing them, on the summit of the Rocky Mountains, standing at times up to one's middle in snow, with no covering above save the arched vault of heaven, seemed to our city friends one of the impossibilities—knowing as they did that iodine will not give off its fumes except at a temperature of 70° to 80°. . . .
> While suffering from frozen feet and hands, without food for twenty-four hours, travelling on foot over mountains of snow, I have stopped on the trail, made pictures of the country, repacked my materials, and found myself . . . some five or six miles behind camp, which was only reached with great expense of bodily as well as mental suffering.[85]

More than once Carvalho found resentment from the muleteers of the crew directed toward his bulky equipment:

> Twice I picked up on the road the tin case containing my buff, &c., which had slipped off the mules, from careless packing—done purposely; for if they had not been fortunately found by me, the rest of the apparatus would have been useless. On one occasion, the keg containing alcohol [for drying plates] was missing . . . and it was found half emptied on the road.[86]

Despite the problems of carrying the daguerreotype equipment, Fremont was completely committed to it. He kept it in active use until the condition of his men forced him to cache it, along with even powder and shot, to lighten the final dash for survival to Parowan, Utah. Somehow the pictures outlasted the expedition, though it is not clear whether they were carried along or cached and retrieved later.

To recuperate, Carvalho left the party in Utah, eventually making his way to San Francisco and taking sea passage back to New York. His book on the expedition, unfortunately, does not deal specifically with the daguerreotype activities he carried out. As a result, we know little of the details of his work. At one point he mentions great herds of buffalo as subject matter:

> at one time there could not have been fewer than two hundred thousand in sight. . . . We stopped for more than an hour to allow a single herd to gallop, at full speed, across our path. . . . I essayed, at different times, to daguerreotype them while in motion, but was not successful, although I made several pictures of distant herds.[87]

At another point he mentions working in a Cheyenne village on the Big Timber River:

> I went into the village to take daguerreotype views of their lodges, and succeeded in obtaining likenesses of an Indian princess—a very aged woman, with a papoose, in a cradle or basket, and several of the chiefs. I had great difficulty in getting them to sit still, or even to submit to having themselves daguerreotyped. I made a picture, first of their lodges, which I showed them. I then made one of the old woman and papoose. When they saw it, they thought I was a "supernatural being;" and, before I left camp, they were satisfied I was more than human.[88]

The plate of the lodges which Carvalho notes here may be the only one of his pictures to survive today (Plate 28). The picture presented here is a damaged plate included in the Mathew Brady Collection of the Library of Congress. Brady was assigned to make glass-plate negatives of Carvalho's plates after Fremont's return to New York, and it has been speculated that this single plate is one of the originals made on the expedition.[89]

Carvalho otherwise notes in his book a few specific pictures he made. He daguerreotyped another Indian princess—a beautiful young woman who followed a nearly universal impulse to dress up for her picture. He notes that she "attired herself in her most costly robes, ornamented with elk teeth, beads, and colored porcupine quills. . . ."[90] He also cites views of Huerfano Butte and a few other points in the mountains, as well as a view of Brigham Young's house in Salt Lake City. All things considered, it is likely that he made between two and three hundred pictures on the trip. With the possible

exception of the view of the Indian village mentioned, none are known to survive, although it is known that they did safely come through the expedition. Mrs. Fremont gave an indefinite account of them later and mentioned something of their effectiveness:

> though new conditions and difficulties made many embarrassments, yet almost all the plates were beautifully clear, and realized the wish of Humboldt for "truth in representing nature." These plates were afterward made into photographs by Brady in New York. Their long journeying by mule through storms and snow across the Sierras, then the searching tropical damp of the sea voyage back across the Isthmus, left them unharmed and surprisingly clear, and, so far as is known, [they] give the first connected series of views by daguerre[otype] of an unknown country, in pictures as truthful as they are beautiful.[91]

Aside from their historical value, Mrs. Fremont notes the combination of truth and beauty which is so often seen as the characteristic response to pictures made by the daguerreotype process. By the time she wrote these words, the plates may already have been destroyed. If they had been, her impression of their combined truth and beauty was obviously very strong—strong enough to cause her to speak of the images in the present tense. If they still existed, it is equally clear that the pictures still carried a full weight of truth and beauty thirty years after the expedition. It is clear that the Fremonts placed great value on the pictures. The plates were copied photographically by the Brady studio, the leading photographic name in America at the time; they were copied into oil paintings, wood engravings, India-ink sketches, and, finally, engraving plates for book reproduction, to be included in Fremont's book on the overall results of his five expeditions. His nomination for President in 1856 set the project aside, not to be resumed until the 1880s. Throughout this time, however, Mrs. Fremont guarded the picture materials for the book in a way that revealed the significance she attached to them as unassailable records:

> During these thirty years the boxes containing the material for this book were so carefully guarded by me, that all understood they must be saved first in case of fire. When we were leaving for Arizona in '78 the boxes containing the steel plates and wood blocks were placed in Morrell's "Fire-Proof" warehouse, which was destroyed by fire in October of '81. We lost much that was stored in that warehouse, choice books, pictures, and other treasured things, but these materials for the book, we had placed for greater security in the safes below the pavement, where the great fire passed over them and left them completely unharmed.[92]

Mrs. Fremont is lamentably imprecise at this point, so that we are not certain whether the daguerreotypes themselves survived the fire or were even involved in it. What is clear from her remarks, however, is that the pictures were essential to authenticate the verbal account of opening the unknown West. Fremont kept journals, and he had access to notes by members of some of his crews, in addition to having firsthand memories. But the protection and concern given the pictures imply that a much greater

degree of reliability attached to them as a *visual* record containing comprehensive detail and, in some cases of intense experiences, triggers for reactivating feelings. They represented events in permanent form, and they were emotional symbols of the most significant activities of Fremont's life, but, in every case, the important fact is that they were *pictures* which were prized far above any verbal record.

The key purpose of Fremont's expeditions was to determine the best route for a transcontinental railroad. After the final trip, Fremont urged the feasibility of crossing the Rockies in winter at Sand Hills Pass. He insisted that snow was minimal in this part of the mountains and cited the visual evidence of daguerreotypes to support his case:

> On the 8th of December we found this whole country free from snow, and Daguerre views taken at this time show the grass entirely uncovered in the passes.
> Along all this line the elevation was carefully determined by frequent barometrical observations, and its character exhibited by a series of Daguerreotype views, comprehending the face of the country almost continuously, or at least sufficiently so to give a thoroughly correct impression of the whole.[93]

The daguerreotype provided sufficient evidence of the character of the landscape that Fremont felt secure in citing it to urge national commitment to building a railroad across the continent. The convincing power of the pictures must have been as great as their realism in Fremont's view of them. It seems certain that he conceived of such pictures as tangible fact.

At the time of Fremont's personally financed last expedition, the War Department also sent an expedition to consider possible routes for a railroad. The daguerreotypist John Mix Stanley was an official member of this expedition. He was an established artist in drawing and watercolor, and the report of the expedition, liberally illustrated with colored lithographs, owes much to his skill. The pictures do not, however, have the character of photographs, and little note is made of Stanley's photographic activities. There is just enough for us to suppose that his experiences with the Indians were similar to those of Carvalho. Isaac I. Stevens, Governor of Washington Territory and director of the expedition, noted Stanley's activities at Fort Union on the Missouri River near the juncture of the Yellowstone:

> Mr. Stanley, the artist, was busily occupied during our stay at Fort Union with his daguerreotype apparatus, and the Indians were greatly pleased with their daguerreotypes.[94]

Later on the trip, Stevens noted an even stronger fascination among the Indians at Fort Benton:

> September 4 [1853].—I concluded not to push off the advance parties today, as many of the animals required rest. Mr. Stanley commenced taking daguerreotypes of the Indians with his apparatus. They were delighted and astonished to see their likenesses produced by the direct action of the sun. They worship the sun, and they considered that Mr. Stanley was inspired by their divinity, and he thus became in their eyes a great medicine man.[95]

The Stanley daguerreotypes have vanished along with those of Anthony and Carvalho. Robert Taft speculated in 1938 that a few of the Indian portraits might have been preserved in Blackfoot lodges in Montana, but no report of any has appeared so far.

Another government expedition which used the daguerreotype began before either the Stevens or the Fremont expeditions and lasted into 1854. This was the Perry expedition to Japan, a major diplomatic and naval operation. Once President Millard Fillmore (Plate 29) and Commodore Matthew C. Perry (Plate 30) settled on a strict naval format for the expedition, few civilians were allowed to participate. Two exceptions were the artist William Heine and the daguerreotypist Eliphalet Brown, Jr., who were signed as "acting master's mates." Brown, a draftsman as well as a daguerreotypist, was continuously active during the voyage.

Arriving in Napha, Lew Chew (now Naha, Okinawa), Perry sent parties ashore to study all aspects of the region as practice for applying similar methods to Japan.

> The Commodore also resolved to procure a house on shore, and gave notice to Mr. Brown, the artist in charge of the daguerreotype apparatus, that he must prepare his materials, occupy the building, and commence the practice of his art.[96]

By early June 1853,

> The daguerreotypists, Messrs. Brown and Draper [master's mate in charge of the telegraph system, assigned to assist Brown], were settled on shore in a house outside the village of Tumai, and some of the embellishments of this volume [of the government report of the voyage] are illustrative of the results of their very useful labors.[97]

The report includes an illustration "Drawn from Nature by Heine, Figures by Brown," lithographed by Ackerman of New York (Plate 31), showing Brown at work with his camera trained on a group of natives before a temple. Lithographs copied after Brown's daguerreotype portraits of the Chief Magistrate of Napha (Plate 32) and the Regent of Lew Chew (Plate 33) vary in the character of the lithographic work, but they exhibit standard conventions of daguerreotype portraiture of the period in terms of the posing of the sitters and the absence or limitation of artifacts and decoration. Both pictures reflect the daguerreotypes underlying them, clear evidence of their being copied as closely as possible for the sake of preserving the accuracy and detail of the originals. If a background is partially drawn in, as in the picture of the Regent, the addition is obvious from its lack of photographic presence. Comparison of these pictures with that of Brown daguerreotyping at Tumai reveals that considerable realism has been added by the camera.

On June 25, Perry reported to the Secretary of the Navy that diplomatic interchanges with Napha had occurred and that "exhibitions of the Daguerreotype, the Magnetic Telegraph, the Submarine Armor and other scientific apparatus have been to the utter astonishment of the people."[98] Perry, with his sense of the dramatic, made demonstrative use of the daguerreotype as a means of impressing the Lew Chewans and later the Japanese with the marvels of American technology. Clearly the medium was considered an American process on this occasion. In 1849, *Godey's Lady's Book* had called the me-

dium an "American Characteristic" within the country; now Perry used it as an American national artifact before the world. The process which had seemed amazing to Europeans and supernatural to American Indians was now applied as a diplomatic device to impress the Asians and expand the influence of the United States in a venture with far-reaching international consequences.

It is noteworthy that both Perry and Fremont should have chosen to use the medium of the daguerreotype in expanding the "manifest destiny" of America in different parts of the world at the same time. Both were aware of the drama they took part in, and both attempted to make full use of the daguerreotype to heighten the impact of that drama as well as to record it. In such terms Fremont symbolically described his aspect of the work both were embarked upon:

> It seems a treason against mankind and the spirit of progress which marks the age to refuse to put this one completing link to our national prosperity and the civilization of the world. Europe still lies between Asia and America; build this railroad and things will have revolved about; America will lie between Asia and Europe—the golden vein which runs through the history of the world will follow the iron track to San Francisco, and the Asiatic trade will finally fall into its last and permanent road, when the ancient and the modern Chryse throw open their gates to the thoroughfare of the world.[99]

Perry and Fremont both relied on the daguerreotype for essential records of their expeditions to bring this ideal to pass, and both were aware of the excitement of the visual medium for lending credence to this ideal. Perry reinvoked the original wonderment of the daguerreotype in full knowledge of America's preeminent skill in using the medium —already established in London at the Crystal Palace in 1851. He moved with equal certainty that the success of his mission would close the circle of the "vein of gold" with Asia toward which goal America was pressing with exuberance.

After his initial visit to Japan, Perry withdrew to headquarters at Macao. Despite a fever epidemic which attacked even Perry himself, all personnel worked at surveying and scientific study.

> The artists and draughtsmen were constantly engaged in making and completing their sketches and drawings, of which more than two hundred were finished. The several apparatus of the magnetic telegraph, the Daguerreotype, and the Talbotype were arranged and put in full operation.[100]

Perry apparently did not distinguish between the daguerreotype and the talbotype paper-negative process as Fremont had done when he rejected Mr. Bomar. According to Francis L. Hawks, both photographic processes were in use, which reflected increasing competition for the daguerreotype by reason of the fact that numerous prints could be made with the talbotype.

The presence of the talbotype, however, opens a new area of inquiry about the photography carried out on the Perry voyage in that its presence has not been noted previously by photographic historians. One must wonder just how much the paper-negative

process was used, since it was barely mentioned in the report of the voyage, and no indication was given as to who used it. No mention of it with respect to Brown exists in the various published sources thus far examined, and no mention of it occurs in the picture credits of the final report. No mention of the talbotype occurs in the comments on the visit to the U.S.S. *Powhatan* of the Japanese legation bringing the Imperial reply to President Fillmore's letter, on March 9, 1854 when

> they appointed the Monday following (March 13th) for the reception of the presents, and it was arranged that those persons who had the supervision of the telegraph, the Daguerreotype apparatus, and steam engine, should land on the previous Saturday, to arrange a place for their suitable exhibition.[101]

Evidently Perry chose to rely on the more visible drama of the daguerreotype process for the occasion, or else the talbotype was actually a secondary item in the equipment of the expedition. Whatever the situation of the Talbot medium, it is clear that the Imperial legation was to be treated to a display of the daguerreotype which Perry hoped would be as strongly impressive as the one in Lew Chew.

It is probable that the Japanese were less obviously impressed. Aside from their training in reserve, it was noted that

> The higher classes of the Japanese with whom the Americans were brought into communication were not only thoroughly acquainted with their own country, but knew something of the geography, the material progress, and contemporary history of the rest of the world. Questions were frequently asked by the Japanese which proved an information that, considering their isolated situation was quite remarkable, until explained by themselves in the statement that periodicals . . . were annually received from Europe through the Dutch at Nagasaki; that some of these were translated, republished, and distributed throughout the Empire. Thus they were enabled to speak somewhat knowingly about our railroads, telegraphs, daguerreotypes, Paixhan guns, and steam-ships, none of which had they ever seen before Commodore Perry's visit.[102]

Theoretical acquaintance with the daguerreotype, however, had never measured up to actual observation of it. Whether the event occurred at the time of the Perry visit or not, Beaumont Newhall and Robert Doty have reported that the first sight of a daguerreotype led the painter Renjio Shinoke to break his brushes and become Japan's first photographer.[103] It seems likely that the Japanese were considerably impressed with the daguerreotype even though the report remains silent about their reaction. Whatever the response of the Japanese, the fact is clear that the Americans were immensely proud of the daguerreotype as part of the group of technological items which they presented every time they wished to impress the Asiatics with American culture.

As was the case with the other expeditionary daguerreotypes, the plates Brown made in the Orient have been lost. A petitition introduced in Congress on Brown's behalf in 1860 reflects the magnitude of his work:

> Besides being employed in various ways on shipboard and on shore in different artistic employment, he provided himself with all the apparatus necessary to the daguerreotypist, and took over four hundred pictures, all of which became the property of the government, and many of which were used in illustrating Commodore Perry's work on the expedition.[104]

Despite the fact that Brown was forced to provide his own equipment, for which he was never reimbursed by the government, the pictures he made became the first official American pictorial archive, although they have subsequently disappeared. As the House and Senate reports on Brown's petition for compensation pointed out,

> The authority to employ artists for the Japan expedition was not directly conferred by Congress on the department having charge of it. As the employment of artists was so very essential to the success of an expedition like that in charge of Commander Perry, the failure on the part of Congress to confer the authority may be safely charged to inadvertence rather than design. Commodore Perry foresaw . . . the evil results of this inadvertency, and engaged suitable artists to join the expedition.[105]

Since Brown's petition was rejected, the substance of the official sanction for his work is tenuous at best. Still, the pictures became the property of the government under this vague official sanction, whether inadvertently or not. The historical significance of this event has been pointed out by a member of the staff of the National Archives:

> Thus an agency of the United States Government in connection with the transaction of public business had consciously created photographic records that were appropriate for preservation as evidence of its operations or as the embodiment of valuable information. The previous sentence paraphrases a part of the definition of records, including photographs, in the Records Disposal Act of July 7, 1943. To one who works with photographic archives this definition gives comfort that is not afforded by European definitions of archives. And the actual treatment of photographs as archives in the United States antedates by almost a century their acceptance as such by the British.[106]

In its official capacity, the federal government was eager to preserve the visual record of its discoveries in the opening of Japan to the modern world. Desiring immortality for a memorable event excited members of government agencies as insistently as the same impulse affected the members of any average family in America. Pictorial records treasured for reasons of pride operated as permanent sources of verification of memorable national events. It is particularly unfortunate that Brown's pictures have been lost; their historical value would be incalculable.

Tantalizing hints of what we might have seen in Brown's pictures filter through the lithographs included in the *Narrative of the Expedition* at times when the reproductions are obviously close to the original daguerreotypes. A full-length portrait of the two principal interpreters assigned to Perry's delegation looks like a photograph in stance and detail (Plate 34). Another, of the Prince of Idzu (Plate 35), implies the accurately un-

studied realism of detail rendered by Brown's camera. A few of the images were not only excellent records, but under study they emerge as handsome pictures.

The copy of Brown's plate of the Bell-House at Simoda (Plate 36) comes closest of all the illustrations to the full tonal range and detailed beauty of a well-made photograph. In this instance we can apprehend something of the atmosphere and the mood of the place. In this picture we are fortunate that Brown's original came into the hands of the lithographer Napoleon Sarony, who became, himself, a noted photographer later in the century. His understanding of photographic rendering is apparent. There is a sense of "the Thing itself—with photographic beauty." The compositional arrangement of light and dark is clearly atmospheric to the place recorded rather than being created entirely from the imagination of the picture maker. The cutting of details at the edge of the picture and the placement of rich dark areas and sparkling whites are unlike those generally employed by engravers of the period, who normally subjected their details to a more visibly studied pattern. In this picture the forest has a character of detail that is random in distribution. Yet it is controlled by choices of the daguerreotypist in selecting his lighting and his viewpoint. Also, his points of emphasis are secured by light and dark tonal contrasts in a manner distinctive to photography.

On the Perry expedition, as in other instances, the daguerreotype was valued for its truth and its recording accuracy. The photographic appearance of the published lithographs underlines this aspect of veracity. This same reliable character of truth made the medium valuable for other types of government uses as well. In Europe the validity of mechanically produced pictures for identification was realized very early. By 1841 it was noted in America that the French were daguerreotyping criminals:

> When a discovery has been made in science there is no telling at the time to what useful purpose it may afterwards be applied. The beautiful process invented by Daguerre, of painting with sunbeams, has been recently applied to aid the police in suppressing crime. When any suspicious person or criminal is arrested in France, the officers have him daguerreotyped and he is likewise placed in the criminal cabinet for future reference. The rogues, to defeat this object, resort to contortions of the visage and horrible grimaces.[107]

Several other European countries followed suit shortly. The four oldest surviving "mug shots" of this type, daguerreotypes made in Belgium in 1843 and 1844, were reproduced in *Fingerprint and Identification Magazine* for January 1962.[108] The San Francisco police department was evidently the first in America to photograph criminals regularly. In 1854-55, Captain Isaiah W. Lees instigated the practice by having a local daguerreotypist make pictures as a hired agent for the department.[109] The daguerreotype was soon supplanted by collodion wet plates for this purpose, and the newer method was the one used initially in most American rogues galleries.

Another application of the daguerreotype for examination of identity is reported by the photographic historian Erich Stenger, who noted that, "In 1856, an American girl, matrimonially inclined, advertised her intentions in a newspaper and requested applicants to send their daguerreotypes."[110] It is to be hoped that her matrimonial involve-

ment with the medium was of happier issue than an earlier photographic event in Europe also noted by Stenger:

> newspapers and periodicals published, in November 1839, startling information of the assistance given by "the daguerreotype as witness in a divorce case;" it was said that a husband had succeeded in photographing his spouse during a tryst without being discovered.[111]

By the 1850s daguerreotypes were so popular in America that they became useful for a variety of promotional and advertising uses. *Humphrey's Journal* recorded one public notice:

> *Rafferty and Leask's* fall style of Gentleman's Hats have had a very large sale already, and as long as so beautiful and elegant hats are sold for $3 and $4 they will continue to have a great sale. The Daguerreotype likeness of each customer, which is inserted in his hat without additional charge, is a great convenience in indicating ones [sic] own hat.[112]

As Humphrey noted,

> These gentlemen employ a Daguerreotype operator, expressly for their own customers. Mr. Parsons has a skylight in their building, where he daguerreotypes the phiz's as the hats and customers are passed up.[113]

In a similar application of the public appeal of the daguerreotype, the major operator Jesse Whitehurst combined the methods of the studio with those of the "art-union" form of lottery in order to promote business. For his grand prize, he chose a form of real estate popular in America at the time:

> Whitehurst is trying the plan of giving Daguerreotypes with farms. We hear he proposes taking thirty thousand Daguerreotypes at three dollars each, and giving the purchaser a chance in the distribution of ninety thousand gifts. We don't know but it will be a profitable undertaking.[114]

At times the daguerreotype came into use along promotional lines in ways that were not altogether desirable. Joseph G. Baldwin illustrated an example of the daguerreotype as an adjunct of the confidence man. In his *Flush Times of Alabama and Mississippi,* Baldwin presented a character sketch of one Simon Suggs, Jr., a typical small-town lawyer of slight learning and substantial pretensions. Suggs was approached by the editor of *The Jurist-Maker,* located in the "City of Got-Him," for the purpose of providing his legal biography to be published in the journal along with those of the distinguished legal men of 1852. Using flattery, the editor painted a glowing picture of the benefits of being included in the pages of the publication:

> It would be affectation, my dear sir, to deny that what mainly consoles us under a sense of the hazardous nature of such an enterprise to our *personal* fortunes . . . is the expectation, that, through our labors, the reputation of distinguished men of the country, constituting its moral treasure, may be preserved for the admiration and direction of mankind,

not a day, but for all time. And it has occurred to me, that such true merit as yours might find a motive for your enrollment among the known sages and profound intellects of the land, not less in the natural desire of a just perpetuation of renown, than in the patriotism which desires the improvement of the race of lawyers. . . .[115]

After a considerable amount of this sort of rhetoric, the editor urges the submission of Suggs's "life, genius, exploits, successes, accomplishments, virtues, family antecedents, personal pulchritudes, professional habitudes, and whatever else you may deem interesting." The request concludes,

> Please send also a good daguerreotype likeness of yourself, from which an engraving may be executed, to accompany the sketch. *The daguerreotype had better be taken with reference to the engraving to accompany the memoir*—the hair combed or brushed from the brow, so as to show a high forehead—the expression meditative—a book in the hand, &c.[116]

The editor's suggestions about details of the portrait are exemplary of current studio conventions. They accurately reflect a sense that sitting for one's daguerreotype was an occasion calling for one's effort to make an appearance according to the standards of the day. Suggs, however, replies,

> As to my doggerrytype I cant send it there aint any doggerrytype man about here now. There never was but won, and he tried his mershine on Jemmy O. a lawyer here, and Jem was so mortal ugly it burst his mershine all to pieces trying to git him down, and liked to killed the man that ingineered the wurks.[117]

Suggs also suggests altering an existing engraving of his father to look younger in lieu of using the photograph. The editor understandably demurs because of copyright problems and points out the difficulty of projecting a suitable likeness by such a method. Then, in a postscript, he notes,

> Our delicacy caused us to omit, in our former letter, to mention what we suppose was generally understood, viz., the fact that the cost to us of preparing engravings &c., &c., for the sketches or memoirs, is one hundred and fifty dollars, which sum it is expected, of course, the gentleman who is perpetuated in our work, will forward to us before the insertion of his biography. We merely allude to this trifling circumstance, lest, in the pressure of important business and engagements with which your mind is charged, it might be forgotten.[118]

Suggs responds with some excitement:

> In your p. s. which seems to be the creem of your correspondents you say I can't get in your book without paying one hundred and fifty dollars—pretty tall entrants fee! I suppose though children and niggers half price—I believe I will pass. I'll enter a nolly prosy q. O-n-e- h-u-n-d-r-e-d dollars and fifty better! Je-whellikens! . . . Suppose you rite to the old man!! May be he'd go in with BARNUM!!! May be he'd like to take TWO chances? He's young—never seen MUCH!! Lives in a new country!!! AINT SMART!! I SAY a hundred and fifty dollars!!![119]

Clearly the daguerreotype was sometimes regarded as an artifact for making money, ethically or not. In some instances it was actually used directly to make money, that is to produce printing plates for paper currency. Robert Taft recounts the memoirs of Stephen Horgan, who came to work for Abraham Bogardus, one of the noted daguerreotypists and photographic studio men of American history, in 1873, years after the daguerreotype had otherwise passed from use. Horgan was trained in the method and set to work:

> The pen or pencil drawings of designs for engraving on steel were reduced to proper size by the daguerreotype method. I was assistant to the daguerreotypist . . . who was quite willing that I should learn the art as he was an old man and I might take his place when he was taken ill (which usually took place after pay day. A long sleep usually rested him). The [American] Bank Note Company were secretive about their use of the daguerreotypes though I suspect the design was etched into the copper plate (of the daguerreotype) with a steel point; the incision filled with sanguine, an impression pulled on transfer paper, which was then transferred to the white wax ground on the steel plate for the engraver.[120]

Although the daguerreotype rapidly became a familiar aspect of American life, it must not be supposed that its use was always totally businesslike. *Humphrey's Journal* reported what was probably one of the most satisfying uses for a daguerreotype, if not the most widespread:

DAGUERREOTYPE FISH HOOKS.

New use for old Daguerreotype Plates. Mr. Stevenson, of Canandiagua [New York], has invented a curious contrivance for lake fishing, which experience has taught us to be one of the finest ever in use. Mr. S. takes a piece of Daguerreotype plate, cuts and beats it into the shape of the bowl of a spoon. This with the silvered side out, and a hook of the proper size soldered in the bowl. It is found that this Daguerreotype hook will, when attached to a line, and in trolling, be kept continually wheeling in the water, and thus decoy the most wise and prudent inhabitants of the lake whose age and prudence has added in no small degree to their weight.[121]

It was further suggested by Marcus Root that this device could be improved in effect by using a photographic image of a frog or a grasshopper, though the suggestion was more whimsical than serious.

When a selection of the varied American applications of the daguerreotype is considered, a number of facts become clear which throw light on the culture of the period. Initially, we can recognize that the medium produced a direct interchange of ideas between America and Europe. Applications of the medium often began as desirable ideas in Europe which were carried into practical operation in America. Daguerre and Arago pioneered in theory a variety of scientific ramifications of photography that were often pioneered in practice by Americans such as Draper. Although America lagged behind Europe in particulars such as using photography for law enforcement, it took only a few years for America to catch up and forge ahead in most applications. In some cases ideas

crossed the Atlantic several times—Fremont tried to apply daguerreotypy to exploration in 1842 on his own initiative and was then led, by reading Humboldt's *Cosmos* in 1853, to use it again despite his original failure. Draper published his results in England and then carried out new experiments in response to English discussion. His activities excited further efforts in Europe, which later responded to results of American skill such as those produced by Whipple. In all these exchanges, the characteristic element in American applications of the medium was pragmatic utility. The daguerreotype was a new means for doing things; as such it was enthusiastically received in America.

Daguerre's process was consciously used early in America to expand national status or influence. Draper and Whipple sent reports and specimens of their work to England and France, and many Americans responded as did Horace Greeley to the American sweep of gold medals for daguerreotypy in London. The daguerreotype in such instances became a ready tool for the display of nationalistic feelings. In other cases it became an agency for nationalistic consolidation, as when James Renwick lectured the British on the evidence of their own senses reinforced by the incontrovertible evidence of daguerreotypes as to the Maine-Canada boundary. In the Fremont and Perry expeditions, the medium also operated to dramatize and expand national influence over the American wilderness and on the self-imposed isolation of Japan.

The daguerreotype furthered the pursuit of nationalism by functioning particularly as a source of authentic information which could be relied on for truth about conditions under which a transcontinental railroad could be constructed or a cultural exchange with other nations could be established. The Daguerreotype brought into play vast areas of new information which affected education and the thinking of influential people in society. Discoveries in science made by means of the daguerreotype became basic material for the construction of new theological systems, new philosophical thought, new allegories in poetry. The medium provided a bridge between practical recording of facts and symbolic responses to the universe, because the pictures it produced were beautiful in their own right. The truth of the recording one saw in the images of the daguerreotype was a form of direct experience which, under some circumstances, was even more complete than in life. Jared Sparks was awed to see visible records of the rotation of the earth in Humphrey's documentary picture of the moon; Draper opened great areas of science by capturing visibly on silver plates the evidence of actinic power beyond the ends of visible light. Accurate recording thus confronted a generation with unknown facts about the universe in new and beautiful images. "The Thing itself—with photographic beauty" became an affective source of information about man's place in the universe and the world.

In all daguerreotype operations, for whatever purpose, a sense of direct visual experience was dominant. Whether it was conscious as it was with Brown at the Bell-House in Simoda or purely pragmatic as with Renwick's wish to stack evidence of the Maine boundary too solidly for argument, intensified perception was the basis of all use made of the medium. Carvalho's transcendental experience at the summit of the Rockies was

incomplete until he made his pictures. Whipple's satisfaction with his records of the moon demanded that the images be visually beautiful. Both men reacted in terms of desiring a permanent emotional record of their visual experiences. A complete and accurate daguerreotype picture was their ideal symbolic way to render their initial experiences permanent. With such pictures they could verify their initial responses to reexperience as often as necessary. Pictures like these were even more permanent as affective agents than the images preserved in the mind and feelings of Thoreau's locomotive driver. Carvalho, Whipple, and others could reexamine the complete facts with a certainty which memories and words failed to assure.

In instances when the original perceptions of such men were keen enough to record insights rather than mere sights, their daguerreotype pictures matched in fact Emerson's ideal of becoming one with nature in terms of spiritual understanding. It is significant that so many of the applications of the medium involved nature in one way or another. The American landscape was scrutinized, light originating on distant stars was registered, and remnants of prehistory were recorded. In all these cases, the landscape, in its greater extensions, provided the starting point for the daguerreotypist's activities.

The pictures recorded nature in factual terms. But the pictures also recorded responses to nature that reflected choices made by daguerreotypists about how, when, where, and why pictures should be made. The photographer's concern was to make as perfect a record of his subject as possible, doing so in images having both physical and spiritual beauty because of the strength of his own experience. The photographer made his choice so as to produce pictures that did reliably what they were intended to do as symbols of reality. Concern for permanently fixing direct experiences or for expanding their significance led him to produce particular images in certain ways. What was recorded was deliberately chosen, consciously or not as to motive, thus revealing something of the interests and judgment of the photographer subject to the context of his time and place in American society. It is to the daguerreotypist himself as a man revelatory of many elements of his time that we must now turn our attention in some detail.

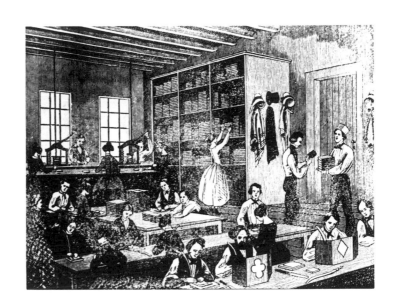

Chapter 5

THE "UNIVERSAL MAN" AND
THE WESTERING ADVENTURER

INCE THE DAGUERREOTYPE PROCESS was never functional without an operator, the next three chapters will consider the varied roles of the daguerreotypist necessary fully to illuminate the function of the medium in American society.

While it is true that public response was mainly to pictures, it is also true that pictures were made by decisions and choices of picture makers. The daguerreotype provided a means for deliberate report of, definition of, and response to things which were significant in the lives and feelings of Americans. It provided affective symbols in a form of direct experience otherwise unattainable—words, memories, and other pictorial processes having proved inadequate by comparison. Applications of the medium were deliberate whether they were made for conscious production of art or commercially in answer to public demand. The daguerreotype process was too slow to produce many snapshots or involuntary pictures. A daguerreotype represented mutually conscious participation between photographer and subject in the presence of the camera. Simultaneously, however, the motive

for producing a daguerreotype was often quite subconscious because the impulses of the operator or the patron were culturally motivated.

Decisions on presentation and subject matter made by daguerreotypists desiring to produce artistic pictures are significant because they reflect responses made to life by sensitive interpreters. Thus, they reveal value judgments, emotional responses, and interpretations of the facts of a given period in the way any body of art indicates the temper of an age. In this instance, the idea of art must take into account the deliberateness of intention on the part of the cameraman. His deliberate intentions caused him to be concerned with technique and aesthetics—as defined or applicable under the nature of his particular medium—in order to produce a chosen result. Whipple's concern to produce a picture of the moon which was both truthful and beautiful within the capability of his medium is a case in point.

It must be recognized at the same time that the process of daguerreotypy was mainly commercial in everyday application. Its major use was to make portraits. Photographers generally did not make completely independent choices of either subject matter or treatment, however much they might try to influence their clients. The average customer in a daguerreotypist's gallery was primarily concerned with a "good likeness" in direct visual terms without concern for principles of style or aesthetics. If a pictorial rendering looked right in terms of accurate recognition of facts and was clearly enough presented to activate suitable feelings, the picture was good.

Choices of subject matter and presentation made for non-artistic reasons in answer to customer demand are also important because individual impulses to acquire pictures were often motivated by the climate of the age. People often responded to attitudes and events, traditions, styles, or whims without being aware of the sources of their impulses. Yet remaining pictures made under these circumstances mirror the sources of these impulses when both pictures and picture makers are considered within the context of their time.

Let us then consider the daguerreotypist as a conscious producer of pictures requiring decisions in the application of the medium. In his conscious picture-making capacity, the daguerreotypist must be seen as a type of "Universal Man" who participated in all aspects of his society—he performed as an eclectic aesthetic technologist, he responded to the tug of westering and national growth, he deliberately summarized the traits of his age and sought to define its character by providing it with visible symbols of its ideals. He served his age as a descriptive artist and a didactic guide—in all these roles using his camera paired with his own sensitivity to show the nation to itself. These roles in particular we must examine specifically through the words, the pictures, and the activities of the picture-making men themselves. To perceive their art fully in its context, we must recognize the universality of the nature of the man who produced it.

The typical daguerreotypist appears in the decades before the Civil War as a man of varied impulses and wide activities—a sort of "Universal Man" in the American scene. We have noted the range of activities of men such as Draper and Whipple and we have

found in them a fascination with discovery and the varied aspects of life. We have seen the dentist Samuel Bemis taking up the daguerreotype to report his world. We have seen Samuel Morse in the role of leading artist and inventor, and we can add that he was active in politics—having run for mayor of New York—and public affairs—having written a number of somewhat scurrilous tracts against Catholics and immigrants. We have seen that he took up the daguerreotype seriously from the viewpoint of an artist as well as from a recognition of its pragmatic utility. Ultimately his decision to open a commercial portrait studio was motivated as much by economic necessity as from delight with the medium. Morse recalled the opening of the studio with Draper and noted both the financial and artistic aspects of its operation some years later:

> As our experiments had caused us considerable expense, we made a charge to those who sat for us to defray this expense. Professor Draper's other duties calling him away from the experiments . . . I was left to pursue the artistic results. . . . My expense had been great, and for some time, five or six months, I pursued the taking of portraits by the Daguerreotype, as a means of reimbursing these expenses. After this object had been attained, I abandoned the practice to give my exclusive attention to the Telegraph. . . .[1]

It is clear that the daguerreotype's function for Morse was primarily economic, despite his artistic interest. The medium was abandoned for other interests when he was more affluent. This progression from interest to interest according to the economic climate was a frequent enough pattern following the Panic of 1837.

We have also seen economic motives active in the artist George Fuller during this same period after his introduction to the daguerreotype. While his grand ideas of making up to $250 profit per day were unrealistic, his dreams were probably related to the same economic climate in which Morse suffered. Mrs. Alice Van Leer Carrick, in discussing her silhouette collection, also suggests that the profit motive was a factor influencing other artists of the period to take up the daguerreotype. She speaks of a silhouette

> likeness of an old Vermont daguerreotypist who, lured by the glitter of California gold, was lost in the rush across the Isthmus in forty-nine. It is possible that he may have made this profile of himself; it would not be the first time that a silhouettist, out of a job by the change of fashion, turned photographer.[2]

Robert Taft reports much the same situation in his discussion of the 1840s:

> As a result of this condition the possibility of the growth of a new profession must have attracted the hopes and interests of a considerable number. . . . In fact, the earliest "portrait takers" were more beseiged with individuals wishing to be trained in the art of portrait taking than they were with clients desiring to have their portraits made.[3]

The pioneer photographer J. F. Ryder recalled in his memoirs that the early daguerreotype period was often "but a step from the anvil or the sawmill to the camera."[4] He noted the variety of origins of the "Professors" from whom he learned the trade, among them Professor Brightly, who

had taught cross-roads school in the country, had a smattering knowledge of and had lectured upon phrenology and biology. The new art of daguerreotype attracted his attention and had been gathered in as another force with which to do battle in the struggle for fame and dollars.[5]

There was also a rival, Professor Bartholomew, who had formerly been a teacher of penmanship. Ryder himself abandoned an apprenticeship to the printing trade to take up daguerreotypy, and he recalled that

> It was no uncommon thing to find watch repairers, dentists, and other styles of business folk to carry daguerreotype "on the side." I have known blacksmiths and cobblers to double up with it, so it was possible to have a horse shod, your boots tapped, a tooth pulled or a likeness taken by the same man; verily, a man—a daguerreotype man, in his time, played many parts.[6]

Beaumont Newhall notes daguerreotypists as coming "from all walks of life: masons, engravers, grocers, express men, windowshade manufacturers, locksmiths, jewelers, carpenters, writing masters, and railroad men. . . ."[7] He refers to them as "jacks-of-all-trades" and quotes a writer of 1858 as observing that

> Today you will find the Yankee taking daguerreotypes; tomorrow he has turned painter; the third day he is tending grocery, dealing out candy to the babies for one cent a stick.[8]

In pioneer America it was common for a man to move from one vocation to another or even to ply several trades at once. Lamenting an erosion of such variety, Emerson designated the tendency as a national trait worthy of admiration in his essay on "Self-Reliance":

> If our young men miscarry in their first enterprises they lose all heart. If the young merchant fails, men say he is *ruined.* If the finest genius studies at one of our colleges and is not installed in an office within one year afterwards in the cities or surburbs of Boston or New York, it seems to his friends and to himself that he is right in being disheartened and in complaining the rest of his life. A sturdy lad from New Hampshire or Vermont, who in turn tries all the professions, who *teams it, farms it, peddles,* keeps a school, preaches, edits a newspaper, goes to Congress, buys a township, and so forth, in successive years, and always like a cat falls on his feet, is worth a hundred of these city dolls. He walks abreast with his days and feels no shame in not "studying a profession," for he does not postpone his life, but lives already. He has not one chance, but a hundred chances.[9]

The stress Emerson places on variety and directness of participation in life relates closely to his thoughts on the value of direct apprehension of nature. If the conventions of education for a single profession intervene, the perception of a young person may be blunted from delaying his active participation in life. He may come to think too much within limited patterns and never fully absorb all the insights he could otherwise perceive—perhaps the extreme tragedy of a life in Emerson's eyes. This sort of emphasis is clearly relevant to the perceptional activities of the photographer. Too much holding

back of one's ability to respond will limit direct apprehension of "the Thing Itself." The daguerreotypist was obliged to be a "jack-of-all-trades" not only for economic reasons but in order to be a successful producer of affective images. He had to be responsive to all aspects of the life of his time, walking "abreast with his days," as Emerson put it. Fortunately, the daguerreotype appeared in America when such a breed of men was present to react to it and apply it.

A prototype of this sort of American "Universal Man" is Holgrave, the daguerreotypist in Hawthorne's *The House of the Seven Gables*. Since Holgrave is a fictional character, he is drawn as an extreme of his type for the sake of embodying the novelist's thoughts clearly. For this reason, he also summarizes characteristics of actual daguerreotypists of the day who were like him in one particular or another. The novel having first appeared in 1851, it is certain that Hawthorne was aware of the type of person who became a daguerreotypist. Holgrave is presented in Emersonian terms of limited education and great variety of direct activities. He is also shown to be both economically and aesthetically motivated. He is fascinated by the potential of the new medium for reporting the truth of life with searching insight. He is young and self-sufficient, able and alert. Hawthorne presents him in the form of a likely model for the American man:

> Holgrave . . . could not boast of his origin, unless as being exceedingly humble, nor of his education, except that it had been the scantiest possible, and obtained by a few winter months' attendance at a district school. Left early to his own guidance, he had begun to be self-dependent while yet a boy; and it was a condition aptly suited to his natural force of will.[10]

In addition to native independence and an openness to the experiences of life unrestricted by needless education, Holgrave epitomizes the wanderlust and the varied impulses of Americans in his time:

> Though now but twenty-two years old (lacking some months, which are years in such a life), he had already been, first, a country schoolmaster; next, a salesman in a country store; and either at the same time or afterwards, the political editor of a country newspaper. He had subsequently traveled New England and the Middle States, as a peddler, in the employment of a Connecticut manufactory of cologne water and other essences. In an episodical way, he had studied and practiced dentistry, and with very flattering success, especially in many of the factory towns along our inland streams. As a supernumerary official, of some kind or other, aboard a packet ship, he had visited Europe, and found means, before his return, to see Italy, and part of France and Germany.[11]

Holgrave has not only carried on a number of activities, but he has placed an obvious stress on firsthand experience; he has actually visited different areas of America, rural and urban, and he has sought to test the old world by direct observation as well. He is almost exactly the manifestation of Emerson's man of "a hundred chances" when it comes to direct perception. He is also shown as being alive to new avenues of experience, willing to examine and test all possibilities which offer enlarged understanding of life and the condition of man:

he had spent some months in a community of Fourierists. Still more recently, he had been a public lecturer on Mesmerism. . . . His present phase, as a daguerreotypist, was of no more importance in his own view, nor likely to be more permanent, than any of the preceding ones. It had been taken up with the careless alacrity of an adventurer, who had his bread to earn. It would be thrown aside as carelessly, whenever he should choose to earn his bread by some other equally digressive means.[12]

With so vast a range of activity encompassed in so brief a span, it is possible that Holgrave might well have become something of a dilettante. Hawthorne stresses, however, that there is a subsurface relationship among all of Holgrave's activities, past and future. The object of all the young man's movements is to define himself relative to all the experiences of his life:

what was most remarkable, and, perhaps, showed a more than common poise in the young man, was the fact that, amid all these personal vicissitudes, he had never lost his identity. Homeless as he had been—continually changing his whereabout, and, therefore, responsible neither to public opinion nor to individuals; putting off one exterior, and snatching up another, to be soon shifted for a third—he had never violated the innermost man, but had carried his conscience along with him.[13]

Holgrave is seen by Phoebe, the heroine of the novel, as being disturbingly perceptive of the world. She finds that his perceptions are keenly acute as well as insightfully truthful because unclouded by anything at odds with his own conscience:

He made her uneasy, and seemed to unsettle everything around her, by his lack of reverence for what was fixed, unless, at a moment's warning it could establish its right to hold its ground. . . . He was too calm and cool an observer.[14]

The foundation of Holgrave's ability to challenge the basis of existence of life around him derives from his keenness as an observer, a perceptive man able to see what is before him clearly and without evasion in spirit, in short an artist. The daguerreotype was a medium ideally suited to such a man whether he elected to use it or not. It offered an extension of permanence to the perceptive vision he already possessed. Holgrave is seen by old Hepzibah, his landlady, as having "a law of his own,"[15] which is the sort of law of self-reliance Emerson derived from being unattached and free in one's perceptions.[16]

Holgrave's insights derive from his reliance on nature in true Emersonian fashion. He comments to Phoebe,

Most of my likenesses do look unamiable; but the very sufficient reason, I fancy, is because the originals are so. There is a wonderful insight in heaven's broad and simple sunshine. While we give it credit only for depicting the merest surface, it actually brings out the secret character with a truth that no painter would ever venture upon, even could he detect it.[17]

His daguerreotype of Judge Pyncheon reveals the inner moral ugliness of the man despite his repeated efforts to produce a more agreeable picture. The medium, acting with

the truth of nature, mercilessly reveals the character of the man. In Holgrave, Hawthorne explicitly links the moral value of such insight with contemporary American traits of varied occupation, desire to define oneself, and freedom of perception to see the truth of nature. His identification of Holgrave as a characteristic American is made explicit when he sums up the character of the man:

> Altogether, in his culture and want of culture—in his crude, wild, and misty philosophy, and the practical experience that counteracted some of its tendencies; in his magnanimous zeal for man's welfare, and his recklessness of whatever the ages had established in man's behalf; in his faith, and in his infidelity; in what he had, and in what he lacked— the artist might fitly enough stand forth as the representative of many compeers in his native land.[18]

The varied activities of the fictional Holgrave were not unique in the period. Actual daguerreotypists were as versatile. A noteworthy example is Anson Clark (Plate 37) of West Stockbridge, Massachusetts. Clark seems to have been a remarkably active man during the 1830s and '40s. A historical article in the magazine section of the *Hartford Courant* in 1949 indicates that he

> had become the master of about 20 different trades, arts and sciences. Among other things he was an accomplished manufacturer of musical instruments, carpenters' levels, kegs, firkins and barrels. He shod horses, repaired watches and guns, ran a store [and] a farm, went about the country lecturing on electricity and demonstrating its uses with his dynamo. Also he taught photography, and he made his own cameras, ground his own lenses, composed his own developing fluids, and learned how to tint pictures. . . . He also engraved plates for printing bank notes.[19]

There is also indication that he wrote music for the melodeons and aeoleons he built. A collection of materials relating to Clark can now be seen in the Historical Room of the Stockbridge Public Library. Remaining artifacts and models of his making include a working electric motor built in 1819, possibly one of the first in North America, an electric dynamo, a belt tightener, a revolving brush street sweeper, and a melodeon which can still be played from sheet music accompanying it. A drilling machine he constructed won an award at the 1839 fair of the New York Mechanics Institute. He had a museum of his models and various mineral and historical items attached to his daguerreotype gallery where he exhibited such questionable items as Cleopatra's fan.

This hint of the charlatan in Clark was a frequent concomitant of Yankee shrewdness in the period, when shrewdness was involved with impressing the public for profit. A testimonial appended to Clark's poster announcing his electrical demonstrations and signed by nine officers of the "Hudson Lyceum of Natural History" and printed by a supposed William B. Stebbins of Hudson, New York, was a complete hoax, apparently devised by Clark himself. There is little challenge, however, to be brought against the quality of his workmanship or the range of his activities. His notebooks contain reflections of an array of interests ranging from agriculture and an electric dynamo of 1829 to

current advances in photography in Boston, New York, and Europe. His fascination with electricity is amply attested, not only by his working models but also by his inclusion of clippings from 1841 relating to Daguerre's efforts to apply electricity to making instantaneous pictures. His own demonstration lectures on the subject must have been quite dramatic judging from the text of his announcements:

> Mr. Clark, Will give a Lecture on Electricity, at———. In which will be represented and explained, the Phenomenon of Electricity produced by Friction; LEYDEN PHIAL; Positive & Negative Electricity; ELECTRICAL ATTRACTION & REPULSION, in which many objects will be put in motion, such as moving a vertical wheel, ringing bells, &c. THE ELECTRICAL ORRERY, Shewing [sic] the motions of the Earth and Moon around the Sun; imitation of celestial fire; the electric shock. The operator will insulate a person in such a manner that brilliant sparks of fire may be drawn from his body. The explosion of a Powder Mill; with many other pleasing experiments.[20]

Clark's involvement with technology and current advances is reflected even in his daguerreotype advertising. Writing of the medium in 1841 as the product of a "regular train of inductive reasoning," he notes its value as "an interesting triumph in the application of the principles of natural science." In an article written a decade before Hawthorne created Holgrave, Clark notes the superiority of science's contribution over the human element in a manner similar to Holgrave's observations on nature's truth in portraits:

> The value of a portrait depends upon its accuracy, and when taken by this process it must be accurate from necessity, for it is produced by the unerring operation of physical laws—human judgment and skill have no connection with the perfection of the picture, any more than with that formed upon the retina of the eye, and the likeness produced will be the exact image of of [sic] the object, from the same causes which enable a perfect eye to see.[21]

Clark's conception of the similarity between the vision of a perfect eye and that of the daguerreotype camera resembles Emerson's emphasis on the power of keen sight as the means to truth. In claiming that human skill had nothing to do with the production of pictures, Clark was wrong. Far from being like much of the early daguerrean work produced by such "jacks-of-all-trades," his own pictures are of very fine quality. A portrait of a young man, possibly his son Edwin H. Clark (Plate 38), has a tonal contrast and a richness that bespeak excellent technical ability. A portrait of a lady descended from John Marshall (Plate 39) employs fine technical quality to project an appealing mood and composition that bring it well above most conventionally posed portraits produced under similar conditions. A picture of a strange-looking child (Plate 40) builds to a compositional climax that is quite striking.

Clark's pictures make strong use of white areas—his own white shirt sleeves for example—as composition elements in a way that indicates he was aware of tonal contrasts in a purely photographic sense. A view of West Stockbridge in 1841-42 (Plate 41) goes

considerably beyond mere report in the way the brightly lighted atmosphere is captured. The recording is minutely accurate in detail, even to a ladder propped against the central building, yet the whole picture holds together to evoke the bright mood of a sunny day in Massachusetts over 125 years ago with a presence that is inescapable. A daguerreotype of an engraving preserved in the Stockbridge Public Library and probably by Clark himself, indicates some degree of practice at drawing, but its comparative dullness underlines the fact that his artistic vision was strongest when activated photographically.

Another of the versatile men who became daguerreotypists was Gabriel Harrison (1818-1902). Noted as an actor in the company of such leading lights as the Wallecks, Matilda Heron, and Charles Kean, Harrison took up the daguerreotype in 1844 and pursued it as a master simultaneously with his theatrical activities. Throughout his life he was active as a painter and a writer, both to some renown, and he actively worked to restore public recognition for the naval hero James Lawrence. In the 1870s his biography of John Howard Payne led to the return of the composer's body to America with honors. He founded the first American opera company in 1863 and established numerous theaters and theater schools around New York.

As a daguerreotypist, Harrison was a technical master. He produced effectively some of the largest pictures ever made in the medium—ranging up to sixteen by twenty-two inches.[22] While working for the firm of John Plumbe in New York, he began making allegorical pictures, perhaps related to his interest in the theater. His "Past, Present, and Future" (Plate 42) won a bronze medal for the studio of Martin M. Lawrence at the Crystal Palace in 1851. He also won a bronze medal at the New York World's Fair in 1853 for a group of allegorical pictures.

In contrast to the interests of Anson Clark in science, Harrison was concerned with the dramatic and sentimental aspects of life in both his writings and his pictures. His writings in the *Photographic Art-Journal* include a series of sentimental vignettes under the general heading "Lights and Shadows of Daguerrean Life." There he also produced a lengthy allegory in prose and poetry called "Reality, in a Dream," which presents an intensely romantic view of an artist led by angels through the despairs of life in quest of pure art. One sample of the language suggests the mood of his imagery:

> 'Twas one of those mysteriously beautiful and soothing autumn nights, when the guiltless soul becomes enamoured with all around it, when the pearl-white moon in romantic majesty walks o'er the dark blue heavens. The lazy pacing clouds with tattered silvery edges in fantastic shapes, glided onward across the broad expanse, and every motion of the soft air, that breathed its eloquent breath on the face of the guiltless (for only the guiltless can sip from the brim full cup of nature's loveliness) seemed like an angel with broad wings fanning the air and dispensing perfumes delicious.[23]

Lush as his style is, Harrison still derives the wonders of full vision from moral apprehension of nature much as Hawthorne defined the truth of vision derived from nature's influence over the sun-portraits of Judge Pyncheon. Harrison's artist is cast in the

mold of Byron, rather than in the form of a Holgrave, and seems physically to resemble Harrison himself:

> The figure of the young artist was tall, his face in expression pale and thoughtful, his eyes dark blue, his brow well marked, his curly locks blacker than the darkest shadow in night's blackest night, and dreamingly beautiful.[24]

Harrison's allegorical daguerreotype "The Infant Saviour Bearing the Cross" (Plate 43) reflects his liking for theatrics as well as his photographic competence. Posed by Harrison's own son, George Washington Harrison, whose resemblance to his father and to the Byronic artist is quite marked, the picture was made for entry in the Anthony Prize competition in 1853. The competition was called by Edward Anthony, the leading photographic manufacturer of the time, as an incentive to increase the professional quality of work being produced in the daguerreotype field. The prizes consisted of an elaborate silver pitcher and two silver goblets (Plate 44). Harrison's letter of entry reflects his strong romantic sense:

> I beg of you to place my name on the list of champions for the prize, earnestly do I enter the ranks, and most hard shall I try to be the victor, not so much for the value of the metal at stake, as to have it said on the occasion I took the best daguerreotype, "simple" as the art may seem to many. . . .[25]

On the basis of groups of four pictures of different sizes submitted by each competitor, the committee of Judges (Morse, Draper, and Renwick) awarded the five-hundred-dollar pitcher to Jeremiah Gurney, probably the finest daguerreotype technician in America at the time, whose studio was one of the three or four leading galleries in the nation. One of his winning pictures is inadequately reproduced on page 81 of Robert Taft's *Photography and the American Scene*. Harrison won first honorable mention for his picture of the Saviour and also submitted three allegorical portraits, *Young America, Helia, or the Genius of Daguerreotyping*, and *Mary Magdalene*.[26]

It is quite clear that Harrison was concerned with employing his chosen medium for the deliberate production of works of art. His own remarks of introduction to a description of his technical procedures, required of each competitor, define his thoughts on the ideal of artistic photography:

> In the production of an exquisite or faultless work of art, there is something more demanded than mere mechanical execution. In the productions of many of our so called "daguerrian artists," there is a decided lack of artistic skill as well as a complete and lamentable ignorance of those distinguishing features that stamp the work of a well skilled operator with indisputable marks of genius. . . . In daguerreotyping, as well as in painting, the artist should endeavor to secure three distinct and marked peculiarities that can hardly fail of making his production a superior work of art. These three points are the high lights, the middle tints, and the shadow.[27]

Even though Harrison ties photography to painting in his statement, he is discussing a tonal gradation that is most notable in photographic images. He does so in recognition that the tonal gradations in photography are definitive for producing effective pictures. Recognition of the importance of the tonal scale is basic to photography. In 1950, Ansel Adams, the world's foremost photographic technician, and inventor of the Zone System of placing gradations of light and dark for greatest visual effect, wrote,

> In the daguerreotype the microscopic revelation of the lens was fully expressed. I confess that I frequently appraise my work by critical comparison with the daguerreotype image; how urgently I desire to achieve that exquisite tonality and miraculous definition of light and substance in my own prints![28]

Harrison notes further in his remarks that securing the tonal range enables an operator

> to secure a charming picture, whose deep and Rembrandt-like shadow contrasts finely with the clear distinct tone of the high light, while the middle tints exhibit an elasticity of appearance so pure and lifelike, that the flesh seems imbued with motion, and the dull, frosty, death-like representation, that is so detestable in a work of art is studiously avoided.[29]

Harrison's chief concern was to apply his medium so effectively according to its own character as to produce pictures with no evasion of the exact truth of life and nature.

His writings make amply explicit his regard for nature as basic to the artistic process, even in allegorical conceptions. The second of his "Lights and Shadows of Daguerrean Life" presents a dream in which he is brought to make a daguerreotype of the light goddess Helia in a setting of green and mossy woods. He replies that he cannot because he has no equipment. The goddess utters a spell and

> up rose before me a camera, inlaid with costly gems, tube of gold, lenses clear as air, and beautiful plate holders; for a camera stand three water lilies with their stems girded in the centre and spreading out triangularly. . . . For plates, large ebony leaves, soft and silvery; for cloth to clean with, rose leaves; for ammonia, dew drops in a lily cup; for buffs, large mullen leaves; for rotten stone, farina—the powder from flowers; for coating boxes, stupendous tulip cups![30]

For chemicals he is given the prismatic drops of the rainbow and succeeds in taking the first natural color daguerreotype. The emotional value Harrison placed on art is obvious from the romantic imagery he applied, yet his sense of the sublimity of the artistic process is merely another manifestation of the nature imagery of many literary statements of the period. That the goddess of light should bring about photography by direct aid of nature in an American forest also suggests that Harrison felt a particular appropriateness in the American landscape for the production of art by means of the daguerreotype. That he believed the production of art generally to be in response to both nature and native American impulse is evident from an article he wrote on the Brooklyn Art Union a few months later:

That the germ for art is among us and is part of our great national being, I think, there is no man who knows anything of our national history and character of topography will pretend to deny. The wild, romantic reality connected with the discovery of our country—the blessed spirit that actuated the pilgrim fathers to trace their way.. . . The adventuresome and battlelike spirits of the aborigines . . . together with the endless variety of scenery—mountains, valleys, lakes and rivers,—our spring, . . . full blooming summer, and fairy colored fall . . . all these beautiful, picturesque things constantly before our eyes must be imbibed in our flesh and blood, for the very atmosphere seems impregnated with the best of materials for the artist's study. And if the passion is looked after and properly nursed, in a half century our country will not only be great in political and mercantile existence, but will be resplendent with her master in art.[31]

In spite of a later comment in the same article that promising young artists should be sent to study in Europe, his sentiment is obviously nationalistic. Since Harrison's "Past, Present, and Future" and other American daguerreotypes had just triumphed at the Crystal Palace Exposition, Harrison may well have been feeling national pride along with Horace Greeley. In any case, it seems evident that he felt American art stemmed from nature, and that he deliberately applied the medium of the daguerreotype to the production of art within the framework of a consciously nationalistic point of view.

In addition to being a sort of "Universal Man," the daguerreotypist very often reacted like a compass needle to the restless expansive pull of American life. As a sensitive man, the photographer responded to the westering impulse and the general mood of manifest destiny. When he did not actually follow the westward migrations, he often moved about locally from place to place. We have seen, for example, how George Fuller took the trail as an itinerant portrait painter and sometime daguerreotypist in Massachusetts and New York. The earliest experiences with the new medium in many communities were provided by traveling men similar to James F. Ryder's "Professor" Brightly, who lectured and made pictures or taught the rudiments of the process, depending on which offered greater income at the moment. Such men wandered freely over the land, sometimes with a goal in mind, more often with only the drive of a restless age urging them along. Notable events and new areas often acted as magnets.

Daguerreotypists followed the path of the Mexican War to provide the first photographic documentation of warfare. Only twelve pictures which directly relate to the war are known to exist. Three are direct records of aspects of the war—a view of General Wool and his staff riding into the Calle Real of Saltillo, Mexico in the winter of 1846-47; a view of the Virginia Regiment from atop a building in Saltillo; and a vista of Webster's Battery in Minon's Pass in the mountains. Fortunately these three were reproduced in James Horan's *Mathew Brady: Historian With a Camera* (his plates 86a-86c) before the entire collection became sequestered in the Yale University Library under a general refusal to allow reproduction.

In the wake of American occupation of Mexico, itinerant daguerreotypists fol-

lowed, taking up brief stands and offering their services in typical advertisements. The occupation paper published in Matamoros, Mexico announced in June 1846 that

> Mr. Palmer, (Daguerreotypist) late from New Orleans, has located himself in this city, and is prepared to take likenesses in the latest and most approved style of the art. He invites the ladies and gentlemen of Matamoros to call and examine his specimens. His rooms are on the second floor of the building known as Arista's head quarters, fronting the main square.[32]

Shortly Mr. Palmer was away elsewhere, disappearing into history. In October another man took the trouble of advertising, while still making clear his temporary intentions:

> DAGUERREOTYPE. Chas. J. Betts would inform the citizens of Matamoros that he is prepared to take miniatures in a superior style. His rooms are in the upper story of the Resaca House. As he will remain but a short time, persons wishing their likenesses are solicited to call as soon as convenient.[33]

Free as were the movements of such men, the form of their advertising was quite standardized in terms of being "prepared" to take likenesses, either in "superior style" or in the "highest perfection of the art" or in "the latest and most approved style," and urging the "ladies and gentlemen" to call at their "rooms" to inspect specimens. The pattern held true in every part of the country; the tone was the same in Oregon as it was in occupied Mexico:

> Mr. Wakefield is happy to say to the ladies and gentlemen of Portland and vicinity that he is now prepared to execute likenesses in the highest perfection of the art. Rooms in the Canton House. Apparatus, stock and gold lockets for sale.[34]

These formalized announcements were usually accompanied by urgent suggestions as to the immediacy of departure of the operator, which might have been worded by Francois Gouraud himself, so like him do they sound. There were, not infrequently, offers of discount prices:

> Mr. Betts would respectfully inform the public, that he will remain in this city but three or four days longer, and all those wishing daguerreotype miniatures had better call soon A liberal deduction from his usual prices will be made to those Volunteers who call immediately. . . . [December 5][35]
> . . . Mr. Betts will remain but a few days longer, positively. [December 19][36]

Some itinerant artists institutionalized their way of life with actual daguerrean wagons, fully equipped as studios (Plate 45). These daguerrean "saloons" were especially common in New England, upstate New York, and gold-rush California, and they ranged from spartan trailers to sumptuously outfitted galleries rivaling the lesser establishments of the cities. Beaumont Newhall reports the movements of one L. C. Champney from letters written back to his teacher Albert Southworth, founder of the great Boston firm of Southworth and Hawes:

Bennington, Vermont, March 9, 1843. I think I shall stay up this way for the present. They all say that my pictures are the best that they ever saw. I have tride [sic] the light as you proposed, but they do not like the dark on one side of the face, and I cant sell a picture that where one side of the face is darker than the other, altho it seems to stand out better and look richer.[37]

In July, Champney visited New York City where he purchased cases from Brady, which, as he remarked, were not as good as Southworth's, but he observed that they "will never know the difference in the country."[38]

While it is likely that country residents often did not really know the difference between average work and fine, it is certain that some appealing pictures were made. Typical in style, and yet possessing a naive directness and charm, is a portrait of a lady named Amanda McBriggs (Plate 46) made by one of these itinerants. The rigidity of posture caused by an iron headrest and a lengthy exposure creates a harshness in the portrait that is reminiscent of primitive paintings of the early nineteenth century. At the same time, however, the exactitude of the photographic medium confronts a viewer forcibly with the presence of Amanda McBriggs. Stiff and uncompromising as is the image produced, there are visual pleasures to be taken from its rendering of detail and its tonal contrasts between hands, collar, face, and cap and the dark background out of which the sitter looms. The tremulous awkwardness of the lady's sense of the camera's eye comes to us over a century of time in the delicate gesture of her hands in a way no painter would think of rendering it. Technically this is a very ordinary picture, yet its record is accurate and it has physically stood the test of time well. As a typical specimen of the work produced by itinerant daguerreotypists, it suggests that these men were adequate to the needs they served in all parts of America at a time when the public of the nation was expanding rapidly in self-awareness.

The operators of traveling saloons had their problems. One woman, Sarah Holcomb, another pupil of Albert Southworth, took to the roads, proceeding from Saxonville, Massachusetts to Manchester, New Hampshire in the winter of 1846. She found a gallery already established there and went on to Concord, being delayed by a storm. She found a good livelihood at Claremont, where she was the first operator to arrive in a year. However, she reported to Southworth, "on unpacking my things, found all my chemicals frozen. The bottle of bromide burst . . . and made sad work for me. . . . I can do nothing till I get more."[39] Robert Taft has recorded an example of the social perils of itinerant rural daguerreotypy:

A young operator, in his traveling van, had reached a small inland town in Madison County, New York, and after advertising his profession he opened the van for business. Among the first of his customers were two respectable young ladies. . . . The "Professor" posed the first young lady and then retired into his darkened cubby hole to prepare the silver plate. The second young lady took advantage of the operator's absence to satisfy the age-old woman's curiosity by peeking into the camera. Imagine her surprise to find her friend upside down on the focusing glass. "Oh, Katy," she exclaimed, "you are standing on

your head.'' Katy leaped from her chair in great confusion, and both ran with unmaidenly vigor from this den of iniquity that had so grossly insulted their girlish modesty. They were not content with running, however, for they spread the news of their experience to the villagers, with the result that an indignant mob formed, beseiged the van, and finally sent it rolling over the hill, where it and its contents were destroyed; the operator felt lucky to get away with his life.[40]

In such situations, perhaps it is not remarkable that the formulas of advertising and conduct for daguerreotypists tended to take on a standardized format of highly conventional courtesy.

On the other hand, however, the portable, rolling galleries had an advantage, especially in California. Perez M. Batchelder organized a chain of wagons which could be quickly relocated to take advantage of fluctuations in trade. In an 1853 letter to Isaac W. Baker, his prize pupil, Batchelder mentions three operators in various towns, in addition to himself and Baker. Writing from Sonora to Vallecito, he observed,

> I think you have done double the business at Murphys [Camp] that either David or Patch would have done. Indeed I think you have done *Muy Bien,* considering all things. I think if you can get down to Mokelumne Hill before the rains commence you will make a good winters job of it. I thought at one time of taking the Saloon at Stockton there and I presume should have done so if I had not got a good location at Stockton. . . . Ben is in the Saloon at Jamestown. Have not heard from him dont know what he is doing.[41]

Moves such as Baker's from Murphy's Camp (Plate 73) to Vallecito were often directly related to new mining activity (Plate 47) that produced temporary affluence among men wanting pictures. In subsequent letters Batchelder mentions one man learning the trade in preparation for going to Mexico, another student who is negotiating purchase of a gallery, and two other established agents in different towns. In his letter to Baker, he comments, "I hear Vallacita [sic] is burnt. If you were there I expect you had the benefit of being on wheels."[42] A similar incident occurred to William Herman Rulofson, who independently bought out Batchelder's first location in Sonora, both men operating in town at the same time, when

> The mobile nature of the gallery saved it from destruction more than once, notably in the fire of 1853 which leveled much of the business district. Rulofson simply "chained a yoke of oxen to the single-trees and had it driven out of harms way."[43]

Some traveling studios became quite elaborate in size and appointments. Beaumont Newhall reports one built in Lockport, New York in 1853 that cost $1200, a princely investment for the period. It "was 28 feet long, 11 feet wide and 9 feet high, with a beautiful skylight and tastefully furnished."[44] In his autobiography, John W. Bear, the "Buckeye Blacksmith," describes a compromise between a true wagon and a permanent gallery he built to free him from the competition of increasing numbers of small-town photographers and to solve the problem of proper light:

I knew what kind of light I required to do good work with, and this light I could not get in country towns. There being a little Yankee in me, I set to work to build me a house adapted exactly to the business, with a large, splendid sky-light, made in such a manner, that I could, by taking off a few screws, take it all apart in small compartments and load it on a car or a big wagon and move it to any place I might wish to, where with the aid of two men, in three hours I could put it up, ready for work. It was three times as large as those saloons which were built on wheels years after that, and far superior; those saloons were too small and were never adapted to the business. . . . I would go into a town, get a vacant lot wherever I could, get two or three men to help me, and have my house all ready for business before any person knew what was going on.[45]

Ambitious as were some of these itinerant daguerreotypists, a humbler pattern of action was widespread for others—one which reacted more directly to the pulse of the countryside and the towns of America. They responded to aspects of the national situation that were determinative in forming the character of the nation. In his landmark paper on the frontier in American history, the eminent historian Frederick Jackson Turner pointed out the basic significance of westward movement in American cultural development. As had others before him, such as Hector St. John de Crevecoeur and Francis J. Grund, Turner noted the magnetic pull of the inner reaches of the continent. In particular he noted the importance of the middle region, opening out from New York into Pennsylvania, thence into Ohio and the far West. After assigning various reasons for the significant character of this region, he pointed out that

it was a region mediating between New England and the South, and the East and the West. It represented that composite nationality which the contemporary United States exhibits. . . . It was democratic and nonsectional, if not national; "easy, tolerant, and contented"; rooted strongly in material prosperity. It was typical of the modern United States. It was least sectional, not only because it lay between North and South, but also because with no barriers to shut out its frontiers from its settled region, and with a system of connecting waterways, the Middle region mediated between East and West as well as between North and South. Thus it became the typically American region.[46]

It is important in light of Turner's evaluation of the New York-Pennsylvania-Ohio axis of movement and cultural development to note that activity by itinerant daguerreotypists was especially strong in that region. John W. Bear moved his portable house through the towns of Pennsylvania; men such as George Fuller spread out across New York as early as 1840. *Humphrey's Journal* noted in 1852 that four traveling wagons were operating out of Syracuse, New York alone.[47] Striking pictures were sometimes made under quite haphazard conditions in outlying towns of the region. George Barnard, not a true itinerant and later famed as one of the major photographers of the Civil War, recorded a large fire in Oswego, New York in 1853 (Plate 48) in a picture of substantial visual interest quite aside from its excitement as a news event.

The pattern of movement and the feelings aroused in men such as these wanderers have been recorded in sufficient detail in the memoirs of James F. Ryder to serve as a

typical illustration for the mood of the period. In 1847 he learned daguerreotyping from the wandering "Professor" Brightly and joined him to set up a gallery over a harness shop in Ithaca, New York. After a year or so, he was independent enough to strike out on his own. He felt the restlessness that was pulling men into the West by the thousands and set out to begin his own life's search. He combined the mood of the time with his personal goal of becoming a professional photographer and joined the moving tide—like other young men hoping to find success:

> A spirit of unrest possessed me, a natural diffidence and lack of confidence in myself was my bane. I was always fancying that people who had known me as a boy about the streets, only a few years back, were seeing the absurdity of my claim to being a daguerreotypist. I had heard "a prophet was without honor in his own country," [sic] and so concluded to go elsewhere. . . . The companionship between Voigtlander [my camera] and myself was congenial and comfortable. We would go out together and see what fortune had to say to us.[48]

Dubious about his prowess in the discriminating atmosphere of a city, he chose to try his luck at the home of a fruit grower some miles out of Ithaca. The man showed him off as a great prize among his neighbors, thus guaranteeing a substantial trade on novelty alone, and he was launched:

> There was a broad veranda extending across the front of the spacious home of Deacon Lyon. Upon this the trunk containing my gallery outfit was placed. . . . Upon this veranda I concluded to take my pictures. The large trees in front proved a good protection from the too strong light, and softened it to my liking. . . . I took quite a number of pictures on the deacon's porch, and was invited to move to other farmhouses and take members of the families. I was kept busy in this work among farm people for some weeks. The district in which I operated was a rich and prosperous one. All were "well-to-do farmers" and could easily afford to spend a few dollars for family likenesses.[49]

In this rural setting, collaborating with nature's own screen for the light, he enjoyed the mood of the area Turner was later to characterize as " 'easy, tolerant, contented'; rooted strongly in material prosperity."

After satisfying the pictorial needs of the neighborhood, Ryder moved into "the village." He took his place among the assorted enterprises of a small New York town of the 1840s, again operating in a private home and again aided by both natural light and good will:

> There was no hotel in the village. There was a main street and a cross street, a store and postoffice, a grist mill and sawmill, driven by a passing stream. In addition to the above was a wagon shop and a blacksmith shop. These comprised the business traffic and industries of the center. The prominent lady of the place, whose husband was merchant and postmaster, welcomed me to her home and permitted me to use her parlor, the finest in the village, in which to make my sittings, rent free. My sleeping room, the best in the house, and board, cost me two dollars per week. My little frame of specimen pictures was hung

upon the picket fence beside the gate. When my camera was set up, the clip headrest screwed to the back of a chair, and background and reflecting screen tacked upon frames, I was ready for business. I used the open door for my light. I could ask for nothing better. . . . Mine was the first camera in the village and it created a sensation. I was busy with customers all the days. The dollars rolled in right merrily; no business in town equalled mine. The good lady of the house was the possessor of a large cluster breastpin which was lent to every female sitter, to the mutual satisfaction of lady owner and lady sitter. It was also a great aid to me, proving a capital point for aiming my focus.[50]

The artist was well received and respected among people whom Thomas Jefferson had termed "natural aristocrats":

The home-coming farmer gave me pleasant greeting. The boy with torn hat and trousers rolled half way to the knee, as he fetched the cows from pasture, hailed me with "Take my likeness, Mister?" The village lasses, shy and sweet, gave modest bows, as they met the "likeness man." I was regarded with respect and courtesy.[51]

Ryder's experience reflects an eager response to pictorial art which involved almost every person in America. It was a fortunate period for a picture maker who could answer the initial desire of a whole people for images of themselves.

After this serene interlude, Ryder set off again toward the West. "For some months I drifted about and at length got into northern Pennsylvania."[52] Here he was included in rural social activities, quilting bees, and dances as the "dogerytipe man." In some communities his reputation began with his making a satisfying likeness of some known resident. In others he was established by pictures reflecting some popular item of the day such as the wagon of a traveling circus. Pleasant connections in all his stops notwithstanding, Ryder pressed toward Ohio to locate a daguerreotypist in Cleveland who had once shown him the finest picture he had ever seen:

Having seen a fine daguerreotype, and that to have another look at it should pull a young enthusiast through three states may appear strange, I will admit; but it was the only way to satisfy a longing, and I yielded to it. . . . I was headed for Ohio, and ultimately for Cleveland, bent upon further instruction from Mr. Johnson.[53]

The essential difference between Ryder and thousands of other young men of his time is that he knew the form of his longing and most did not.

Ryder seems to have been aware, at least in retrospect, of the vast drama in which he moved. Perhaps the sensitivity of the daguerreotypist allowed him to have greater perception than guided the average person; perhaps, on the contrary, the mood of the time made him a daguerreotypist. In either case, his memoirs reflect at the personal level the general westering march of the nation. Riding the railroad home before his departure for Ohio, he speculated on the pioneering mood of his decision:

While recognizing and enjoying the beauty along the Susquehana [sic], my mind reached out in a grasping sense to Ohio, wondering if it could be anything like this. The compar-

ison was soon dropped, for Ohio was a new country and could not yet presume to rival the Keystone state.

There were occasional instances of people emigrating from the neighborhood of my home in Central New York, to the western states. My boyish impressions were that in those new countries, or states, Ohio, Michigan and Illinois, those of which I heard most frequent mention, log houses, rail fences and stumps were the [way of life]. . . .

. . . And now I was going to a "far country"—to Ohio; which, to my dear mother, seemed the other side of the world. . . .[54]

Carrying his mother's parting gifts of a pair of mittens and a Bible, he took the lake steamer *Simeon Dewitt*:

We passed through Geneva, Canandaigua, Rochester, and arrived at Buffalo, where we took the steamboat *America* for Cleveland—no railroad west of Buffalo at that time.[55]

A symbolic novelist could hardly have chosen the Ohio steamer more aptly.

Cutting his trip short in the spring of 1850, he made pictures for a time in Painesville, Ohio and then grew restless once more. In Kirtland, he visited the original Mormon Temple, turning the fact of its abandonment to his own use:

The room above [the main floor] was similar in size as to floor space, but lower in height of ceiling. There were no dividing partitions in this room. It was filled with pews, and at either end with curious pulpits. . . . In this room, which had broad and high north windows, I determined to locate my studio. I built a floor over the tops of the pew-backs, using them as joists; constructed a flight of steps with a hand-rail, by which to ascend and descend from the floor proper. With my background, my side-screen, a little table and *Voigtlander* set up on my studio floor, I was ready for business. Here permit me to claim the unique distinction of being the only photographer extant who ever had a Mormon temple for a studio—a distinction of which I am proud.[56]

Again, a symbol-conscious fiction writer would be hard pressed to find a more striking metaphor of Ryder's connection to the western trend than the spiritual point of origin of the great Mormon migrations to Utah. He gained a substantial trade from both local people and tourists who were pleased with a daguerreotype souvenir of visiting the Temple. At Bedford, Ohio, a dozen miles from Cleveland, he joined a group who were eager to be the first to walk across the first railroad trestle being built in the area, a token of the westward growth of the nation. As his experience of American life grew, his professional skill also expanded. He acquired his first pupil in Elyria, Ohio, and his own goal was reached when,

One day, to my surprise, [Mr. Johnson] came into my rooms at the Beebe House in Elyria, to find me, and, as he soon advised me, to secure my services as operator and manager of his business in Cleveland. He was opening a studio in New Orleans, where he would remain through the winter, and paid me the great compliment of offering me a position to step into his Cleveland establishment to take charge; to represent him until the following spring. . . . It was an advance beyond my wildest dreams. . . . Now, instead of the

limited facilities of outfit that I carried in a packing trunk . . . from village to town, in my practice up to this time, I was to step into an established studio having permanent fixtures and furnishings upon a liberal scale. A city gallery, with fine accessories and surroundings. Here I would have, too, fine examples of work to study. I would be taken out of a field and transplanted into a garden of richer soil.[57]

Unlike the painters of the period, Ryder and the other daguerreotypists, rather than looking to Europe, saw opportunities for ideal work and study in America. Ryder found his ideal opportunities in Ohio, and for him the search was over; his goal was achieved. He stayed in Cleveland as a professional photographer of major reputation for over fifty years.

Even within his own trade Ryder was not unique. The waterways of America provided mobility for daguerreotypists in many directions. Beaumont Newhall quotes John R. Gorgas, operator of a gallery that floated for three years on the Ohio and Mississippi rivers, as terming this period

the happiest of my life, with a handsome boat 65 feet long, well appointed, a good cook, with flute, violin and guitar, had a jolly time, did not need advertising, and never did any Sunday work.[58]

Another operator, one Sam F. Simpson, made repeated excursions down the Mississippi before 1855:

my business now, is wholly conducted on the River. I have run two floating galleries down, and am now fitting out another, and expect to start down in a few weeks.

This kind of Gallery, I suppose, is rather new to most of your eastern operators; however, it is becoming quite popular in the west.[59]

Simpson described a typical arrangement for his operation and indicated why such ventures were popular with men who wished to feel unbound and free to wander:

Last year I fitted up one at this city, which I took down as far as Bayon [sic] Goula, on the sugar coast, one hundred miles above New Orleans. We have our boats fitted out with every convenience for taking likenesses. In front of all, is the reception room; back of that, the sitting room; still farther back, the chemical room. In our sitting room we have a large side and sky light that enables us to operate in from five to ten seconds in fair weather. . . .

There is something about a Flat-Boat Gallery that savors very much of the romantic; however, it is not half so romantic as convenient. I am almost induced to think that there cannot be a more convenient plan devised for travelling operators than a Floating Gallery. As soon as the boat is landed we are ready for operations, without all that trouble that travelling artists usually experience. . . . Besides we are entirely independent. If business is good, we can remain, if dull we can leave. . . . When we are not employed we can fish or hunt, as best suits our fancy, as the rivers are thronged with ducks and wild geese.[60]

In 1854, in his "artistic craft," *Magic No. 3,* Simpson had

left New Albany, on the first of March; stopped at about fifty landings, took something near one thousand likenesses, travelled (by water,) near fourteen hundred miles, arriving . . . upon the sugar coast, where the French language is universally spoken.[61]

Like Ryder, Simpson was alert to the panorama of America through which he traveled, appreciating with a roving visual sense the implications of the river in the restlessly moving life of the mid-continent:

there is no kind of business that does not find its way on the river. There are merchants, grocers, carpenters, cabinet-makers, blacksmiths, tinners, coopers, painters, show-makers, wagon-makers, plough-makers, (and I should have said likeness makers), saddlers, jewellers, potters, glass-blowers, doctors, dentists, showmen, ventriloquists, machinists, jugglers, Barnums, black-legs, gamblers, thieves, humbugs, museums, concerts, circuses, menageries, Tom Thumbs and baby shows, "till you can't rest." Indeed you could not name any business from the quack doctor to the Bar tender, that is not represented on the western rivers. And the bosom of the "Mighty Father of Waters" may truly be compared to the streets of a great city, where motley crowds from every nation are flocking to find sale for their merchandise, produce and manufactures.[62]

As de Crevecoeur had pointed out the mixture of races as a democratic force in America and as Grund had noted the mobility of Americans, so Simpson observed these influences along with the symbolic effect of a great mixture of social levels and occupations freely moving about the heartland of the continent, all of the individual participants seeking, as he did, independence and good fortune.

There were those among the daguerreotypists wandering the continent who were directly impressed with the significance of the expanding nation during the middle decades. They made heroic efforts to record and interpret the vastness of America as it affected those who traveled over it. The California daguerreotypist Robert H. Vance, for example, though well established in a chain of galleries in San Francisco, San Jose, Sacramento, and Marysville, expended over a year of effort and almost $4000 producing a collection of views of gold-rush California to take to New York for exhibition. The preface to his exhibition catalog makes clear that his intention was a serious artistic attempt to make California immediately available to the viewing public. Stressing the recording accuracy of the medium, Vance stated his reliance on direct apprehension of "the Thing itself":

To such a pitch has public curiosity been excited [about California], that the smallest item of news in regard to this newly discovered El Dorado, is eagerly seized upon. Much valuable information has been given in regard to the country, by several excellent works, but inasmuch as the sight of a place affords so much more pleasure, and gives so much better knowledge than the bare description possibly can, the Artist flatters himself that the accompanying Views will afford the information so much sought after. These Views are no exaggerated and high-colored sketches, got up to produce effect, but are as every daguerreotype must be, the stereotyped impression of the real thing itself.[63]

The collection, framed in rosewood and gilding, included 300 whole plate (6½″x8½″) daguerreotypes, several made in panoramic groups of San Francisco or other points of interest. *The Daguerreian Journal* referred to the difficulty of Vance's project and commented on the accuracy of the minute detail in the pictures:

> we must say the operator has the proof of untiring industry and liberal enterprise in making such a display of Daguerreotypes. When we consider the disadvantage of operating in a tent or the open air, and in a new country, we are much surprised at such success; as a collection, we have never seen its equal, many of the pictures will compare with any taken with all the conveniences at hand. . . . Here we have every line faithfully portrayed and possessing a degree of minuteness in detail not to be equalled by the hand of man.[64]

The Photographic Art-Journal was also concerned with realism and acute recording, but it paid greater attention to Vance's pictures as deliberate and seriously produced works of art:

> They are the most artistic in design, and executed with a skill, evincing, not only a perfect mastery of the manipulatory art, but an exquisite taste for the sublime and beautiful. On looking upon these pictures, one can almost imagine himself among the hills and mines of California. . . .[65]

The excellence of Vance's pictures was further attested in the same source by an unnamed artist designated "one of our best landscape painters." Comparing the daguerreotypes with various panoramic paintings then before the public, he praised the daguerreotypes in terms that were definitive to photography:

> Form, in color, is perhaps the greatest charm upon which the eye can dwell, therefore a panorama in distemper colors, should be considered of paramount importance to one produced by the Daguerreotype. We speak understandingly on this subject, and do not hesitate to say that Mr. Vance's views of California created in us a greater degree of admiration than did Banvard's or Evers' great productions of the Mississippi and noble Hudson.[66]

Even without color the daguerreotypes were superior to the paintings in effect and presence. That a landscape painter should say so is not without significance, and that he should say so in relation to some of the most popular landscape productions of the period is a strong judgment. It is also worth noting that the daguerreotypes won this recognition despite their comparatively tiny size, which might have limited their dramatic impact. Their impressiveness was of quality rather than of size.

The painter also reviewed the question of detail and unified general impression which had disturbed European painters since the introduction of the daguerreotype:

> Detail, with general effect, should be the principal aim of all artists, and if any desire to see this achieved to the highest state of perfection, let them call and examine the . . . productions of Mr. Vance.
> Not a blade of grass, nor the most minute pebble—hardly perceptible to the naked eye— nor the fibers of the bark of the tree . . .—but are wonderfully portrayed in these pictures in miniature most incomparable.[67]

In praising general effect as well as detail, the painter bowed in recognition of the daguerreotypes as artistic productions of a high order. At the same time, however, he implicitly defined the pictures as direct samples of reality:

> Some of the pictures, so far as wild and romantic scenery and the general effect of the lights and shadows—the water especially, so life-like in its reflections—are concerned, are the finest studies an artist can have from which to practice his pencil.[68]

For an artist to speak thus seriously of studying a pictorial surrogate for reality may seem restrictive to his creative possibilities, but it is strong testimony to the strength of the influence that a good photograph can have on a sensitive viewer. In 1939, Edward Weston was to define photographic beauty in the same terms:

> The photographer's power lies in his ability to re-create his subject in terms of its basic reality, and present this re-creation in such a form that the spectator feels that he is seeing not just a symbol for the object, but the thing itself revealed for the first time. Guided by the photographer's selective understanding, the penetrating power of the camera-eye can be used to produce a heightened sense of reality—a kind of super realism that reveals the vital essence of things.[69]

Many painters fell prey to this particular power of photography during the period of the daguerreotype, especially in the field of portraiture. Too often painters saw the photographs as reality with all the visual problems solved and simply transcribed the pictures onto canvas with relatively adverse results. In *The Magazine of Art,* Beaumont Newhall has briefly discussed some of the ventures into such copywork and illustrated his article with pairs of illustrations showing original daguerreotypes and paintings made from them with varying degrees of success.[70] In every case the daguerreotype is substantially stronger as a searching portrait than is the painting based on it, especially in the case of images of Daniel Webster. Nonetheless, such response to the daguerreotypes reiterates the strength of impact of the little silver images in terms of their acceptance as reality with a "heightened sense" made clear by subtle tonal gradations.

Acute delineation of form, perfect rendering of detail, and effect achieved by light and shadow (tonal distribution) being three definitive aspects of the photographic medium, the painter was clearly awarding his favorable judgments to Vance's pictures in response to the particular character of photography. As Gabriel Harrison and others had pointed out, these aspects of photography were also necessities in painting so that Vance's daguerreotypes were simultaneously being given solid recognition as fine pictures on the same basis as any other type of visual art. The painter concluded that "the whole collection reflects the highest credit on the artistic ability and indefatigable exertions of Mr. Vance."[71]

As has often been true before, the sad fact is that none of Vance's pictures from this exhibition is known to exist today. After his New York show did not do well financially, he sold the entire collection to Jeremiah Gurney for about half of what it had cost to produce. After being shown for about a year at Gurney's rooms, the pictures were sold to

John Fitzgibbon, the leading St. Louis daguerreotypist. He exhibited them for some time, and there the trail ends. The pictures were not included in the large Fitzgibbon archive which eventually came to the Missouri Historical Society, and no one has accounted for them since. A similarly historic picture known with reasonable certainty to be by Vance, though sometimes improbably attributed to his student C. E. Watkins, is a view of Sutter's sawmill at Coloma, California, the gold-discovery site, with James Wilson Marshall, the discoverer of gold, standing in the foreground (Plate 49). Even this picture exists only in a relatively poor copy made in the 1890s; the daguerreotype was presumably destroyed in the fire resulting from the San Francisco earthquake of 1906. A good many portraits by Vance exist in public and private collections. They are almost invariably excellent photographs. One of the best is a magnificent portrait of Captain William Anthony Richardson (Plate 50), more or less the founder of the city of San Francisco and a major California pioneer. In the presence of so fine a daguerreotype, it is unfortunate that no form of reproduction comes anywhere near the quality of the original. If the collection exhibited in New York contained pictures of this character and excellence, the judgment of the reviewers as to their artistic worth was in no way exaggerated.

A far more ambitious project than even Vance's coverage of the California gold rush was John Wesley Jones's *Pantoscope of California*. We have already noted the great popularity of panorama paintings in the 1840s and their stress on the natural landscape wonders of the American continent. As the 1850s broke, panoramas became still more popular owing to the increase of westward exploration and settlement:

> The excitement of the gold rush gave a new stimulus to [panoramas]. One picture of a voyage around Cape Horn was being exhibited in New York in mid-September of the first gold rush year. The spring of 1850 saw at Gothic Hall in Brooklyn a panorama of the Gold Mines of California produced by Emmert (or Eimert) and Penfield. James Wilkins' Moving Mirror of the Overland Trail, painted in Peoria by a St. Louis artist, began its tour in September 1850. Beale and Craven's Voyage to California and Return was showing at Stoppani Hall, New York, in November 1850. At St. Louis in January 1851, Charles Rogers was busy painting another panorama of the Land Route to California. February 1853 saw the opening of Ball's Model of San Francisco at 312 Broadway, New York. Another picture with a special publicity appeal, showing at Hope Chapel, New York, in November of this year, was still doing business the following March: Jones' Pantoscope of California had been painted not from mere artist's sketches but from fifteen hundred daguerreotypes taken by J. Wesley Jones himself.[72]

Even the title of Jones's panorama does not convey the full scope of his project. Rather than merely documenting the appearance of California, he traversed the entire western half of the continent from the Pacific Ocean to the Mississippi River! When it is noted that Vance made 300 daguerreotypes for his New York exhibition, expending nearly $4000 and a year's travel and work, the Jones venture of producing 1500 daguerreotypes over half of America seems almost mythological.

Jones was another of the versatile men who took up the daguerreotype to express their response to the American continent. The sketchy information thus far available about Jones indicates that he had some training in art and law. Almost all that is known of him has come from a rare and fantastic volume on his experiences written for him by a hack poet in 1854 to advance his commercial exploitation of the *Pantoscope*.[73] How reliable the book is remains to be seen, but its chief facts harmonize with such known evidence as New York newspaper advertisements. In late 1849 or 1850 Jones went to California with a party of mixed characters, experiencing the usual hardships of people unprepared for such a trek. Arriving in Hangtown, California on the verge of starvation, he was approached by someone from the East who recognized him, and within an hour of arrival he was pleading a landholding case in court. He won the case and was guaranteed a livelihood from as much legal practice as he wished. The account of his California days indicates that he was at times engaged in practice of law. At other times he was active in other pursuits:

> Mr. Jones has been well tried in California, and has established an enviable reputation. As Deputy U.S. Marshal, he was decidedly efficient, enforcing the law where others failed;—as a merchant, he has been prompt and business-like;—as an orator before the people, and the court, he is eloquent and popular;—as an artist, and manager he is certainly skilful and energetic; and as a writer his numerous articles in the California Press, "Inkling's on the trail of the Census Man," &c., &c., have gained him an honorable reputation. . . .[74]

The Sacramento Daily Union is quoted as saying of him at the time of his departure on the daguerreotype expedition,

> J. Wesley Jones, Esq., the leading artist and projector, though a young man, is favorably known to our citizens, as a writer, an officer, and a merchant,—of a fine order of talents and great energy of purpose.[75]

Occasional mention is made of Jones's artistic activities throughout the account, and he evidently conceived his grand project while sketching amid the hardships of the western trip. At times his artistic concerns are noted in conjunction with two other essential attributes of the man which recur often in the book—an attraction for hardship and a vast stubbornness. The original conception of the venture is noted in these terms:

> He had taken sketches of the route, which highly interested his friends; and it was determined to complete his plan and daguerreotype the entire country, and thus, by means of the first artists of the age, give to the world a complete, magnificent, and reliable Mirror of the entire overland journey, and the State of California. A company was formed of talent and capital. The labors commenced, but were met in the outset by the defalcation of the travelling manager; the inefficiency of the daguerreotypist, and the difficulty of procuring material, and of working out of doors in all kinds of weather. Mr. Jones was obliged to come to the rescue; and taking hold of the matter with energy, procured other artists, materials, and a carriage so arranged as to obviate the difficulties which had so well nigh proved fatal to the expedition, himself took charge of the enterprise and pushed it through

every difficulty. Wherever there was a city of note, a great mine, a prominent object of curiosity, he worked his way. Sometimes without roads, they climbed over the loftiest mountains, swam through dangerous streams, and penetrated into Indian fastnesses.[76]

Once again, here is recognition of the daguerreotype as "complete, magnificent, and reliable" for the purpose of recording the world. Here again, too, is the same driving response to the medium we have seen in men like Solomon Carvalho—a near heroic sense of urgency to apply the picture-making medium to the land. With Jones the interaction between the photographic artist and the American landscape becomes epic in proportions, but it is by no means unique as a way of responding to the basic impulses of the nineteenth century as we have defined them for the United States. Jones felt the impact of the American continent and reacted to it with a scale of action which, if true as described, is previously unmatched in American history. Should the Jones account ultimately prove exaggerated, the attitude it reflects is still quite solid evidence that the provocative impact of American scenes on the particular sensitivity of the daguerreotypist exceeded that on almost any other type of person in contemporary society. The Jones project is on the grand scale of thought hinted at by Walt Whitman:

> The Americans of all nations at any time upon the earth have probably the fullest poetical nature. The United States themselves are essentially the greatest poem. . . . Here at last is something in the doings of man that corresponds with the broadcast doings of the day and night. . . . [The American poet's] spirit responds to his country's spirit . . . he incarnates its geography and natural life and rivers and lakes. . . . Of all nations the United States with veins full of poetical stuff most need poets and will doubtless have the greatest and use them the greatest. . . .
> The greatest poet hardly knows pettiness or triviality. If he breathes into any thing that was before thought small it dilates with the grandeur and life of the universe.[77]

James Russell Lowell's exaggerated whimsical remarks on the causative influence of American landscape on native art seem more nearly to establish a suitably grand scale of response for describing Jones's project:

> Our geographers should . . . say, for example, that such a peak is six thousand three hundred feet high, and has never produced a poet. . . . On the other hand, they should remember to the credit of the Mississippi, that being the longest river in the world, it has very properly produced the longest painter [Banvard], whose single work would overlap by a mile or two the pictures of all the old masters stitched together.[78]

At other times, the Jones account bears strong resemblance to Henry Hunt Snelling's description of James Wattles's efforts to invent photography in the American wilderness. With Jones there is a similar stress on the strength of character necessary to bring about such ventures:

> Worn out and wearied, one would think it was too much for humanity to bear. Some of the partners proposed disbandonment. But what can withstand the indomitable energy of man when once firmly determined on the accomplishment of a noble aim? His sole en-

ergy, however, triumphed, and the work progressed. A suitable party of men having been collected early in July [1851], they commenced the homeward journey [to Missouri] across those deserts and mountains where they had already suffered so much.[79]

Jones decided the route across Nevada was insufficiently interesting for his pictorial purposes and set out through the Oregon Territory. One of the present external sources which verifies his activities is an Oregon City newspaper. He evidently wished to include in his collection daguerreotypes of western areas he did not reach himself and posted notice of his plan by mail:

> J. Wesley Jones, being engaged in making pictures of the route across the plains and prominent points on the Pacific Coast, desires us to state that he wishes some artist or daguerreotypist to take some views in Oregon, viz; the important towns, and the most interesting river and mountain scenery, for which he will pay $5 each for half plate views, delivered at any of the eastern cities or St. Louis during the coming winter.[80]

Unfortunately no record has appeared of responses to this announcement.

The Jones party included four daguerreotypists: Jones himself, William and Jacob Shew, and S. L. Shaw. The Shew brothers are documented in photographic history. Along with two more brothers, Myron and Trueman, they had learned the daguerreotype trade from the great chain-studio operator John Plumbe and had operated his galleries in various cities. William had been his casemaker and operator of the Boston depot, and Jacob had been his operator in Baltimore. William ultimately became the dean of photographers in San Francisco, arriving in the city in 1850 and continuing operation until 1903. He was a first-rate daguerreotypist and many California collections are richer for the presence of his work. His Imperial (oversize) plates and whole-plate portraits were especially notable for their quality (Plate 51). He was also known for making panoramic sequences of pictures of the city. Beaumont Newhall reproduces his panorama of the view from Rincon Point in *The Daguerreotype in America* (his plate 62). Shew made many excellent views of the city which record with full detail the commercial life of the day. One picture also shows some of the many abandoned ships, left in the harbor by desertions to the gold fields (Plate 52).

In the account of the Jones Expedition S. L. Shaw is described as being from New Orleans, but no further information is given about him. Since he was in California, however, it is possible that he is the Shaw who worked with the widely active daguerreotypist George Johnson. A possible example of his work may exist in the plate of a popular San Francisco Coffee House of the period (Plate 53).

Jones also included a number of sketch artists in his party, among them William Quesenberg of the *Sacramento Union*, Frederick Coolwine, and others identified only as Arreck, Shoap, Prugh, and Shufelt. With these forces, Jones pushed into the region of present-day Idaho to a geological feature known as Steeple Rocks (Plate 54). The party was attacked by Indians and several members, including Jones, were severely wounded. Jones stubbornly wished to record the rocks in considerable detail anyway,

But Indians were lurking behind every rock, and dangers stood thick around. The company were not for stopping a moment, even to daguerreotype the "Steeples." A portion of the employees who were immigrants . . . declared they would not wait an hour. Fired with the excitement of the moment, our Artist forgot his wounds and debility, and rising from his litter said *"Gentlemen I shall daguerreotype this scenery though deserted by every man*. Who will volunteer to stay with me? The rest can start on—I force no man to expose his life." His faithful men gathered around him and the work commenced. Sick and faint the artist directed and accomplished the task. The gigantic rocks were faithfully mirrored on his plates, and are one of the grandest features of this invaluable collection.[81]

Again, the form of the account, even if ultimately fictitious, stresses the intensity of the daguerreotypist's impulse to apply his medium to the landscape. Only five men stayed with Jones, and the group was soon menaced by Indians. Later *Harper's Monthly* recounted what happened:

The artist turned toward the advancing party his huge camera, and mystically waving over the instrument, with its apparently death-dealing tube, the black cloths in which his pictures were wrapped, held his lighted cigar in frightful proximity to the dreadful engine, whose "rude throat" threatened to blow any enemy out of existence![82]

The Indians, fearing the resemblance of the camera to a cannon, began to veer around Jones, but

the strange mortar followed them, its dangerous muzzle ever keeping them in a straight line. Pop! pop! pop! went the revolvers from beneath the instrument. This was but the prelude of the death-waging storm that was about to burst upon them. They could no longer stand the shock, but with a simultaneous yell broke away toward the rocks. Bang! bang! bang! went the artists' guns after them. Strange and terrific sounds reverberated through the mountain gorges, and were echoed back by the cavernous rocks—yells, shrieks, and rumbling thunders![83]

This artillery defense with a daguerreotype camera was effective enough for the party to leave the Indian country, carrying the badly wounded Jones to Salt Lake City (Plate 55).

Arriving in St. Louis in November 1851, Jones proceeded to Massachusetts where he began directing the painting of the panorama. His corps of painters included Bartholomew of Boston, Alonzo Chappell, Burnham, Piersons (or Pearsons), and others. As a "Citizen of Melrose," probably Jones himself, is quoted reporting to the *Boston Journal*, these forces were producing a decidedly national work:

The lovers of the beautiful in art and nature; the admirers of romance and thrilling incident; the intellectual and patriotic, will rejoice to learn, that this *Chef-de-ouvre* [sic] of American scenery, by American artists, is soon to appear before the Boston public, elucidated by the vivid description of the artist traveller himself. . . .[84]

It becomes clear in this context that the artist was motivated not only by his response to the American landscape, but also by a desire to produce a nationalistic monument.

The account of the *Pantoscope* quotes *The Boston Bee* to summarize the public success of the completed picture, which was first shown in Boston sometime in 1852:

> to overflowing houses, where it met with the most triumphant success, for six months. Returned Californians came and brought their friends, and pointed out to them houses in which they had lived. Extra railway trains brought in large parties on excursions from the neighboring towns. In the city of Lowell, the Pantoscope was crowded for many weeks by thousands. In New Bedford, Liberty Hall was crowded nightly, to the highest gallery, and now it has been in New York City, for upwards of eleven months, every where attracting enthusiastic audiences of the elite, and intellectual, and winning the highest encomiums of the press.[85]

Numerous "encomiums of the press" are extracted in the account of the *Pantoscope*. Reported comments by Dr. Beecher, from *The Congregationalist and Christian Times,* sum up the factors which would have influenced public reaction to the *Pantoscope*. He observes the accuracy of the panorama, noting that "the daguerreotype has been used to give exactness to its delineations." He notes also the informational and emotional aspects of the picture:

> It communicates important knowledge of a large tract of our own territory, the like of which for its peculiar, wild and original features, is no where else to be seen on earth. These scenes are linked in, too, with sketches of deep and sometimes tragic interest in connection with the life and fortunes of those successive caravans of emigrants, who have tracked the wilds and deserts and mountain passes of Western America. . . .[86]

These remarks reflect not only a sense of nationalistic involvement with American scenery, but they suggest the symbolic function of pictures in re-creating emotional experiences which the landscape has provoked. Beecher observes further that,

> On looking at these scenes, one feels a confident assurance that they accord with the realities. They deserve not merely to be *seen once,* but to be *studied often,* and we doubt not that each view will bring a new conviction of the merit of the work, and a new accession of valuable knowledge. It was a bold undertaking, to daguerreotype such a route. . . .[87]

Beecher also notes the reliable nature of the picture derived from daguerreotypes. His remarks suggest again Thoreau's locomotive driver who continues to be affected by natural images he absorbs and reacts to later. The permanence of the images in the *Pantoscope* allowed close study and reiteration of visual experience which provided both knowledge and further insight. For Beecher, the daguerreotype expressly provided this latter sort of perpetuation of the momentary experience:

> All the varieties of mining life pass before us, and all the processes of mining. Nay, we see the very identical miners who were at work when the views were taken, in the very attitudes of real work; for they kept their positions for a time, by request, that the daguerreotypes might fix them *forever.*[88]

A surviving plate of miners by William Shew (Plate 56) indicates the sort of view that must have been included in this part of the *Pantoscope*, though we do not know

whether this picture is one Shew made for Jones. No extant daguerreotypes are known certainly to have been connected with the *Pantoscope,* but a few that are relatively similar do exist. A view of Hangtown (Plate 57) , unidentified as to maker, relates to a sketch from the Jones Expedition (Plate 58) , though the two views are not from exactly the same vantage point. Other scenes of miners in suspended action further illustrate Beecher's remarks (Plates 59-60) . Beecher also observed that one could see "the various stages of civilization, from the newest and most recent town, up to the metropolitan grandeur of San Francisco."[89] It is possible to show types of pictures similar to those from which the *Pantoscope* was made though, once more, it is not possible to declare with certainty that any single picture is from the *Pantoscope* project. An unidentified board town in the mountains mirrors one of the earlier stages of town building (Plate 61) as contrasted with a view of the Banking House of James King of William in San Francisco (Plate 62) from a later date than the *Pantoscope.*

The final chapter in the story of the *Pantoscope* is obscure. Jones continued to exhibit the picture in New York until late 1854, but he increasingly tied promotion of it to a "Gift Enterprise" plan of a sort popular at the time. This operated somewhat along the lines of the Art Unions except that every ticket purchased guaranteed some form of gift. The Jones distribution offered the *Pantoscope* itself, valued at $40,000, as its grand award, along with a farm, three houses, a horse and carriage, pianos, gold watches, and books of Jones's adventures. Since his project developed at the time New York authorities were moving against such promotions, Jones had difficulty completing it. The New York papers were advised by the District Attorney to refuse advertising to all gift enterprises, and his notices do not appear after July. By advertising in the "country" papers, he did complete sale of his tickets, though by this time he had placed the management of the distribution in the hands of a committee of respected businessmen of New York and Boston to guarantee its propriety. The distribution evidently was made in November of 1854. Presumably the *Pantoscope* was awarded to someone, but there is no record of its disposition. Some confusion exists in the matter because the account of the *Pantoscope* closes with a note of its being sold:

> The Daguerreotypes for the great Pantoscope of California cost the round sum of $10,000, and much risk of life and property. The painting and materials upwards of $20,000. It has been sold for $40,000 and on exhibition has paid 10 per cent. interest on $100,000.[90]

Reference to substantial amounts of money and the payment of interest implies that the *Pantoscope* was typically American in the sense of being a business investment on a decidedly grand scale. The *Pantoscope* was a remarkably nationalistic venture in every aspect. In terms of direct photographic response to the American landscape, it was heroic. In terms of being an economic undertaking, it was a grand conception. In terms of personal ambition and physical expenditure of energy, it seems fit to stand in the realm of American mythology. If its artistic merit was as solid as the "encomiums of the press" indicated, then it was a wonderful achievement in every way. The reaction of the *New York Tribune* quoted in the Dix account would seem a fitting summation:

Nothing but rare talent combined with indomitable energy, could have produced a work of such *fine taste, elaborate finish* and *mammoth proportions* as unite in the Pantoscope. . . . American scenery and American talent have here stamped their own eulogy—and an eloquent one it is! Such productions make us proud of our country and our countrymen![91]

We must recall, however, as did Jones himself, that underlying the grand work was the reliable foundation of the daguerreotype:

J. WESLEY JONES—the first to daguerreotype the overland route to California successfully, though amid great danger and peril, took one thousand five hundred daguerreotypes of some of the wildest and grandest scenery in the world, and has painted from them his great Pantoscope. . . .[92]

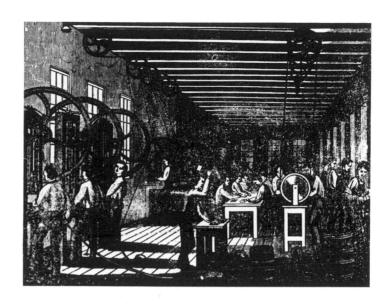

Chapter 6

THE RECORDER AND
THE SYMBOLIST

N ADDITION TO BEING a versatile man and a man sensitive to an expanding America, the daguerreotypist was a maker of pictorial symbols for national characteristics and ideals. Not only did early photographers document the appearance of the wilder half of the continent, but they visually recorded the character of urban America. Deliberately they captured the local color of various parts of the country. The occupations and work of Americans were extensively recorded. Most of all, however, national figures were pursued by daguerreotypists in the belief that American ideals could be symbolized in images of the great men of the time.

By 1850 urban development was becoming a substantial fact of American life. Cities had grown rapidly in the East and almost instantly in the far West. By 1853 the Reverend Dr. Beecher was impressed with Jones's *Pantoscope* for showing "the various stages of civilization, from the newest and most recent town, up to the metropolitan grandeur of San Francisco." Yet San Francisco as a city was less than a decade old. With urban

centers becoming a part of the national landscape as surely as farms or the wilderness, it was natural that the daguerreotypist should turn his lens on the city and the town. The daguerreotypist has already appeared as a man sensitive to the movements of his time; it seems reasonable, then, that he should be intrigued with this newly emerging face of American life and wish to record it. In addition, the greatest audience for the work of most daguerreotypists was in the cities. By 1850 there were more daguerreotypists in New York alone than in all of England. We have already examined the pictures of Boston in 1840 by Dr. Bemis (Plates 9-11) and the view of West Stockbridge, Massachusetts by Anson Clark (Plate 41), made in 1841-42, which indicate that urban views were early subjects for photography in America. In these instances, each picture was deliberately composed to reveal a specific aspect of a community rather than merely reflecting an urban background. Later cameramen were even more deliberate in mirroring the conditions of urban development.

Almost every major American city of the period is represented to some extent in daguerreotypes. Not all have been identified, but many are worthy pictures of great historical importance. Very early pictures of major cities, however, are relatively uncommon. New Orleans, in particular, is rarely found in daguerreotypes. It is thus of considerable interest that a view of New Orleans came to light in the collection of Robert Bretz of Rochester, New York in 1965 (Plate 63). The view, dating from about 1843-45, shows the Bank of Orleans and other buildings, reversed as in a mirror, across a somewhat European plaza with newly planted trees. One of the few previously known views of the city, dating from some years later, shows a larger area that includes the same buildings and the plaza with the trees grown (Plate 64). Both views are obviously from upper floors of buildings, partly to secure proper perspective, partly to secure adequate distance. Daguerreotype studios were usually on the top floors of buildings because of the large skylights needed for portrait work, and most extant city views reflect an elevated point of view. At other times, cameramen would specifically climb to some high point to produce panoramic vistas. A poor wet-plate copy of a daguerreotype of Washington in 1843 (Plate 65) exists in the Brady Collection of the Library of Congress. While 1843 is early to be attributed directly to Brady, it is likely that he copied it for his later gallery. The view looks down Pennsylvania Avenue toward the White House from a height of the U.S. Capitol. A similarly elevated early view, which may be a street in Baltimore, shows the increasing vehicular traffic that was beginning to create urban congestion even in the 1840s (Plate 66).

The 1850s left a considerable record of the development of American cities and towns. The gold rush created great public interest about California, and many plates were made in San Francisco and various mining towns of the Mother Lode. We have already noted the pictures of San Francisco by William Shew (Plate 52), and the firm of Shaw and Johnson (Plate 53), and others (Plate 62). The multiple-plate panorama was especially popular among San Francisco daguerreotypists, and a great deal of exact information about the city can still be derived because of the thorough coverage

given it at intervals between 1850 and 1855. A handsome set of eight whole plates in the collection of the California Historical Society presents a sweeping view of the ship-choked harbor and of a city rapidly growing by use of prefabricated houses (Plate 67). These structures were devised in the late 1840s and sent around Cape Horn, pre-cut, in considerable numbers. Their presence in the San Francisco of 1852 forecasts the standardization of urban building which was rapidly to become characteristic of American cities.

In the plates of this panorama especially we are again forcibly reminded of the truthfulness and acute detail of the daguerreotype. In Plate 68, for example, a particularly appealing "genre" picture, we have not only the major significant facts of the ships and the Bay, but we are given a familiar glance into the lives of people living in a plank house above the shore as they sit in the sunshine or hang out freshly done laundry. This vignette could be lifted out as a charming scene of "America at Home" as well as any produced in the nineteenth century, yet it has the great appeal of unselfconscious naturalness on the part of the subjects who are sensitively seen by the daguerreotypist at that "decisive moment" most nearly "the Thing itself." To pictures such as this we can apply the observation made at the time by the *Alta Californian* about a daguerreotype panorama of the city, now lost, made by one S. C. McIntyre:

> Decidedly the finest thing in the fine arts produced in this city, which we have seen, is a consecutive series of Daguerrean plates, five in number, arranged side by side so as to give a view of our entire city and harbor, the shipping, bay, coast and mountains opposite, islands, dwellings and hills—all embraced between Rincon Point on the right, to the mouth of our beautiful bay on the left. . . . It is a picture, too, which cannot be disputed —it carries with it evidence which God himself gives through the unerring light of the world's greatest luminary. . . . [The scene] will tell its own story, and the sun to testify to its truth. . . .[1]

In the city or in the rural areas, the response was the same to the wonder and the truth of the medium—to the point of attributing Divine assistance conferred upon the picture maker who chose to work with the daguerreotype.

A view of San Francisco's South Park (Plate 69) indicates the affluence of the developing city and relates the row-house architecture of new sections to similar areas in New York or Boston. Quite another type of housing is recorded in a deteriorated plate of early-settler construction in Hangtown in the Mother Lode (Plate 70), and views of Nevada City in various stages of its development demonstrate how a settlement in the gold country could begin as a ragged town jerry-built of raw lumber (Plate 71) and become a neatly painted and thriving community in a few years (Plate 72). The traveling daguerreotypist Isaac W. Baker recorded Murphy's Camp in the summer of 1853 (Plate 73) as a business community which differed from San Francisco only in development (Plate 74). Both communities were brought into being essentially by the gold rush, and both were but stages in the progress from initial settlement in tents (Plate 75).

In other parts of America towns came into being for other reasons, such as logging,

but there, too, daguerreotypists were active. A given Oregon town may not be identifiable, but logs in a river tell a story of subduing the wilderness (Plate 76). By showing stumps in the foreground and snake rail fences in the distance before great pine trees, a badly solarized plate of Jacksonville, Oregon during the gold rush period attests further to the immediate destruction of the forests (Plate 77). Pictures such as these may have been only partly conscious efforts by the daguerreotypists to report the transition from the wilderness into towns and cities. It is a fact, however, that each picture was deliberately made—it was wanted for some reason. Each picture was also composed to show what we now see—a selection by the photographer of cut logs or stumps in conjunction with a town. While we cannot say absolutely that a given cameraman wished to comment on the despoiling of the wilderness, we can recall that cutting the trees was a matter of artistic pain to Thomas Cole as early as 1841 when he protested the destruction of the forests for profit.

By collecting a series of plates from successive stages of such development, it is possible to trace the growth of Minneapolis, Minnesota from a few houses and an Indian village near St. Anthony Falls on the Mississippi into a substantial town. The river changes from an angry torrent full of logs and rocks to a subdued and timber-cluttered stream crossed first by tributary branch bridges and finally by the first bridge over the main river while houses appear, change, and multiply (Plates 78-85). Since many of these pictures are similar in style and view, it seems reasonable to assume that a local daguerreotypist was consciously documenting the growth of the area as a deliberate project.

A fragmentary record also exists for the sister city of St. Paul. We can trace its growth from the original log chapel for which the city was named (Plate 86) and a wintry view of old Fort Snelling (Plate 87) to a town beginning to develop refinements such as a bookstore (Plate 88), public buildings, and a street grid (Plate 89). A given picture in such collections, such as a view of the McCloud Hardware Store (Plate 90), is often not only a useful document, but a novel pictorial composition in which the daguerreotypist has allowed his sensibilities as an artist to take control of an otherwise stock situation.

There is evidence for claiming that daguerreotypists were specifically eager to reflect the cities of America. A particularly fine case in point is a panorama over eight feet long of whole plates of the Cincinnati riverfront in 1848 made by Charles Fontayne and William Southgate Porter. One can be sure that planning and intent were necessary in the making of this series because the results are so well seen. A decidedly nationalistic involvement enters in when the fact is noted that the panorama was sent to the Crystal Palace in London in 1851 where it won considerable praise. Beaumont Newhall reproduces two of the eight plates in his *Daguerreotype in America* (his Plate 32), and the daguerreotypes themselves are now in the Cincinnati Public Library. Similarly, Newhall reports the activities of

Alexander Hesler of Galena, Illinois, [who] set up his camera on the deck of the steamboat *Nominee* in 1851 and photographed the river landings on the Mississippi from Galena to St. Paul, to be used as illustrations for a guidebook.[2]

One of the plates from this period exists in the Chicago Historical Society in a sharply detailed view of Galena's shoreline showing the stern of the *Nominee* projecting from behind the mail packet *New St. Paul* (Plate 91).

In 1853, *Putnam's Monthly* began a series of articles on "New-York Daguerreotyped." Its reliance on the photographic medium was explicit:

> This paper is the first of a series in which we propose to give a rapid glance, at the progress of New-York and its architecture. The present article, in addition to a general outline of the subject, commences a notice of the business district of the city. The succeeding papers will revert to this topic, and discuss . . . the Public Buildings generally; and also the private houses, and the domestic life of the commercial metropolis. These will be followed by similar papers on Boston, Philadelphia, and other places. These papers are illustrated with engravings from Daguerreotypes. . . .[3]

The wood engravings of the article clearly reflect the photographic basis of their images, even to random accidental details of construction booms and bent light poles that run counter to pictorial composition. The curious fact in this instance, when one recalls that New York was the center of American daguerrean activity, is that not one daguerreotype of New York is known today. Articles such as this one assure that many were made, as do various wood engravings in illustrated magazines of the time. The problem is that most of the daguerreotypes for such purposes were regarded as a means to the end of reproduction and were easily dismissed. Engravers frequently destroyed the plates by tracing directly on them, and others threw them away when their wood blocks were done. As a result we have no verified photographic images of New York dating from before 1850 except for a few experimental calotype pictures. The closest we can come to an actual daguerreotype is a painterly composition by the visiting English daguerreotypist John Werge which exists in a collotype reproduction that loses most of its fine detail (Plate 92).

The *Putnam's* article shows that daguerreotype projects were undertaken to mirror the general character of rising American cities. Still more specific evidence exists in a notice in *Humphrey's Journal* for 1854 on the interests of H. E. Insley, a New York daguerreotypist:

> Mr. I. has sent us the following, which we consider of sufficient interest to the Daguerreotype public to give a more permanent position than a mere advertisement. Should this plan be carried out, and the Daguerreotypists take an interest in the matter, it would make a valuable and interesting collection. Mr. I makes the following
>
> > PROPOSITION—Having, according to arrangement, resumed the contract of my Patent right for my Illuminated Daguerreotypes, I would make the following proposition to the Daguerreotypists of the United States, viz: Being desirous of making a large

collection of views of the cities and villages of the United States, I would offer to each and every Daguerreotypist, for a whole plate view done up under an 8x10 inch plate glass, and fine gilt mat—an individual right to my Illuminated process. . . .[4]

By this method, Insley evidently wished to establish a comprehensive exhibition of the nature of America as revealed in its communities and cities. That the project was underlain by an impulse to display the overall character of the nation is implicit in a later part of Insley's notice:

To such as have no whole size camera, I offer the same right for three half size pictures, or a view of the place they are in, the others of natural curiosities, such as water falls, or one may be of the Governor of the State. . . .[5]

His project, in short, was meant to be a summation of the American scene in its cities, its natural wonders, and its public men.

A remarkable project of a related nature was proposed by P. T. Barnum in 1855 and given substantial attention in *Humphrey's Journal*—The American Gallery of Female Beauty. Both Barnum and Insley approached their summational projects by asking help from daguerreotypists on a national scale under what was patently a competitive nationalistic impulse, particularly in the case of Barnum:

An eminent publishing house in Paris is engaged in issuing a series of the most distinguished FEMALE BEAUTIES in the world, which, when completed, is to include TEN *of the most Beautiful Ladies in the United States and the Canadas.*

In order to obtain such specimens of American beauty as will compare favorably with any that the Old World can produce, as well as to secure in a permanent form a Gallery of Original Portraits, unequaled in the world for graceful perfection, and at the same time encourage a more popular taste for the Fine Arts, stimulate to extra exertion the genius of our Painters, and laudably gratify the public curiosity, the subscriber will give over FIVE THOUSAND DOLLARS IN PREMIUMS.[6]

Barnum further proposed

that every person having a fair friend over 16 years of age (single or married) whom he believes competent to compete for the premiums and *eclat* embraced in this enterprise, shall forward to him (free of expense) her Photograph or Daguerreotype. . . . They must be taken of a size not less than a "Half-Plate" [4½" x 5½"], so as to include the hands of the sitter, and be placed in a plain frame for hanging.

A sealed envelope must accompany each portrait, enclosing the address, with or without the real name of the fair original, furnishing the color of her eyes, the shade of her complexion, and a small lock of her hair, in order that the artists may do their celebrity and their subjects justice in executing the subsequent Gallery and Oil Paintings.[7]

All pictures arriving by October 15, 1855 were to be numbered and displayed for most of one year, during which time votes were to be cast by the visiting public for the

one hundred most beautiful. These winners, each to receive a token prize of ten dollars, were then to have their portraits painted, from life or from their photographs, for the final competition. Once more the public would vote, this time for twenty pictures, and on September 15, 1856 the prizes would be distributed ranging downward from $1000. "Those obtaining the Ten Highest Premiums will be engraved and published in the French 'WORLD'S BOOK OF BEAUTY.' "[8]

Barnum bowed to regionalism to the extent of displaying the pictures according to states of origin, and his desire to submit ten national beauties able to stand European competition foreshadows both the Miss America and Miss Universe pageants of the twentieth century.

Samuel Dwight Humphrey remarked on the mutual stimulation between photography and American beauty provoked by Barnum's project in terms of both nature and photographic artistry:

> The curtain rises, and we see Nature represented by her own pencilings: she has impressed herself in all her delicacy and decision—in all her softness and her grandeur—in all her richness of tone and breadth of effect. In an instant she is indelible,—her fascinating charms of yesterday securely held to-day: fleeting shadows have been secured, and for ages will remain as monuments of what has been.[9]

The photographic medium was being called on to define and monumentalize forever a characteristic of America previously impossible to calculate. Definition of America for herself, literally and symbolically, and national competition with Europe seem to have been paramount even in this relatively frivolous aspect of American life, and both impulses, as well as a drive for permanence of beauty, were to be satisfied by the daguerreotype. Humphrey echoes these impulses in his remarks of the following February, at the same time making clear that the project ran well behind its October target date for submissions:

> Have we any Handsome Women Amongst Us?—The question will soon be settled. England claims all the beauty. So does France. But, when *Barnum's Gallery of Beauty* gets fairly under weigh, the United States will put in a handsome claim for this side of the Atlantic. Messrs. Greenwood & Butler, the new proprietors of Barnum's Museum, are prosecuting the gallery with great vigor. Several hundred Daguerreotypes, by our first artists, have been already sent in, and some of them are extremely fine specimens of the art, as well as of female loveliness.[10]

It is not presently certain whether the Gallery was ever completed. Little more information has appeared about it, and its ultimate disposition is in doubt. While it would, perhaps, be enlightening to observe the final selection of American beauty for the period, the outcome is less important for our purposes than the conception and the method of the enterprise. It was one more venture that applied the daguerreotype to a national cultural impulse.

We have earlier discussed the American institution of work and the national ten-

dency to spiritualize labor. We have also noted that such a climate made for production of works of art reflecting American occupations and pastimes by the genre and local color painters (see Chapter 1). Since interest in occupations was so explicit, it is appropriate that the daguerreotypist in the role of an "American Characteristic," to which he had been designated by *Godey's* in 1849, should have responded to this aspect of the national scene. Essentially two approaches were made by daguerreotypists to the subject of occupations. In a relatively few instances, daguerreotypists went through the process of setting up staged tableaux representing Americans at work. Such compositions tended too much to reflect the genre paintings of the day. At best they were relatively simple presentations of a common situation, such as "Driving a Bargain," a scene at a blacksmith's by Alexander Hesler (Plate 93). In other instances they were too artificial or cute to be altogether effective, as was "The Young Bachelor's Sunday Morning" (Plate 94) by J. T. Harrison of Oshkosh, Wisconsin. This scene was criticized by the public even at the time for being artificial and unconvincing. Such a reaction may account for the relative infrequency of such compositions.

One of the best-known genre compositions is "The Woodsawyer's Nooning" by George N. Barnard (Plate 95), of Oswego, New York, made in 1853 for the Anthony Prize competition, in which it received third honorable mention. A description of the picture by a friend of Barnard's, submitted to the competition with the plate, indicates something of the spiritualized view of work held at the time:

> This picture is on a large sized plate . . . combining more of life and spirit, and a stricter attention to artistic rules than usually falls to the lot of a daguerreotype. It represents an aged Canadian Wood-sawyer and his son, surrounded by the instruments and objects of their labor, enjoying their noon-tide meal. . . . The old man, by his upright, sturdy air, plainly shows that he is habituated to [industry], and retains vigor enough for the calls of the remaining half day. But the chief beauty of the picture is the boy . . . [whose] intelligent, reflective face, while looking directly in your eye [with fatigue], betokens by its abstracted air that his thoughts are absent. Perhaps his imagination is soaring in aerial flight, and enjoys a glance of improved destiny in the future. In this happy [dream] land—as he has learned, that rank and title are of no avail in running the race of life— that the lowliest can aspire to the highest attainments. His frank and manly countenance indicate [sic] his nature, and who knows but the boy of the wood-sawyer before us, may yet be a brilliant star in the constellation of his country's glory.[11]

This description is obviously a sentimental response to the facts presented in the picture. The direction of the sentiment, however, implies an idealized attitude toward opportunities for youth in North America to reach any goal. The remarks about rank and title being of no avail are an echo of Thomas Jefferson's faith in the "natural aristocrat" who will make his success by labor, innate virtue, and talent rather than by means of inherited rank or position. This sort of sentimental allegory overwashed everyday facts of American life with a democratic view of work which had become a national trait by the time of the daguerreotypist's picture.

Other occupation pictures made by daguerreotypists were straightforward records of people at work or people with the tools of a trade shown as artifacts in a formal portrait. These were made in every part of the country in considerable numbers.

Actual scenes of people at work are infrequent because of the comparative slowness of the daguerreotype. While pictures such as those of miners (Plate 96) are not uncommon, they usually have a staged appearance deriving from their actually being posed or interrupted and frozen (Plate 97). When such pictures were planned and executed by competent daguerreotypists, the results were often creditable pictorial compositions in addition to being reliable records of the moment (Plate 98). Some picture-making situations provided relatively normal-appearing subjects, as in the case of the formal stance of a Kansas "Free State Battery" of militia (Plate 99) or the instance of an expressman with his wagon (Plate 100).

Once in a while a daguerreotypist was able to make a picture conveying a developing activity with seeming spontaneity. One case in point is a view of two men sharpening a millstone in an early Minneapolis flour mill (Plate 101). While the action is interrupted, the informality of the postures and the blurring of the focus produce a momentary immediacy that implies action. A shepherd with a flock of sheep provided one anonymous daguerreotypist with a transient subject reflecting the pastoral charm of the country (Plate 102). At times truly spontaneous pictures were accomplished under circumstances which remain puzzling. The Society of California Pioneers has two such plates which project a spontaneity and fascination that planned pictures of the period never contain. A roughly arranged picture of men transporting what appears to be a steam boiler (Plate 103) carries an immediacy of experience which the daguerreotype seldom achieved—it has the kind of raw documentary quality of vision we commonly associate with pictures of the Civil War or periods of high-speed camera work. Here we capture time forcibly, knowing that the moment could not last except for this hastily grabbed image of it, made for whatever reason the photographer had. The other, puzzling as it is, is a scene of true action (Plate 104). Blurring of the figures of men, presumably Indians, makes clear that the subjects were moving at the time the lens was open, and the entire activity seems to have been recorded without knowledge of the subjects.

In seeking to characterize the occupations of America, daguerreotypists commonly reverted to standard portrait methods and relied on distinctive appearances or the presence of tools as symbolic objects. A great many such plates still exist which picture various trades and professions (Plates 105-115). These portraits are often conventional in pose and manner in a fashion typical of thousands made during the ascendancy of the medium. Their use of tools or artifacts relates to painterly conventions reaching as far back as the seventeenth and eighteenth centuries. The presence of an elaborate clock as a symbol of a man's professional skill (Plate 116) is merely an extension of the inclusion of a bunch of grapes by John Singleton Copley in a portrait of the wife of a wine merchant. Daguerreotypists were normally quite direct and literal in their uses of artifacts, considerably more so than the painters usually were. American daguer-

reotypists seldom resorted to covert symbolism. Despite the activities of Gabriel Harrison or John Jabez Edwin Mayall, creator of groups of allegories on themes such as "The Old Rocking Chair," "The Lord's Prayer," and "The Soldier's Dream," the allegories we have noted earlier seldom exceeded the literal implications of studio arrangements or enacted tableaux.

This literal treatment prevailed in portraiture of occupations as well. The most extreme case of symbolic sophistication thus far visible occurs in a portrait of a doctor-historian (Plate 117) in which a book, a skull, and an hourglass imply the related interests of the sitter. Even in this instance, the metaphoric use of artifacts is relatively explicit when the facts are known. American operators seldom, if ever, cared to go as far into allegorical mystique as European daguerreotypists. No American picture thus far known approaches the manner of a French "memento mori" still life using basic elements similar to those in the portrait of the doctor (Plate 118). For the American picture maker allegorical symbols were evidently required to perform a utilitarian function as far as possible rather than being used for themselves strictly as artistic elements. This sort of literal, "head-on" approach to subject matter was squarely in line with most of the prevailing painterly impulses of nineteenth-century America. It was similarly aligned with other aspects of the cultural atmosphere—pictures were not only to look at aesthetically, but they were expected to give complete and accurate information clearly enough to be usefully reliable as sources of factual truth. A woodsman shooting for a beef had to be accurately portrayed in all details including his equipment or the painting was apt to be regarded as bad art. Similarly, the daguerreotypist wishing to portray a turkey hunter (Plate 119) had to show the proper trappings—a shotgun, a shaggy dog, and a bagged turkey.

This literal-minded sort of directness, which is, after all, another form of the Emersonian concept of direct experience which we have summed up thus far in the Weston phrase "the Thing itself," also influenced the styles of occupational portraits in subconscious ways. The turkey hunter is shown in a pose appropriate for a woodsman after hunting, and he is shown sitting on the rough boards of what is probably a porch floor with a hastily arranged blanket for a backdrop. The more severely formal impression conveyed by a militia man in dress uniform with a sword seems better shown by the daguerreotypist in an upright geometrical posture with a perfect, featureless backdrop (Plate 120). While it is probable that the turkey hunter was photographed by an itinerant daguerreotypist and the militia man in a formal studio, there is still a notable sense of aptness in such pictures which suits the subject and the artifactive tokens of occupation. Because of his direct vision, the daguerreotypist was uniquely able to bring about this type of aptness in his treatment of occupations and pastimes. Many pictures exist which do not have this particularly suitable mood, but more memorable daguerreotypes do possess it (Plate 121). A few fine pictures deliberately contradict this aptness of mood to make their visual impact in another way such as by use of significant detail or by presentation of a forceful personality (Plate 122).

160

An American tendency to stress a central subject rather than the overall pictorial composition is closely related to this visual aptness of presentation. European operators often gave greater concern to producing pictures which were conceived as overall compositions rather than direct experiences of a central subject. In the area of occupations, genre, and local color, stylistic distinctions can be drawn fairly clearly in a few instances between French and American pictures. Comparing two street scenes (Plates 123-124), we find the French plate to be a more nearly total composition. Less emphasis is put on the woman with her donkey than upon her placement as a visual element in the entire scene. In the American picture, the man in a pony carriage dominates the picture completely. Minor details of the background appear only incidentally in a manner that conveys a more immediate moment than in the French scene. In American pictures where a general scene is allowed to become the subject of a picture (Plate 125), there is still a sense of centralized emphasis that the French picture avoids. The unfocused edges of the American picture are arbitrary and seem determined more by the location of the central object of the picture than by aesthetic composition of the total view—with the result that the French picture seems more timeless and self-contained than is the immediate moment hacked out of the passing scene often shown in American pictures. This sort of jagged directness tends to emphasize the "truth and reality" of the American picture in a way suggesting that the picture is less a distinct entity than a view *into* the world beyond it in an almost Emersonian sense. Even a relatively painterly presentation by Samuel Morse of two women playing chess on an outdoor veranda (Plate 126) retains more of this American trait than does a French scene in a similar outdoor setting (Plate 127).

With this tendency of American daguerreotypists to emphasize the immediate moment, the direct activity, the particular person, it is not remarkable that occupations and pastimes should have appealed to picture makers. Likewise it follows that the more sensitive daguerreotypists may have felt moved to make such pictures in answer to an impulse to characterize the manner and life of the nation. One serious operator with this concern was John Fitzgibbon. We have already noted his interest in the American scene with his purchase of the Vance collection of plates of the California gold rush. In making pictures of early St. Louis, he and Thomas Easterly carried out similar interests by capturing the atmosphere and the passing parade of types of people found in the city. Easterly's view of Lynch's Slave Market not only recorded a local institution, but it capitalized pictorially on the presence of a number of town loungers (Plate 128). That efforts along these lines were probably deliberate is suggested by an article in the *Photographic and Fine Art Journal*. The account describes the daguerreotyping of the "Arkansaw Traveler" by Fitzgibbon, who mentions hearing of the possible presence of this legendary figure "at a great ball-play [of lacrosse] that was to take place near the line of the Cherokee, Osage, and Seneca nations," near Neosho in southwestern Missouri. "Who has not heard of the famous 'Arkansaw Traveler?' What would I not give, thought I, if I could only get his physiognomy for my gallery?"[12]

A variety of elements of American consciousness in the nineteenth century are present in the daguerreotypist's account. His search takes him to the agrarian frontier, which is present in glowing terms of frontiersmen and Indians harmoniously associated with unspoiled nature:

> The sun was retiring to his bed of grass behind a beautiful green knoll, far in the great ocean prairie that stretched limitless to the west. The hum of voices arose on all sides; herds of ponics were grazing on the plain; the smoke of camp fires were [sic] rising like pillars of cloud to the heavens; night came on, and I retired to my pallet on the ground and anxiously wished for the morrow.
>
> It came, and all nature was astir. Horses were scampering and neighing on all sides. The language of four Nations was heard, and that of the Osages rose high above the rest, as they howled their morning prayers to the sun. A faint south breeze and a cloudless sky betokened a scorching day. . . . The shade of the walnut grove where I had encamped, was thrown far out upon the prairie; the waters of the rivulet that ran from the spring in the grove, ran dancing, and sparkling in the new sunbeams.[13]

Finally, at a hoedown of Cherokee half-breeds, the photographer found his subject:

> As I drew nearer I saw the Arkansaw Traveler. I knew him at a glance. There needed no hand to point him out. He was standing elevated on the stump of a lone tree that some of the campers had cut down. Just as I got up to the crowd he finished his tune and descended for a "horn." I immediately approached him, told him I was a daguerreotypist, and requested his picture.[14]

The Traveler tells him, "I've got no time for picturing," but allows him to try anything he can during the progress of the dance. The Traveler, a true frontier aristocrat, observes that the basic value of a man is not to be taken from his surface appearance:

> "Colonel, I don't vally picters much. Howmsoever, if you can git anything from me as I go along, you're welcome to it. (Down the middle Sakee and Jack!) I wouldn't stop this tune now if General Jackson was to come along and want to take my image. (Dance to head!) Picters can't show the innard man, (turn partner!) that's the part I vally. . . ."[15]

The Traveler seems to substantiate on behalf of the characteristic American man the attitude that led Brady into European competition by sending American portraits to the Crystal Palace. The keenest daguerreotypists actively sought to reveal the "innard man" valued by the Traveler. As the ideal was stated by the leading portraitist Marcus Aurelius Root,

> the face is altogether the most important subject for representation by the portraitist whether with the camera or the pencil,—since *its* true expression, when transcribed, is the revelation of the real man. . . .[16]

Fitzgibbon must at last have convinced the Traveler of his discernment of the "innard man," because he consented to sit for his likeness. In appearance he was a striking ex-

ample of frontier bravado, an appearance that Fitzgibbon must have found emblematic of powerful elements in American character, to judge from his description:

> I arranged his position on the stump, and succeeded in getting a brilliant, precious likeness. I now have it in my gallery. It may be known by its peculiarities, at a glance. A splendid buckskin hunting shirt, variegated and ornamented with many colored silks and several rows of broad fringe, a red calico shirt, black cloth pantaloons, a red sash, a Kossuth slouched hat and beaded moccasins—these formed his dress when he sat for my camera. His countenance I need not, cannot describe. But as it appears, hanging among the specimens of my gallery, I regard it as one of the most remarkable of the day.[17]

Fitzgibbon implies that he regarded this picture as a significant document of the American man in one of his strongest and most characteristic forms. His account clearly indicates that his concern to make the document was both deliberate and very strong.

The variety of pictorial styles and treatments in American daguerreotypes is greatest in pictures of the national situation as it was reflected in occupations, genre scenes, and local color generally. National pastimes seem to have drawn an eager response from daguerreotypists. Formal studio portraits were sometimes lightened with an artifact of play (Plate 129). At times studio portraits under these conditions became clowning sessions (Plate 130); at others they became tableaux of play or sport (Plates 131-134). Homely scenes were taken directly (Plate 135) or re-created in the studio (Plate 136). The hobby of the butterfly collector (Plate 137) was documented as readily as the remarkable faces of an ensemble of brass players (Plate 138). Daguerreotypists recorded activities which were also treated by painters of the period under the impetus of the same cultural interests. Caleb Bingham painted a well-known frontier pastime, the political rally, in which he idealized the appearance of rural democracy in action. From a daguerreotype we can observe at firsthand the sort of raw material Bingham had to work with on the Missouri frontier (Plate 139).

The American landscape was recorded along with American activities. Pictures of Niagara Falls, for example, were as common in daguerreotypes as in paintings (Plate 140), both in a natural state (Plate 141) and in a state of being imposed on by civilization (Plate 142). Niagara was taken once as the scene of a piece of early news photography. John Werge recounts the story:

> One morning, at daylight, a man was discovered in the middle of the rapids, a little way above the brink of the American Fall. He was perched upon a log which was jammed between two rocks. . . . No one could possibly reach him in a boat. . . . One of the agonized spectators, a Southern planter, offered a thousand dollars reward to anyone that would save the "man on the log." [A] raft was let down to him, and this time was successfully guided to the spot. He got on it, but being weak from exposure and want, he was unable to make himself fast or retain his hold, and the doomed man was swept off the raft and over the Falls almost instantly, before the eyes of thousands. . . . His name was Avery. He and another man were taking a pleasure sail on the Upper Niagara River, their boat got into the current, was sucked into the rapids, and smashed against the log or the

rock. The other man went over the Falls at the time of the accident; but Avery clung to the log, where he remained for about eighteen hours. . . . Mr. Babbitt, a resident photographer, took several daguerreotypes of the "man on the log," one of which he kindly presented to me.[18]

This picture of Mr. Avery (Plate 143) is a distinct exception to the usual, both photographically and in mood. More normally in daguerreotypes of the natural scene under the impact of human developments, nature is shown subservient to the advance of man. This relationship is at times maintained visually in the composition of a picture, particularly when the advance of railroads is concerned (Plate 144); even Niagara was overcome in this way, pictorially as well as in fact (Plate 145). As we have seen, daguerreotypists were responsive to nature, but as sensitive men under the influences of their time, they also responded to the reduction of the wilderness.

Despite the considerable volume of daguerreotype pictures produced to summarize aspects of the American scene in human activities and in the face of nature, the most comprehensive effort to characterize the nation was made in national portraiture. The earlier nineteenth century held the view that history was definable as the lengthened shadows of great men. There was interest among daguerreotypists to record the faces of the noted from the very beginning of the medium in America.

In a nation which idealized the democratic process of government, it was natural that governmental personages should exemplify the successful operation of the country. In Chapter 1 we have already spoken in some detail of public interest in picturing the leaders of the nation from as early as the period of the silhouette and the establishment of national painters. We have read John Quincy Adams's account of having sat for some form of portrait thirty-five times before the introduction of the daguerreotype and being satisfied with only four of the results. We have noted, too, how quickly the very word "daguerreotype" became associated in public consciousness with image making, so that within nine years of its introduction Joseph G. Baldwin could write of Zachary Taylor, the Whig candidate of 1848, as having "daguerreotyped" himself on the popular heart along with George Washington and Andrew Jackson. Within this framework of popular concern for the symbolic function of the images of public men, it is appropriate that the city of Washington, as the seat of the national experiment in democratic government, should have attracted daguerreotypists almost at once.

By 1840 there was already at least one professional daguerreotypist operating a studio in Washington—John G. Stevenson, a pupil of Alexander S. Wolcott who was the original studio operator in the world.[19] During this first year of the medium, Stevenson taught the process to John Plumbe, who was in Washington to urge plans for a transcontinental railroad before Congress. Plumbe had sunk all his money into promotions and publicity for the venture and turned eagerly to the new medium as a source of revenue. Gifted as a promoter, Plumbe soon expanded his initial daguerreotype activities into the most extensive chain operation in the period. By 1846, he was nationally known and had operator-agents established in leading cities and resort towns across the country. His

advertisement in the *Scientific American* for September 1845 showed studios in Washington, New York, Boston, Louisville, Saratoga Springs, Petersburgh (Va.), Alexandria (D.C.), Philadelphia, Baltimore, Harrodsburgh Springs (Ky.), Newport, Dubuque, Cincinnati, and St. Louis.[20] A similar notice in the Washington *City Directory* for 1846 added affiliated galleries in New Orleans, Liverpool, and Paris.[21]

Since, practically speaking, the medium was but six years old in America, Plumbe's operation on such a scale is a remarkable entrepreneurial accomplishment in a day when very few businesses of any kind had even considered operating more than two or three local branches. It is certain that Plumbe must have been a decided contributor to having *Godey's* declare the daguerreotype an "American Characteristic" by 1849. At the height of his enterprise, Plumbe moved in august circles of national society as "Professor Plumbe." His activities in the capital city are reported in the *New York Morning News* of February 1846:

> The art of Daguerreotyping has been brought to such extraordinary perfection that we now not only have exquisitely finished, but almost living, breathing, representations of men. The best we have yet seen were shown us a day or two since. They consist of admirable likenesses of the Hon. John Quincy Adams, the Hon. Thomas H. Benton, the Hon. Dixon H. Lewis, of Alabama, the Hon. Levi Woodbury, Judge of the United States Supreme Court, and other Senators and members of the House of Representatives which Professor Plumbe has recently taken in Washington and transmitted to his extensive gallery in Broadway for exhibition.[22]

Plumbe's activities typify the general practice among operators of making celebrity portraits and then circulating them for exhibition in their own galleries or copying them and selling daguerreotype reproductions to other daguerreotypists for exhibition.

Unsatisfied with the unique nature of daguerreotypes or direct copies, Plumbe employed artists to copy the more popular pictures onto lithographic stones and published them under the name "Plumbeotypes."[23] The *United States Journal* reported,

> We are pleased to learn that this ingenious artist is now engaged in taking views of all the public buildings in Washington, which are executed in a style of elegance that far surpasses anything of the kind ever seen. It is his intention to dispose of copies of these beautiful pictures, either in sets or singly, thus affording to all an opportunity of securing perfect representations of the government buildings, whose intrinsic worth is hardly exceeded by their worth as specimens of the most wonderful art ever discovered.[24]

The implications of popular symbols in this commentary are clear; the project's greatest appeal was in allowing everyone to have images of the monuments of national government. The appeal was intensified by association of the daguerreotype process with the prints because accuracy was thus supposedly guaranteed. Unfortunately, the few surviving Plumbeotypes are not striking and possess almost nothing of the appeal or quality of detail of daguerreotypes. Beginning in 1847 in Philadelphia, Plumbe began to expand his publications with the *National Plumbeotype Gallery,* a collection of portraits from

daguerreotypes made in his various galleries around the country. The project was a further effort to capitalize on popular interest in pictures of personages whose character implied the character of the nation written large.

Despite the magnitude of his empire building in the daguerreotype business, Plumbe was still obsessed with the thought of a transcontinental railroad. Because he divided his attention, he faltered in his business management. Unscrupulous men in some of his far-flung galleries began to take advantage of him so badly that he suffered financial collapse in 1847, and all his branch galleries were sold for debt. After a period of years in California during the gold rush, Plumbe returned to Iowa, where he cut his throat. Even the end of Plumbe's story is indicative of his time, when a man could take a completely new process, develop it into a towering business enterprise, and complete the cycle to total ruin within seven years. Many of his studios were bought by his agents and became notable in their own right. Men such as the Shew brothers and Gabriel Harrison began their careers with Plumbe, and for over a decade galleries found it worthwhile to indicate that they had been "formerly Plumbe's."

In the early 1840s Plumbe was not the only daguerreotypist in Washington, D.C. Edward Anthony, whose daguerreotypes aided in the conclusion of the Webster-Ashburton Treaty on the Northeast Boundary, established a gallery in partnership with J. M. Edwards shortly after his return from the Maine survey. Robert Taft summarizes the activities of the firm, which began in 1843:

> They secured daguerreotypes of all the members of Congress, doubtless by offering them free daguerreotypes for themselves. As a number were made at each sitting, their profit must have come from the sale of the additional daguerreotypes secured.

> Business affairs at the nation's capital were then conducted in a free and easy manner, for Thomas H. Benton, the chairman of the Senate committee on military affairs, offered Anthony and his partner the use of the committee room for the practice of their profession. . . . Edwards and Anthony were doing a very good business, and they succeeded in recording on the silver plate all the notables of Washington. The likenesses which they secured here formed a National Daguerrean [Miniature] Gallery, which was for many years on exhibition in New York City.[25]

John Quincy Adams, who more than once sat as a subject for this firm, noted in his diary on April 12, 1844 that

> At the request of J. M. Edwards and Anthony, I sat also in their rooms while they took three larger daguerreotype likenesses of me than those they had taken before. While I was there, President Tyler and his son John came in; but I did not notice them.[26]

One of the pictures of Adams was included in Anthony's National Daguerreotype Miniature Gallery, the major exhibition of the faces of the nation's great at the time. The collection passed through various hands for some years, occasionally being added to —particularly by the brothers Langenheim of Philadelphia—until it burned down on

February 7, 1852. Samuel Dwight Humphrey editorialized on the great loss its destruction meant to the nation in terms of historical symbols:

> This was not alone an individual loss, but the whole community had here an irreparable interest—an interest that can never again be satisfied. There is not such another collection of the likenesses of our old Statesmen and distinguished individuals; and numbers of the subjects have long since departed from this world leaving no duplicate Daguerreotypes of themselves . . . the greatest endeavors were made to obtain likenesses of the most distinguished citizens of America. We give one, as a single instance, of the exertions made by the enterprising proprietors to gather in this collection the great men of the world.—Mr. Anthony went from this city to the residence of *Gen. Andrew Jackson,* for the purpose of securing a likeness of the old hero before his death. Thus we see no expense of time or money was spared to accomplish the grand object.[27]

The degree of exertion the Anthony firm put forth implies a sense of commitment about making a pictorial monument of the nation's leading men, but it also reflects the degree of public interest which must have attached to the project to make it commercially feasible. Such a commitment seems relevant to the scope of other large projects of the time such as Jones's *Pantoscope,* Insley's project on the American cities, and Barnum's Gallery of American Female Beauty—all trying to define and summarize what was worthwhile and distinctive in terms of national characteristics.

One picture alone survived the burning of the National Daguerreotype Miniature Gallery—a portrait of John Quincy Adams. Humphrey noted its discovery, "as pure and unspotted" as the original subject, among the ruins of "ashes, coals, melted glass, brass, copper, and silver," commenting,

> The enthusiasm manifested on this occasion, can be better imagined than described. Should that *good* man appear in person before the living Representatives of our country, no greater surprise could be manifested than was on the finding of his perfect likeness in *these* ruins.[28]

Adams was a very popular subject with daguerreotypists, although he was usually not satisfied with the results. His diaries contain several entries referring to efforts to record his features. In August 1843, while on a speaking tour through New York state, he noted, "on my way returning to Mr. Johnson's I stopped, and four daguerreotype likenesses of my head were taken, two of them jointly with the head of Mr. Bacon—all hideous."[29] In November of the same year he was in Cincinnati, where he noted, "Before returning to the Henry House, we stopped at a daguerreotype office, where three attempts were made to take my likeness. I believe neither of them (succeeded) ."[30] Plumbe's Broadway Gallery included a portrait of Adams in 1846, and one of the more fortunate portraits of the ex-President was made about 1847 by Mathew Brady.[31] Perhaps the finest daguerreotype of all made of Adams came from the firm of Southworth and Hawes of Boston (Plate 146) , who showed him seated in his parlor with an appropriateness of setting and detail as well as an insight into the man, that has made it one of the great por-

traits in the history of the daguerreotype medium and one which holds its own with fine portraits in any medium.

Despite his dissatisfaction with his own likenesses, Adams seems to have had keen insight into the relationship of the daguerreotype process to political image making. In April 1843 a questioner asked Adams's view of the

> prospects of the approaching Presidential election. He asked my opinion of the chances, and agreed with me that the prospects were in favor of Martin Van Buren. He thought the prospects of Henry Clay irretrievably gone; as I have no doubt they are. Those of Tyler, Calhoun, Cass, are equally desperate. Buchanan is the shadow of a shade, and General Scott is a daguerreotype likeness of a candidate—all sunshine, through a camera obscura.[32]

The comment is more than a reflection of his acid view of his own likenesses, considering that Adams wrote this passage five years before Joseph G. Baldwin remarked of the same man that he did not "daguerreotype" himself on the popular heart. It is clear that Adams was keenly perceptive. He looked shrewdly into the process of political charisma and was remarkably quick in seizing new imagery of language to express himself in the matter. His application of the new word further implies the dramatic force with which the process of the daguerreotype impinged upon American consciousness in a very short time.

Like Plumbe, the Anthony firm began to publish pictures, bringing out one of the first important large engravings produced by reliance on daguerreotypes for accuracy. In 1846 the firm issued "Clay's Farewell to the Senate," a mezzotint containing ninety-six portraits, presumably all from daguerreotypes produced by the firm. Beaumont Newhall notes that an engraving of Daniel Webster was issued from a daguerreotype by John Adams Whipple which proved to be so popular that it was recopied as a daguerreotype in its own turn.[33]

Less known but equally serious efforts to monumentalize the members of government began still earlier than either those of Plumbe or Anthony. Even the granting of a senatorial committee room to Anthony was preceded by a direct action of the Vice-President of the United States. In a letter to Senator Willie Person Mangum, chairman of the Senate Committee on Naval Affairs, dated June 17, 1841, the Philadelphia firm of Moore & Walter provides evidence of the earliest known daguerreotype activities within the U.S. Capitol:

> During the course of the last Session, we had the honor of introducing into the Capital the interesting discovery of Mr Daguerre, of Paris, for the taking of portraits by the action of light only; and the art, as we employ it, has been perfected by an ingenious American citizen, Mr. Moore of Philadelphia. Through the courtesy of the then Vice president, we were accommodated first with his own apartment, and afterwards with the Committee Room on Military affairs of the Senate. We have applied for the same room, but regret to learn that we are unable to obtain it. The Committee Room adjoining it, on Naval Affairs has been point [sic] out as probably not likely to be occupied, and we venture, Sir, to apply to you for your interest and patronage.[34]

While Mangum's answer has not come to light, the request is clear evidence of the very early date at which the daguerreotype had achieved sufficient power in the mind of the public to be accorded signal privileges. The "then Vice president" would have been either Richard M. Johnson in late 1840 or, more likely, John Tyler, who acceded to the presidency in April 1841 on the death of President Harrison. Obviously the making of portrait images of the members of Congress held a novelty and appeal that related to a general drive for symbolic nationalism during the period. The new medium was also quickly recognized as having value in the symbolic process of making public political images. American politicians, by virtue of democratic election, were keenly aware of the importance of any process for developing public images—the remarks of Adams and Baldwin make this recognition as plain as does the action of the Vice-President in providing his own office for such activity. The public, in turn, wished as direct a confrontation with national figures as possible. Drawings and paintings were unreliable or flattering at best, and not every man in America could hope to travel to see the President directly. Thus, once the photographic medium appeared, it was immediately accepted as a means by which the confrontation of politician with public could become more direct.

Popular figures such as Henry Clay (Plate 147) were repeatedly daguerreotyped, and the daguerreotypes further copied by daguerreotype, electrotype duplication, engraving, and other methods including painting. Daguerreotypists took advantage of sittings granted them to make multiple exposures. Marcus Aurelius Root, the leading Philadelphia daguerreotypist, describes his making of multiple portraits of Clay:

> In 1848, an appointment being made for my taking the daguerreotype of Henry Clay, I requested the mayor of our city and the sheriff of the county, together with several other of Mr. Clay's friends, who were present, to keep the statesman in brisk conversation till I was ready to expose the plates to the image; as I wished to catch the intellectual, lively look natural to him under such conditions. . . . And in twenty seconds three good portraits were taken at once; the plates were removed from the instruments and four fresh ones got ready. In a few seconds more, Mr. Clay the while conversing pleasantly with his friends, all else was prepared, and then his likeness again was daguerreotyped by four cameras at once; all representing him, as we *then* saw him. . . . Thus seven portraits were taken in but thirteen minutes,—with such success, too, that Mr. Clay remarked, after inspecting them:—
>
> "Mr. Root, I consider these as decidedly the best and most satisfactory likenesses that I have ever had taken, and I have had many."[35]

The portrait of Clay here reproduced was probably made at this session. While it was only recently discovered and is not known to have been published before, it fits perfectly Root's description of good portrait composition and lighting, and is similar enough in general ways to others known previously to suggest its being one of several made at once. When we view it with the eye of history, it is the kind of image that could

have served as an ideal for a type of American statesman of that period, yet it has a sense of immediate life and personal force that could have given a contemporary viewer a sense of direct confrontation. An opportunity to inspect a portrait such as this or to own one and live with it on the wall could give a citizen a sense of insight into a man who symbolized certain public characteristics of the nation in a way that could not be approached even by a transitory meeting with the real man.

The nearest similar impact would perhaps be the reappraisal of image making forced on both public and politicians by the introduction of television into political conventions in the twentieth century. With the development of the daguerreotype, the public felt a new depth of insight had opened, which permitted a greater, more direct response to the political man. It is not without significance that so astute a politician as Abraham Lincoln may have sensed this. According to a probably apocryphal story told by Mathew Brady many years later, Brady was presented to Lincoln at his inaugural ball in 1860 as if the two had never met. Lincoln was reputed to have remarked, "Mr. Brady and the Cooper Institute made me President."[36] Historically, such a remark would be perceptive since Brady's collodion wet-plate campaign portrait was circulated throughout America after the Cooper Union speech. It did much to create an image of Lincoln suggesting forthright strength and compassion equal to the challenge of a rapidly fractionating country. In order for a photograph to have so great an effect, however, the public needed to have been prepared to respond to such a photograph. In a manner of speaking, Lincoln's remark or Brady's—whichever it really was—reflected the fact that two decades of acquaintance with daguerreotypes had accustomed the American public to photographs as accurate and immediate experiences. The people also had developed a sense of national character through the agency of the daguerreotype. In these ways the medium helped them intuitively to prepare for the nationalistic demands brought about by the Civil War. The medium helped the American nation face challenge because its pictures had helped produce a symbolic certainty of what the American nation was. In Brady's portrait of Lincoln part of the American national character seemed clearly enough indicated to encourage the election of Lincoln.

Looking back on his own part in this national development, Mathew Brady indicated how deliberate was his involvement with national portraiture as a symbolic index of the United States:

> From the first I regarded myself as under obligation to my country to preserve the faces of its historic men and mothers. Better for me, perhaps, if I had left out the ornamental and been an ideal craftsman [so as to be even more sure of the truth]![37]

Brady voiced directly a belief that his portraits of great men were symbolic. An interviewer asked him if all men were to him as pictures, and he replied, "Pictures because events."[38]

Brady set about producing a summary of the great persons of America so comprehensive that Robert Taft has accorded him "rank equal to the greatest historian of the American scene."[39] Despite the fact that Brady's two New York galleries and one in

Washington precluded his personally making all the major portraits associated with his name, and despite the fact that his eyesight was failing so badly by 1851 that he could not personally use the camera, his was the defining response and the guiding principle in the collection of a vast archive of American portraiture before the Civil War. His eagerness to define and summarize the nation in the faces of its great personages was exploited by his contemporaries. Hardly a major American biography between 1850 and 1870 fails to include at least one engraving with a cut line indicating its origin in a daguerreotype by Brady. A more explicit statement of the significance of Brady's symbolic efforts occurs in an 1871 Report of the House of Representatives Joint Committee on the Library of Congress, urging purchase of Brady's collection for the nation:

> His collection presents, in the highest perfection to which the photographic art has attained, an historical gallery in which the most illustrious men in our history are embraced, and is therefore a property unique in its character and interest, and of a value not to be estimated solely by a pecuniary standard. It is, as it were, a Photographic Pantheon, in which the votive genius of American art has perpetuated, with the unerring fidelity with which the lens of the camera does its inimitable work, not only the likeness of form and feature, but the very expression, of those in whose achievements in all walks of life the American heart takes pride, and whose memory we endeavor to glorify by whatever means it is in our power to exert.[40]

A "Photographic Pantheon" implies a basic need of the nation for visible heroes. Gabriel Harrison, speaking as an artist, gave voice to the same need in allegorical terms. In his fanciful essay on the artist's encounter with the goddess Helia, the goddess leads him to a romantically described pantheon of somewhat the sort the congressional report probably envisioned:

> The form of the place is now amphi-theatrical, walled in with clouds of purple and gold. Here and there can be seen, rolling up in volumes, dense silvered smoke from goblets of incense, exhaled by burning diamonds, and on either side, are numerous figures in various forms, both young and old, with costumes ancient and modern, and in positions, none are alike, but all their faces beaming with intelligence. They seemed healthy in flesh and blood, but motionless, and looked like things living in death.
> "This place," said good Helia, "is POSTERITY."
> "There are none here," said she, "that you have seen in life, but many you may recognize by having seen their pictures."[41]

In this elaborate setting Helia points out such leading Americans as Franklin, Washington, Allston, and Poe in the company of the immortals of the world such as Plato, Goethe, Voltaire, and Shakespeare. Her remark about one's recognizing these symbolic figures from their pictures seems particularly telling in our consideration because of the image-making implications of the living detail of daguerreotypes. Harrison sounds the romantic note of nationalism by pleading with the goddess to

> here let me rest, and do homage at the shrine of my country's glory, for my soul hath its content so absolute, that if it were now to die, it were now to be most happy.[42]

Despite the exaggerated tone of the author's words, the feeling of apotheosis of one's patriotic impulses in the presence of men symbolizing national values is obvious. The same sense was explicitly related to the process of the daguerreotype and to Brady's Broadway Gallery by one Caleb Lyon after a visit there in December 1850:

> Soul-lit shadows now around me;
> They who armies nobly led;
> They who make a nation's glory
> While they're living—when they're dead,
> Land-marks for our country's future,
> Have their genius left behind;
> Victors from the field of battle;
> Victors from the field of mind. . . .
>
> From the hills and from the valleys,
> They are gathered far and near,—
> From the Rio Grande's waters,
> To Aroostook's mountain drear,—
> From the rough Atlantic's billows,
> To the calm Pacific's tide,
> Soldier, statesman, poet, painter,
> Priest and Rabbi, side by side.
>
> Like a spirit land of shadows
> They in silence on me gaze,
> And I feel my heart is beating
> With the pulse of other days;
> And I ask what great magician
> Conjured forms like these afar?
> Echo answers, 'tis the sunshine,
> By its alchymist Daguerre—[43]

Such an effusion makes clear that visitors to Brady's "Photographic Pantheon" were impressed with the nationalism of the pictures and responded to them as an effort to reflect the character of the nation. This particular reaction by Caleb Lyon connects the great men of the time with the natural features of the American landscape under the all-revealing light of heaven from which only truth of experience can be expected. The result is felt to be sublime. In the light of the statements of both Lyon and Harrison, it appears that the language of the House Committee Report on Brady's collection was not excessive in summarizing the feelings of national significance attaching to the pictures:

> in the possession of our Government this Collection of Historical Portraits would become a monument to the inventive genius of our own country, through which photography has

reached its present degree of perfection. As a memorial of the illustrious dead, whose names are connected with the great events of American history, there can be no more worthy act performed by the Congress of the United States than to secure for it a fixed place . . . in an accessible and suitable form for general inspection and study—an historical album both of the living and of the dead—would be a constant source of national gratification, and its locality the very shrine of patriotism. "A portrait," according to an eminent authority, "is superior in real instruction to half a dozen written biographies;" nor can we doubt that the purchase by the Government of this Collection, and its exhibition in the Library, will fail to exert the most salutary influence, kindling the patriotism as well as the artistic taste of the people. Through its means the country will become possessed of a rare collection of the portraits of her most distinguished sons.[44]

Brady sought to expand the public impact of his pictures in 1850 by publishing a *Gallery of Illustrious Americans,* an elaborate folio book of lithographic copies of daguerreotypes of twelve of the leading men of the time, including Henry Clay, Daniel Webster, John C. Calhoun, William H. Prescott, John James Audubon, Winfield Scott, Millard Fillmore, William Ellery Channing, Zachary Taylor, and John C. Fremont. The book was expensively produced, the stones costing $100 apiece, but it did not sell well enough at thirty dollars a copy to continue with the projected second volume.

Brady also claimed issue of

the first sheet of photographic engravings of a President and his Cabinet, namely Gen. Taylor in 1849. I sent this to old James Gordon Bennett and he said: "Why, man, do Washington and his Cabinet look like that?" Alas! They were dead before my time.[45] [Plate 148.]

In Bennett's remark, facetious as it is, and Brady's regret at being too late, we can feel the immense symbolic significance of the first President which permeated the time so thoroughly that any public evocation of him was received with emotion. A case in point occurs in the suggested program designed by a flamboyant impresario for the Philadelphia farewell of the European pianist Henri Herz. Tabbed a "political concert" by the manager, who wished maximum public feeling to be stirred up from nationalistic symbolism, the program was to include a "CONSTITUTION CONCERTO," a "GRAND TRIUMPHAL MARCH dedicated to Young America and arranged for forty pianists," and "THE CAPITOL, a chorus of apotheosis to the spirits of the presidents of the United States," very much in the vein of Harrison's emotional desire to honor America's great spirits. A high point on the program was to be

HOMAGE TO WASHINGTON, cantata in eight parts, with solos and choruses, performed by five orchestras and eighteen hundred singers. NOTE. The bust of the father of his country will be crowned at the last chords of the cantata.[46]

An allegorical tableau by Gabriel Harrison (Plate 149) reflects the involvement of the daguerreotypist with this same emotionalism surrounding the image of Washington. We have already noted a similar daguerreotype by Southworth and Hawes (Plate 16)

as typical of specifically arranged "adorations" of the father of the country. During this period Hawes also lavished all his technical skill on minutely exact daguerreotype copies of the Athenaeum portrait of Washington by Gilbert Stuart.

It is to Southworth (Plate 150) and Hawes (Plate 151) that we must look for the finest portraits of Americans, great and small, made during this period. By assessing their conception of portraiture as art, we can recognize Southworth and Hawes as preeminent in the history of American photography. Perhaps more than any others active in the daguerreotype period, these men combined the new sensibilities of the photographer with the high ideals of serious artists throughout history. It is to these men, therefore, that we must turn to begin the final aspect of our consideration of the daguerreotypist, namely that of sensitive artist and mentor in response to his time.

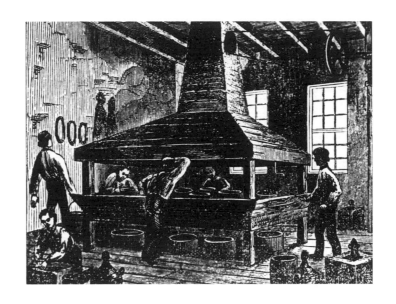

Chapter 7

THE ARTIST AND
THE MENTOR

PEAKING to the National Photographic Association of the United States at Cleveland in the spring of 1870, Albert Southworth estimated the presence of five thousand photographic artists who were directly engaged in photographic picture making and portraiture throughout the country. He declared that

Upon these devolve the responsibility of the design, and character, and finish of the picture. Mechanical manipulations, not more difficult of acquirement than in many other arts, attend upon this, and must be at the time performed by the artist photographer. For his apparatus and materials he is dependent upon those who have by life-long efforts, with genius, ability, and zeal, perfected themselves in the science of optics and chemistry. . . . Such must be placed high in the order of mental culture and knowledge. In certain specialties they are accounted geniuses of distinguished merits, and the enlightened world accords to them deserved and lasting honor. So does it to any who worthily search for and discover the truths of science, for science is truth.[1]

Having thus defined the foundation of photography in the technological area of life and admitted the need for scientifically accurate fact in making pictures, Southworth went on to set up a high standard for the photographer as an artist:

> But the artist, even in photography, must go beyond discovery and the knowledge of facts; he must create and invent truths and produce new developments of facts. I would have him an artist in the highest and truest sense applicable to the production of views or pictures of any and every kind, or to statues and forms in nature, universally.[2]

Southworth opted for having the photographer rely on nature as basic to all art, but we have already noted that close attachment of the artist to nature was a solid part of nineteenth-century American thought. To this attachment he wished the photographer committed so thoroughly that his artistic responses become automatic and reach for the insight beyond nature:

> I would have him able to wield at pleasure the power of drawing nature in all her forms, as represented to vision, with lights and shadows, and colors and forms, in all of nature's changes. I would have him as familiar as with his alphabet of letters. He should not only be familiar with nature and her philosophy, but he should be informed as to the principles which govern or influence human actions, and the causes which affect and mark human character. History and poetry should be to him mere *pastime;* observation of nature, cause and effect, should be his employment.[3]

"Observation of nature, cause and effect" appears before us as a new form of the same request for direct experience of nature that we have seen pressed by Thoreau, Emerson, and Edward Weston in various perceptional ways. Thoreau put essentially the same idea in almost the same language, similarly placing indirect experience, such as that of history, in secondary importance:

> No method or discipline can supersede the necessity of being forever on the alert. What is a course of history, or philosophy, or poetry, no matter how well selected, or the best society, or the most admirable routine of life, compared with the discipline of looking always at what is to be seen?[4]

Southworth's desire to have the photographer so familiar with nature as to respond directly reaches a common ground with Emerson's wish to perceive nature so completely as to pass beyond its surface to insight and total unity of understanding:

> Standing on the bare ground—my head bathed by the blithe air and uplifted into infinite space—all mean egotism vanishes. I become a transparent eyeball; I am nothing; I see all; the currents of the Universal Being circulate through me; I am part or parcel of God.[5]

Southworth turned specific attention to the practice of photographic portraiture, in part explaining the approach which led him and Hawes—the firm never used any other cameramen—to their magnificent results:

> that which is necessary and requisite to fit one for the disposition of light and shade, the arrangement of the sitter, and accessories for the design and composition of the picture,

is of a far higher order in the scale of qualifications, demands more observation and comprehensive knowledge, a greater acquaintance with mind in its connection with matter, a more ready and inventive genius, and greater capacity for concentrated thought and effort with prompt accompaniment in action.[6]

This concept of intensive knowledge and concentration constantly ready to produce "prompt accompaniment in action" is almost as basic a description of the process of making a significant photograph as the modern photographer Cartier-Bresson's phrase, "the decisive moment." Southworth stressed this decisiveness as the key to effective portraiture:

> What is to be done is obliged to be done quickly. The whole character of the sitter is to be read at first sight; the whole likeness, as it shall appear when finished, is to be seen at first, in each and all its details, and in their unity and combinations.[7]

In 1930, Edward Weston described his method of photographing with reference to "the finished print pre-visualized complete in every detail of texture, movement, proportion, *before exposure*. . . ."[8] Reference to Weston is made not so much to show similarity of working methods among photographers, regardless of the era in which they worked, as it is to underline that there is a *directness* of working method and perception which demarcates photography from other artistic media. It is necessary to recognize the operation of this defining attribute in the making of all significant photographs in order to clarify the artistic function of the daguerreotype.

Considering the pictures of Southworth and Hawes in terms of their application of the three elements mentioned by Southworth—"disposition of light and shade, the arrangement of the sitter, and accessories for the design and composition of the picture"—we can discern, at least in part, some of the sources of the effectiveness of their work. With each sitter the two men varied their approach to the final image in all three of these particulars, suiting each to the moment as their judgment responded to the immediate presence of the sitter. In daguerreotyping two young women of differing demeanor, for example, Southworth and Hawes varied the lighting and the emphasis on light and dark in the picture. One is treated as a light-shot bust in a light field, emphasizing the dark mass of her hair (Plate 152). The other is seen as mysteriously emerging from darkness in a vague glow, dark-haired and dressed in black which emphasizes her white blouse and the surface of her cheek (Plate 153). Light and dark composition might be emphasized by placing light accents on particular features of a given sitter, such as the dominating white hair of an old man otherwise thrown into general shadow (Plate 154). In some cases light and dark composition becomes almost totally abstract in presenting the image of a sitter, as in the massive arrangement of white counterbalancing dark shapes in a portrait of a lady in a lace cap (Plate 155).

The arrangement of sitters varied along with the application of lighting. Some are treated in a head-on fashion that produces maximum confrontation with a strong personality (Plate 156), while others are given a theatrical style (Plate 157) or made an

exercise in tableau (Plate 158). A child might be treated with a sweetly direct informality which yet reveals the solemnity of a pensive mood (Plate 159).

In knowing when and how to use props or artifacts, Southworth and Hawes were inspired. Their varying treatments of two small children attest their powers in this area. Small children are among the hardest portrait subjects in photography, not only because they are uncooperative, but because they have only indefinitely formed personalities. Yet by forcing a formalized pose upon one child (Plate 160) in a setting of adult-sized furniture, the daguerreotypists created a portrait notable for capturing the tremulous forlornness of a little child in an alien adult world. A vaguely delineated potted plant in the unfocused background appears as the perfect index of the uncertain emotional state of the child. In another instance a little girl in white is placed in a spot of sunlight on the floor of a darkened room (Plate 161), where she becomes a dazzling little object echoed in mood by diffused light patterns behind her on the wall.

Southworth and Hawes carried their unique sensitivity for photographic composition over into their work with leading personages. The conjunction of strong personalities with their ability to grasp significant images has produced a body of likenesses fit to stand among the great portraits of history in any medium. When Massachusetts Chief Justice Lemuel Shaw arrived for a sitting, he came slightly early and stood quietly waiting at the top of the stairs in a patch of broken sunlight. Seizing on the intensification of his craggy features and the wrinkles in his coat, they took him on the spot (Plate 162) and produced a study which has never been matched for strength and directness of insight.

When the painter William Willard brought the aging Daniel Webster to Southworth and Hawes for a daguerreotype from which to paint a portrait, he little suspected that the daguerreotype would so far exceed the character of his painting that it would come to be recognized as one of the great portraits of the world (Plate 163), while his own painting would soon fall into deserved obscurity.

Rarely have the differences in the character of two women been more searchingly revealed by posture and artifact than in the portraits of Lola Montez with a cigarette (Plate 164) and Harriet Beecher Stowe with a sensitive plant (Plate 165). It is rare for portraiture to be genuinely inspired in any medium or in any period, but in the presence of many of the works of Southworth and Hawes, we can readily accept Southworth's own dictum that

> The artist is conscious of something besides the mere physical, in every object in nature. He feels its expression, he sympathizes with its character, he is impressed with its language; his heart, mind, and soul are stirred in its contemplation. It is the life, the feeling, the mind, the soul of the subject itself.[9]

Joining in the activity of summarizing national character in the faces of national men, Southworth and Hawes did a great deal with their powerful images, though they seem not to have been so publicly explicit as Brady or Anthony about trying to make exhibitions of the great. They did provide the public with pictures of current celebrities,

particularly after their Grand Parlor Stereoscope became a popular attraction, and numbers of pictures were presented in this form of noted persons such as Lajos Kossuth. They also followed the practice of keeping a file of extra plates of any sitter they took. Their collection, carefully shepherded for fifty years by Hawes, and then by the Hawes family, is the only comprehensive body of work from the hands of known daguerreotypists to survive relatively intact. Their collection of celebrity portraits has been divided between the Metropolitan Museum of Art in New York and the Boston Museum of Fine Arts. The remaining plates, largely unidentified, are mostly in the George Eastman House, Rochester, New York. This last collection, owing to its unidentified nature, offers considerable opportunity for research. As an example of what may be found, it was the good fortune of this writer to discover a previously unknown profile portrait of President Franklin Pierce (Plate 166) among these plates which appears to have been the source for a painting of Pierce owned by the New Hampshire Historical Society.

While few daguerreotypists were as effective artists as Southworth and Hawes, many considerd the medium as one suited to the production of works of art. Even operators who entered the field purely for commercial reasons felt vestiges of aesthetic impulse and realized that to take on themselves the character of "artist" added value to their work beyond public acceptance. Many recognized, however, that merely assuming the title of artist did not guarantee their work insight or power. Still others saw that true art was a demanding ideal seldom realized and still more seldom appreciated by the public.

In a letter to Samuel Morse, Mathew Brady expressed feelings of concern that the daguerreotypist was inadequately appreciated in his time as an artist:

> Permit me to request your opinion in reference to the aid which the progress of Daguerreotyping has afforded the kindred arts of painting drawing & engraving. As the first successful introducer of this rare art in America, the first President of the National Academy of Design, and in virtue of your long & distinguished artistic experience your views upon this topic will be received by the public & the world of art with high consideration.[10]

Having sounded this plaintive note, Brady went on to explain his own conception of the role of the photographic artist:

> The influence which Daguerreotyping has exercised upon the social amenities, universalizing as it has the rarest & most subtle of artistic effect, placing within general reach the results which before its introduction were laboriously & slowly wrought with the pencil, is understood and appreciated. The fact that it has found its way where other phases of artistic beauty would have been disregarded is recognized. During my experience, however, I have endeavored to render it as far as possible an auxiliary to the artist. While the other features of its development have not been disregarded I have esteemed this of paramount importance. How far I have succeeded & whether the recognition of the effort among the Artists has been commensurate with the aid they have derived from it I know of none so eminently qualified to judge as yourself.[11]

A limited conception of the role of the daguerreotypist as artist emerges from Brady's statement. Initially, it is obvious that Brady's remarks betray a slighter grasp of the artistic nature of the medium than was achieved by Southworth and Hawes. Even as reputed leader in the practice of American portraiture, Brady felt that photography was most significant as an aid to other kinds of artists. He was aware that painters and engravers owed major benefits to the photographer—who provided accurately detailed subjects for study, who solved compositional problems of rendering three dimensions into two on a flat surface, and who provided a strength of direct perception that tempted many painters to imitate so closely that their pictures often became little more than tinted photographs. Brady's is a weak and hesitant statement compared with Southworth's commitment of the photographer to the same high standards that prevail throughout the serious arts.

Brady's statement does acknowledge the "universalizing" effect of daguerreotypy for making the "rarest & most subtle" artistic effects available to the public as never before. In this comment he verifies the affective nature of photographic art and adds emphasis to the thought by pointing out that "it has found its way where other phases of artistic beauty would have been disregarded." Since we have previously seen Brady wishing to be an "ideal craftsman," concerned first with accuracy of recording, we can recognize that his view emphasizes how exceptional was the artistic position of Southworth and Hawes within the contemporary scene. And, in fact, although Southworth and Hawes were widely regarded as leading operators and were highly respected by other daguerreotypists, they were never household names as were Brady and Plumbe.

Brady's view of daguerreotypy as a universally affective agent and as an auxiliary to other art media implies a conception of art that derived from the medium's accuracy and its effectiveness for communicating information. Brady thus appears to relate the daguerreotypist as artist almost completely to the general thought of his time about art. His view of the affective scope of daguerreotypes also suggests a vaguely didactic conception of art which is emphasized by his great reliance on accurate rendering of factual information. This educative function of photography comes about partly because the mechanical nature of the medium makes artistic effects more directly available than would the traditional tools of other artists. Summing up the implications of Brady's various statements, together with his practice and his position in the American scene, we can define four essentials of his thinking about the medium that seem in harmony with prevailing national attitudes.

His primary conception of the daguerreotype as an artistic medium seems to have been practical or utilitarian, rather than holding it as art valuable purely for itself. We have seen Brady's commitment to preserving the faces of the nation's great men as symbols of historic events. We have also seen him employing direct photographic vision to give his symbolic portraits the greatest communicative strength. His letter to Morse indicates his sense that the greatest use for photographs is as a source of information for artists—he conceives of the photographic medium as a tool.

As a basically informational and symbolic tool, daguerreotypy becomes, second, a didactic medium. If the facts in a portrait are clear enough and complete enough, a viewer learns something of the personality of the sitter. If the sitter is a nationally symbolic figure, the viewer can learn something about the character of the nation. Recognition of this attitude was thoroughly expressed in the 1871 House Report on Brady's "Photographic Pantheon."

What made the medium still more valuable in terms of American ideas of the nineteenth century than either its utility or its didactic qualities was its universal application and impact. Photographs were conceived of as being scientifically accurate, and science was viewed as truth, even by Southworth. Thus, if photographs were truthful, presumably they would not be subject to variation of effect from one viewer to another so that all the lessons learned would be the same. Patriotic inspiration aroused by seeing the nation's celebrities would, ideally, be the same for everyone, with the result that the nation would be more unified in its self identification, as was suggested in Caleb Lyons's poem on Brady's gallery and in the House Report.

Finally, it was conceived that the utility, the didactic nature, and the universal effect of daguerreotypes as artistic items stemmed from new technical skills. Mechanical perfection in daguerreotype reporting was Brady's wish in his interview of 1891 when he regretted that he had not been a more nearly ideal craftsman. Recognition of the technological nature of the photographic process, only a necessary starting point for Southworth, was the essence of the process for Brady and most other daguerreotypists. For Brady the daguerreotypist was a technological man—oriented to the machine as were few artists in history. He felt that the potential of his medium, including its symbolic and didactic effects, could be realized if only he were a sufficient technical master.

Gabriel Harrison shared Brady's concern for having daguerreotypy gain respect and recognition as a serious form of art. In a letter to Henry Hunt Snelling for the first issue of *The Photographic Art-Journal,* Harrison expressed irritation at the man who became a daguerreotypist without taste or artistic sense:

> no longer will the Daguerrian be classed among fish-mongers, from the fact that one or more from the piscatory regions have laid by their nets and endeavored to robe themselves in the sunbeams of our divine art; and (Heaven save us) have been particularly successful on one or two occasions, and, by dint of hard labor, have produced on a plate the image of the tip end of some individual's nose, pronounced it a magnificent production of the art, and obtained as the reward of their *immense skill,* the approbation of the most critical *parvenus* of oysterdom.[12]

Harrison further showed concern for approval of the daguerreotype medium by established artists:

> Most happily, however, the artists, (I mean those who work with the brush,) begin to think and speak of our art as it deserves, acknowledging that it does require some merit, taste, and a little genius to produce a Daguerreotype, fine in tone, position, and expres-

sion; for a Daguerreotype can possess these as well as a painting; but to obtain them the operator must possess the true refinement and discernment of the limner.[13]

He also indicated a more explicit grasp of the creative power of the photographer than did Brady in the matter of the basic elements of photographic composition—and came nearer the ideal of Southworth.

> To arrange the folds of the drapery gracefully and boldly, so that the lights and shadows may coincide with the character of the *face,* and make it appear to the best advantage, is not the work of mere mechanical skill or accident. A harsh, a mellow, or a cold tone picture may be produced according to the taste and skill of the operator, as well as a graceful line drawn by the *hand of the painter.*[14]

Despite his ability to recognize, as did Southworth, the basic characteristics which defined the photographic medium, Harrison, like Brady, seemed uncertain about the artistic role to be played by the daguerreotypist:

> I would not be understood as placing the Daguerrian on a par with the painter or sculptor, but most *emphatically* I will say, that our art is the hand-maid to those higher branches of the fine arts, and who will dare to say, we cannot compose and put poetry in our types as well as the painter in his sketch book. . . .[15]

Harrison's conception of the function of the daguerreotype in the fine arts led him to making allegories, such as we have already examined:

> [who will dare to say] that we cannot have our representatives of Faith, Hope, and Charity, as well as *Sir J. Reynolds;* a *Holy Family* as well as Murillo; or the Infant Saviour, with cross and lamb, as well as Raphael.[16]

Harrison made the basic assumption common to many artists of the period, that subject matter defined art. In the case of photography, this belief is relevant as showing appreciation of the great detail and accuracy of the medium, but with respect to the creative artist in general, it reiterates the degree to which accuracy of representation was regarded as the basis of art. Scientific accuracy, seen as truth, provided a daguerreotypist with directness of experience. It also made his medium essentially fact-oriented and symbolic, even for a committed artist like Harrison. In many ways Harrison probably comes nearer to summarizing the feelings of serious daguerreotypists of the period than either Southworth or Brady. He had a romantic vision of his medium and a considerable insight into its nature which allowed him to produce significant pictures. At the same time, however, he also had cultural limitations on his ability to conceive of the medium apart from practical application and symbolic function.

Marcus Aurelius Root expressed his philosophy as a noted professional daguerreotypist in his book *The Camera and the Pencil.* He struck out repeatedly for his belief that photography was fit to rank with any other art, but he, too, regarded as its basis of artistic merit the fact that it was factual and symbolic in its effect on the viewer. On taking up the medium initially he

was mortified to find [that it] was considered a merely mechanical process, which might be learned in a few weeks, by a person of the most ordinary capacity and attainment.

. . . my ambition forbade my *patiently* being ranked among *recognized* imbeciles and incapables. Why (I queried with myself) should not Heliography be placed beside Painting and Sculpture, and the Camera be held in honor with the Pencil and the Chisel?[17]

His view of how "Heliography," as he called it, was to be regarded as art is especially enlightening in terms of both the practical function of the process as a precise recording medium and as a set of cultural concerns and longings that were closely attuned to the spirit of the time in America:

Is that . . . a low and vulgar art, which can bid defiance to time and space, and triumphantly look into the eye of the so-named "King of Terrors [that is death];" which grants me, at my own fire-side, to behold the rocky heights once trodden by prophets and apostles, and, more inspiring still, by Him who was the "brightness of the Father's glory," "the chiefest among ten thousand and altogether lovely;" to gaze on the immemorial pyramids and catacombs of Egypt . . . which, in a word, enables me, without crossing my threshold, to view the multitudinous populations of the total globe, past and present, with the monuments of beauty and grandeur, that immortalized their earth-existence? Finally, should that art be contemned, which is helping to train society, from its topmost to its nethermost stratum, to an appreciation of the beautiful? For, be it noted, the specimens, inferior as so many of them are, exhibited at the doors of the Heliographic Galleries, in numbers of our city streets, constitute a sort of artistic school for the developing of idealistic capabilities of the masses that daily traverse those streets.[18]

For Root, facts, information, didactic experience, and enlightenment all go to increase the insight and the sensitivity of the public. Symbols of the past or the faraway and tokens of present feelings conjoin for Root as did facts and emotive images for John Adams Whipple working to daguerreotype the Moon or for Solomon Carvalho approaching God at the crest of the Rockies.

Root spells out his concern with the didactic aspects of "Heliography," noting what "this art is doing, and is still more largely to do hereafter for increasing the knowledge and happiness of the masses."[19] He cites in particular his view that the world at large becomes an endless source of information in the presence of photography and his view that the public will be increased in taste and artistic judgment. Like Brady and Anthony, Root posits a nationalistic benefit to be derived from public pictures of leading men. Stressing the directness of experience of photographs, he notes that

not alone our near and dear are thus kept with us; the great and the good, the heroes, saints, and sages of all lands and all eras are, by these life-like "presentments," brought within the constant purview of the young, the middle-aged, and the old. The pure, the high, the noble traits beaming from these faces and forms,—who shall measure the greatness of their effect on the impressionable minds of those who catch sight of them at every turn?[20]

Root here touches a basic essential for the didactic function of photographs—he saw that daguerreotypes and other photographs were becoming so obviously an element in the daily life of each individual that they provided an affective climate to which the individual responded:

> our education is accomplished far more by the circumstances amid which we live, than by all the direct technical instruction we receive; and from infancy to old age we are continually acted upon for good and for evil by the sights and sounds with which we are familiar. And he who beholding, on every side within his dwelling, spectacles of the class above named, derives from them no elevating moral influences, must be made of almost hopelessly impenetrable stuff.[21]

To Root the educational effectiveness of photographs derives not so much from their accuracy and comprehensive detail as from their effect on the feelings of the average person. Once the symbolic images of photography are taken into one's everyday life, their affective force comes into play and is consciously or subconsciously influential. Through such means, the conscious artist following nationalistic impulses or other didactic motivations can affect the public deeply. We have seen implications of such a function for the daguerreotypist in the writings of Brady and Harrison, in the House Report on Brady's photographs, and in the artistic practices of Southworth and Hawes. We have likewise seen the function operative in the practice of creating national pantheons of celebrities such as Anthony's National Daguerreotype Miniature Gallery.

Root held a view of national art in America similar to that we saw earlier in Horatio Greenough, feeling that once we had solved our utilitarian and practical problems of living, we should blossom in the arts. Root expressed the thought in similarly pragmatic terms:

> That in material prosperity and mechanical utilities our country stands high, very high, in the scale of nations, there can be no doubt whatever. As little doubt can there be that in artistic culture many a contemporary people are our superiors.

> This, however, may be admitted without humiliation. Pioneers and tamers of a primitive world, as we have been hitherto, we have had neither leisure nor means for largely cultivating the mere embellishments of life. But with our present material attainments, it is quite time that the energy and inventive ability, which have accomplished so much here, should be turned towards the fine arts.[22]

In light of these sentiments it is significant for our purposes to note that this observation follows a general dictum that "Heliography is entitled to rank with the so-named Fine Arts."[23] Root's view is that not only is America ready to commence her artistic development, but she is most appropriately to do so with photography as a basic tool ideally suited by its factual, symbolic, and didactically practical nature. While he does not explicitly state that photography is *the* American art form, he does certainly imply such a belief. The entire content of his book is predicated on his recognition of the values of the medium within its time and place in American life. He goes so far as to assert that

In the variety and extent of its *possible* applications, both useful and ornamental, Heliography promises to go even beyond its sister arts. From the extreme celerity with which these pictures may be taken, their numbers can be indefinitely multiplied; while their cheapness brings them within reach of all classes save absolute paupers. By consequence, in the humblest of cabins, not less than in the most sumptuous of palaces, they will be in the future among the most frequent spectacles.[24]

Root's vision of America implies creation of a new aesthetic based on accessibility and commonality of the sort of direct, accurate images of experience only photography could supply. For evidence that some of Root's expectations were coming true, as regards cheapness leading to widespread influence on public taste, we may turn to a remark by Rembrandt Peale, a distinguished painter of the period. Speaking explicitly about the effect of daguerreotypes on public response to portraiture, he observed,

Their cheapness is a general advantage, which, by degrees, will widely spread a taste for portraiture, which will ultimately profit by the innovation; for even now it has become necessary for the portrait painter to make his portraits not only *as* true, but expressly *more true* than the daguerreotypes. . . .[25]

Even for painters, the daguerreotype implied truth made inescapably available, with a resulting improvement in public discrimination about the acuteness of portraits.

Much the same thought was stated by Samuel Morse in a letter to the painter Washington Allston at the time of the introduction of the daguerreotype into America:

every one will be his own painter. One effect, I think, will undoubtedly be to banish the sketchy, slovenly daubs that pass for spirited and learned; those works which possess mere general effect without detail, because, forsooth, detail destroys general effect. Nature, in the results of Daguerre's process, has taken the pencil into her own hands, and she shows that the minutest detail disturbs not the general repose. Artists will learn how to paint, and amateurs, or rather connoisseurs, how to criticise [sic], how to look at Nature, and, therefore, how to estimate the value of true art.[26]

It becomes clear, with examination of the words of so many diverse daguerreotypists and artists, that the factual accuracy of the photographic medium was regarded by all as the basis of great new aesthetic possibilities in both the production and the appreciation of works of art in America. The daguerreotype as a symbolic and didactic source of information was presumed generally by serious daguerrean artists to hold great promise for a new form of nationally expressive art.

Aware of the informational utility of photography in much the same manner as Peale and Morse were, Root was also aware that the new arts of the nation would reach their greatest significance if they avoided imitation of other cultures—a thought parallel to Emerson's view that "imitation is suicide"[27]—and if they were direct manifestations of the spirit of the nation. He specifically predicted that American successes in the arts would outrank those of the Greeks and Romans, adding,

It will assuredly be so, if that American energy, so prolific of prodigies in the domain of utility, shall fling its total self into the culture of art. And would we rid ourselves of that servile propensity to imitation, implanted in us by our constant intercourse with old Europe, and act fully out the originality springing from our novel conditions, in this respect, as we have done in so many others, I doubt not, that a new and magnificent type of universal art would be ushered into the world. The copyist—as the American has too generally been—can never equal his model, since he works not with the freshness and surging enthusiasm of a primal impulse. To be alike true and great, American art must be America's spirit and life, with all their individualities, idealized and encircled with the magic halo of beauty![28]

The factual nature of the daguerreotype, which was basic to this optimistic view by Root, did create artistic problems for a few persons connected with the medium. There were applications in which photographic reality was too direct for complete satisfaction. Henry Hunt Snelling, always eager to flourish the banner of artistry over the advancement of daguerreotypy, professed his unhappiness, as did Harrison and Root, with

> the mere mechanics, dabsters, or whatever you are pleased to call those operators who jump from the stable, the fishmarket, the kitchen, or the poultry-yard into the operating room of the Daguerreotypist. . . .[29]

But he singled out one particular order of cameramen as being "so devoid of common honesty as to care little about the quality of the pictures they take, so long as they can pocket the dollar in the quickest possible manner." These daguerreotypers were capitalizing on the realism and the directness of camera images for the uses of pornography. With high indignation Snelling took note of such operators in an extremely rare admission that the daguerreotype medium was used for such purposes anywhere in America:

> Their rooms are frequently the resort of the low and depraved, and they delight in nothing more than desecrating the sabbath by daguerreotyping these characters in the most obscene positions. Their rooms become a by-word and a reproach, and alas! there are too many who are ever ready to attribute to all the follies and foibles of the few.[30]

For Snelling it was worse that a daguerreotypist should be concerned with nudity than for other types of artists:

> We may here be met by the question; why is a daguerreotypist more culpable in this respect than the painter, who frequently resorts to nude life models in the practice of his art? We will answer, there are two reasons: in the first place, the painter and the sculptor are, from the very nature of their art, obliged to make the anatomical proportions of the body a close study, in order to depict upon their canvas or to chisel from the stone, nature as it truly exists. Every line, every muscle, every vein, and all the most minute details in the composition of the human form are necessarily subjects of earnest scrutiny. To the Daguerreotypist this is not absolutely necessary; all he requires is a perfect knowledge of the general outline of the figure before him in order to be enabled to sit his subject in the most attractive and graceful attitude.[31]

Snelling's lumping together the life studies of the artist with the erotica of the commercial pornographer seems to be an emotional reaction to the experience of having attributed to the general trade "the follies and foibles of the few." He seems unable to grasp the possibility, implicit in Brady's desire to make daguerreotypy the handmaiden of the other arts, that the daguerreotypist could legitimately make nude studies for the painter. While he admits the need of the painter for close study of the nude figure, he does not appear ready to grant the aptness of this subject for photographic treatment under any circumstances.

Snelling's view is in contrast to the European attitude of the same time. Almost as soon as the daguerreotype process was published, professional models were employed by Paris firms such as N. P. Lerebours to sit for "academies," or nude studies for artists (Plate 167). Use of the pictures was widespread among such artists as Ingres, Courbet, Henner, and Constant.[32] Delacroix in particular made use of the photographic medium as an aid to exactness and composition. He recognized the uses of exactly that reality and directness of the medium which made Snelling uncomfortable, and he put high value on them. In 1850 he wrote that a daguerreotype

> is the mirror of the object, certain details almost always overlooked in drawing from nature take in it great characteristic importance, and thus introduce the artist to the complete knowledge of construction; light and shadows are found in their true character, that is to say with the exact degree of strength or softness, a very delicate distinction without which there is no depth of space. However it should not be lost sight of that the daguerreotype should be considered only as a translator entrusted to initiate us further into the secrets of nature. . . .[33]

Delacroix joined the French Photographic Society as a charter member and devoted many hours to posing nude models in photographers' studios to produce independent photographs as well as to direct pictures for study in painting. The Belgian painter Constant Dutillieux, a friend who often made photographs for him, has written:

> Delacroix not only admired photographs theoretically, he drew a good deal from daguerreotypes and paper prints. I own an album of models, men and women, posed by him, seized by the lens under his eyes. . . . Incredible phenomenon! Choice of type, attitude, distribution of light and shade, twist of limb, are all so personal, so requisite, that one would say of many of these prints that they were taken from the originals of the master. The artist was in a measure sovereign master of the machine and of the material. The radiance of the ideal he carried with him transformed models at three francs a session into vanquished heroes and dreamers, nervous and panting nymphs.[34]

Delacroix's attitude was, at bottom, the same as that of Southworth—the artistic ideal is superior to medium or method; the medium is selected to do a job and must be treated as its nature demands under the dictates of the character of the artist.

The intentions of the picture maker did carry some weight with Snelling, though he still seemed adamant about not yielding the daguerreotypist any ground on which to photograph the nude:

In the second place the motive of the two is widely different, the painter has a noble, glorious object in view; he aims at the elevation of his art, and the improvement of public taste; while the class of Daguerreotypists to whom we allude are actuated by the desire to pander to a vitiated and gross appetite, to accomplish which the most obscene positions are required from the degraded characters obtained for the purpose.[35]

In one sense Snelling is here activated by the same conception of photography's role in society as moved several of his contemporaries. He saw the medium as a potentially didactic one to improve "public taste" and evidently felt that any art which did this was exonerated from guilt in studying the nude, as long as it was not photography. Even with good intentions, photography was still too realistically direct to be granted all subjects.

One difficulty with Snelling's article is that we are unable to determine exactly what he meant by "obscene." His choice of words suggests pictures more extreme than mere nudes. He is never more explicit, and we have no records of what sorts of pictures were actually made. Extensive research has failed to locate for this author any American daguerreotypes of nudes or pornographic subjects at all. Even a few would be helpful to indicate the character and nature of such early pictures for comparison to Snelling's reaction. Copies of eleven daguerreotypes described as "sexual action" exist in the collections of the Kinsey Institute for Sex Research of the University of Indiana, but since these were originally derived from a major European collection, their origin in America is doubtful. If such pictures were extensively made in America, they have remained clandestine as historical artifacts. The nearest thing to an American nude study to appear thus far is Gabriel Harrison's "Infant Saviour Bearing the Cross" (Plate 43). To date, the only other picture even vaguely like a nude study is a curious portrait bust by Southworth and Hawes of a bare-chested man who looks somewhat like Thoreau (Plate 168). Allowing for possible foreign origin, we may find occasional ethnological pictures of Indians or other natives which could be regarded as nude studies (Plate 169), but with such plates we completely exhaust potential illustrations of the point of Snelling's wrath and are forced to fall back on supposing that he meant true erotica. As evidence of this possibility, *The American Journal of Photography,* October 15, 1858, speaks of the arrest and prosecution in New York of makers of indecent paper photographs, although, again, the indecent character of the pictures is left uncertain.

There is some reason, however, for supposing that Snelling did perhaps actually mean studies of the nude and that his adverse view stemmed from bad publicity for the daguerreotype trade. His third reason for opposing the making of such pictures by daguerreotypists while allowing nude studies by painters

is the fact, that the Daguerrean room is a more public place of resort, than the painter's, and every act within its walls is more publicly commented upon, and its reputation is more apt to be injured by such comments.[36]

His article also takes up "another class who in a great measure tend to depreciate the art." After the strength of his views against the daguerreotypists who made "obscene"

pictures, we might expect a particularly low order of photographer to appear, but this class is made up of men who cut their prices to attract trade. We have noted in the past, as with his biographical material on James Wattles, that Snelling is given to excessive language, which makes it reasonable to wonder if he does not exaggerate the offense he attacks. In general, it seems likely that the artistic question of the nude before the camera was seldom discussed because it was not a viable concern in America.

Before putting aside the question of the nude in American art, we should consider one other aspect of the subject as an index of the times within which the daguerrean artist worked. In an article appearing in *The Crayon* in 1859, William Page's *Venus* and Erastus Dow Palmer's sculpture *The White Captive* were both harshly attacked as specimens of a commercially oriented

> low spirit which disgraced our city with model artists and forced our municipal authorities to suppress them—it is this low spirit which has lately begun to inundate us with naked art. Paganism loved to worship the naked body—to steep the senses in luscious physical forms, to become inebriate with the tantalization of fleshly outlines and protuberances, to forget the soul in the contemplation of the body. This led to horrible degradation and vice, to the blotting out, almost, of humanity in the ascendancy of animality. . . . Are we again, after eighteen centuries of Christian effort, about to have a reproduction of pagan art?[37]

Proceeding from this statement of united enjoyment and condemnation, and turning specifically to Palmer's *The White Captive,* the critic observes,

> The man who wrote the puff of this work must have forgotten that there is a chronology and history of moral feeling in art as well as in the secular acts of men, and that to reverse the moral sequence of this chronology and history of Art is to render it ridiculous, if not worse. It is a pity that money should ever lie at the bottom of any moral or intellectual undertaking—it generally strangles or perverts it.[38]

From these outspoken remarks we can derive three basic thoughts relative to photography.

Initially, it is obvious that there were those in America to whom the nude in art was unchristian, immoral, and offensive at worst and barely tolerable at best. An 1866 drawing by Thomas Eakins in the Philadelphia Museum of Art illustrates that some American art schools covered the faces of nude models to hide their identity. If an art magazine with the national stature of *The Crayon* should voice such extreme statements in this regard, we must suppose such views to have had some currency in the national milieu outside the arts. It is not remarkable, therefore, that photography would have been regarded as intolerable should its inevitably direct realism have been applied to this area of art. It is not remarkable either that photographers, as sensitive men partaking of the mood of their times, would condemn such applications from within their own ranks.

Second, we can recognize an undertone of belief that there is a tide of continuing progress in the history of humanity, here linked to morals and art. Such a belief harmo-

nizes with the views of Peale, Harrison, and Root that improvement of public taste and patriotism would come from the didactic uses of photography as a symbolic medium. Photography, conceived of as an agent for improvement of the public and as a source of increased public happiness, would seem to embody the ideal of art expressed in *The Crayon.*

Finally, we recognize a connection between this view of art, opposed as it is to commercialism, and the often expressed view of leading daguerreotypists that a serious artist in the medium could remain a serious artist only if he did not cut prices. Price-cutting was usually regarded as a cheap commercial trick to gain increased business at the expense of artistic quality—the light in which Snelling viewed price-cutting as comparable to pornography. It was generally held that men such as Southworth and Hawes, who never charged less than five dollars for a portrait, even while some operators were making portraits by mass production methods at two for twenty-five cents, would be the ones to serve the purposes of true art with the daguerreotype medium. These were the men who would, in Root's view, summarize America's spirit in a "new and magnificent type of universal art."[39]

In order for the daguerreotype to accomplish the high work set for it by Root, it would be necessary for all its opportunities for spiritual insight to be used. Thoreau saw that reliance on the truth of the inner spirit of nature—what Southworth also valued first—would be the only valid means to achieve significance for the medium. Writing in his journal in February 1841, Thoreau commented,

> It is easy to repeat, but hard to originate. Nature is readily made to repeat herself in a thousand forms, and in the daguerreotype her own light is amanuensis, and the picture too has more than a surface significance,—a depth equal to the prospect,—so that the microscope may be applied to the one as the spy-glass to the other. Thus we may easily multiply the forms of the outward; but to give the within outwardness, that is not easy. . . .[40]

Thoreau also recognized that the new medium demanded a keen ability to discern the moment of true insight from among the many moments a photographer could choose. He saw that the photographic act was not only a capturing of the moment when the subject was most completely "the Thing itself." It was not only giving the "within outwardness" to reveal the inner spirit. At basis, it was the ability to make permanent that "decisive moment"—as Cartier-Bresson called it a century later—when artist and subject are attuned in spiritual insight *together,* although the point of attunement may otherwise be undefinable:

> Our sympathy is a gift whose value we can never know, nor when we impart it. The instant of communication is when for the least point of time, we cease to oscillate, and coincide in rest by as fine a point as a star pierces the firmament.[41]

As he observed, a moment of creative repose is essential in all the arts:

> That an impression may be taken, perfect stillness, though but for an instant, is necessary. There is something analogous in the birth of all rhymes.[42]

Emerson also recognized the need for a similar moment of stillness, though he stated it simply in terms of the necessity of holding still for a photograph to be rendered accurately:

> The Daguerreotype is good for its authenticity. No man quarrels with his shadow, nor will he with his miniature when the sun was the painter. Here is no interference, and the distortions are not the blunders of an artist, but only those of motion, imperfect light, and the like.[43]

In Emerson, too, we can see the temper of the times which moved Root and Peale to note a widening public influence for truth in portraiture because of cheap photographs widely available:

> 'Tis certain that the Daguerreotype is the true Republican style of painting. The artist stands aside and lets you paint yourself. If you make an ill head, not he but yourself are responsible, and so people who go Daguerreotyping have a pretty solemn time. They come home confessing and lamenting their sins. A Daguerreotyping Institute is as good as a national Fast.[44]

Emerson, like Root, seems to discern that in America the new medium has produced a new aesthetic based on directness of confrontation in producing a work of art. Implicit in the process as he describes it is the mechanical nature of photography—the chemical and optical facts which make the process possible.

In 1850, Emerson further examined the varied national significance of the machine art of the daguerreotype in conjunction with the other great symbolic technological marvel of the age, the telegraph:

> God flung into the world in these last ages two toys, a magnet and a looking-glass; and the children of men have occupied themselves wholly with one or the other, or with both. . . . The most unexpected splendid effects are produced by [the magnet], as a cone is generated by the revolution of a triangle. Religions, philosophies, friendships, loves, poetries, literatures, are all hid in the horse-shoe magnet; as galvanism, electricity, chemistry, heat, light, and LIFE and Thought are at last only powers of this fruitful phenomenon. . . .
> For the looking-glass, the effect was scarcely less. Poor dear Narcissus pines on the fountain-side. Colonel Fremont, on the Rocky Mountains, says, "How we look!" and all cities and all nations think what the English, what the French, what the Americans will say. Next, the trick of *philosophizing* is inveterate, and reaches its height; and, last *Symbolism* is the looking-glass raised to its highest power.[45]

Emerson's observation that symbolism is the ultimate degree of the looking glass tallics with Brady's "Photographic Pantheon" and the didactic impulses of the artists of the period such as Harrison, Root, Morse, and Peale. Yet his view adds the further element of the mechanical nature of the process—which he restated again more exactly many years later:

In my lifetime have been wrought five miracles,—namely, 1, the Steamboat; 2, the Railroad; 3, the Electric Telegraph; 4, the application of the Spectroscope to astronomy; 5, the Photograph. . . .[46]

From this context, Emerson saw the character of the nineteenth century as being determined by technology, whatever the artistic or symbolic significance of the application of technical advances.

Daguerreotypists, even when most eager to be ranked as artists, were sensitive to the technological cast of their age. They often made efforts to align the mechanical aspects of their trade with their character as artists. John Adams Whipple, for example, powered all the operations of his gallery, including his novel advertising, by steam and was quite proud of the fact. We have also seen the wide technical interests of Anson Clark early in the period of the daguerreotype medium, and we have noted how very early such people as Dr. Bemis and the painter George Fuller welcomed the technical facts of the new medium for artistic uses. Throughout his memoirs, James F. Ryder notes his repeated efforts to acquire and master the latest technical advances in the field, and we note that this attitude of willingness to accept new methods tended to carry over into other areas of current life. Both Henry Hunt Snelling in his *Photographic and Fine Art Journal* and Samuel Dwight Humphrey in his *Daguerreian Journal* gave extensive space to technological innovations.

In late 1850 in the first issue of the *Daguerreian Journal,* we find core articles devoted to photography in both its artistic and its technical aspects. In addition, however, we find articles on new methods in sculpture and a review of the Art-Union of New York along with articles on the nature and chemistry of mercury and bromine, an article on a new Swiss watch which winds without a key, an enthusiastic report of the possibilities inherent in applying electricity as motive power, an article entitled "Effect of Atmospheric Electricity on the Wires of the Magnetic Telegraph," and items on the manufacture of soda ash and chloride of lime and on the possibilities of gutta-percha paving blocks for city streets.

In March 1852, Snelling's *Photographic-Art Journal* carried the notice of one J. K. Fisher of New York addressed to *Traveling Daguerreans:*

I propose to contract for the exclusive use, in particular places or routes of a new invention of mine, during the time when its novelty will make it serviceable by attracting general notice to itself and to whatever business is connected with it. It is a steam carriage. It may be built of a size to suit a daguerrean operator to take pictures in; it may be kept warm by the waste steam, without expense while running, and with little expense while standing; it can be managed by one person, with less trouble than a horse; and it may be worked twelve hours or more without stopping, except for water or fuel . . . and the labor of keeping it in order will be less that [sic] that of taking care of a horse upon the road. The current expense of running it will be within one cent per mile, on common roads, if weight do not exceed a ton. The first cost of machinery will be about $700, and that of

the carriage from $400 upwards; $1500 would probable [sic] fit up a very commodious carriage, with all the conveniences required by an operator.[47]

Even the most consciously artistic daguerreotypists stressed technical mastery throughout the period of the medium. Southworth and Hawes, for example, held several basic patents for devices such as multiple-image plate holders, and the Grand Parlor Stereoscope was a prize novelty in their gallery. The statement can be made that American operators remade the basic process of Daguerre within the first year after its publication. From the moment Daguerre's complex method of polishing and preparing plates appeared in America, native cameramen began trying to shorten the procedure to make it simpler and more effective. As early as 1847, the leading Paris firm of Lerebours et Secretan published a treatise, *Daguerreotypie* by J. Thierry, which contained an enthusiastic chapter detailing the *Procede Dit Americain.* By the 1850s, "the American Process" had become the world standard for the medium, and leading European daguerreotypists found profit in advertising that they used this method of mechanical polishing and enrichment of the silver surface by electroplating at the time of use of a plate. The English daguerreotypist John Werge summed up the European view of American operators, noting that

> all employed the best mechanical means for cleaning and polishing their plates, and it was this that enabled the Americans to produce more brilliant pictures than we did. Many people used to say it was the climate, but it was nothing of the kind. The superiority of the American Daguerreotype was entirely due to mechanical appliances.[48]

The public freely associated the daguerreotype with remarkable technological progress in general, at times coming to bewildering conclusions about the process and attributing to the daguerrean artist all manner of remarkable powers. As late as 1859, *The American Journal of Photography* carried an account of an Irish lady who entered a daguerreotype gallery in the Bowery to ask,

> "Is it hereabouts that ye take the likenesses iv absint frinds? . . . I've a son in the United Sthates Army, an I wud like to have his pictur, an shure I tho't as I was passing along wid a little sphare money that I'd call in an see if ye wouldn't make his likeness for me by tilegraph."
> The artist explained to the old woman the manner of taking likenesses, at which she seemed much astonished, and laughed at her own ignorance—"fur," said she, "I surely tho't yer cud take pictures by tilegraph, as I see the wires run right inter yer hoose."[49]

Peculiar as is the lady's conclusion, it does reflect the sense of the public that the daguerreotype was one of a puzzling series of current technological marvels. Her connection of photography with one of the leading technical artifacts of the period is little different in basic concept from the comments by Horace Greeley on visiting the American section of the Crystal Palace in London and wishing certain manufactured items had been included along with the pictures:

> A light Jersey wagon, a Yankee ox-cart, and two or three sets of American Farming Implements, would have been exactly in play here. Our Sythes [sic], Cradles, Hoes, Rakes, Axes, Sowing, Reaping, Threshing and Winnowing machines, &c., &c., are a long distance ahead of the British—so the best judges say; and where their machines are good they cost too much ever to come into general use. . . .
>
> Yet there are many good things in the American department. In Daguerreotypes, it seems to be conceded that we beat the world, when excellence and cheapness are both considered. . . .[50]

In Greeley's remarks we can discern several aspects of American thinking about the daguerreotype as an art medium, noting its utility, wide availability, cheapness combined with aesthetic effect, and, in addition, a sense of technological significance at a nationalistic level. Such was the climate within which the daguerreotypist functioned, willingly using the mechanical character of his process to serve the artistic purposes which motivated him.

The photographic artist fused his aesthetic concerns, his technological interests, and his nationalistic impulses with a large degree of public showmanship whenever the occasion allowed. Consider, for example, the details of the decorations put up by leading New York galleries during the celebration of the completion of the Atlantic cable. At Gurney's "Palace of Art,"

> At night the whole building was illuminated with colored lamps; covering the entire front was a transparency representing a pyramid, composed of five figures: Peace was in the centre coming up behind the electric batteries and giving crowns to Science and Art, (represented by two female figures on her right and left). On the right was a colossal figure of Young America, and on the left a similar figure representing Old England, both in sailor's costume, and each holding the flag of his own country, they being crossed at the top. The whole on a rock in the middle of the ocean. On one side below the Lion of England, and on the other the American Eagle, each holding an end of the cable.[51]

At the bottom of the transparency, below boxes signalizing Queen Victoria, President Buchanan, and the captains of the cable ships, appeared the legend,

<div align="center">

DAGUERRE AND MORSE

ONE HARNESSED THE LIGHT, AND THE OTHER THE LIGHT-NING.[52]

</div>

"Connected with these figures were several instruments of art, among which was the camera obscura with the name: J. GURNEY, 1858."[53]

At Brady's the entire front of the building was illuminated by six hundred candles and bore a transparency twenty-five by fifty feet under the title "Science, Labor and Art —Union Cable."[54] At 585 and 587 Broadway, Charles D. Fredericks, at his "Photographic Temple of Art," carried through the implications of the title of his gallery by posting a pantheon of "all the great men and women of the day" illuminated with a "blaze of light." Over his large window, he erected a transparency, pairing figures of Europe and

America and of Daguerre and Morse, the design underlain by "the figure of a Camera Obscura, resting on a coil of Cable."[55]

While descriptions of other types of business establishments indicate that allegorical decorations were generally placed around New York at the time, we can recognize from the photographic elements these included that photographers were consciously involved in the technological mood of their day. The fact of their thinking about their own art in symbolic conjunction with science, mechanics, nationalism, and a kind of progressive pantheism deriving from their reliance upon nature becomes clear. The fact also becomes clear that the symbolic uses of both artistic and technological media were felt to be nationalistically beneficial and were seen as aids to a greater life for Americans in the world at large.

Among the thousands of operators who employed the daguerreotype medium, few were inspired artists. To a greater or lesser degree, however, many were sensitive men, alert to the varied aspects of the time in which they lived. Those who were not gifted with the artistic traits expected by Southworth or Harrison still were concerned to employ the photographic process with respect for its characteristic nature. They sought to create images which were beautiful in their truthfulness and affective to the feelings of the public. By coming from every quarter of society, the daguerreotypists were themselves a cross section of America. For this reason there were among them men who were able to respond to some part of national life in any situation. Their mobility gave them a direct experience with American life that sharpened into keen insight under the demands of trading with their medium. Their commercial application of the daguerreotype attuned them closely to society and impelled them to share their findings in projects which mirrored the sentiments of the time.

Because of their artistic concerns, daguerreotypists tended to develop a subconscious sense of mission which only their medium could satisfy. Deliberately, yet often unwitting of their motives, these cameramen attempted to define American character by making and collecting exhibitions of pictures which symbolically indicated phases of the national scene. John Wesley Jones and Robert Vance laboriously summed up in panoramas and exhibitions the unknown half of the continent, the far West, and presented them to the public as necessary sources of information which were also beautiful. Alexander Hesler cataloged the inland towns along the Mississippi for a guide book. John Plumbe distributed inexpensive pictures of the monuments of the federal government so that all could participate vicariously in the operation of the republic under the world's great democratic experiment. H. E. Insley wished to typify the urban face of America by collecting city pictures from every part of the continent into one place where Oregon, Maine, Texas, and Louisiana could be experienced directly as the mirror of the nation. Collections of accurately recorded scenes such as these made available to the public more exact information about their country than was ever given to any people in history. A citizen visiting Jones's *Pantoscope* and Vance's exhibition from California could better

grasp the character of western America than if he traveled there himself. The sensitivity of the artist had selected and emphasized significant information for him, and technological methods guaranteed him the truth.

Other daguerreotypists and exhibitors made available public visions of the character of America which no one person could discern by any amount of personal observation. Barnum's Gallery of American Female Beauty gave the public an opportunity to recognize and assist in defining types of American women. Brady and Anthony provided visible symbols for national faith specifically meant to inspire Americans to define themselves and their country according to high ideals. In all these deliberate projects, the daguerreotypists were knowingly trying to confront Americans with their own national image—they were acting as teachers to the public. They conceived of their art as a means of informing public taste and heightening emotional sophistication toward the symbolic elements of American life. They recorded facts as truthfully as they could to define the spirit of life beneath the visible surface. In defining the spirit of American life, they taught Americans to be more completely American and then recorded the change, in a pattern like widening circles on a pond, until recorder and subject became one in a unified response to American life. In this fusion they achieved Root's ideal of producing art which would be "America's spirit and life . . . idealized and encircled with the magic halo of beauty."[56]

The daguerreotypist brought about this ideal artistic influence because he was himself a part of American life. He felt the westering impulse and he was fascinated by the advances of science and manufacturing. He was curious about the basic nature of his country though unique in his gift of discernment when seeing it. He followed the truth of nature as basic to his art—whether in recording the wilderness or in the genre scenes of urban life he sometimes arranged in his studio. He was equipped by interest and situation to discover and inform. He was moved by temperament and economics to be a universal man in defining the truth of life as he saw it through the lens of his camera. Fully aware of his camera as a machine and his process as scientific, he was closely involved with using the powers of his age to produce images which were as significant as he wished them to be for himself and for America. The daguerreotype pictures he made were nearly perfect fusions of technology and art, partaking ideally of the nature of both as symbols and as objects—the exquisitely beautiful results of complex technical operations. Their significance, great as it is in terms of the pictures themselves, however, must always be assessed finally in light of the fact that it took the conscious efforts of devoted men to bring them into being. The significance they do possess is the gift of the daguerreotypist-artist to his time.

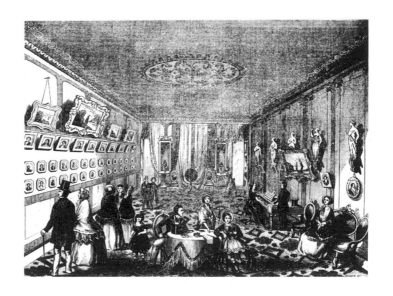

Chapter 8

THE DAGUERREOTYPE AS HUMAN TRUTH

IN ASSESSING the role of the daguerreotype in American life, we must be aware that the silver pictures and the men who made them were but two of three essential elements. Without large-scale public response and use, the pictures would have been little more than charming novelties and the picture makers merely temporary hobbyists. We can appraise something of the degree of public interest by noting the rapid growth of professional activity in making daguerreotypes. Robert Taft estimates such an increase in the 1840s that by 1850 some 2,000 operators were professionally serving a population of about twenty-three million. He admits the uncertainty of his figures because of the variety of trades followed by some men, and he also notes a census report of 938 declared operators in 1850. By 1860 the United States Census listed 2,650 daguerreotypists and 504 other types of photographers.[1] Even these figures do not reveal a complete picture of daguerrean activity because of the number of operators who took up the trade for various reasons and soon abandoned it. Beaumont Newhall reports that of 180 names listed as daguerreotypists in Boston city di-

rectories between 1840 and 1860, "only seven stayed in business for ten years or more, and seventy-seven are listed for one year only."[2]

A further index of public enthusiasm for the medium is the number of pictures produced. Newhall cites official reports of the Commonwealth of Massachusetts in 1855 indicating that "403,626 daguerreotypes had been taken in the state during the past twelve months, the work of 134 'Daguerreotype Artists' and 260 hands."[3] Taft notes that by the peak year of 1853, three million pictures were being produced annually,[4] and estimates have been made that the total production of pictures reached above thirty million in the two decades of the medium's popularity. Figures such as these combined with facts of large-scale operations such as those of Plumbe or Whitehurst indicate that daguerreotypy was a major business in America. The commonest size of picture, the sixth plate ($2\frac{3}{4}''$x$3\frac{1}{4}''$), brought about $5 during the early part of the period. During the 1850s the price declined to about $2.50 where it remained until paper photographs crowded daguerreotypes off the market. Taft gives the recorded average of D. D. T. Davie, a prominent operator of Utica, New York during the 1850s as $2.53 for a sixth plate and $4.35 for a quarter plate ($3\frac{1}{4}''$x$4\frac{1}{4}''$).[5] We have noted that Southworth and Hawes never charged less than five dollars for a portrait, which was almost double the average for most respectable galleries. Reckoning on this average basis and allowing for both extravagant and "cheap" operators, we can cautiously assess the daguerreotype trade in America at eight to twelve million dollars a year by 1850 for the direct purchase of pictures alone, or about fifty cents per person for everyone in the United States. In 1856 after the daguerreotype was already in decline because of competition from paper prints and ambrotypes, the *United States Mercantile Guide* estimated that

> not less than fifteen millions of dollars are paid annually by the people of the United States for daguerreotypes alone and, in addition to the numerous persons who are employed directly as artists, the [photographic] processes have called into existence many trades that give support to thousands.[6]

This volume of picture making is further significant in light of the fact that over ninety-five percent of all daguerreotypes made in America were portraits of individuals, couples, or groups. That is to say that the commonest reason for the making of a daguerretoype was the wish for a portrait. It is to say, further, that nearly every daguerreotype produced in the country was made by a daguerreotypist performing a commercial service. The pictures resulting from this impulse formed a body of images which affected national life at the personal level of acceptance and feeling—scarcely a home in the land was without its treasured family mementoes and pictorial records. It is necessary to consider both the practical and the symbolic effects of these images on American life to define the subconscious motives and responses of the public. In particular we must examine the interplay of the daguerreotype with the public in four aspects.

Initially, we find that once the daguerreotype had become so widespread, it provided a nearly universal experience for Americans in the picture-making situation. Gen-

erally, people responded in the same fashion to having their portraits made, and they liked or disliked the results for generally similar reasons. Standardized responses to the pictorial experience helped an age define its own image collectively along certain lines of feeling which operated widely in national consciousness and colored a growing national self-awareness.

Second, the medium provided a means of self-definition to each person, individually for himself and for his loved ones. These pictures transcended the limits of time and place and even of mortality to offset the deeply felt impermanence of human life and experience.

Further, and closely related to a longing for immortality, there was a great body of sentimental impulses which the picture medium was almost ideal to satisfy. By providing images of loved ones or those departed, the daguerreotype gave immeasurable aid to memory. Daguerreotype pictures became catalysts for a variety of responses embodying the sentimental mood of the nineteenth century. To human wishes the mirror pictures provided symbolic gratifications which appeared almost magical. The pictures themselves became objects of emotion to which people often responded as directly as they did to the original picture subjects.

Finally, after some years, the various individual and collective responses to daguerreotypes amalgamated into national feelings toward the pictures. By informing and educating public taste along the lines emphasized by Brady and Root in particular, the daguerreotypists' works aided in developing an iconological definition of American character within the context of the nineteenth century. Even as individuals interpreted their lives in new ways because of the daguerreotype images they experienced, the nation also developed a novel awareness of itself because of the presence of millions of daguerreotypes as affective symbols each contributing its fragment of responsive awareness or feeling to the total. The total became so extensive that in 1849 *Godey's* declared the daguerreotypist an "American Characteristic" because of the number of operators already spread over the nation after only ten years. In his article, T. S. Arthur commented,

> If our children and children's children to the third and fourth generation are not in possession of portraits of their ancestors, it will be no fault of the Daguerreotypists of the present day; for, verily, they are limning faces at a rate that promises soon to make every man's home a Daguerrean Gallery. From little Bess, the baby, up to great-great-grandpa', all must now have their likenesses; and even the sober [Quaker], who heretofore rejected all the vacuities of portrait-taking, is tempted to sit in the operator's chair, and quick as thought, his features are caught and fixed by a sunbeam. In our great cities, a Daguerreotypist is to be found in almost every square; and there is scarcely a county in any state that has not one or more of these industrious individuals busy at work in catching "the shadow" ere the "substance fade". . . . Truly the sunbeam art is a most wonderful one, and the public feel it is a great benefit![7]

In order to examine each of the major aspects of public interaction with the daguerreotype in some detail, we must first consider the picture making situation itself in its

relatively standardized national form, particularly the situation of the studio to which a sitter went for his likeness.

Most of the studios to which the public came were relatively alike. Most separated their "operating rooms," where pictures were taken, from their reception rooms and chemical finishing areas, so that a fair investment was needed to establish a suite even before photographic equipment was included. Because of the need for large skylights, studios were normally on the top floors of buildings, necessitating a climb of two to four flights of stairs even in the best galleries. In an effort to draw the public up the stairs, street entrances were usually made inviting, with appealing specimens of the studio's best work on display. Once aloft, the public was cajoled into waiting for the daguerreotypist by richly appointed surroundings and pleasant diversions. In New York gallery design reached elaborate heights which operators in other parts of the country attempted to emulate to whatever degree they could afford. In 1851 the French photographic journal *La Lumiere* spoke of the typical New York studios as

> most elegantly furnished, perfect palaces, worthy of comparison with the enchanted dwellings of Eastern fabulous heroes. Marble, carved in columns, or animated by the chisel of the sculptor, sumptuous frames enclosing costly paintings; the feet press without noise the softest carpets; gilded cages with birds from every clime, warbling amidst exotics of the rarest kind, which diffuse their perfume and expand their flowers under the softened light of the sun. This is the American studio. The visitor under this charming influence forgets his cares, his features brighten and soon assume an expression of calm contentment.[8]

In 1852 the newly opened Brooklyn studio of Gabriel Harrison was described by the *Photographic Art-Journal* in details that bear out the French view of American rooms:

> The entrance is ten feet wide, with the Gallery and Operating Room all on the second floor; doors of brilliant stained glass; size of the Exhibition Room, forty-five feet long, twenty-five feet wide, and fourteen feet high, octagon in form, and elegantly painted in fresco, with Crocus Martis tint, white and gold, Elizabethian [sic] in design, and the whole lighted with a large oblong skylight of ground glass, thereby producing a light of such softness that Daguerreotypes, and other works of Art, can be looked at with a degree of pleasure hitherto not afforded in like establishments.
> The Operating Room.—Is fifty feet long, thirty feet wide, and frescoed in a quiet, subdued tint. . . .
> The Light.—Under which the sitters are placed to have their portraits taken, is the largest in the world, and contains over *two hundred and fifty square feet* of the best English white plate glass. . . .
> The Ladies Dressing-Room.—Is contiguous to the Operating Room; is fifteen feet square, and fitted up in the most chaste and beautiful style with salmon color and marble top furniture.[9]

By contrasting European with American practice we can see that Americans outdid the rest of the world in elaboration of galleries, tending to lavish on them every sort of

novelty and embellishment in the public reception areas. A satiric article from France describes a typical Paris studio:

> Attracted by the frame of portraits, you walk up-stairs, and into a room that looks something like a shop without the wares. There is no display of goods here to beguile customers; nothing looks like business but the small compartment at the window, screened off with canvas, in which recess the sitter is placed. But this little chamber is not always unoccupied on your arrival. . . . In the mean time you are at liberty to walk about, to sit down, or to chat with the assistants of the establishment, whilst choosing a plate. . . .[10]

Against this bleak, small-scale studio, let us set Ball's Daguerrian Gallery of the West in Cincinnati (see chapter heading cut). Instead of a "small compartment at the window, screened off with canvas," Ball had two operating rooms, "each twenty-five by thirty, and fitted up in the best manner. One of these was prepared expressly for children and babies." Instead of a bare waiting room, Ball had a gallery "twenty feet wide by forty feet long. The walls are tastefully enamelled by flesh-colored paper, bordered with gold leaf and flowers." Two walls were decorated with sculpture of ideal figures in color representing the goddesses of Beauty, Science, Religion, Purity, Poesy, and Music, together with the Three Graces. Another wall contained 187 of Mr. Ball's finest pictures, including celebrities such as Jenny Lind and views of Niagara Falls, along with works of native painters. As against the blank impression produced by the Paris studio, Ball's offered a situation in which

> Every piece of furniture in this gallery is a master-piece of mechanical and artistic skill. The very seat on which you sit and the carpet on which you tread seem to be a gem culled from the fragrant lap of Flora; all of these, reflected by two bright mirrors in the east end, present you a scene replete with elegance and beauty—to cap the climax, there is a noble piano by whose sweet notes you are regaled, while the skilful operator is painting your face with sunbeams. . . .[11]

Between London and New York the discrepancy was the same. A London correspondent for *Humphrey's Journal* observed of English operators that

> Their reception, or exhibition rooms are small, and not fitted up with any particular regard to taste or comfort, while, you know, in the States, the rooms of the best practitioners are like the best furnished drawing rooms. One of the best and most celebrated Daguerrean artists here has a specimen room not more than eight feet square, with a very small number of pictures, of course.[12]

In a nettled reply to this article, J. J. E. Mayall, the leading daguerreotypist in London and an American, objected that the dimensions cited were unfairly small and noted that his own exhibition room was eighteen feet square. Humphrey himself appended comments to this protest in which he noted a studio in New York with "a reception-room 62 by 27 feet, beautifully furnished," and commented that another studio had a room twelve feet square merely for the minor technical operation of electrotyping. When

Mayall claimed the critic was giving inadequate attention to British efforts to bring the art before the public, Humphrey emphasized preparation for attracting the public by

> the show at the door. One of our professors has over *five hundred dollars* invested for this purpose. This we are creditably informed far exceeds any thing now in all Europe.[13]

In 1853, Brady moved into a new studio at 359 Broadway, the public area of which typified the American practice in decorating galleries, exceeding general details only in richness, and reflecting the tone of "rooms" all over the nation. *Humphrey's Journal* gave the premises considerable attention:

> At the door hangs a fine display of specimens which are well arranged in rich rosewood and gilt show cases. The Reception Rooms are up two flights of stairs, and entered through folding doors, glazed with the choicest figured cut glass, and artistically arranged. This room is about twenty-six by forty feet. . . . The floors are carpeted with superior velvet tapestry, highly colored and of a large and appropriate pattern. The walls are covered with satin and gold paper. The ceiling frescoed, and in the center is suspended a six-light gilt and enamelled chandelier, with prismatic drops that throw their enlivening colors in abundant profusion. The light through the windows is softened by passing the meshes of the most costly needle worked lace curtains, or intercepted, while the golden cornices, and festooned damask indicate that Art dictated their arrangement. The harmony is not in the least disturbed by the superb rosewood furniture—tetes-a-tetes [sic], reception and easy-chairs, and marble-top tables, all of which are multiplied by mirrors from ceiling to floor. Suspended on the walls, we find the Daguerreotypes of Presidents, Generals, Kings, Queens, Noblemen—and more nobler men—men and women of all nations and professions.[14]

Other areas of the suite were of similar decor and grandeur.

In the descriptions of even the most lavish galleries, two things become clear almost immediately. Initially, we must notice that the elements and applications of decor in the daguerreotype gallery are those of the upper middle-class American home of the period. John Kouwenhoven devotes the fifth chapter of his book *Made in America* to a discussion of the fusions and contradictions in American decoration between a native tendency to brightness and glare—that is light, the chief necessity and sign of the photographer—and the wish of designers such as A. J. Downing and critics such as Poe to subdue and soften the texture and color of American homes in an effort to heighten "taste." In a manner of speaking, the daguerreotypist's studio reconciled these two views of decor in one public place. The public areas, such as the reception rooms and galleries, and the rooms governing moods, such as the dressing rooms, were treated with a mixture of soft richness and subdued glitter. Operators often lighted sparkling chandeliers while they used heavy draperies to subdue the light of the windows, and they heightened soft color schemes with gold accents and "prismatic drops." As *La Lumiere* noted, these elaborate surroundings affected the moods of clients so that

> The Merchant, the Physician, the Lawyer, and even the restless Politician, forget in this abode the turmoil of business. Surrounded thus, how is it possible to hesitate at the price of a portrait?[15]

The word "abode" in this context is a telling indication of how far the atmosphere of "home" was designed into these studios. Similarly we may recall that Humphrey's London correspondent noted that leading American galleries were "like the best furnished drawing rooms." In the operating room, decor was secondary to purely photographic considerations. We have seen earlier that the tendency in America from Gouraud on was to simplify the camera room and concentrate on diffusing and controlling light even while attempting to intensify it. This fusion of impulses in the operating room echoed the decorative character of the exhibition areas so that both practicality and atmosphere were served by similar means. By employing current taste in residential decoration in his studio, the daguerreotypist could promote desirable moods—he could deal with clients as visitors in a home different from their own only in degree. He could thus encourage a favorable predisposition of mood in his customers.

The other factor operative in these galleries was an unconscious result of proper atmosphere. If one felt at home in a gallery because of its similarity to a pleasant dwelling of the time, he was more apt to regard the pictorial images produced as favorably as he might at home. If he found a familiar face among the pictures on display, for example, he could warm to the entire situation more easily. At a still deeper level, he was put into a position of equality with all daguerreotype sitters—as Humphrey's description of Brady's gallery points out. Finding "more nobler men" of all nations and professions among the kings and queens, presidents and generals tended to minimize the separations of social level between these persons. A democratic leveling process of great appeal to Americans was thus implicit in the gallery display. Since almost every established studio in America sought to exhibit celebrity portraits along with favorable specimens of the local daguerreotypist's work, there was a general, if subtle, pressure on a client to associate himself in a homelike mood with such distinguished people. Should a visitor returning to, say, Root's gallery in Philadelphia find his own three-dollar portrait next to the likeness of Henry Clay, he would be brought into closer intuitive conjunction with the statesman than he might ever be otherwise, as if Clay were a visitor to his home or he to Clay's.

Since even well-to-do families could seldom approach at home the elaboration of Brady's studio despite a similar basic attitude about decor, visitors to the studio were made to feel that the aura of a special occasion hovered over having one's likeness made. The mood of quality and high purpose desired by better operators was reinforced by the atmosphere of their galleries and the museum-like presentation given their displays of pictures. Daguerreotypists wanted the visitor to feel comfortably at home among the various items of their craftsmanship, but they simultaneously desired to present something finer than the visitor's everyday surroundings. These mixed impressions usually

operated on sitters to produce serious moods and to encourage personal ornamentation which are visible in the portraits. It is rare to find a smiling subject, though in part this lack stems from the long exposure necessary before the camera. It is quite normal, however, to find ordinary citizens dressed to the upper limit of their ability so as to meet the implicit demands of the atmosphere of the studio. Formality prevailed nationally with standardized postures matching best clothing.

A fine portrait by Jeremiah Gurney (Plate 170) typifies the attributes of thousands of similar likenesses produced all over America. The gentleman is sober in expression, well-dressed in black; his posture is formally stiff and one hand rests on a table at his side. He is Ellsworth Eliot, but he could be any man in America sitting for his daguerreotype. Likewise, Eliza R. Snow, the Mormon poet, could be any woman (Plate 171), and Francis Le Baron any child (Plate 172). All reflect the seriousness and formality of the way in which the average citizen responded to the situation of having his likeness made.

The problem of instilling a suitable mood to be reflected in a daguerreotype portrait was given much attention by operators. Marcus Aurelius Root, for example, summarized the necessary factors in his book *The Camera and the Pencil*. He urged that the waiting room be supplied with books of varied appeal and advised that the room should also be supplied with

> an ample variety of the finest engravings, prints, &c., to be procured; together with curiosities of different kinds, more especially such as have classic, romantic, and historic associations connected with them—*e.g.,* medals, coins, vases, urns, &c., whether originals or copies.[16]

A similar intention, though with a more technological emphasis, will be recalled from our examination of the career of Anson Clark, who displayed scientific and mechanical devices along with mineral specimens and whimsically fraudulent historical items such as Cleopatra's fan. Root and Clark both appear to have felt that exposing sitters to educational and cultural artifacts woud not only amuse them but would enlighten them in a way to enliven their expressions. Root specifically advised the selection of works of art for his gallery which would be

> so various, as to correspond to the leading types of character which might be expected among the sitters, and to be calculated to call into vivid action the feelings pertaining to these characters.[17]

He also included in his book chapters on physiognomy and expression in both live and inanimate objects so as to stress the need for a daguerreotypist to direct the formation of mood and response within his sitter.

In evoking moods Root also followed his didactic impulses as we have seen them related to national character. He advised that displays of portraits by the studio should be of "Individuals of both sexes, who have been renowned for high traits and noble deeds," and wished "to affix the name to each, as this would enhance the interest."[18] He sought further to evoke feelings receptive to such ideal examples by the presence of singing birds meant to divert

the mind from a consciousness of self[;] they tend to awaken emotions and call up recollections and associations which impart to the face an amiable, genial expression.[19]

Root wished not only to produce a pleasant atmosphere such as would evoke associations of good taste and high character, but he wished to elevate the public spiritually as a part of the picture-making process:

> In sum, I would have the heliographic rooms a temple of beauty and grandeur, so that those entering therein may inhale a spirit which shall illumine their faces with the expression which the true artist would desire to perpetuate.[20]

Considerable attention was given to preparing the public even before they arrived at the daguerreotype studio. Root and many others published articles about how to dress and prepare one's appearance and attitude. *Godey's,* for example, carried items of advice regarding dress:

> In order to obtain a good picture . . . it is also necessary to dress in colors that do not reflect too much light. For a lady, a good dress is of some dark or figured material. [Plate 173.] White, pink, or light blue must be avoided. Lace work, or a scarf or shawl sometimes adds much to the beauty of a picture. [Plate 174.] A gentleman should wear a dark vest and cravat. [Plate 175.] For children, a plaid or dark-striped or figured dress is preferred by most Daguerreotypists. [Plate 176.] Light dresses are in all cases to be avoided.[21]

The prohibition against light dresses for children was because of the chance of so overexposing a plate as to solarize it and spoil the image (Plate 177). This was a particular danger with children in bright light because of their small size and because extreme light was usually applied to them in an effort to shorten exposure time. Fine craftsmanship could overcome this difficulty, as we have seen with Southworth and Hawes (Plate 161), but for most operators it remained a problem.

Root gives advice in his book about the various problems of lighting and composition as well as proper dress for the best appearance. As a serious artist, his stress throughout is on the natural character of the sitter which the daguerreotypist should seek to capture by any means necessary. Other operators, however, found need to improve on nature for the sake of a pleasing picture. Abraham Bogardus recalled half a century later, for example, that

> We always had sticking-wax by us to keep wing-shaped ears from standing out from the head, and we often placed a wad of cotton in hollow cheeks to fill them out. The ladies called them "plumpers."[22]

There were also difficulties in selecting an expression which a sitter was willing or able to keep. Misconceptions gained currency, such as the belief that the sitter must not blink his eyes during the exposure. Many fixed stares testify to this view which some operators encouraged and many sitters believed with fierce enthusiasm. Bogardus observes that

No operator of intelligence ever told the sitter not to wink, for the effort to refrain would have given the eye an unnatural expression. We found it a duty to tell the sitter to wink as usual; that natural winking did not affect the picture [because of its brief duration]. Even then it was not always understood. One old lady jumped out of the chair before a sitting was half over, raising both hands, and exclaiming: "Stop it! stop it! I winked!"[23]

Some sitters never quite grasped that they must remain still throughout an exposure. An elderly woman was told she must keep her eyes in the same direction or she might appear cross-eyed in the picture. She became upset, "Goodness, gracious! I won't be taken if you are going to make me cross-eyed, for I am sure my eyes are very straight and good."[24] She was not only unaware of the problem of movement spoiling the image, but she was deeply impressed with the fact that the camera registered the truth and worried lest she might appear defective in real life. Her picture turned out well, but her daughter seemed to have four hands because of her desire to show them off to advantage. Perhaps the worst difficulty with adult sitters came from subjects who tried to project a contrived appearance. One account tells of a lady who spoiled a series of plates during exposure by

> irresolution as to attitude, fickleness in fixing upon a smile. Now she assumes a saucy, pouting expression, with half-parted lips. The next moment brings a dissolving view of sentimental languor, immediately supplanted by a sad picture of settled melancholy. At last, however, she appears to have decided on a very elaborate combination of charms. . . .[25]

The result presented by the operator appeared to be "a strife of noses, each trying to blow the other out."

Some sitters fell prey to various "weaknesses," as one article described them, in trying to make a false impression for permanent record. The article observed that there was a distinct connection between the type of falsity a person chose to project and his basic psychology—a recognition in part that a searching portrait could reveal something of the inner person. The "weaknesses" were classified accordingly. Among them was the

> *literary weakness.* Persons afflicted with this mania are usually taken with a pile of books around them—or with the fore-finger gracefully interposed between the leaves of a half-closed volume, as if they consented to the interruption of their studies solely to gratify posterity with a view of their scholar-like countenances [Plate 178]—or . . . with the head resting on the hand, profoundly meditating on—nothing.[26] [Plate 179.]

As often as not in these cases, the book used added a note of absurdity, as in the case of a formal middle-aged man holding *The Boy's Own Book* or in the picture of an earnest young man reading one book while hugging another to himself upside down (Plate 180). Of equal abuse was the

> *musical weakness* which forces a great variety of suffering, inoffensive flutes, guitars, and pianos, to be brought forward in the company of their cruel and persecuting masters and mistresses.[27] [Plate 181.]

One other aspect of appearance noted by the article was that of personal adornment:

Jewelry is generally deemed indispensable to a good likeness. Extraordinarily broad rings —gold chains of ponderous weight and magnitude, sustaining dropsical headed gold pencils, or very yellow-faced gold watches, with a very small segment of their circumference concealed under the belt—bracelets, clasps, and brooches—all of these, in their respective places attract attention, and impress the spectator with a dazzling conception of the immense and untold riches of those favored beings whose daguerreotypes he is permitted to behold.[28]

With the jewelry and the stiff formality of dress and the determination of sitters to project artificial personalities, the daguerreotypist faced many difficulties, yet even these problems reveal two enlightening facts about America in this period. The first is that all these malpractices were common enough to be standard across the country. Californians sitting for a daguerreotype behaved pretty much as did New Yorkers, and the results were similar wherever obtained. Thus, these practices were both contributory and responsive to the underlying conception that the American people had of themselves. In addition, such behavior on the part of sitters is obviously related to other attributes of national life—much as the daguerreotype studio reflected the decor of American homes. Taste in personal images, when it emanated from the average sitter, echoed taste in other phases of life. Mark Twain makes this relationship clear with his wonderful chapter describing "The House Beautiful" in *Life on the Mississippi*. He indicates how much of one fabric was every item in the home in meaning, taste, and nationally standard culture —all seen by Twain in the tint of purest acid even though viewed with an eye of fond reminiscence. Along with the assorted curiosa and modernities jostling each other in the American parlor, he reflects on

spread-open daguerreotypes of dim children, parents, cousins, aunts, and friends, in all attitudes but customary ones; no templed portico at back, and manufactured landscape stretching away in the distance—that came in later, with the photograph; all these vague figures lavishly chained and ringed—metal indicated and secured from doubt by stripes and splashes of vivid gold bronze [Plate 105]; all of them much too combed, too much fixed up; and all of them uncomfortable in inflexible Sunday-clothes of a pattern which the spectator cannot realize could ever have been in fashion. . . .[29]

Twain's remarks on the typical portrait as an attribute of American taste emphasize another national characteristic of the pictures themselves—the practice of visually concentrating attention wholly on the sitter. Aside from items such as jewelry or an occasional plant or book, elimination of pictorial elements which would detract from the main subject was a general American daguerreotype practice. European and a very few American portraitists provided painted backgrounds (Plate 182). Considering the absurdity of some pictures with backgrounds of painted scenery (Plate 183), it is perhaps fortunate that Americans did not apply these effects more often. Normally, in portraits the practice was to concentrate on revealing the sitter as directly as possible. This ap-

proach often produced a striking picture that has much to say about a given sitter (Plate 184).

A basic difference in attitude between Europe and America is reflected in the comments of the catalog of the Crystal Palace Exposition. The European view was that photography was too direct and too unselective to be fully artistic by itself. Remarking on the daguerreotypes exhibited by Antoine Claudet, a leading French operator in London, the catalog observed that

> M. Claudet . . . first perceived the necessity of aiding the artistic effect of his representations by subsidiary adjuncts of a different kind. He it was who first practiced the placing of painted back-grounds behind the persons whose portraits were to be taken. Thus an infinite variety of scene might be afforded by the operator simply providing himself with a few subjects skilfully adapted to the requirements of the occasion.[30]

In the same exhibition, however, Mathew Brady of New York took the gold prize medal as the prime winner in the total American sweep of awards for daguerreotypes. Brady relied on the American practice of concentrating on the sitter as directly as possible. It was a personal style with Brady's studio to emphasize this concentration further by placing the sitter as a lighted object emerging from a dark background so as to throw him strongly to the fore (Plate 185). Stressing his avoidance of painted "art" backdrops, the catalog remarked of Brady's collection,

> These are excellent for beauty of execution. The portraits stand forward in bold relief, upon a plain background. The artist having placed implicit reliance upon his knowledge of photographic science, has neglected to avail himself of the resources of art . . . all are so good that selection is almost impossible.[31]

The distinction between Claudet's "infinite variety of scene" and Brady's "bold relief, upon a plain background" appears to be more than a difference of opinion about artistic style. It emerges more nearly as a national emphasis placed on the value of the sitter as against the value of an overall pictorial composition—as if Americans placed first importance on the truth of the individual sitter and wished to reveal his character before any other consideration.

That some such national characteristic was involved was sensed by a contemporary lecturer on the Exposition who defined national styles in the photography shown:

> I may here observe, that the characteristics of the contents of the collections severally furnished by the United Kingdom, America, and France, were remarkably distinct; those of France were very bright, sunny, and not entirely divested of glare; those of America, which consisted almost entirely of portraits, were distinguished by a depth and harmony of tone to which those of France were totally a stranger, and, equally removed from violent contrasts and from insipidity, exhibited a degree of truth and reality only to be obtained by a close agreement with the rules of art.[32]

That America chose to emphasize portraits, with Brady sending forty-eight of leading persons such as William Cullen Bryant (Plate 186), indicates that American daguerreotypists saw portraits as their finest work and their most telling pictures. Giving portraits first emphasis in a world competition of nationalisms implies the belief that American character could best stand contest in the form of national personalities revealed to a viewer as directly as possible. Concern to reveal the sitter thus directly underlay all the exertions of most legitimate daguerreotypists in America. Their efforts to activate suitable moods and to provide congenial situations were important only insofar as they helped prepare the subject for the fullest rendering of his character in the final picture.

Once all the preparations of mood and appearance were settled and the sitter was established before the camera, the daguerreotypist was ready to bring about the miracle that would give his sitter his living image fixed on a silver plate. We are fortunate that some fragments of impressions remain to us which can evoke how the moment of truth before the lens felt to the sitter. In that interval when sitter and medium confronted each other under the watchful eye of the daguerreotypist all the implications of meaning in the process came to bear. Would the image be true? Would it reveal the sitter as the sitter was or as he wished to be? Would the moments before the camera really allow themselves to remain forever as the sitter and all of an age summed up in him were at that hour of eternity? The feelings of sitters ran in such channels and they felt associations with other sitters, wondering whether it had seemed the same way to Daniel Webster or to Jenny Lind. Some were fearful, others wondering:

> The different impressions made upon sitters is curious enough. The most common is the illusion that the [camera] exercises a kind of magentic attraction, and many good ladies actually feel their eyes "drawn" towards the lens while the operation is in progress! Others perceive an impression as if a draft of cold air were blowing on their faces, while a few were affected with a pricking sensation, while the perspiration starts from every pore. A sense of suffocation is a common feeling among persons of delicate nerves and lively fancies, who find it next to impossible to sit still; and on leaving the chair, they catch their breath and pant as if they had been in a vacuum. . . . Of course, these various impressions are all the result of an excited imagination and an *effort* to sit perfectly still and look composed.[33]

The editor of the *South West Independent* of Fayetteville, Arkansas has left his impression of the feelings of a sitter under the lens of John Fitzgibbon. His account suggests how strong a response daguerreotypes elicited in the public even as late as 1854 and reflects a sense of common experience with all sitters:

> Since the arrival of Mr. Fitzgibbon from St. Louis, with his magnificent collection of Daguerreotypes, the whole town has been in a high state of excitement. We were the first to take the fever, and a sitting. And there, with our head lying in the same rest, the iron arms that held the head of the queen of song, the peerless Jenny . . . where Kate Hayes'

ringlets fell—where tens of thousands of the gifted, celebrated, beautiful, rich, poor, honest, ugly, rascally have sat, we colly [sic], calmly took our chance.[34]

He also had the feeling of tension and trepidation mentioned previously:

It is said a drowning man will recall every action of a long life in a second of time. A Daguerreotype sitter's thoughts will also flash like a train of powder from *now* back to his cradle. But our life has been uneventful and we had ample time to think of other things.[35]

Upon being told to look at the adjustment screw of the camera, his mind ran over fame and the relative permanence of image provided by the pictures thus produced:

Immediately we commenced an intense screw scrutiny—just as did Kossuth, Millard Fillmore, Tom Thumb, the Fat Woman, and Franklin Pierce. Ah! thought we, if that screw could break loose now and tell what it had witnessed, it would be the most interesting screw since the days of Mary Queen of Scots. And then that brass tube, just below, brought up visions of artillery, howitzers, culverins, twenty-four pounders, Waterloo, and the 8th of January. But how unlike the death-dealing tubes of war! *They* give oblivion—*this,* perpetuity, or a pretty good chance for it.[36]

He concludes his account with a sense of the definitive accuracy of daguerreotype portraiture even though the likeness produced may not be altogether pleasing—the medium is seen as having conferred a type of immortality and a degree of searching insight unavailable otherwise:

"That'll do," said Mr. Fitz., and our cognitions snapped. The deed was done, the picture was taken off to be salted in mercury and cased like a canvassed ham for preservation. Presently it was brought out ready for use—an ugly little thing, and a capital likeness— "the standard of all our portraits" when we shall become great.[37]

Notable personages felt much the same response to sitting for portraits as did the rest of American society. Ralph Waldo Emerson was typical in not liking to be photographed although he was charmed with the daguerreotype medium; his own comment was that he "looked like a pirate."[38] In his *Journals,* Emerson gave his impressions of sitting in much the same way as did the Arkansas editor although, characteristically, he universalized the significance of the occasion more than most people:

Were you ever daguerreotyped, O immortal man? And did you look with all vigor at the lens of the camera, or rather, by the direction of the operator, at the brass peg a little below it, to give the picture the full benefit of your expanded and flashing eye? and in your zeal not to blur the image, did you keep every finger in its place with such energy that your hands became clenched as for fight or despair, and in your resolution to keep your face still, did you feel every muscle becoming every moment more rigid; the brows contracted into a Tartarean frown, and the eyes fixed as they are fixed in a fit, in madness, or in death? And when, at last you are relieved of your dismal duties, did you find the curtain drawn perfectly, and the coat perfectly, and the hands true, clenched for combat, and the shape of the face and head?—but, unhappily, the total expression escaped from the

face and the portrait of a mask instead of a man? Could you not by grasping it very tight hold the stream of a river, or of a small brook, and prevent it from flowing?[39]

Emerson's dissatisfaction with his own likeness was emblematic of the reactions of thousands—they saw what they recognized happily in the pictures of others, but they rarely welcomed their own images. Abraham Bogardus commented many years later that

> sitters seldom acknowledged their own likenesses. "All good but mine," was the common decision. An aged couple, after examining their pictures, came to this conclusion: "Maria, yours is perfect, but this does not look like me." But the old lady answered: "Jeems, yours is as natural as life, but mine is a failure." After a longer consultation, the old gentleman said: "We must know each other better than we know ourselves."[40]

We have previously seen the response of John Quincy Adams to his likenesses in his consistently declaring them to be all horrible, and it appears that Daniel Webster had similar doubts about his own images while yet being more realistic about the question of his visible outward appearance as a public figure. Turning away from his picture, he once remarked, "I am not to judge of my own looks; it is for you to decide whether the work is worthy of your reputation."[41] Other sitters to Bogardus were less restrained. One reaction was made in the complaint, "My picture looks like the *Devil*," to which Bogardus replied that he "had never seen that personage and could not say as to resemblance, but sometimes a likeness ran all through a family."[42]

N. P. Willis commented on this problem of accurate likeness, recognizing that the very accuracy of photography made it less than appealing to many:

> even good artists have not the courage of the photograph. Cromwell was obliged to insist that the wart upon his nose should be painted, and there is many a departure from beauty, which a too flattering pencil will slight over, but which, at the same time, is indispensable even to an ideal of the face's character.[43]

The key to many personal dissatisfactions was a lack of the good appearance one idealized for himself and which was not reflected before the searching lens.

Willis also identified another difficulty with the daguerreotype in this aspect of portraiture—one deriving from time and the ability of the sitter to project or reveal himself:

> Some of us know better than others how to put on the best look; some are handsome only when talking, some only when the features are in repose; some have most character in the full face, some in the profile. . . . A portrait-painter usually takes all those matters into account, and, with his dozen or more long sittings, has time enough to make a careful study of how the character is worked out in the physiognomy, and to paint accordingly. But in daguerreotyping, the sitter has to employ this knowledge and exercise this judgement for himself.[44]

Rembrandt Peale felt similarly:

> daguerreotypes and photographs all have their relative merit; and as memorials of regard, are not to be despised. The task of the portrait painter is quite another thing—an effort

of skill, taste, mind, and judgement . . . to render permanent the transient expression of character which may be the most agreeable.[45]

From both these comments it is clear that one source of public dissatisfaction was the rigidity of appearance forced on many sitters by the length of the daguerreotype exposure. Many people were unable to remain truly at ease in this situation and gave forth a stiff likeness which was not well regarded. In other instances this long exposure destroyed the spontaneity of aspect which some persons require to seem fully natural.

In the main, however, the common objection to the image of the daguerreotype was that it did not reflect the personal image a sitter held of himself—it was simply too accurate and too acute. *Godey's* noted some

> various little suggestions by way of improvement that certain persons will make when about sitting for a likeness. A stout, fat lady would like to be made a little smaller, as she is more "fleshy than common;" while a lean one, with a low-necked dress and bare arms, desires a full, handsome bust and round plump arms, as she is just now rather "thinner than common. . . ."[46]

Personal dissatisfaction with one's likeness sometimes reached poetically inspired dimensions as in the case of Emily Dickinson. One daguerreotype of her as a schoolgirl was made in 1848 (Plate 187). It has been repeatedly declared unsatisfactory by her biographers, and it possesses a stiffness of aspect that could hardly have pleased. With so personalized a sense of life as hers, it is possible that this wooden image conditioned her aversion to photographs and other likenesses for long afterward so that in 1862 it may have led her to reply to Colonel Higginson's request for a photograph with genuine if poetic distaste:

> Could you believe me without? I had no portrait, now, but am small, like the wren; and my hair is bold, like the chestnut burr; and my eyes, like the sherry in the glass that the guest leaves. Would this do just as well?

> It often alarms father. He says death might occur, and he has molds of all the rest, but has no mold of me; but I noticed the quick wore off those things in a few days, and forestall the dishonor.[47]

From reactions such as those of Emily Dickinson, Emerson, Webster, Adams, and others, it appears that the daguerreotype became deeply involved with an American sense of what constituted a "good likeness." We have previously considered the daguerreotype with respect to public image building and accuracy of representation. Both these concerns were influential in how far the medium affected popular consciousness of public figures and national character. But when the medium personally impinged on each member of the public, we find a hesitancy about being able to acknowledge the medium without reservations—at least until enough familiarity with it developed for sitters to become conditioned to the results. During decades of being confronted with the fact that everyone could approve one's likeness except oneself, the public of necessity became more

aware that one's self-image was probably not accurate and that the camera saw with the same eye of recognition as did one's relatives and friends, like it or not. The question became a matter of law in an Alabama court case touching on the painting of photographs in 1863 when it was stated judicially that a familiar eye is the best determiner of a "good likeness." The court observed that

> A most important requisite of a good portrait is, that it shall be a correct likeness of the original; and although "experts" may be competent to decide whether it is well executed in other respects, the question whether a portrait is like the person for whom it was intended, is one which it requires no special skill in, or knowledge of, the art of painting to determine. The immediate family of the person represented, or his most intimate friends, are, indeed, as a general rule, the best judges as to whether the artist has succeeded in achieving a faithful likeness. To eyes sharpened by constant and intimate association with the original, defects will be visible, and points of resemblance will appear, which would escape the observation of the practiced critic. "We should think the painter had finished the likeness of a mother very indifferently, if it did not bring home to her children traits of undefinable expression which had escaped every eye but those of familiar affection." The fact of likeness, of resemblance, is one open to the observation of the senses, and no peculiar skill is requisite to qualify one to testify to it.[48]

Such language fits perfectly with the character of an age democratically inclined to believe that each individual was competent to judge merit and worth in most things for himself. It also harmonizes with Emerson's stress on determining truth by keen observation and clear vision. A view that each man is able to decide the value of a portrait irrespective of its artistic technique also corresponds to the sense of Americans that art was somewhat utilitarian and meant to convey the reality of one's visual experience into permanent form. Common encounter with this form of portraiture and concern for questions of judgment previously restricted only to professional artists gave the average American a new orientation toward portrait images. He grew increasingly familiar with having his portrait made and was often pressed into considering its merits. This was the situation which led Root and others to hope that the daguerreotype would prove the means by which new aesthetic sensitivity would come into American life.

One effect of increased photographic portraiture in popular life was that consciousness of picture making became more democratic. In 1861 the *Photographic News* of England voiced what had since become a fact of life in America:

> Photographic portraiture is the best feature of the fine arts for the million that the ingenuity of man has yet devised. It has in this sense swept away many of the illiberal distinctions of rank and wealth, so that the poor man who possesses but a few shillings can command as perfect a lifelike portrait of his wife or child as Sir Thomas Lawrence painted for the most distinguished sovereign of Europe.[49]

During the 1850s this sense of art for the public was further advanced by the field of photography with the introduction of plastic daguerreotype cases. These cases, often called "gutta-percha," "hard rubber" or "composition," are genuine plastic of fine quality.[50]

Manufacturers such as the Florence Company began to produce moulded cases carrying bas-reliefs of paintings by noted artists such as Sir Thomas Lawrence, Emanuel Leutze, and Sir Joshua Reynolds. The Pro-Phy-Lac-Tic Brush Company, successor to the Florence Company, still owns an elaborate die for Leutze's *Washington Crossing the Delaware,* one of the most popular case designs of the period. Other favorite pictures reproduced included John Vanderlyn's *Landing of Columbus,* Raphael's *Madonna of the Chair,* and *The Calmady Children* by Lawrence. In this manner daguerreotype sitters found their own images encased within pictures by great artists originally made for the elite. The effect of such conjunctions was subtly to bring the average sitter closer to a sense of his own aesthetic equality—as was socially the case when he saw his own image next to that of a leading figure on a gallery wall. It must be admitted that this democratizing process never did offset the personal dissatisfaction of many sitters, especially those who desired to project certain types of images, but its effect tended to produce a more nearly unified sort of popular self-awareness which the usual studio situation reinforced.

The strongest impulse to popular employment of daguerreotype portraiture was that of documenting relatives and friends—loved ones of whom few things could be more treasured than a lifelike image. The value of the daguerreotype medium for this purpose was summarized by the operator N. G. Burgess in terms which leave little doubt of the strength of feeling attaching to it:

> No enchantress' wand could be more potent to bring back the loved ones we once cherished than could those faithful resemblances wrought out by this almost magic art of Daguerre. For true indeed has this art been termed magic, as it works with such unerring precision, and with such wonderful celerity, that it only requires the spells and incantations of the device to complete the task. . . . When the speaking eye and warm cheek of loved ones, and the thousands of living statesmen and men of learning shall have passed away and left only their impress upon the tablet, then, and not till then, will this art assert its true greatness.

> Viewed in this light, how valuable are the productions of the Daguerrean artist, and with what pleasurable emotions does he fulfill the task of awarding to his patrons perfect specimens of his skill. The satisfaction so often expressed by friends who have been called to mourn the death of one they loved so much, when they fortunately possessed a likeness of that endeared one, fully compensates for all the perplexities attendant upon their occupation.[51]

This urgency of affection to overcome mortal barriers of distance and time gave the daguerreotypist his most significant duty to the public, and many operators felt it a deep and almost sacred obligation. In 1854 the Webster Brothers of Louisville, Kentucky declared it the "legitmate business" of a daguerreotypist to

> take the form and features of "the loved ones at home," in such a way that when the eye rests on the "shadow" of some departed friend it will become full of soul, which will cause the curtain of the past to "roll back" and permit us to view our "school boy days," when we

gamboled on the green "with light feet and lighter hearts;" this is the kind of photographs we should study to produce, and where before you is the reflection of a sage with nothing before or behind or around to attract the eye; then it is the *man* rises in all his former majesty before you, then it is that your *soul* sees the *man* himself, and until some heedless person calls you "back to earth" you believe you are looking on a "thing of life." We do not like to see *premiums* awarded for fancy or *comic pictures,* it is not what the parent wants of the daughter, nor the wife of the husband, nor the brother of the sister, nor the lover of the beloved, but a true and faithful likeness.[52]

Samuel Morse projected essentially this same awareness of need for permanent images of loved ones in advertising his original studio in 1840:

How cold must be the heart that does not love. How fickle the heart that wishes not to keep the memory of the loved ones for after-times. Such cold and fickle hearts we do not address. But all others are advised to procure miniatures at Professor Morse's Daguerreotype Establishment. . . .

. . . In after-years to retain in our possession the likeness of some one who has been loved by us is a delicious, even if sometimes a melancholy, pleasure. Such a pleasure can anyone enjoy who patronizes Professor Morse, the celebrated Daguerreotype Artist in his Palace of the Sun on Broadway.[53]

Operators continually alluded to this aspect of portraiture with the phrase, "Secure the shadow ere the substance fade." An announcement for the firm of Cannon and Chaffin of Salt Lake City is typical:

Secure the shadow, while the substance yet remains. . . . Do not neglect this opportunity, and say when it is too late, "I wish I had attended to it before." Now's the day and now's the hour; remember that Old Time has no hair on the back part of his head in the place where the hair ought to grow, so you must take him by the foretop.[54]

The portraits of Mr. and Mrs. Elijah Coffin (Plates 188-189) point up the strength of the affectionate impulse to document loved ones. A Quaker couple, the Coffins were opposed to having likenesses made because of the doctrine of their church, but when their daughter was to move 250 miles away following her marriage, they yielded to her pleas by sneaking down a back alley to a daguerreotype studio so that she could carry their likenesses with her. In a closely related manner, sitters for portraits were often shown holding daguerreotype likenesses of their loved ones as an indication of linkage of feeling between themselves and relatives at a distance (Plate 190).

At times concern about portrait likenesses became so strong as to suggest a tendency for the public to respond as intensely to a picture as to its original subject. Such a reaction was particularly likely to come about in the case of portraits of subjects no longer living, but the bond of affection attaching to portraits was often tremendous in any event. *Humphrey's Journal* reported an extreme illustration in 1854. Speaking as a daguerreotypist, the editor noted of the average picture that

In our hands it is a mere article of commerce. But how changed when it is received by those for whom it was originally designed; they look upon every feature, and trace in the expression some happy remembrance. The care exhibited in the charge of this memento is marked by a gentleness known and prompted only by pure love or the warmest friendship. No price can rectify the loss. Such is the feeling in a case recently brought before us. On board of that ill-fated vessel, the San Francisco, was a Daguerreotype—it sunk with the vessel; its owner was saved, and with the warmest anxiety offered a reward of *five thousand dollars* for the recovery of that single impression. This fact is worthy of the consideration of those who are putting off obtaining Daguerreotype likenesses until a more convenient season.[55]

In some instances an image of a beloved person was carefully preserved for a lifetime as a token of feeling. The great pioneer photographer William Henry Jackson made a daguerreotype of a girl he loved in Rutland, Vermont in 1866. Shortly afterward they parted never to meet again, but he kept the small portrait as a treasured memory for nearly eighty years, when it was discovered by his family among his personal effects after his death in 1942.[56]

Children were particularly apt subjects for this aspect of photography. Mrs. Anna L. Snelling, wife of the editor of *The Photographic Art-Journal,* summarized both the impulse to record children in daguerreotypes and the impossibility of doing so adequately to capture the life inherent in them:

> What! put *her* in daguerreotype,
> and victimize the pet!
> Those ruby lips, so cherry-ripe,
> On lifeless silver set!
>
> The frisking, laughing, bouncing thing,
> So full of life and glee—
> A restless bird upon the wing—
> A sunbeam on the sea! . . .
>
> Now she is still—fly to the stand;
> The smiling features trace!
> In vain—up goes a tiny hand,
> And covers half her face.
>
> Give up the task—let childhood be
> Nature's own blooming rose!
> You cannot catch the spirit free,
> Which only childhood knows.
>
> Earth's shadows o'er that brow will pass
> *Then* paint her at your will;
> When time shall make her wish, alas!
> She were a baby still.[57]

Despite the technical problems of photographing children, a sense of the urgency to capture "nature's own blooming rose" before time corrupts it is plain in these verses. To see how completely this impulse was given specific form, we can turn to an illustration which reveals both the desire to capture childhood and the urgency to preserve even an unsatisfactory image if none better could be had. The Minnesota Historical Society owns just such a daguerreotype of Mrs. John H. Stevens and her daughter Mary Elizabeth (Plate 191). The picture was carefully preserved by the Stevens family for years and has been similarly kept for decades by the Society, despite the fact that the child's face is no more than a blur—the image was still regarded as an evocative document to be kept and valued for over a century because it was a portrait of the first white child born in Minneapolis.

At times daguerreotypes were called on to offset the bounds of life itself. As N. G. Burgess put it,

> The Daguerreotype possesses the sublime power to transmit the almost living image of our loved ones; to call up their memories vividly to our mind, and to preserve not only the sparkling eye and winning smile, but to catch the living forms and features of those that are so fondly endeared to us, and to hold them indelibly fixed upon the tablet for years after they have passed away.[58]

The first daguerreotype made in Indiana, in 1844, later became a response to such a concern. The *Indianapolis Star* reported in 1907 on the career of Dr. Oscar F. Fitch, then still living, noting the successful portrait of his youthful love, Phoebe Shirk:

> He still has the picture . . . and it is remarkably clear considering the sixty-three years that have passed since the sunlight brought forth the image from the magic surface of the copper plate. . . . The picture was a success and the romance was a success, for the subject of the daguerreotype later became the bride of Dr. Fitch. She lived but five years after the happy marriage. The grief-stricken husband placed a slab of pure Italian marble at her grave and in it he set the girlhood picture of his young wife. Since the death of Mrs. Fitch, in 1853, the picture has faced storm and sunshine unprotected, and yet the hand of love had done its work so well that the picture may be copied today by any ordinary camera.
>
> Although Dr. Fitch seldom mentions the daguerreotype now, the making of the picture is one of the tenderest and most sacred moments of his long and useful life.[59]

Other gravestones were similarly marked with portrait likenesses by means of daguerreotypes, sometimes in place for up to half a century. In 1891, for example, it was reported that

> A remarkable example of the durability of the daguerreotype is to be found in the old graveyard at Waterford, Conn. In the headstone that marks the grave of a woman who died more than forty years ago, her portrait is inlaid, covered with a moveable portable shield. The portrait is almost as perfect as when it was taken.[60]

The use of life images for gravestones was specifically urged in *Hutchings' California Magazine* in 1857, as part of a plea to deny the sense of death which hovered over graveyards:

> If on every tombstone there could be seen the life-likeness of the sleeper, as with sparkling eye, and noble mien, he walked "a man among men;" or of some gentle lady, whose kindly and generous impulses could be read in every feature of the "face divine;" or of the angel-child, whose joyous laugh, and innocent smile speaks of the loss to its bereaved and loving parents—and of its passage from earth to heaven—how much more inviting would then be the last resting places of the departed,—could we thus seek the "living" among the "dead," and on every tombstone see the living representative of the sleeper.[61]

Even the use of words such as "living" and "life-likeness" in such writings clarifies the sense of the public that daguerreotypes were able to confer a form of immortality by which a sitter could be held indefinitely before a loving eye.

Children were subjects of especial concern in this period because of the high infant-mortality rate in the population. In addition to being satisfied with sometimes inadequate images, the public was grateful for any image at all in cases where none might otherwise have been made. *Godey's* reports an incident which more than one daguerreotypist must have witnessed:

> Not a great while ago, one of our Daguerreotypists observed in his rooms an old lady in deep mourning. She was a stranger, and was looking with evident eagerness along the walls at the various portraits that were exhibited as specimens of the art. All at once she uttered a low exclamation, and then sank half fainting upon a sofa. Water was brought to her, and after a little while she was restored to self-possession. She then stated that news of the death of her only daughter, a resident in the west, had been received by her a few days before. Remembering that a likeness had been taken a short time previous to her going to the west, the faint hope had crossed her mind that there might be a duplicate in the rooms of the Daguerreotypist. She had found it, and gazed once more into the almost speaking face of her child![62]

The Daguerreian Journal reported an incident which reveals the degree to which the magical nature of the daguerreotype's living images impressed the public, even to a point of spiritualism:

> A lady and gentleman called in, and wished to be "Daguerreotyped together." When our arrangements were made, and they were about to "take a seat," the lady remarked, that she had lost a child about three months previous, and desired me to take them with her child upon her lap. As you may imagine, her husband was startled at her request.[63]

A similar misconception of the nature of the photographic process illustrates the degree to which the symbolic nature of daguerreotype images affected the feelings of the public as tokens of lost loved ones. An Irish man approached the operator W. Campbell of Union City, New Jersey with a request that his wife be daguerreotyped. On learning

that the lady was "dead and buried," Mr. Campbell painfully explained that a picture was not possible. He left after Campbell's assurance that any material object could be pictured if put before the camera, rather than only the human face as he somehow had supposed. Shortly after, he returned with a basket and

> proceeded to place the contents on the floor; first came a woman's bonnet, then a shawl, a gown came next, a pair of stockings and a pair of shoes emptied the basket, no; not quite, a small parcel carefully laid on one side was unrolled, and two oranges, one of them half sucked was laid beside the apparel. Amazed, we looked on in silence; there was nothing there we could not take a picture of that was certain.[64]

These preparations being completed,

> "Now then" said he, "ye said ye could take a picture of anything I'd bring, them's the old woman's clothes; it's all I've left of her, an' if ye can give me a picture of them I'll be pleased." At first we were at a loss to know if he were really serious, but there was no mistaking that when we looked in his face, so we proceeded to arrange the clothes in as artistic a fashion as our skill and the subject would permit. We took two pictures, both good, and after colouring them, with an extra touch to the orange at his own request, he took one, and we kept the other. "Thankee Sir," said he, as he left, "them's all I've got of the ould woman, they're sure to get scattered about, but when I looks at this, I shall think I see my wife. Thankee Sir."[65]

Strange as this incident is, it betrays the fact that in some mysterious symbolic way a daguerreotype had the power to evoke a strength of emotional response even the actual picture subject could not. In one sense the picture had a greater affective quality of being real than did the original objects which were represented in an effort to compensate loss by mortality. That the man could think he saw his wife in a picture of her clothes implies an extra dimension of life and permanence attributed to pictures by the public, a dimension of spirit somehow manifest in the photographic images which physical objects of other kinds did not possess.

There were unfortunately many instances in which loved ones were lost and no image remained other than that of memory. This was particularly apt to be so with infants who died before a portrait had been made. Yet so strong was the desire to retain a more reliable likeness than memory could guarantee, that posthumous portraits became fairly common. We have previously considered the funereal aspect of the period by noting the sentimental poetry widespread in popular magazines. Given a climate of sentiment that could appreciate frequent evocations of "The Dying Poet," "The Dying Shepherd," "The Dying Child," "The Grave," and similar subjects, it is perhaps not surprising that the daguerreotypist would have been called on to document the same concern pictorially.

In 1854, *Humphrey's Journal* reprinted an advertisement for a daguerrean studio which indicates how popular the practice of funerary portraiture actually became in some areas:

DAGUERREIAN GALLERY FOR SALE.—The only establishment in a city of 20,000 inhabitants, and where the pictures of deceased persons alone will pay all expenses.[66]

In 1855 the practice was sufficiently popular that the *Photographic and Fine Art Journal* ran an article of advice on how best to take such portraits, noting particularly that

> All likenesses taken after death will of course only resemble the inanimate body, nor will there appear in the portrait anything like life itself, except indeed the sleeping infant, on whose face the playful smile of innocence sometimes steals even after death. This may be and is oft-times transferred to silver plate.[67]

Children were sometimes presented as if sleeping, in arrangements with bed clothes (Plate 192). At other times they were regarded as objects of loss and grief in posed tableaux (Plate 193). Sometimes these posed groupings went beyond conventional bounds to become grotesque, as in the case of a deformed infant flanked by weeping parents.

Usually funerary portraits were straightforward and presented as ordinary likenesses as far as possible. Southworth and Hawes made a number of these studies with some of the same discernment evident in their life portraits (Plate 194). On some occasions the significance of the deceased called for an impressive presentation that removed some of the funereal attitude from the picture, as was the case with a Roman Catholic bishop in full canonicals (Plate 195). In still other instances, a bereaved family might desire whatever remembrance was to be had of a member who had died far from home, and a picture of a grave might become a treasured document (Plate 196). A more generalized form of the same interest is reflected in a number of surviving stereoscopic daguerreotypes of graves and funeral monuments in Cambridge's Mount Auburn cemetery made by Southworth and Hawes for their Grand Parlor Stereoscope.

The sentimentalism of the mid-nineteenth century was not restricted to funereal situations but extended to romance and other aspects of response to life. However, there did seem to be a general cast of melancholy over the age which stressed not only death but unhappy love, separation, and longing reminiscence. As in its recording of lost loved ones, the daguerreotype answered many of these sentimental impulses. The actual or symbolic function of a daguerreotype or of the medium itself appear frequently in various forms of sentimental literature.

Pictures were also used as agencies of romance in ways much like their function in current sentimental fiction. One early news report noted a young woman's advertising for a husband and requesting that prospective candidates submit daguerreotypes of themselves for consideration. As early as 1841, Anson Clark was capitalizing on romantic impulses to promote his business, as is attested by an article in the *Berkshire Eagle* which recounts the manner in which a young man tricks his love into being daguerreotyped and then approaches her for her opinion concerning his intention to marry the subject of the unknown "miniature." Since he had never before declared specific affection,

Ellen started and turned suddenly pale. . . . Amazement, doubt, terror were all depicted upon her face, and she grew a moment paler than before and then, as the conviction came upon her that those were her own sweet features, a blush deeper than the red rose overspread her face, and she gazed eagerly into Henry's face for explanation. . . . Not long ago in the presence of the holy man, she gave unequivocal evidence that she approved his choice.[68]

The daguerreotype appeared in a number of short stories and cheap novels as some sort of plot device or moral agency. In *The Daguerreotype: or Love at First Sight* by Fred. Hunter, published in 1849, a portrait seen in a gallery street display leads a young doctor unwittingly to fall in love with his best friend's wife, with disruptive consequences when the situation becomes clear. In 1846, Augustine Duganne wrote an entire short novel, *The Daguerreotype Miniature or Life in the Empire City,* which relied for its unraveling of plot on a daguerreotype which simultaneously saves the hero's life, identifies him to the heroine, and wins the heroine. In its issue of May 1855, *Harper's New Monthly Magazine* published "The Inconstant Daguerreotype" by an unidentified author. The story might well have been by Hawthorne to judge from its complexity of moral thought and ocular symbolism, although the style leaves much to be desired. A great deal of play is made on the transience of human nature and the constancy of a daguerreotype which in the story becomes fleeting. Two daguerreotypes have fallen in love and are happy until the picture of Ferdinand becomes enamored of the woman who is the original subject of his beloved picture and also begins to assume his sweetheart will likewise come to love his own original. Cecilia, the daguerreotype, muses on what has happened to her lover in a passage which distinctly foreshadows by decades the moral interconnection between a person and a portrait which Oscar Wilde was to explore in his *Picture of Dorian Grey*:

Ferdinand was changed! Yes, in this thought she must needs be confirmed when she saw in him the hateful idea that it was possible for her, for Cecilia, to love another! A daguerreotype change! Yes, she fancied she could trace upon that plate, once so highly polished, spots and stains. She remembered hearing that if the air were allowed to penetrate to the plate of a daguerreotype, it was destructive to its impression. Yes, the air must have penetrated to Ferdinand—the air of the world! It was that which had stained his purity, and impaired his refinement![69]

The story also contains a suggestion that living persons absorb traits of character from daguerreotype images:

It was not unnatural that, living under the influence of such a daguerreotype as Cecilia, [her friend] should be affected by that refinement of feeling that it always presented to her. During two years, the ideal Cecilia had been taking her character from the daguerreotype Cecilia.[70]

The plot is finally resolved unhappily when the real Cecilia sees the real Ferdinand and, finding that she can never love the reality as she does the picture, steals the portrait and

disappears forever. The pictorial Cecilia falls from the wall and is scratched away by the shattering of her glass.

Other writings featured the daguerreotype process in various ways as symbolic answers to a considerable range of concerns. Dion Boucicault adapted a peculiar self-operating form of photography into his play *The Octoroon* to serve as the agency of moral retribution against the villain of the plot. Despite the oddity of a self-developing picture and a camera which selects a single image out of a sequence of actions performed before it, Boucicault's treatment of photography is closely related to the sense of the public of the accuracy and reliability of the medium. Early in the play, when the photographer tests his apparatus, he describes it in terms that establish its inerrancy:

> The apparatus can't mistake. When I travelled round with this machine, the homely folks used to sing out, "Hillo, mister, this ain't like me!" "Ma'am," says I, "the apparatus can't mistake." "But, mister, that ain't my nose." "Ma'am, your nose drawed it. The machine can't err—you may mistake your phiz but the apparatus don't." "But, sir, it ain't agreeable." "No, ma'am, the truth seldom is."[71]

After this preparation, the camera witnesses a murder and, even though smashed by an Indian who is later accused of the murder, has made its fateful record. When the plate is at last revealed and the actual murderer unmasked, the evidence of the camera is described in terms which closely relate it to the all-seeing divine eye of truth:

> You slew him with that tomahawk; and as you stood over his body with the letter in your hand, you thought that no witness saw the deed, that no eye was on you—but there was, Jacob M'Closkey, there was. The eye of the Eternal was on you—the blessed sun in heaven, that, looking down, struck upon this plate the image of the deed. Here you are in the very attitude of your crime![72]

As late as August 1862, after the daguerreotype process was essentially out of use, a mystical fascination still clung to it for literary fancies. In an anonymous short story, "My Lost Art," *The Atlantic Monthly* carried an account of magical scientific applications of the daguerreotype by which human life was seen on the planet Jupiter. The story reflects the atmosphere of the Great Moon Hoax retold in the idiom of Edgar Allen Poe or Fitz-James O'Brien. As with the magical aura given the photographic medium in *The Octoroon,* this story carries a sense of confusion between science and magic which the public often seems to have felt to be somehow inherent in the mirror pictures. The same sense was carried to an extreme in a short story, "The Magnetic Daguerreotypes," reprinted in *The Photographic Art-Journal* in June 1852. In this instance the evil and satanic Professor Ariovistus Dunkelheim devises a new form of daguerreotype that not only captures a permanent likeness but takes a living image which shows a viewer what the subject is doing at any time. The disastrous emotional effect of this on the courtship and marriage of a young couple can be imagined and is satisfactorily resolved with the self-justified murder of the Professor by the young hero.

Both of these short stories and Boucicault's play reflect a conception of the photo-

222

THE DAGUERREOTYPE AS HUMAN TRUTH

graphic medium as something which effectively if mysteriously granted its age powers to exceed the limits of time and space. For the public at large it somehow appeared to answer problems of symbolic importance. Again, it must be noted that an aura of permanence and discernment subconsciously colored thinking about the daguerreotype so completely that a sense of immortality was frequently evoked by it. Actual photographic events attest further to this conception of the medium. As early as 1841 the L. P. Hayden studio of New York was advertising the still novel pictures in such terms:

> The Daguerreotype art is nothing more or less than the power of rendering shadows tangible. It is a process by which the reflection of the sitter is permanently retained on the plate. . . . The silver plates on which they are taken, remain unaffected by time. . . . They will retain the expression fresh and unimpaired for centuries.[73]

At the laying of the cornerstone of the Temple Street Reservoir in Boston in 1847, Mayor Josiah Quincy, Jr., betrayed a similar concern for the immortality which the daguerreotype was able to bestow:

> To enliven the scene, after, or during, the settling of the corner-stone, the Mayor requested the crowd, or the principal *actors,* to face the *lens* of a Daguerreotypist, perched up in an opposite window, for the purpose of catching a view of the performance and performers of this interesting occasion. "That the people of distant ages," said Josiah, "may also form some opinion of what a good-looking set of fellows we all were that laid this cornerstone!" Of course this was the *proper* place for the *laugh* to come in, and a grand guffaw took place, as well as a general gaze (with their best looks) upon the camera of the daguerreotypist up in the opposite window. There was something of a jostle, too, to get good positions and prominent display of faces, each of the ambitious desiring, doubtless, to look important in the eyes of future ages.[74]

The humor of the occasion cannot mask the fact that these men were concerned to leave a direct and permanent memory of themselves to later generations even should their names be lost.

The same impulse to make a permanent report of people at significant events is visible in a plate of another historic occasion. On February 14, 1853 the entire population of Salt Lake City came together for ground-breaking ceremonies for the foundation of the Mormon Temple and were daguerreotyped *en masse* (Plate 197). The plate shown here is one of two widely differing exposures made at the time to guarantee that at least one was correct. The cameraman followed this standard photographic practice of "bracketing" his exposure because he felt an urgency not to lose the record of the event through technical failure. History had to be served and the demonstration of the functional truth of Mormon beliefs had to be clear in a picture which could serve as a lesson to the outside world and which would render the event itself more permanent than a memory could be. When the Jones Expedition stopped in Salt Lake City in 1851, the *Deseret News* carried a telling commentary on their activities which specifically indicates this conception of photographic images as permanent indicators of truth as the Mormons felt they possessed it:

These gentlemen are Daguerreotyping the whole country for a grand Panorama. They have many fine pictures, and *have taken some elegant views of our "settlements" and the city, which are perfect, for Daguerreotypes cannot lie.* They will astonish the "gentiles" of the "States" when they show them what the "Lords' [sic] people of the latter days," have accomplished by unity and faith—in the short space of three years.[75]

If the pictures were obviously correct and permanent, a form of direct communication with future generations could be achieved. The living ideals of the Mormons could be presented in their apparent truth by means of a visual demonstration which could not adequately be rendered in words or other media. As George A. Townsend expressed a similar thought in his 1891 interview with Mathew Brady, "For want of such art . . . we worship the Jesus of the painters, knowing not the face of our Redeemer."[76] A picture such as the Temple ground breaking assured the Mormons that their latter-day history need not include laments about evidence of what had been accomplished as did a news article in speaking of earlier days:

What would we now give to see before us the realities of past history,—to see Jerusalem with its dazzling temple when it contained its nine millions of inhabitants,—to see encamped the hosts of Israel. . . .[77]

It is in picture situations such as these in Boston and Salt Lake City that public response to the daguerreotypist's medium visibly began to display a sense of historic iconology. When bodies of people taking part in noteworthy events were so deliberately involved with pictorial situations, a form of group consciousness of communication with later generations was activated. We have also seen, however, that the greatest use of the medium was in answer to demands for pictures from individuals motivated by personal feelings. The commonality of public experience in the picture-making situation from one part of the United States to another tended to universalize the responses of the people into national behavior and attitudes held in general.

Americans were repeatedly presented to themselves in similar pictorial ways. In some cases the public determined this similarity by acquiescing to current style trends or in responding to wishes to appear in desirable ways. In other instances the daguerreotype studio with its standard fixtures and methods and its conventional gallery displays tended to exert a standardizing pressure on sitters. In still other situations sitters responded more or less spontaneously to the picture-making event but were moved to do so by concerns freely broadcast within the era—such as highly sentimentalized popular moods of melancholy romance and morbidity. Similarly a sense of self-satisfaction in nineteenth-century America with her national role and position in history led to great public concern with images of characteristic leading men and events. We have already examined the conscious development of national portrait galleries of leading men intended to make Americans aware of who and what they were in terms of national character. This same consciousness prevailed at the level of the individual studio which displayed and sold portraits of the famous along with those of its everyday clients.

The ultimate determiner of a type of national iconography of character, however, was the presence of millions of individual pictures in households and public places in every part of the nation. Good, bad, or indifferent, these pictures taken together formed a comprehensive account of how the American public could see itself—each person responding in his own way to his image and to the images of others. Yet the specific pictures themselves limited what each person had as an available vision of himself or others. The presence of myriads of images stood for two decades as a tacit report of how Americans looked before the camera. Whether they liked the comprehensive image or not, it was theirs to emulate or reject. Merely by its presence, such a body of pictures conditioned the process of visual perception along particular lines of development so that people came to conceive of certain kinds of visual images as being true, or permanent, or typical. In such a fashion, and quite unconsciously, the public fell into stock postures for portraits and came to accept the searching vision of the camera as accurate in fact even while they tried to standardize it or wished to soften it. The truth of the daguerreotype likeness might be challenged as unflattering, but it came eventually to be felt as inescapable by the average person—who tolerated his portrait as "an ugly little thing, and a capital likeness."[78]

For some the accuracy of the camera encouraged acceptance of unpleasant physical facts as if, like Cromwell's warts, they became positive elements of the person once they were clearly and permanently recorded. A cross-eyed woman (Plate 198) or a man with a defective hand (Plate 199) could be presented in standard manner without evasion once they understood that a photograph was reliable and truthful. In such instances only a direct record would be other than a lie. For Americans the basic facts had to be perceived accurately within the conventional patterns of the day. Daguerreotypists considered flattering angles of view and favorable lighting, but they were primarily concerned with defining the sitter in the strongest truth of his character. If that character was sometimes unfavorable, it was still regarded as the central object of concern so specifically that it tended to become the measure of judgment for portraiture in general. Once we grasp the completeness of that concern nationally in American response to daguerreotype photography, we recognize that the mid-nineteenth century has defined for later generations how we shall conceive of it visually with great care and finality. If the American of the time did not similarly know himself pictorially, it was not for lack of opportunity. As *Godey's* observed at the time,

> If our children and children's children to the third and fourth generation are not in possession of portraits of their ancestors, it will be no fault of the Daguerreotypists of the present day. . . .[79]

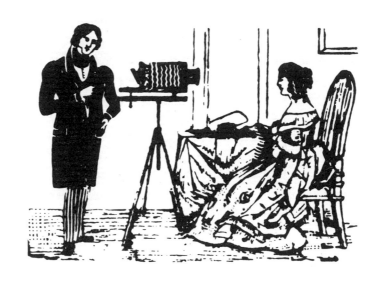

Chapter 9

THE MIRROR OF AMERICA

THE DAGUERREOTYPE completely captured public favor in America during the twenty years before the Civil War. In that time it answered a myriad of needs with effectiveness, and it played a major part in the cultural development of the time. As a technological medium in the hands of devoted operators, the daguerreotype was assimilated into national consciousness as few inventions have been accepted in history. No other nation produced more or better daguerreotypes, and no other nation more widely employed the medium than the United States. When all the facets of the daguerreotype's use in America come together for review, we can summarize the medium's function in three primary ways—it served as a direct aid to cultural nationalism, it helped Americans adjust themselves intuitively to the transition from an agrarian to a technological society, and it was ultimately a reflection of spiritual concerns motivating the nation.

The first half of the nineteenth century found Americans eager to produce national artifacts of culture whenever possible, preferring to endorse native conceptions loudly

or to berate just as loudly an absence in local productions of quality equal to that of European productions. Within such a climate of nationalistic impulse, it is not surprising that stress should have been laid on the worth of what America excelled at doing. Hence the attitude of a man like Horatio Greenough, who warned against expecting Americans to sit down in the wilderness between an Indian and a rattlesnake to play European airs on the violin. Hence, also, the stress of Greenough and others on the mechanical ingenuity of America, which was often given favorable attention as being worth more than artistic luxuries in answering national needs. In such a climate Horace Greeley grew so excited about the significance of anything at all American in competition against Europe at the Crystal Palace Exposition that he could twit the Europeans by referring to Yankee ploughs, hoes, wood screws, axes, clocks, and even cut nails.[1] In such a time anything which could enhance national feelings or reflect national qualities stood to become a source of pride.

Greeley hailed American superiority with the photographic medium at London, observing that in "Daguerreotypes . . . we beat the world."[2] Not only did Greeley appropriate the French invention to the ends of American nationalism, but American daguerreotypists themselves had already given him basis for doing so with their refinements of the medium universally called "the American process." At the Exposition, Mathew Brady led the victorious Americans by placing in competition a summary of American character mirrored in the faces of the nation's leading men. He was joined at the Crystal Palace in stamping "Made in America" upon use of the medium by operators such as Jesse Whitehurst who presented Niagara Falls to the Europeans, and John Adams Whipple who captured the moon and sent it to London on a silver plate.

The Crystal Palace triumph merely emphasized the fact that America was nationally involved with the photographic medium. Throughout the period at home, daguerreotypists in all parts of the country were at least indirectly active under the same impulses to define American culture pictorially. There was Insley's American cities project which was planned to summarize the urban face of the nation into one definitive exhibition. There was Barnum's project of identifying the first "Miss America" by photographic competition. There were Vance's *Views in California* and Jones's *Pantoscope* of half the continent, of which it was proudly said that

> American scenery and American talent have here stamped their own eulogy—and an eloquent one it is! Such productions make us proud of our country and our countrymen![3]

The list of activities and operators was varied—Carvalho in the Rockies, Anthony on the Maine boundary, Brown with the Japan expedition, Moore and Walter in the Capitol, Simpson up and down the Mississippi, Ryder moving across New York and Ohio, Hesler on the inland rivers, Draper in the laboratory of New York University, Whipple at the Harvard Observatory, and portrait-makers everywhere.

The portrait-makers in particular grappled with the problem of national character.

Their work reflected the underlying feeling that the true nature of the American would stand revealed if only adequate representations of each citizen could be produced. Most daguerreotypists were concerned with reflecting the maximum of character in making a portrait. They sought to reveal the individual person whether he was an ordinary citizen (Plate 188) or a leading figure such as Lemuel Shaw (Plate 162). It was generally felt in the trade that a searching portrait was the best indication available of who a person was and what he meant to his loved ones—and successful portraits were displayed in every studio in the country, where Americans were confronted with Americans as the daguerreotype revealed them. Characteristic types such as Fitzgibbon's portrait of the Arkansaw Traveler were juxtaposed with the remarkable, such as a portrait of General Tom Thumb, until a mosaic of images was spread before the public that displayed every attribute of the people and their moods.

In summarizing attributes and appearances, daguerreotypists came to the point of deliberately attempting to define national characteristics. Expanded summaries such as Brady's collection at the Crystal Palace and Anthony's National Daguerreotype Miniature Gallery were conscious efforts to display the nation in her ideal character as defined by images of the men who determined it. Great popular attendance at such exhibitions and at other summarizing projections such as the *Pantoscope* indicate that Americans found encouragement and reinforcement as nationals in these pictures. Gabriel Harrison romantically expressed the nationalistic sentiment that welled up in him during contemplation of such a pantheon:

> here let me rest, and do homage at the shrine of my country's glory, for my soul hath its content so absolute, that if it were now to die, it were now to be most happy.[4]

In nationalistic summations of this type, a conscious didactic element is visible. The daguerreotypist saw his role as one of guide as well as recorder. Mathew Brady spoke of the influence of the daguerreotype as having "found its way where other phases of artistic beauty would have been disregarded."[5] Marcus Root wrote of the daguerreotype's power to "train society" even at the level of the

> specimens, inferior as so many of them are, exhibited at the doors of the Heliographic Galleries, in numbers of our city streets [which] constitute a sort of artistic school for the developing of idealistic capabilities of the masses. . . .[6]

Operators such as these tried consciously through pictures to educate Americans about themselves and about the qualities of their society and their time. Root and Brady both made clear that the individual portrait and the collection were significant elements in this national encouragement of taste and response to ideals. Even non-professionals became sensitive to the didactic potential of national picture collections. A congressional committee noted of Brady's gallery of celebrity portraits that, if put on permanent display in the Library of Congress, it would "exert the most salutary influence, kindling the patriotism as well as the artistic taste of the people."[7]

In a subsidiary way, the operation of the daguerreotype was pressed beyond defining America for Americans to the point of informing other nations of how Americans saw the world. Eliphalet Brown, Jr. applied American vision to the opening of Japan. His selection of subject matter and his interpretation of it in pictures were the basis of the first representations of the hidden land for the outside world. Similarly, Americans actively recorded the appearance of far places such as the Philippines, Hawaii, Mexico, and South America. North Americans were often first to introduce the photographic medium into Central and South America where they established extensive portrait practices that set the style for native developments. Even in Europe an American often stood as one of the leading daguerreotypists in a chief city—Warren Thompson was a major operator in Paris and John Jabez Edwin Mayall vitalized the trade in London. London and Paris alike acclaimed Draper and Whipple for scientific and astronomical daguerreotypes. Both American vision and American technology were thus influential in the development of daguerreotype photography over much of the world even before the full international triumph with the medium came at the Crystal Palace.

During the decades before and after the Crystal Palace Exposition, the daguerreotype quietly operated in American life as an instrument of cultural transition. In addition to helping Americans regard themselves as persons and as nationals, the mirror-pictures provided a bridge over which national society moved toward wider acceptance of machine technology into everyday affairs. Personal visual art was linked to the machine more closely than before.

The 1840s and '50s saw a burgeoning of mechanical ingenuity across American life —the telegraph, the sewing machine, the reaper, prefabricated building, refrigeration transport, mass-production factory methods, expanding railroads, gas lighting, and a host of other marvels. Despite fascination with the new devices themselves, the public was often bewildered or hesitant about the speed of change, particularly when traditional ways seemed threatened.

Hawthorne wrote unhappily about the despoiling of the wilderness by railroads; Thoreau questioned the value of immediate telegraphic communication between Maine and Texas when Maine and Texas had nothing to say to each other. Melville wrote in horror of the human ruin brought about by mass-production machines, and substantial numbers of people located utopian communities around the country hoping to restore the simplicity of agrarian ways of living as the basis of American life. Hardly a technological innovation appeared in those years without challenge from some quarter. Yet, once the painters were satisfied of their safety, nobody seriously challenged the daguerreotype because it was a mechanical product. Hawthorne wrote *The House of the Seven Gables* as a major work based on the character and perception of a daguerreotypist without any qualms about the technical nature of the medium—the medium was acceptable because it served human needs and because it was both utilitarian and reliable as to its truth. Thoreau was willing to accept the value of the medium because it used nature in its work. The founders of the experimental communities often avoided

new mechanical artifacts, but many did not hesitate to sit for their portraits. Most of the leading figures of Brook Farm, for example, are visible to history through daguerreotypes.

Many people never really understood the daguerreotype process. The medium was confused with magic, with the telegraph, or with some sort of divine power from the sun. Some people credited the camera with being able to produce likenesses of absent persons; others felt it could produce a likeness with a new suit of clothes or neatly combed hair lacking in the original sitter; many never understood the need to sit still during an exposure. Yet, despite all sorts of incomprehension, the daguerreotype remained a piece of mechanical technology acceptable in nearly every household in America without hesitation other, perhaps, than vanity. In general, the feeling prevailed that the mechanical nature of the process guaranteed its freedom from human fallibility. A common ground of trust was soon established which equated a picture made by the camera with the truth of a direct perception. Once this sort of reliability was attributed to the medium and it was placed into wide use, it was inevitable that national imagery should henceforth have to base itself on the evidence of the machine. Political candidates must "daguerreotype" themselves on the public imagination; popular portraiture of statesmen, entertainers, or criminals in the press had to credit origin in the daguerreotype when laying claim to accuracy. Painters had to accept the conventionalized appearance of daguerreotype portraits as well as being forced to try to outdo the realism of detail characteristic of photography.

The fact that public imagery came to be so closely reliant upon the daguerreotype as a mechanical medium inevitably affected public perception and public modes of thinking. Once an image could be certified as reliable by its origin in a daguerreotype, it was acceptable as definitive truth to be questioned thereafter only on the basis of a better image produced by the same means. Through such circumstances, definitive collections such as those of Anthony or Brady exerted their nationalistic effect *because* of their reliable basis of mechanical vision. As a result of such a connection between mechanically defined truth and public perception, new types of responses were created within the public which helped prepare the nation to face the Civil War. The public image of war before 1860 was largely a stylized and romantic conception provided by the sketch artist or the documentary painter, both of whom usually softened the ugliness of reality. But a nation accustomed by twenty years of photographic experience to even unpleasant visual truth was prepared in new ways to meet the horror of the Civil War when confronted with it by the camera. While the daguerreotype was almost completely out of use by 1860, its photographic successors, the tintype and the paper print, owed their acceptance in large part to the same reliability the silver plates had first brought into the world.

When Mathew Brady organized his great staff of cameramen and brought war home into the private parlors of America, the public saw a divided nation bent upon destroying itself. Oliver Wendell Holmes wrote of some of the Brady war prints,

It is so nearly like visiting the battlefields to look over these views that all the emotions excited by the actual sight of the stained and sordid scene, strewed with rags and wrecks, came back to us, and we buried them in the recesses of our cabinet as we would have buried the mutilated remains of the dead they too vividly represented.[8]

Holmes's reaction equates the photographs with reality in terms of emotional response and intensity of experience. In this fashion the public was directly confronted with the fact of the War. Coming as this confrontation did, at the end of twenty years of expansive nationalism which was partially consolidated by photographic means, it relied upon a national public conditioned by pictures. The camera *as a machine* first prepared Americans to define themselves more certainly as Americans, and then it prepared them to face with a new directness the sight of potential destruction of the nation. In this light it is possible to suggest that without prior conditioning by the daguerreotype, America would not have been intuitively ready to experience the Civil War.

By 1865, both the daguerreotype and the exuberant nationalism of the 1840s were gone from the American scene, yet each had contributed substantial elements to the culture that emerged out of the trials of war. Each had activated public response by means of the other, and both had aided in the definition of American society. In particular the daguerreotype had given visible form to otherwise indefinite aspects of national feeling, making ideals and qualities accessible to direct experience. Daguerreotypes which permanently recorded events such as the ground breaking for the Mormon Temple or the laying of the Boston Reservoir cornerstone linked the feelings of the public inescapably to history. By viewing a picture, one could participate in the first westerner's vision of Japan or the mood of the Rockies before white men came. Moments in time remained forever in the present. Leaders such as Jackson or Webster became humanly immortal in their own living features, remaining men before the public eye while becoming national symbols within the public heart. As it was observed of Brady's "Photographic Pantheon,"

> the votive genius of American art has perpetuated, with the unerring fidelity with which the lens of the camera does its inimitable work, not only the likeness of form and feature, but the very expression, of those in whose achievements in all walks of life the American heart takes pride, and whose memory we endeavor to glorify by whatsoever means it is in our power to exert.[9]

Regarded in this way, the daguerreotype is not only a technological medium of art and a source of national pride, but it is also a means of projecting direct experience into the realm of affective symbol in American society.

We have seen repeatedly how far the public responded to daguerreotype images as if to reality, tending to treat pictures as direct experiences. Pictorial influences operated on every level of consciousness from the most personally valued sentimental portrait to the national pantheon of historic figures. Marcus Root remarked of these influences that

not only our near and dear are thus kept with us; the great and the good, the heroes, saints, and sages . . . are, by these lifelike "presentments," brought within the constant purview of the young, the middle-aged, and the old. The pure, the high, the noble traits beaming from these faces and forms,—who shall measure the greatness of their effect on the impressionable minds of those who catch sight of them at every turn?[10]

If Root's view was overly idealistic, the pictures nevertheless operated in significant symbolic ways by evoking memory, by preserving sentiment, or by broadening experience beyond one's immediate environment. The pathetic eagerness of a man studying the daguerreotype of his dead wife's clothes in order to remember her is of a symbolic part with Jared Sparks's fascination at seeing in a daguerreotype of the moon undeniable evidence of the rotation of the earth which he could not experience directly otherwise. Both turned to photographs to perceive things they felt to be real and important because the camera bore witness reliably and left a permanent record of what was observed.

In the final analysis, however, it is at the level of the spirit that we must seek for the most important operations of the daguerreotype in American life. The medium was certainly a technological process which served nationalistic ends and which sharpened direct experience with symbolic influences throughout American life. But its use was basically a further manifestation of existing national faith in spiritual insight derived from nature.

The period of the introduction of daguerreotypy into America was also the period of Emerson's ocular concern for spiritual insight through perceiving nature. This was the time when Emerson could speak of becoming a "transparent eyeball" as the means to achieving unity in creation with God. This thought of seeing beyond the surface of nature by keenly observing the surface was ideally the same concern for perception as the wish of the portrait maker to reveal the inner character of his sitter by making a searching likeness of his features. The daguerreotypist's concern was specifically enunciated by Hawthorne as a way of relating the photographic medium to the spiritual truth of nature. In the words of Holgrave, the novelist's typical example of the American daguerreotype artist,

> There is a wonderful insight in heaven's broad and simple sunshine. While we give it credit only for depicting the merest surface, it actually brings out the secret character with a truth that no painter would ever venture upon, even could he detect it.[11]

As Holgrave speaks the thought, it is actually nature herself who provides the insights of truth—the sun sees all things more precisely than even a painter can. We have also seen that Dion Boucicault drew upon the same thought of the all-seeing eye of heaven as an agent of justice projecting its truth through the camera in *The Octoroon*. The camera thus becomes a sort of insight machine by which limited human capacity is enabled to receive the truth which nature provides out of herself. It becomes a means of intensifying human perception to the point that man can produce pictorial records of the essence underlying nature and within man himself.

Dr. Edward Hitchcock, President of Amherst College from 1845 to 1854, saw nature as the source of a total photographic record of the character and existence of man within the universe. A former Congregationalist minister, he preached on the idea that the image of whatever man does is imprinted on the fabric of the universe forever—a permanent moral record of the history of human existence to be observed by a greater Being able to see it—making the entire universe a great picture gallery in which the truth alone remains of what man has been.[12]

Emerson himself, and others such as Thoreau, relied specifically on the landscape in their search after spiritual insight. Emerson's speculations about the Oversoul began with observation of the forest or the countryside. Thoreau wrote of the uplift of the spirit of a locomotive driver who recalled visual images of Walden Pond. One of the oldest surviving daguerreotypes in America is a simple view of a tree in a meadow made in the summer of 1840 (Plate 14) which still carries a sense of perception beyond the visible facts—a transcendental experience recorded in permanent form. The daguerreotypist Solomon Carvalho reported in words the feelings of a man making a picture during such an experience at the summit of the Rocky Mountains:

> Standing as it were in this vestibule of God's holy Temple, I forgot I was of this mundane sphere; the divine part of man elevated itself, undisturbed by the influences of this world. I looked from nature, up to nature's God, more chastened and purified than I ever felt before.
> Plunged up to my middle in snow, I made a panorama of the continuous ranges of mountains around us.[13]

For Carvalho the making of the picture was the necessary completing step in the experience; he had to capture a permanently reliable image of the truth he found. In the American view, the spiritual insight arising from such an experience ultimately depended on the objective recording accuracy of the photographic machine.

Strictly speaking, the daguerreotype process was involved with objectivity at two levels, both of which contributed significantly to the ways Americans employed the medium. The more obvious function of the process was that of an objective recorder relatively not subject to human fallibility of vision and interpretation. If the camera reported the appearance of something in a particular way, the public quickly accepted that view as the way the subject really was. The adage grew that the camera did not lie, and one soon came to feel that truth was best served under the lens and the light of the sun. When both mechanical technology and nature agreed on something, few were eager to argue.

At the same time, however, use of the daguerreotype revealed a public fascination with objects as such which offset widespread uneasiness at the speed of technological change. It is worthy of note that substantial numbers of daguerreotype pictures were made of objects of some sort, though their presentation often exceeds mere surface recording. Once the medium became sensitive enough to be applied to human beings, the necessity of photographing inanimate objects was ended, but the practice continued.

Such subject matter as locomotives, ships, buildings, and wagons was common, but an underlying interest in "things" by the public demanded photographs that sometimes reflected the taste and the subconscious concerns of the time rather obviously. Southworth and Hawes, for example, capitalized on the sentimental aura of morbidity that prevailed in the 1850s by producing an entire series of stereo views of tombs and monuments in Cambridge's Mount Auburn Cemetery. On another occasion, they made several views of a popular statue for the stereoscope which were attended with greater interest by the public than the statue itself.

It reflects the increasingly technological aspect of the period that many "object" pictures are of machines of one sort or another—trains, steamships, a telegraph device, a 400-day clock treated as equally important with its builder (Plate 116) . At times certain of these machines were treated visually as they sometimes were in fact, with regard almost approaching reverence. A case in point is a plate of a splendid fire engine (Plate 200) . The engine is seen as a shining and monumental object, its brightness and decoration magnified by its being lighted against a dark background from which it emerges with a thrusting force suggesting the power in the machine. The camera angle has been carefully chosen to display the engine with a strongly linear movement that emphasizes its grace and its implicit mobility. One is made to feel most certainly that here is a striking object. Its visual presentation is as impressive as the affection undoubtedly given it by the fire company which operated it. John Kouwenhoven notes, in *Made in America,* an extensive concern of Americans for such machines, pointing out from historical evidence that fascination with machinery reached a national intensity in the 1850s with fire engines.[14]

The daguerreotype combined objectively accurate recording with recording of objects in a way that made it ideal for reporting the details of situations using machinery. For this reason, the medium was repeatedly employed in the California mining region, where it was commented that

> The daguerreotype is especially suited to reproduce all these mechanical mining devices. In the mining region nature, too, seems bare of all cheerful embellishments, with a stark contrast between the naked masses of rock and the thin, straggly pine woods. Luxurious foliage is seen but rarely. Rich material for observation is offered in the photographic views of the American River region exhibited in Vance's Panorama. Similar photographs of other mining regions would complete a picture gallery the inspection of which would almost be a substitute for a visit to the places themselves.[15] [Plates 47, 60, 96, 98.]

At times pictures made as exact records of machinery became visual conceptions of genuine aesthetic power, as in the instance of a plate of a machine for washing gravel (Plate 201) . Presented as a starkly lighted object against a dark background, the machine is seen as directly as a composition of modernistic sculpture. The picture signalizes an unconscious insight into functional beauty that visibly exceeds the documentary reason for which it was probably made.

The same method of stressing the objective character of the subject of a picture by

lighting it against a dark ground was, as we have seen, a portrait practice of the Brady studio, and it was the method Brady employed in his victorious series of portraits at the Crystal Palace. Like most of the serious daguerreotypists, Brady was concerned to reveal the sitter's inner nature as far as possible by means of the searching objectivity of his images. It appears that such a method was employed throughout daguerreotype photography whether one was trying merely to record fact or was grasping insight by means of searching beyond visible fact. The effect of this treatment was rather widely to create portrait likenesses in which the sitter was literally treated as an object to be regarded by the camera in the same way as it would examine a mining machine or a statue (Plate 202). In this way Dolley Madison is humanly revealed, but she is presented for scrutiny as if she were some sort of mechanical specimen. A viewer can respond subjectively to her personality because she is presented as objectively as if under a microscope. Aside from its appeal to the American public on grounds of its accuracy in reporting factual truth, this employment of the medium provided a common ground for the seemingly opposed impulses to mechanical "objectivity" in looking at the world on the one hand and to a search for transcendent spiritual insight beyond "things" on the other.

The daguerreotype process itself appealed to its operators partly because of the appeal of the "things" employed in using it—the camera in particular. In the reminiscences of James F. Ryder we can see his fascination with the technological character of the machine combined with awe at the spiritual insight of the wonderful device. Referring to his "little box machine," fifty years later, Ryder described his first camera in terms glowing with charm and affection:

> I can picture it in my mind's eye now as plainly as though I had seen it last week. I can see its rosewood veneer, the edges at front and back chamfered to an angle of forty-five degrees; its sliding inside box, with the focusing glass which was drawn up and out of the top through open doors and the plateholder was slid down into its place. These doors were hinged to open one toward the front and the other toward the back, each having a little knob of turned bone by which to lift it, and there were two little inset knobs of the same material turned into the top of the box upon which the knobs of the doors should strike, and the concussion of those bone knobs more than fifty years ago is remembered today as plainly as though I had been hearing them every day from then until now; while the odor of iodine from the coated plates in that dear old box lingers with me like a dream. The box was the body, the lens was the soul, with an "all-seeing eye," and the gift of carrying the image to the plate.[16]

There is no doubt in Ryder's view that his camera held the power of discernment and searching insight. He personifies the machine as

> truth itself. What he told me was as gospel. No misrepresentations, no deceits, no equivocations. He saw the world without prejudices; he looked upon humanity with an eye single to justice. What he saw was faithfully reported, exact, and without blemish.

> He could read and prove character in a man's face at sight. To his eye a rogue was a rogue; the honest man, when found, was recognized and properly estimated.[17]

A machine gifted with discernment of character and truth must have seemed the ultimately desirable fusion of technology and natural spirit to an age eagerly concerned with both.

The pictures made by the daguerreotype process in themselves held a great public appeal as objects. From the beginning they were spoken of as "fairy work" or "a gem," and one of the first reviews of an American photograph referred to sunbeams captured in a morocco case with golden clasps.[18] The pictures were normally presented in the most elaborate fashion ever given photographs. Styles of picture cases usually determined picture costs and were limited only by the taste and purse of the sitter. Pictures were encased in plastic copies of noted paintings or in carved leather or in stamped *papier-mâché* as a general rule, but some pictures received hand-painted covers or inlay work. In particularly elaborate instances cases were made of pieced mother-of-pearl, ivory, or solid silver. Within the case, even the simplest picture usually was enhanced with a gilt-brass mat and an inner cover of padded satin or figured velvet. Part of the justification of these fancy packages doubtless came from the delicate beauty of detail captured by the medium.

No other photographic process has ever matched the subtlety of rendering of the daguerreotype. Even mundane objects or unattractive sitters emerged from a daguerreotype session with an image of heightened appeal and delicacy resulting from precise rendering of light and dark. In 1839 the New York press was already remarking on this characteristic of the medium. "It is surprising how beautiful appears almost any assemblage of objects delineated by the help of the Daguerreotype."[19] This quality of intensified preciousness has remained part of the nature of photography and has sometimes made difficult the rendering of deliberately ugly images. The jewel-like quality of the daguerreotype so forcefully presented viewers with this increase of visual appeal of any subject that only the most incompetently made pictures ever seem unappealing even today. All the more reason, then, why the public before the Civil War should have been fascinated by the charm of these beautiful little images and treated them as precious things. Even within this concern for "things," however, the pictures carried a spiritual implication because of their power to evoke feelings and carry the viewer beyond the limits of time, place, and memory. No part of the interplay between the objects of daguerreotypy and the operators or the public was completely free of hints of greater truth lying beyond the facts of surface reality.

Irrespective of any of the medium's other qualities—its permanence, its accuracy, its beauty and subtlety, its objective totality of rendering, or its evocative power—it is to the fact that these pictures always seem to reflect a greater truth beyond what is seen and recorded that we must turn for our essential recognition of what the medium was. Thoreau seemed quite early to sense the implications of this fact. In 1841 he wrote,

> It is easy to repeat, but hard to originate. Nature is readily made to repeat herself in a thousand forms, and in the daguerreotype her own light is amanuensis, and the picture too has more than a surface significance,—a depth equal to the prospect,—so that the mi-

237

croscope may be applied to the one as the spy-glass to the other. Thus we may easily multiply the forms of the outward; but to give the within outwardness, that is not easy. . . .[20]

He saw that nature was the source and that mechanically keen vision was the method. He also felt that there was meaning underlying the surface, but it remained for the best active operators such as Albert Southworth to employ the method with enough sensitivity to achieve the insight that reached beyond the surface:

> The [photographic] artist is conscious of something besides the mere physical, in every object in nature. He feels its expression, he sympathizes with its character, he is impressed with its language; his heart, mind, and soul are stirred in its contemplation. It is the life, the feeling, the mind, the soul of the subject itself.[21]

In their attempts to reveal the soul of the subject the daguerreotypists of America employed their mirror images for the definition and recording of their time and their society. They taught Americans to be American more completely; they confronted Americans with themselves and sought to help them recognize their own significance. The daguerreotypists were themselves men of their age, subject to the same influences as their clients, fortunately, since their own human situation enabled them to answer the needs of their contemporaries by the use of their chosen medium. They were generally not special men of their time, merely typical. Yet in that fact lay the power of their sensitive medium to seek for the truth. They called on themselves and their process to make handsome pictures that were accurate to the facts they saw, and their concern to make searching images led them at their best to achieve both beauty and insight beyond the facts. Under the eye of wistful retrospect and the gratitude of a later time in recalling their pictures, it was reasonably said that

> Misty morning, noonday sun, and evening splendor found them worshiping at the shrine of earthly beauty, honesty, and truth, giving to their creations that eternal stamp of character that made the subjects live.[22]

ANNOTATED
BIBLIOGRAPHY

Adams, Anscl. *The Print: Contact Printing and Enlarging.* New York: Morgan & Morgan, Inc., 1950, p. 2.

Comment by the world's leading modern photographic technician on his use of the daguerreotype as his personal ideal of quality in a photographic print.

Adams, John Quincy. *Memoirs of John Quincy Adams,* edited by Charles Francis Adams. Philadelphia: J. B. Lippincott & Co., 1876, vols. X-XII.

Contains scattered references to Adams's being daguerreotyped and normally not liking the results. Some comments perceptively reveal Adams's grasp of the symbolic imagery of the daguerreotype in public affairs.

American Journal of Photography. New Series, vols. I and II, 1858-60.

A useful miscellany of articles and observations on photography and the public response, together with technical articles and items of historical note. Often relatively whimsical in tone, therefore having the added benefit of being entertaining reading.

The American Repertory of Arts, Sciences, and Manufactures. March 1840—May 1841.

Annual of Scientific Discovery: or, Year-Book of Facts in Science and Art, 1850-1854.

Valuable brief articles on astronomical daguerreotypy and various technical experiments with the medium.

Arthur, T. S. "American Characteristics: The Daguerreotypist," *Godey's Lady's Book,* vol. XXXVIII, May 1849, pp. 352-55.

Somewhat whimsical article on public response to photographic portraiture, particularly among persons facing the camera for the first time. Significant comment on the rapid expansion of the medium throughout society.

"The Atlantic Cable and Photography," *The American Journal of Photography,* New Series, vol. I, no. 7, September 1, 1858, pp. 111-13.

Presents details of the decorations of the various Broadway galleries at the opening of the Atlantic cable. Many of the images used specifically relate the photographer and his art to the advancing machine technology of the time.

Baker, Isaac W. and Perez M. Batchelder. Unpublished correspondence (Calif., 1853) in the collection of the late Frederick S. Baker and Mrs. Pine Lea, Berkeley, Calif.

Firsthand impressions of the daguerreotype business in gold-rush California, exchanged between two traveling operators who were part of a chain. Business details, prices, and general activities are discussed along with impressions of the situation in the gold fields for daguerreotypists.

Baldwin, Joseph Glover. *The Flush Times of Alabama and Mississippi.* New York: Hill and Wang—American Century Series, 1964 [original publication 1853].

Contains whimsical description of daguerreotype applications for "con game" purposes.

Barnes v. *Ingalls,* 39 Alabama 193, 1863.

A significant court decision that a good portrait likeness does not require an expert to determine, being instead best defined by the eye of loving recognition.

Bear, John W. *The Life and Travels of John W. Bear, "The Buckeye Blacksmith."* Baltimore: D. Binswanger & Co., 1873.

Reflects the varied activities of typical daguerreotype men. Specifically discusses economic motives and itinerant practices within the context of the period.

Bogardus, Abraham. "The Lost Art of the Daguerreotype," *The Century Magazine,* vol. LXVIII, no. 1, May 1904, pp. 83-91.

Good article by a leading early daguerreotypist. Comments on portraiture and the public, noting some of the practical operating tricks of the trade for making people appear better.

[Boston] *Daily Evening Transcript.* March—April 1840.

Boucicault, Dion. *The Octoroon, or Life in Louisiana,* reprinted in *Representative American Plays,* edited with an introduction and notes by Arthur Hobson Quinn. New York: the Century Company, 1917, pp. 431-58.

Contains various reflections of public response to the accuracy of photographic likenesses. Presents a fanciful, self-operating form of photography as a mechanical but divinely motivated agency of justice wrought by the "all-seeing eye of Heaven."

"Boundary Between Maine and New Hampshire and the Adjoining British Provinces," 27th Cong., 3rd sess., House of Representatives Executive Document No. 31, December 29, 1842.

Discusses the use of daguerreotypes as undeniably accurate evidence in settling the Maine-Canada boundary. Reflects very early commitment to the medium by the government as well as the basic trust placed in mechanically aided perception.

"Brady's Collection of Historical Portraits," 41st Cong., 3rd sess., House of Representatives Report No. 46, March 3, 1871.

Examines the significance of pictures of national men as symbolic indications of the character of the nation desirable for enlightening the public and for solidifying national feeling. Reflects the great respect placed on photographic portraiture when nationalistically motivated.

[Bryant, William Cullen]. "Redwood" [a review], *The North American Review*, vol. XX, no. 47, April 1825, pp. 245-57.

Strong indication of the desire for nationalistic culture.

Busey, Samuel C., M.D. "Early History of Daguerreotypy in the City of Washington," *Records of the* [District of] *Columbia Historical Society*, vol. III, 1900, pp. 81-95.

Useful for details of early operators but not absolutely accurate in every case. Some claims to primacy are no longer valid in light of later research. Especially helpful regarding the scale of the operations of John Plumbe.

Carmer, Carl. "O Ye Great Waters!" Introduction to the catalog of the exhibition *Three Centuries of Niagara Falls*. Buffalo, N.Y.: Albright-Knox Art Gallery, 1964.

Reflects the fascination of the American landscape for artists and indicates the transcendental involvement with accurate perception as shown in many of the pictures produced.

Carrick, Alice Van Leer. *Shades of Our Ancestors*. Boston: Little, Brown, and Company, 1928.

A general examination of silhouette making in America in the period 1750 to 1850. Impulses to portraiture and operational methods of some profilists foreshadow the period of the daguerreotype.

Carter, Kate B., compiler. *The Story of an Old Album*. Salt Lake City: Daughters of Utah Pioneers, 1947.

A small booklet presenting numerous local details otherwise relatively inaccessible. Presented primarily in reminiscence form and, thus, subject to the imprecisions of such reports, but useful for reflecting attitudes toward the photographic media and for details of careers and advertising.

Carvalho, S. N. *Incidents of Travel and Adventure in the Far West; with Col. Fremont's Last Expedition Across the Rocky Mountains: Including Three Months' Residence in Utah, and a Perilous Trip Across the Great American Desert to the Pacific*. New York: Derby & Jackson, 1857.

Description of the expedition by the daguerreotypist of the party. Much useful information about difficulties of operation and about the transcendental response to the American landscape as it was aided by the photographic medium. Little specific information about particular pictures or picture-making situations.

Clark, Anson. Unpublished notebooks and papers, in the Historical Room of the Public Library, Stockbridge, Mass.

Valuable primary source material revealing the varied impulses, concerns, and activities of an important and representative New England daguerreotypist. Reflects the universality of such men by the range of subjects covered and ideas noted.

Cobb, Josephine. "Daguerreotypes made on that part of the Northeast Boundary Survey conducted in 1840 by Professor James Renwick," *Reference Service Report* [unpublished typescript]. Washington, D.C.: National Archives and Records Service, March 31, 1965.

———. "Daguerreotypes made on that part of the Northeast Boundary Survey conducted in 1841-1842 by Professor James Renwick," *Reference Service Report* [unpublished typescript]. Washington, D.C.: National Archives and Records Service, April 2, 1965.

These two reports, sent to this writer in letter form, reveal several previously unpublished details about the daguerreotype activities of Edward Anthony on the Survey, particularly making clear that the scope of his picture making was larger than had hitherto been known. While the actual daguerreotypes themselves have been lost, these reports indicate that drawings made from some of them are in the files of the National Archives.

———. "Daguerreotypes made on the Expedition to Japan, 1852-1854," *Reference Service Report* [unpublished typescript]. Washington, D.C.: National Archives and Records Service, March 25, 1965.

This report mainly emphasizes information contained in the published report of the Perry Expedition by Francis L. Hawks. It does, however, add emphasis to the previously passing mention of the presence of the competing talbotype (paper-negative) process of photography on the Expedition, though evidently little use was actually made of this medium.

Coke, Van Deren. "Camera and Canvas," *Art in America,* vol. XLIX, no. 3, 1961, p. 68.

Initial publication of Coke's research into the extensive relation of photography to the needs of painters which was later developed into an exhibition and a monograph under the title *The Painter and the Photograph* (Albuquerque, N.M.: University of New Mexico Press, 1964). The two presentations do not overlap very much, and the first is useful for illuminating the early response of painters to the potential threat of the daguerreotype.

Cole, Thomas. "Lecture on American Scenery," *The Northern Light,* vol. I, no. 2, May 1841, pp. 25-26.

Reflects the nationalistic interest of the American landscape for the artist.

Conway, M. D. "My Lost Art," *The Atlantic Monthly,* vol. X, no. 58, August 1862, pp. 228-35.

Imaginative short story written after the daguerreotype was almost completely out of use. A "mad scientist" type devises the ultimate developing "fluid" for perfect detail in enlarging daguerreotypes from details of previous daguerreotypes to the final degree that he discovers human life on the planet Jupiter. Reflects the aura of scientific mystery the public felt hovered over the medium.

Curti, Merle, Willard Thorp, and Carlos Baker, eds. *American Issues: The Social Record* (Fourth Edition). New York. J. B. Lippincott Company, 1960.

A useful anthology reproducing nationalistic essays by Channing, Whitman, Lowell, and others. Also reproduces Frederick Jackson Turner's essay on the frontier.

The Daguerreian Journal, 1850, also later called *Humphrey's Journal.*

The world's first photographic magazine, edited by Samuel Dwight Humphrey, himself a practicing operator who made one of the better early photographs of the moon. A major source in every way. Provides not only technical information and advice on the entire professional field of activity, but reflects the cultural context through numerous articles on

other topics. Often badly proofread; and reprinted articles are often cut without warning and inadequately documented. In cases of overlap, Snelling's *Photographic Art-Journal* provides the better text. A fascinating array of entertaining small items that recapture the sparkle and life of the trade and the time.

"The Daguerreolite," *The* [Cincinnati] *Daily Chronicle,* vol. I, no. 38, January 17, 1840, p. 2, col. 1.

A particularly important response to the daguerreotype medium in terms of its truthfulness and permanence and its urgency for directness of communication. Also notable for indicating how quickly American ingenuity was put to improving the process and domesticating it.

"The 'Daguerreotype,'" *The Knickerbocker, New-York Monthly Magazine,* vol. XIV, December 1839, pp. 560-61.

A review of the first major exhibition of daguerreotypes in America. Reveals impressions of the new medium as well as basic ocular concerns of the period.

"Daguerreotypes," *Littell's Living Age,* vol. IX, no. 110, June 20, 1846, pp. 551-52.

Discusses some of the psychological implications of how daguerreotype portraits reveal the character "weaknesses" of sitters by what they choose as poses or props for the occasion.

"Daguerreotypes on Tombstones," *Hutching's California Magazine,* vol. I, no. 11, May 1857, p. 519.

Reflects the sentimental morbidity widely prevalent at the time. Daguerreotype portraits are urged as a means of offsetting the aura of death in graveyards by reminding of the living persons.

"Daguerrian Gallery of the West," *Gleason's Pictorial Drawing-Room Companion,* vol. VI, no. 13, April 1, 1854, p. 208.

Typifies the lavish decor of galleries all over America, along with a wood engraving emphasizing the size and appointments of Ball's Great Western Gallery in Cincinnati.

Dauthendey, Max. *Der Geist meines Vaters.* Munich: Albert Langen, 1925, pp. 39-41.

While unavailable in English, this is a definitive work on the introduction of daguerreotype photography into Germany and Russia. The pages cited contain the most scathing attack on the invention of the daguerreotype ever written, as it appeared in the *Leipziger Anzeiger.*

Davidson, Marshall B. "The Panorama of American Art" in the catalog of the exhibition *Four Centuries of American Art.* [Minneapolis]: the Minneapolis Institute of Arts, 1963.

Summary of the arts in the first half of the nineteenth century.

Davis, Mrs. D. T. "The Daguerreotype in America," *McClure's Magazine,* vol. VIII, no. 1, November 1896, pp. 2-16.

A good basic reference for general history on the subject. The author includes reminiscences at firsthand by Edward Everett Hale, who learned the art directly from Gouraud in Boston, and reproduces some excellent portraits.

Delabarre, Edmund Burke. "Recent History of Dighton Rock," *Transactions 1917-1919,* Publications of the Colonial Society of Massachusetts. Boston: the Colonial Society of Massachusetts, 1920, vol. XX, pp. 286-462.

Notes very early use of daguerreotypy for examination of Dighton Rock, as well as giving an account of later application by Seth Eastman.

The Diary of Philip Hone, edited with an introduction by Bayard Tuckerman. New York: Dodd, Mead and Company, 1889, vol. I, pp. 391-92.

Dickinson, Emily. *Letters of Emily Dickinson,* edited by Mabel Loomis Todd. New York: Harper & Brothers, 1931, pp. 275-76.

Her reply to a request by Col. Higginson for a photograph of herself indicates her distaste for the stiff character and inadequate sense of life in typical daguerreotype portraits. Her remarks about her father's concern to have a life portrait against possible death reflect an urgent concern of the period.

Dix, John Ross. *Amusing and Thrilling Adventures of a California Artist, While Daguerreotyping a Continent.* Boston: published for the author, 1854.

A very rare and, if completely authentic, important source which describes the J. Wesley Jones Expedition to make daguerreotypes of the entire western half of America as the basis of a major panorama. Significant reflections of nationalism, concern with the landscape, attitudes on art, and daguerrean motivations are presented along with extracts from numerous commentaries on both the project and the resulting *Pantoscope.* Taken together with Jones's actual lecture script for the panorama, this constitutes a major document which deserves serious attention as well as further study into its background.

Draper, John William. "On the Process of Daguerreotype, and its application to taking Portraits from the Life," *The London, Edinburgh, and Dublin Philosophical Magazine,* Series 3, vol. XVII, no. 109, September 1840, pp. 222-24.

Reflects the early priority of American application of the daguerreotype and the early international recognition given American work.

———. "Remarks on the Daguerreotype," *The American Repertory of Arts, Sciences, and Manufactures,* vol. I, no. 6, July 1840, pp. 401-04.

Discusses early efforts at portraiture.

———. *Scientific Memoirs: Being Experimental to a Knowledge of Radiant Energy.* New York: Harper & Brothers, 1878.

Contains essays on many of Draper's experiments with light-sensitive materials. Includes his applications of the daguerreotype to lunar astronomy, chemistry, microscopy, spectroscopy, and other uses.

———. "The Tithonic Rays," Lecture XXII, *A Textbook on Chemistry for the Use of Schools and Colleges.* New York: Harper & Brothers, 1846, pp. 90-94.

Uses the daguerreotype process as a teaching device and enunciates the basic principle that light energy is absorbed in the process of chemical reaction.

[Duganne, Augustine Joseph Hickey.] *The Daguerreotype Miniature; or Life in the Empire City.* Philadelphia: G. B. Zieber & Co., 1846.

Early fiction using the daguerreotype as a plot device. Mentions the studio of John Plumbe and presents Plumbe as a character. A rare publication in the Pamphlet Collection of the New York Public Library.

"Editor's Drawer," *Harper's New Monthly Magazine,* vol. VII, no. 42, November 1853, p. 851.
Brief article on a battle of John Wesley Jones with Indians using his daguerreotype camera as a simulated cannon. Tends to verify the Dix book on Jones.

Edward Weston: Photographer, edited by Nancy Newhall. Rochester, N.Y.: Aperture, Inc., [1964].

"Eliphalet Brown, Jr." 36th Cong., 1st sess., House of Representatives Report No. 208, March 23, 1860.
This report on a petition of Brown for compensation for his activities as daguerreotypist for the Perry Expedition reveals the scope of his picture making and indicates that the pictures were to be retained by the government as significant archives.

Emerson, Ralph Waldo. *Journals of Ralph Waldo Emerson,* edited by Edward Waldo Emerson and Waldo Emerson Forbes. Boston: Houghton Mifflin Company, 1912, vol. VI (1841-44).

————. *The Selected Writings of Ralph Waldo Emerson,* edited by Brooks Atkinson. New York: Modern Library College Editions, 1950.
Basic writings to illuminate the ocular concerns of the early nineteenth century. "The Poet," "Nature," and "Self-Reliance" are particularly important.

Epstean, Edward, and John Tennant. "Daguerreotype in Europe and the United States, 1839-1853," *The Photo-Engravers Bulletin,* November 1934, pp. 262-74.
A good general historical source containing several details not otherwise readily available in English.

Ewbank, Thomas. *The World a Workshop; or, The Physical Relationship of Man to the Earth.* New York: D. Appleton and Company, 1855, "Preface," pp. v-x.

"A Few Photographs," *The Knickerbocker,* vol. XLII, August 1853, pp. 137-42.
Useful article for illustrating the national differences in gallery decor and practice between America and France. Also reveals that problems of portrait sitters were universal.

"The First Daguerreotype Made in Indiana," *The Indianapolis Sunday Star,* November 3, 1907.
Connects the making of the first picture to romance and to the sentimental impulse to overcome mortality with portraits. Also indirectly attests to the permanence of a daguerreotype by noting the perfect condition of this first picture after fifty-four years of exposure on a tombstone.

Fleming, Donald. *John William Draper and the Religion of Science.* Philadelphia: University of Pennsylvania Press, 1950.
A thorough study of Draper as reflective of the scientific emphasis of the period. Useful for interpretive commentary on the significance of Draper's experiments with the daguerreotype.

Fraprie, Frank R. "Photography for Personal Adornment," *American Photography,* vol. XXXVIII, no. 1, January 1944, pp. 8-10.
Discusses daguerreotype pictures used in brooches, pins, medallions, and watch cases.

Freedley, Edwin T., ed. *Leading Pursuits and Leading Men: A Treatise on the Principal Trades and Manufactures of the United States. (United States Mercantile Guide.)* Philadelphia: Edward Young, 1856.

Useful source for manufacturing and economic facts on the daguerreotype trade.

Fremont, Jessie Benton. "Some Account of the Plates," *Memoirs of My Life* by John Charles Fremont. Chicago: Belford, Clarke & Company, 1887, vol. I, pp. XV-XVI.

A discussion of the significance of Carvalho's daguerreotypes, together with a vague account of what was done with them.

Gabriel, Ralph Henry. "The Pre-Sumter Symbolism of the Democratic Faith," Chapter 8, *The Course of American Democratic Thought.* New York: the Ronald Press Company, Second Edition, 1956, pp. 91-104.

A highly useful discussion of the need for nationalistic symbols, particularly of the sort derived from public men.

Gernsheim, Helmut. *Creative Photography: Aesthetic Trends 1839-1960.* Boston: Boston Book and Art Shop, 1962.

———. *Lewis Carroll: Photographer.* New York: Chanticleer Press, 1950.

Glaisher, James. "Philosophic Instruments and Processes, as Represented by the Great Exposition," Lecture IX, *Lectures on the Progress of Arts and Sciences, Resulting from the Great Exposition in London.* New York: A. S. Barnes & Co., 1856, pp. 281-82.

Discusses national differences between American picture making and European.

"Gold Rush Panoramas: San Francisco—1850 to 1853," *Sea Letter* [of the San Francisco Maritime Museum], vol. II, nos. 2 and 3—double issue, October 1964.

Important presentation on the daguerreotype panoramas made in early San Francisco. All extant plates made from rooftops or from Nob Hill are reproduced and discussed as to dating. Unfortunately, a later issue containing the remaining pictures made at Rincon Point was never published.

Goodman, Theodosia Teel. "Early Oregon Daguerreotypers and Portrait Photographers," *Oregon Historical Quarterly,* vol. XLIX, no. 1, March 1948, pp. 30-49.

A rich source of important regional material. Reproduces advertisements that reflect the cultural impulses drawn upon by operators. Discusses specific early pictures, mentioning the only portraits of Chinese known in published sources to exist today. Reproduces an advertisement that verifies some of the activities of John Wesley Jones.

[Gouraud, Francois]. *Description of the Daguerreotype Process, or a Summary of M. Gouraud's Public Lectures, According to the Principles of M. Daguerre. With a Description of a Provisory Method of Taking Human Portraits.* Boston: Dutton and Wentworth's Print, 1840.

One of the first American publications on the medium, by the American agent for Daguerre. The section on portraiture established an ideal form that foreshadowed actual practice in setting up studios and arrangements. The pamphlet is very rare today.

———. Letter of Invitation, November 29, 1839. Manuscript included in the Papers of Asher B. Durand in the New York Public Library.

[Great London] *Exhibition of the Works of Industry of All Nations, 1851: Reports by the Juries on the Subjects in the Thirty Classes into Which the Exhibition was Divided* [Class X]. London: William Clowes & Sons, 1853.

Itemizes the winning presentations of the American entries. Does not give complete lists of pictures, but presents comments on specific pictures regarded as significant.

Greeley, Horace. *Glances at Europe: in a Series of Letters from Great Britain, France, Italy, Switzerland, &c., During the Summer of 1851*. New York: Dewitt & Davenport, 1851, p. 26.

Greeley's famous outcry of nationalism in response to America's sweep of medals in photography at the Crystal Palace. Set in a context of value attaching to American mechanical ingenuity.

Greenough, Horatio. "American Art," reprinted in *A Memorial of Horatio Greenough* by Henry T. Tuckerman. New York: G. P. Putnam & Co., 1853.

Reveals the commitment of American art to realistic imitation of detail along with very strong nationalistic impulses.

Gross, Michael. "The 'Wet' and the 'Dry,' " *Photo-Era*, vol. XLII, January 1919, p. 13.

Reprints extracts from advertisements for Morse's portrait studio in 1840. Indicates a tone of sentimental concern for portraits from the beginning of the medium.

Grund, Francis J. *The Americans, in their Moral, Social and Political Relations*. Boston: Marsh, Capen and Lyon, 1837.

Discusses the intensity of the national impulse to work and the fascination of Americans with industry seen elsewhere in genre paintings.

Haas, Robert Bartlett. "William Herman Rulofson: Pioneer Daguerreotypist and Photographic Educator," *California Historical Society Quarterly*, vol. XXXIV, no. 4, December 1955, pp. 289-300.

The only extensive publication on the subject of one of the leading California photographers. Particularly useful for the gold rush period.

Hagen, Victor Wolfgang von. *Maya Explorer: John Lloyd Stephens and the Lost Cities of Central America and Yucatan*. Norman, Okla.: University of Oklahoma Press, 1947.

Hawks, Francis L. *Narrative of the Expedition of an American Squadron to the China Seas and Japan, Performed in the Years 1852, 1853, and 1854, Under the Command of Commodore M. C. Perry, United States Navy, by Order of the Government of the United States*. Washington, D.C.: Published by order of the Congress of the United States, A. O. P. Nicholson, Printer, 1856, vol. I.

Various references are made to the daguerreotype activities of Eliphalet Brown, Jr., together with passing note that the talbotype medium was also included on the Expedition. Many of the illustrations are from Brown's daguerreotypes and some, particularly the better lithographs, reflect the underlying photographic basis clearly.

Hawthorne, Nathaniel. *The House of the Seven Gables*. New York: the New Modern Library —a Signet Classic, 1961 [original publication 1851].

The daguerreotype is presented as the central moral agency for revealing character in the plot. The daguerreotypist Holgrave is established as a typical American "universal man"

who employs any available means of perception or experience for self-definition. A major work of significant response to both the daguerreotype itself and the climate which made it singularly appropriate for America.

——— "Monsieur du Miroir," *Mosses from an Old Manse.* Boston: Houghton Mifflin Company, 1901.

Fiction based on making one's reflection the character of a story. Reflects fascination with the immortality implied in a portrait, together with the fascination of mirror images frequently seen both in Hawthorne and in popular magazines of the period.

———. "The Prophetic Pictures," reprinted in *Century Readings in the American Short Story,* edited by Fred Lewis Patee. New York: D. Appleton-Century Company Incorporated, 1927.

Further indication of the fascination of the period with the implications of portraiture, particularly when convincingly lifelike. Suggests the power of the artist to confer immortality and to search the inner recesses of human character.

Herz, Henri. *Mes Voyages in Amerique,* reprinted in translation in *This Was America,* edited by Oscar Handlin. New York: Harper & Row—Harper Torchbooks TB 1119, 1964, p. 192.

Remarkable account of the symbological implications of George Washington for American nationalism. Also highly entertaining.

Hitchcock, Edward. "The Telegraphic System of the Universe," Lecture XII, *The Religion of Geology and Its Related Sciences.* Boston: Phillips, Sampson, and Company, 1851, pp. 409-44.

Important essay on the universe as a great sensitive medium in a manner similar to the daguerreotype. Both the daguerreotype and the telegraph are specifically mentioned in a context of theology that indicates the impact of technology on the age.

Horan, James D. *Mathew Brady: Historian with a Camera.* New York: Crown Publishers, Inc., 1955.

Contains a particularly rich cross section of Brady's daguerreotypes previously unpublished. Offers some valuable material on Brady, but much in the book is unreliable, even to inaccurate quotation and captions.

Humphrey's Journal, 1851-58; see *The Daguerreian Journal.*

Hunter, Fred. *The Daguerreotype: or, Love at First Sight.* Boston: F. Gleason, 1849.

A "cheap novel" making use of a daguerreotype picture as a plot device.

Image of America: Early Photography 1839-1900 (A Catalog). Washington, D.C.: Library of Congress, 1957.

"The Inconstant Daguerreotype," *Harper's New Monthly Magazine,* vol. X, no. 60, May 1855.

A romantic short story fancifully giving life to daguerreotype portraits and establishing a triangle between two portraits and the person from which one was made. Useful as a reflection of the sense of the public of the searching power of daguerreotypes to reveal the character of a sitter and as a reflection of the influence of pictures in one's environment.

Jackson, Clarence S. *Pageant of the Pioneers: The Veritable Art of William H. Jackson.* Minden, Nebr.: the Harold Warp Pioneer Village, 1958.

James, Henry. *A Small Boy and Others.* New York: Charles Scribner's Sons, 1913, pp. 49-50.
> A charming description of the effect of famous men on the imagery of the public. Another section of the book contains a description of a visit to Brady's studio to have a daguerreotype made.

"Jones' Pantoscope of California," *California Historical Society Quarterly,* vol. VI, no. 2, June 1927, pp. 109-29; and vol. VI, no. 3, September 1927, pp. 238-53.
> The complete text of the lecture John Wesley Jones gave with exhibitions of his *Pantoscope.* The strongest piece of verifying evidence for the Dix account. Also reproduces a handbill for the "Gift Distribution" of the *Pantoscope* and a number of drawings made from daguerreotypes or on the Expedition. Provides a few additional facts about Jones from correspondence with his publisher's agent.

Kouwenhoven, John A. *Made in America: The Arts in Modern Civilization.* Garden City, N.Y.: Doubleday & Company, Inc.—Anchor Book A300, 1962.

"The Last Look," *The New Pictorial and Illustrated Family Magazine,* vol. III, 1846, p. 88.
> Notable for a sense of the sentimental morbidity of popular taste at the time.

"Letter of J. C. Fremont to the Editors of the National Intelligencer," 33rd Cong., 1st sess., Senate Miscellaneous Document No. 67, June 13, 1854.
> Fremont reflects the impulse of Manifest Destiny in his support of building a transcontinental railroad to link the halves of the world with America as the center. He comments on the accuracy of daguerreotype pictures as evidence of the practicality of the route he proposes.

The [London] *Athenaeum* (January–June 1839).

[Lowell, James Russell]. "Longfellow's Kavanagh: Nationality in Literature," *The North American Review,* vol. LXIX, no. 144, July 1849, pp. 196-215.
> Request for a sensible approach to nationalism in American culture so that quality is not lost in urgency for national color. Refers to the panorama painters as indication of the nationalistic production of art by direct response to the American landscape.

McDermott, John Francis. "Gold Rush Movies," *California Historical Society Quarterly,* vol. XXXIII, no. 1, March 1954, pp. 29-38.
> Discusses the panorama painters' responses to the gold rush with reference to John Wesley Jones's reliance on the daguerreotype.

McMillan, Malcolm C., ed. "Joseph Glover Baldwin Reports on the Whig National Convention of 1848," *Journal of Southern History,* vol. XXV, 1959, p. 373—letter from Baldwin to George B. Saunders, Philadelphia, June 12, 1848.
> This letter contains Baldwin's remark about a presidential candidate "daguerreotyping" himself on the "popular heart" as did Washington, Jackson, and Harrison. Taken together with the remarks of John Quincy Adams, an essential insight into public image making.

"The Magic Mirror: or the Way to Wealth," *The Visitor, and Lady's Parlor Magazine,* vol. I, no. 6, December 1840, p. 167.

[The Matamoros, Mexico] *Republic of Rio Grande and Friend of the People.* Also later called *The* [Matamoros, Mexico] *American Flag,* June–December 1846.

Millet, Josiah B., ed. *George Fuller: His Life and Works.* Boston: Houghton Mifflin and Company, 1886.

Notes very early employment of the daguerreotype by an itinerant portrait painter and discusses economic motivations.

Moenssens, Andre A. "The Origins of Legal Photography," *Fingerprint and Identification Magazine,* vol. XLIII, no. 7, January 1962, pp. 3-17.

Particularly interesting for reproductions of the world's oldest surviving "mug shots," four daguerreotypes made in Belgium in 1843. Taken together with the related article by Harris B. Tuttle, Sr., this article provides a useful general history of this aspect of photography.

Moore, Mrs. Clara Moreton. "Niagara, Below the Cataract" and "Genesee Falls" from "Records of a Summer Tour," *Sartain's Magazine,* vol. VIII, no. 6, December 1850, p. 379.

Morse, Edward Lind, ed. *Samuel F. B. Morse: His Letters and Journals.* Boston: Houghton Mifflin Company, 1914. vol. II.

Contains numerous writings by the most important American pioneer with the daguerreotype medium. Morse introduced the medium to America with a letter from Paris and was a major practitioner and experimenter in the initial period.

Morse, Samuel F. B. Letter [from Paris] to the Editor of the *New York Observer,* reprinted in *Niles' National Register,* vol. LVI, no. 1439, April 27, 1839, p. 134, col. 2.

This letter was the first major American impression of the daguerreotype by an eyewitness. It was widely reprinted throughout the country and did much to create a climate of anticipation for the medium. A more accurately proofread text is reprinted in *The Life of Samuel F. B. Morse* by Samuel Irenaeus Prime.

"Naked Art," *The Crayon,* vol. VI, Part 12, December 1859, pp. 377-78.

Outraged discussion of the abuses of nudity in current art. Reflects the attitude which kept daguerreotypists from being involved with this aspect of picture making except for occasional producers of pornography—as noted in Snelling's *Photographic Art-Journal.*

"A Natural Theology of Art," *The North American Review,* vol. LXXIX, no. 164, July 1854, pp. 1-30.

Valuable article for reflecting the great stress on utility and technology which the middle nineteenth century developed.

Newhall, Beaumont. "The Daguerreotype and the Painter," *Magazine of Art,* vol. XLII, no. 7, November 1949, pp. 249-57.

Discusses the uses and problems of daguerreotypes as bases for painters of portraits.

———. *The Daguerreotype in America.* New York: Duell, Sloan & Pearce, 1961.

The only book on the subject. A major work of research, though somewhat inadequately documented. Certain to remain the definitive landmark in the history and aesthetic aspects of the subject. Includes a particularly fine selection of pictures.

———. "Delacroix and Photography," *Magazine of Art,* vol. XLV, no. 7, November 1952, pp. 300-03.

Reflects basic differences in attitudes between America and Europe toward art and the role of art media in the hands of the artist.

————. *The History of Photography from 1839 to the Present Day.* New York: the Museum of Modern Art, 1964.

The best general history of photography.

————, and Robert Doty. "The Value of Photography to the Artist, 1839," *Image: The Bulletin of the George Eastman House of Photography,* vol. XI, no. 6, 1962, pp. 25-28.

Indicates the excitement caused by publication of the daguerreotype in France and presents the initial responses of painters in various parts of the world to the acute detail of the new medium. Also discusses early publications based on daguerreotypes.

"New-York Daguerreotyped," *Putnam's Monthly,* vol. I, no. 2, February 1853, pp. 121-36.

More than the text, the wood engravings are important as specific evidence of application of the daguerreotype to reveal in summary the character of American cities. The pictures also verify the making of daguerreotypes of New York, though none are known today.

[New York] *Evening Post,* December 1839–February 1840.

[New York] *Morning Herald,* February 1840.

Niles' National Register, April 1839–May 1843.

Norman, Daniel. "Development of Astronomical Photography," *Osiris,* vol. V, 1938, pp. 560-95.

"The Old New," *To-Day: A Boston Literary Journal,* vol. I, no. 16, April 17, 1852, pp. 252-53.

Presents the climate of anticipation and developing need foreshadowing a number of important nineteenth-century inventions. Presents an extract from *Giphantia,* written in 1760 by Tiphaigne de la Roche and describing an imaginary process for capturing images which remarkably prefigured photography.

Osgood, Mrs. Frances S. "Daguerreotype Pictures: Taken on New Year's Day," *Graham's Lady's and Gentleman's Magazine,* vol. XXIII, 1843, pp. 255-57.

The Papers of Willie Person Mangum, edited by Henry Thomas Shanks. Raleigh, N.C.: State Department of Archives and History, 1953, vol. III (1899-49), p. 179.

A letter to Senator Mangum from the daguerreotype firm of Moore & Walter which establishes priority for daguerreotype activities in the U.S. Capitol. Reflects the great urgency of the medium for politicians as a symbolic image-making device.

Parkman, Francis, Jr. *The California and Oregon Trail.* New York: George P. Putnam, 1849.

Peale, Rembrandt. "Portraiture," *The Crayon,* vol. IV, 1857, pp. 44-45.

Observations on the quality of photographic portraiture compared with paintings. Also reflects attitudes on visual art relative to photography.

Perry, Clay. "Yankee Genius," *The Hartford Courant Magazine,* January 2, 1949, p. 7.

Article on the life and varied career of Anson Clark, early and important New England daguerreotypist.

Photographic Art-Journal, later called *The Photographic and Fine Art-Journal,* 1851-56.

The second photographic periodical in America. Edited by Henry Hunt Snelling, the attitude of the *Journal* was more serious and aesthetically emphatic than that of *Humphrey's Journal.* Texts were carefully transcribed and documented, but the magazine occasionally suffers from Snelling's moralizing. Later volumes are large, handsome presentations with

very early crystallotype paper-photographic prints bound in, often copies of daguerreotypes. A very important source for the trade and the artistic attitudes of the day as well as a complement to Humphrey. The writings of Gabriel Harrison are of particular importance. Snelling's strong attacks on abuses of photography are especially significant.

"Photographs in the Last Century," *The Eclectic Magazine of Foreign Literature, Science, and Art,* vol. LXIII, December 1864, pp. 465-69.

Reports English historical research into apparently successful experiments in photography in the period after 1760.

"Photography," *The* [English] *Quarterly Journal of Science,* vol. I, January 1864, p. 154.

Announces discovery of apparently successful daguerreotype-like photographs made in England as early as the 1790s.

Preuss, Charles. *Exploring with Fremont: The Private Diaries of Charles Preuss, Cartographer for John C. Fremont on his First, Second, and Fourth Expeditions,* translated and edited by Erwin G. and Elisabeth K. Gudde. Norman, Okla.: University of Oklahoma Press, 1958.

The only source to record Fremont's use of the daguerreotype on his first expedition in 1842. Despite his total failure at making pictures, Fremont thus pioneered scientific exploratory use of photography even before von Humboldt urged application in his *Cosmos.*

Prime, Samuel Irenaeus. *The Life of Samuel F. B. Morse.* New York: D. Appleton and Company, 1875.

"Prospectus" and "Introduction," *The Daguerreotype: A Magazine of Foreign Literature and Science,* vol. I, 1847, pp. 4-8.

Having nothing specifically to do with photography, the magazine took its name from its intention to provide an accurate sample of life. This response to the daguerreotype medium is extensively discussed.

Roche, Tiphaigne de la. *Giphantia: or a View of What Has Passed, What is Now Passing, and During the Present Century, What Will Pass in the World.* London: Printed for Robert Horsfield, 1761, Part I, pp. 93-98.

This Swiftian French novel of 1760 remarkably foreshadows not only photography but television and communications satellites as well. The fanciful description of a photography-like process reflects the desire for such a process of image making as early as the eighteenth century.

Root, M. A. *The Camera and the Pencil.* Philadelphia: J. B. Lippincott & Co., 1864.

Root was one of the most frequently published writers among the daguerreotypists. His book was in process for over fifteen years, finally emerging as a history of photography containing many otherwise unrecorded items. He also discusses problems and methods of practice in portraiture, comments extensively on the didactic and artistic uses of the medium, and generally reveals much of value for students of the period. An essential source.

Ryder, James F. *Voigtlander and I in Pursuit of Shadow Catching.* Cleveland: the Cleveland Printing & Publishing Co., 1902.

The autobiography of a leading inland daguerreotypist and photographer. The diversity and wide geographic range of Ryder's activities as an itinerant reflects many of the signi-

ficant impulses abroad in America in the 1850s, particularly regarding the westering movement.

Sartain, John. (Editorial comment.) *Sartain's Magazine,* vol. V, no. 3, September 1849, p. 189.

Comments by a leading engraver on the artistic quality of a new style of daguerreotype portraiture introduced by Marcus Aurelius Root.

Schiller, Rudolph. *Early Photography in St. Louis.* St. Louis: W. Schiller & Co., n.d.

A useful booklet providing important materials otherwise unavailable. Contains portraits of notable daguerreotypists such as Easterly and Fitzgibbon.

"Self-Operating Processes of Fine Art: The Daguerreotype," *The Museum of Foreign Literature, Science and Art,* New Series, vol. VII, January–June 1839, pp. 341-43.

Very early article on the daguerreotype before one had been seen in America; speculates on the involvement of the machine in the arts.

Snelling, Henry Hunt. *The History and Practice of the Art of Photography.* New York: G. P. Putnam, 1849.

One of the earliest histories of photography in America. Includes the only presently known material on the efforts of James Wattles to devise a photographic process in Indiana twenty years before Daguerre and Talbot succeeded in Europe.

Southworth, Albert S. "An Address to the National Photographic Association of the United States," *The Philadelphia Photographer,* vol. VIII, no. 94, October 1871, pp. 315-23.

A major document to reveal the intention and clarify the motivations of leading operators.

Stenger, Erich. *The History of Photography: Its Relation to Civilization and Practice,* translated and footnoted by Edward Epstean. Easton, Pa.: Mack Printing Company, 1939.

Stenger was one of the leading European historians of photography; his work tends to be a remarkable compendium of details more than a readable or interpretively unified account.

Stephens, John Lloyd. *Incidents of Travel in Yucatan.* Norman, Okla.: University of Oklahoma Press, 1962 [original publication 1843], 2 vols.

Describes early efforts by amateurs to apply daguerreotypy to the needs of major archaeology in Mexico. Also reflects the problems and the initial responses to the medium in areas where it was not known.

[Stevens, Isaac I.]. [U.S. War Department] *Reports of Explorations and Surveys, to Ascertain the Most Practicable Route for a Railroad from the Mississippi River to the Pacific Ocean.* 36th Cong., 1st sess., Senate Executive Document. Washington, D.C.: Thomas H. Ford, Printer, 1860, vol. XII, Book I.

Mentions and comments on the daguerreotype activities of John Mix Stanley among the Indians.

Taft, Robert. "John Plumbe," *American Photography,* vol. XXX, no. 1, January, 1936, pp. 1-12.

The only major publication on the operator of the largest chain daguerreotype business in history. A few further items are added by Dr. Busey's history of early photography in Washington and Taft's own *Photography and the American Scene* and Newhall's *Daguerreotype in America,* but far too little work has been done on Plumbe.

———. *Photography and the American Scene: A Social History, 1839-1889*. New York: Dover Publications, Inc., 1964.

Still the definitive work in the field. Taft pioneered so many avenues of research in American photographic history that one must still regard his as an ultimate landmark. Inevitably some items have dated in the decades since the original 1939 Macmillan publication, but very little has shown up to be wrong. A necessity for anyone seriously planning to explore America's first half century as a photographic nation.

"Taking the Corner Stone Daguerreotype," *The* [Boston] *Weekly Symbol and Odd Fellows' Magazine*, vol. II, no. 27, January 1, 1848, p. 2, col. 7.

A whimsical but significant account of the urgency of desire for immortality that was a major element in making the daguerreotype so popular in America.

Tallis's History and Description of the Crystal Palace and the Exhibition of the World's Industry in 1851. London: John Tallis and Co., 1851.

Thierry, J. *Daguerreotypie*. Paris: Lerebours et Secretan, 1847.

Devotes a chapter to "The American Process" of daguerreotypy—evidence of speedy American superiority.

Thomas, Joe D. "Photographic Archives," *American Archivist*, vol. XXI, no. 4, October 1958, pp. 419-24.

Discusses the initial establishment of photographic archives by the federal government with the acquisition of the daguerreotypes made on the Perry Expedition to Japan by Eliphalet Brown, Jr.

Thoreau, Henry David. *Walden; or, Life in the Woods*. New York: Holt, Rinehart and Winston, 1961.

Important for reflecting the importance of observing nature closely and accurately as a basis for spiritual understanding. The stress is ocular with a concern for the "objects" of nature singularly relevant to major schools of photography from the daguerreotype period to the present.

———. *The Writings of Henry David Thoreau: Journal*, edited by Bradford Torrey. Boston: Houghton Mifflin Company, Walden Edition, 1906, vol. I.

Townsend, George Alfred. "Brady, the Grand Old Man of American Photography," *The* [New York] *World*, April 12, 1891, p. 26, cols. 5-7.

A major historic memoir despite certain fuzzinesses and apocrypha of memory and a few outright errors. Notable for revealing the nationalistic impulse under which Brady worked.

Trapp, F. A. "The Art of Delacroix and the Camera's Eye," *Apollo*, vol. LXXXIII, no. 50, April 1966, pp. 278-88.

Tuttle, Harris B., Sr. "History of Photography in Law Enforcement," *Fingerprint and Identification Magazine*, vol. XLIII, no. 4, October 1961, pp. 3-28.

Taken together with the related article by Moenssens, a good cross section of this field. Presents several significant court decisions reflecting responses to the photographic media.

Twain, Mark. "The House Beautiful," *Life on the Mississippi*. Boston: James R. Osgood and Company—Subscription [First] Edition, 1883, pp. 398-407.

Explicitly relates the daguerreotype to the other aspects of its cultural context as they are visible in the American parlor.

[Vance, Robert H.?]. *Catalogue of Daguerreotype Panoramic Views in California, by R. H. Vance.* New York: Baker, Godwin & Company, Printers, 1854.

Notable as the only surviving specimen of a daguerreotype exhibition catalog; presently in the Pamphlet Collection of the New York Public Library. The introduction reflects the specific intent of the daguerreotypist to reveal in a summatory way the character of a part of the American scene.

Vanderbilt, Paul, compiler. *Guide to the Special Collections of Prints & Photographs in the Library of Congress.* Washington, D.C.: Reference Department, Library of Congress, 1955.

Vischer, Edward. "A Trip to the Mining Regions in the Spring of 1859," translated by Ruth Frey Axe, *California Historical Society Quarterly,* vol. XI, no. 3, September 1932, p. 229.

Comments on the accuracy of daguerreotypes for recording details of mining machinery and landscape as a near substitute for the real thing.

Werge, John. *The Evolution of Photography.* London: Piper & Carter, 1890.

An engagingly written English view providing many aspects of daguerreotypy and later photography in America. Provides essential material on Whipple's astronomical work, on visual responses to American scenery, and on the various phases of photographic practice.

Weston, Edward. *Day Books* (unpublished), *Masters of Photography* by Beaumont and Nancy Newhall. New York: Bonanza Books, 1958, p. 12.

Whitman, Walt. *Pictures: An Unpublished Poem,* with an Introduction and Notes by Emory Holloway. New York: the June House, 1927.

A manuscript catchall of Whitman's ideas before 1850, in which the images are initially arranged as in a picture gallery. While the pictures are not specifically photographic, some seem to be closely related and reference is made to some magically polished form of mirror which functions to reveal accurate images. This manuscript served as the storehouse from which Whitman later developed many of his major works. In this light the pictorial influence is doubly significant.

Willis, N. Parker, "Letter XXVIII," *The Convalescent.* New York: Charles Scribner, 1859, pp. 281-90.

A chapter on Brady's gallery and some of the attitudes and problems of portraiture and the public. Another chapter examines the response of a man of 103 to his first daguerreotype portrait.

———. "The Pencil of Nature," *The Corsair,* vol. I, no. 5, April 13, 1839, pp. 70-72.

Very early article on the daguerreotype before Morse's letter had been published; speculates on potential uses for and responses to the medium very perceptively in a way to indicate a lasting consistency in American response.

NOTES

CHAPTER 1

1 [William Cullen Bryant], "Redwood" [A Review], *The North American Review*, vol. XX, no. 47 (April 1825), p. 248.

2 William Ellery Channing, "Remarks on National Literature," reprinted in *American Issues: The Social Record*, edited by Merle Curti et al. (New York: J. B. Lippincott, Fourth Edition, 1960), pp. 302-03.

3 Walt Whitman, "Preface to 'Leaves of Grass,'" reprinted in ibid., pp. 319-21, passim.

4 Mrs. Clara Moreton Moore, "Niagara, Below the Cataract" from "Records of a Summer Tour," *Sartain's Magazine*, vol. VIII, no. 6 (December 1850), p. 379.

5 Ibid., "Genesee Falls."

6 [James Russell Lowell], "Longfellow's *Kavanagh*: Nationalism in Literature," *North American Review*, vol. LXIX, no. 144 (July 1849), p. 210.

7 Ibid., p. 198.

8 Thomas Cole, "Lecture on American Scenery," *The Northern Light*, vol. I, no. 2 (May 1841), p. 25.

9 Horatio Greenough, "American Art," reprinted in *A Memorial of Horatio Greenough* by Henry T. Tuckerman (New York: G. P. Putnam & Co., 1853), p. 108.

10 Cole, "Lecture on American Scenery," p. 26.

11 Carl Carmer, "O Ye Great Waters!" Introduction to the catalog of the exhibition *Three Centuries of Niagara Falls* (Buffalo, N.Y.: Albright-Knox Art Gallery, 1964), p. 11.

12 John Werge, *The Evolution of Photography* (London: Piper & Carter, 1890), p. 150.

13 Greenough, "American Art," p. 113.

14 Samuel F. B. Morse, letter [from Paris] to the Editor of *The New York Observer*, reprinted in *Niles' National Register*, vol. LVI, no. 1439 (April 27, 1839), p. 134, col. 3.

15 Francis J. Grund, *The Americans, in their Moral, Social and Political Relations* (Boston: Marsh, Capen and Lyon, 1837), p. 202.

16 Ibid., p. 204.

17 Ralph Waldo Emerson, "Self-Reliance," *The Selected Writings of Ralph Waldo Emerson*, edited by Brooks Atkinson (New York: Modern Library, 1950), p. 146.

18 Thomas Ewbank, *The World a Workshop, or, The Physical Relationship of Man to the Earth* (New York: D. Appleton and Company, 1855), p. vi.

19 Emerson, "The Poet," *Selected Writings*, p. 328.

20 Henry James, *A Small Boy and Others* (New York: Charles Scribner's Sons, 1913), pp. 49-50.

21 John Quincy Adams, *Memoirs of John Quincy Adams*, edited by Charles Francis Adams (Philadelphia: J. B. Lippincott & Co., 1876), vol. X, p. 116.

22 [Samuel Dwight Humphrey], "Visit to the Art Union," *The Daguerreian Journal*, vol. I, no. 1 (November 1, 1850), pp. 9-11.

23 Marshall B. Davidson, "The Panorama of Amer-

ican Art" in the catalog of the exhibition *Four Centuries of American Art* ([Minneapolis]: Minneapolis Institute of Arts, 1963) , [p. 19].

24 Emerson, "Nature," *Selected Writings*, pp. 5-6.

25 Ibid., p. 9. 26 Ibid., pp. 9-10.

27 Henry David Thoreau, *Walden; or, Life in the Woods* (New York: Holt, Rinehart and Winston, 1961) , p. 91.

28 Emerson, "Nature," *Selected Writings*, pp. 9-10.

29 Thoreau, *Walden*, p. 162.

30 Ibid., pp. 107-08.

31 Emerson, "Nature," *Selected Writings*, p. 6.

32 Ibid.

33 Nathaniel Hawthorne, "The Prophetic Pictures," *Century Readings in the American Short Story*, edited by Fred Lewis Patee (New York: D. Appleton-Century Company Incorporated, 1927) , pp. 42-43.

34 Ibid., p. 45.

35 Nathaniel Hawthorne, "Monsieur du Miroir," *Mosses from an Old Manse* (Boston: Houghton Mifflin Company, 1901) , vol. I, p. 234.

36 Ibid., p. 235.

37 "The Magic Mirror: or The Way to Wealth," *The Visitor, and Lady's Parlor Magazine*, vol. I, no. 6 (December 1840) , p. 167.

38 Hawthorne, "The Prophetic Pictures," *Century Readings*, p. 45.

39 "The Last Look," *The New Pictorial and Illustrated Family Magazine*, vol. III (1846) , p. 88.

40 Hawthorne, "The Prophetic Pictures," *Century Readings*, p. 48.

41 Alice Van Leer Carrick, *Shades of Our Ancestors* (Boston: Little, Brown, and Company, 1928) , p. 18.

42 Ibid., pp. 42, 51.

43 Quoted by Beaumont Newhall in *The History of Photography from 1839 to the Present Day* (New York: Museum of Modern Art, Revised and Enlarged Edition, 1964) , p. 12.

44 Ibid., p. 11.

45 Reprinted in *To-Day: A Boston Literary Journal*, vol. I, no. 12 (March 20, 1852) , p. 192.

46 Emerson, "Nature," *Selected Writings*, p. 28.

47 Ibid.

48 Quoted in *To-Day: A Boston Literary Journal*, vol. I, no. 16 (April 17, 1852) , pp. 252-53. Despite its alteration of the author's name to Tiphaigne de la Roque, this translation has been used because it is American and is smoother than the one published in the original English source: *Giphantia: or A View of What has Passed, What is Now Passing, and, During the Present Century, What Will Pass, in the World* (London: Printed for Robert Horsfield, 1761) , Part I, pp. 95-97.

49 "A Natural Theology of Art," *North American Review*, vol. LXXIX, no. 164 (July 1854) , p. 8.

50 Ibid., p. 13. 51 Ibid., p. 14. 52 Ibid., p. 26

53 Emerson, "Nature," *Selected Writings*, p. 413.

54 "A Natural Theology of Art," p. 20.

55 Ibid., pp. 20-21. 56 Ibid., p. 21. 57 Ibid., p. 27.

CHAPTER 2

1 Details of this account of the activities of Boulton and the Lunar Society are from "Photography," *The [English] Quarterly Journal of Science*, vol. I (January 1864) , p. 154; and "Photographs in the Last Century,"

The Eclectic Magazine of Foreign Literature, Science, and Art, vol. LXIII (December 1864) , pp. 465-69.

2 The picture is reproduced in both color and strengthened black and white in *Life*, vol. LXI, no. 26 (December 23, 1966) , p. 32.

3 Samuel F. B. Morse, letter [from Paris] to the Editor of the *New York Observer* in *The Life of Samuel F. B. Morse* by Samuel Irenaeus Prime (New York: D. Appleton and Company, 1875) , p. 400.

4 Henry H. Snelling, *The History and Practice of the Art of Photography* (New York: G. P. Putnam, 1849) , p. 11.

5 Ibid., p. 12. 6 Ibid., p. 10. 7 Ibid., p. vii.

8 Reprinted in *The [Philadelphia] Museum of Foreign Literature, Science, and Art*, Whole Number vol. XXXV (1839) , p. 341.

9 *The [London] Athenaeum*, no. 587 (January 26, 1839), p. 69, col 2.

10 Ibid. 11 Ibid. 12 Ibid.

13 Reprinted in *Museum*, Whole Number vol. XXXV (1839) , p. 342.

14 *Athenaeum*, no. 589 (February 9, 1839) , p. 114, col. 2.

15 *Athenaeum*, no. 587 (January 26, 1839) , p. 69, col. 2.

16 Quoted in translation by Beaumont Newhall and Robert Doty in *Image: The Bulletin of the George Eastman House of Photography*, vol. XI (1962) , no. 6, p. 25.

17 Ibid., p. 26. 18 Ibid. 19 Ibid.

20 Quoted in translation by Helmut Gernsheim in *Creative Photography: Aesthetic Trends 1839-1960* (Boston: Boston Book and Art Shop, 1962) , pp. 24-25.

21 [Nathaniel P. Willis], "The Pencil of Nature," *The Corsair*, vol. I, no. 5 (April 13, 1839) , p. 71.

22 Ibid. 23 Ibid. 24 Ibid., pp. 71-72.

25 Morse, letter in *Life of Morse* by Prime, p. 401.

26 Ibid., p. 400. 27 Ibid., p. 401.

28 Ibid., pp. 401-02. 29 Ibid., p. 406.

30 Edward Epstean and John Tennant, "Daguerreotype in Europe and the United States, 1839-1853," *The Photo-Engravers Bulletin* (November 1934) , p. 264.

31 Morse, letter in *Life of Morse* by Prime, p. 406.

32 Marc-Antoine Gaudin, *Traite Pratique de Photographie*, Paris, 1844, quoted in translation by Gernsheim in *Creative Photography*, p. 25.

33 Marc-Antoine Gaudin, *Traite Pratique de Photographie*, quoted in translation by Beaumont Newhall in *The Daguerreotype in America* (New York: Duell, Sloan & Pearce, 1961) , p. 21.

34 Robert Taft, *Photography and the American Scene: A Social History, 1839-1889* (New York: Dover Publications, Inc., 1964) , p. 14.

CHAPTER 3

1 Edward Epstean and John Tennant, "Daguerreotype in Europe and the United States," *The Photo-Engravers Bulletin* (November 1934) , pp. 262-67, passim.

2 *Der Leipziger Anzeiger* (1839) , quoted by Max Dauthendey in *Der Geist meines Vaters* (Munich: Albert Langen, 1925) , pp. 39-40. Translation by Dr. Karl Schleunes, Department of History, University of Illinois, Chicago, whose kindness is greatly appreciated.

3 Ibid., p. 40. 4 Ibid. 5 Ibid., p. 41.

6 M. A. Root, *The Camera and the Pencil* (Philadelphia: J. B. Lippincott & Co., 1864), p. 350.

7 Ibid.

8 "The 'Daguerreotype,'" *The Knickerbocker, New-York Monthly Magazine,* vol. XIV (December 1839), p. 560.

9 Beaumont Newhall, *The Daguerreotype in America* (New York: Duell, Sloan & Pearce, 1961), p. 158 n. 18.

10 Quoted by Robert Taft in *Photography and the American Scene: A Social History, 1839-1889* (New York: Dover Publications, Inc., 1964), p. 16.

11 Ibid. 12 Ibid.

13 *The Diary of Philip Hone, 1828-1851,* edited and with an introduction by Bayard Tuckerman (New York: Dodd, Mead and Company), 1889, vol. I, pp. 391-92.

14 Ibid., p. 391.

15 Edward Weston, unpublished *Day Books,* quoted by Beaumont and Nancy Newhall in *Masters of Photography* (New York: Bonanza Books, 1958), p. 12.

16 *Edward Weston: Photographer,* edited by Nancy Newhall (Rochester, N.Y.: Aperture, Inc. [1964], p. 39.

17 "The Daguerreolite," *The* [Cincinnati] *Daily Chronicle,* vol. I, no. 38 (January 17, 1840), p. 2, col. 1.

18 Quoted by Van Deren Coke in "Camera and Canvas," *Art in America,* vol. XLIX, no. 3 (1961), p. 68.

19 Ibid.

20 *Sartain's Magazine,* vol. V, no. 3 (September 1849), p. 189.

21 *George Fuller: His Life and Works,* edited by Josiah B. Millet (Boston: Houghton Mifflin and Company, 1886), p. 14.

22 Ibid.

23 F. D. Millet, "An Estimate of Fuller's Genius," *George Fuller,* edited by J. B. Millet, p. 60.

24 Root, *The Camera and the Pencil,* pp. 154-56.

25 Ibid., p. 391. 26 Ibid.

27 Ibid., p. 392. 28 Ibid.

29 New York *Observer,* November 30, 1839, quoted by Beaumont Newhall in *Daguerreotype in America,* p. 28.

30 Ibid.

31 Unpublished manuscript included in the papers of Asher B. Durand in the New York Public Library.

32 *Knickerbocker* (December 1839), p. 560.

33 Ibid. 34 Ibid., p. 561. 35 Ibid.

36 *The* [New York] *Evening Post,* no. 11533 (December 9, 1839), p. 2, col. 5.

37 Ibid., no. 11543 (December 23, 1839), p. 2, col. 4.

38 Francois Gouraud, *Description of the Daguerreotype Process. . . . With a Description of a Provisory Method of Taking Human Portraits* (Boston: Dutton and Wentworth's Print, 1840), p. 14. From a George Eastman House photostat of a copy in the New York Public Library.

39 A self-portrait of Fitz in this manner is reproduced by Newhall in *Daguerreotype in America,* Plate 2. The portrait is also reproduced in *Life,* vol. LXI, no. 26 (December 23, 1966), p. 34.

40 John William Draper, "Remarks on the Daguerreotype," *The American Repertory of Arts, Sciences, and Manufactures,* vol. I, no. 6 (July 1840), p. 404.

41 Taft, *Photography and the American Scene,* p. 28.

42 Letter dated July 28, 1840, reproduced in Taft, *Photography and the American Scene,* p. 29.

43 Ibid., p. 31.

44 John William Draper, "On the Process of Daguerreotype, and its application to taking Portraits from the Life," *The London, Edinburgh, and Dublin Philosophical Magazine,* series 3, vol. XVII, no. 109 (September 1840), pp. 222-24.

45 Reprinted in *American Repertory,* vol. I, no. 2 (March 1840), p. 132.

46 Gouraud, *Description of the Daguerreotype Process,* pp. 15-16.

47 Ibid., p. 16.

48 "The Daguerreolite," *Daily Chronicle,* vol. I, no. 38 (January 17, 1840), p. 2, col. 1.

49 Ibid.

50 *Evening Post,* no. 11556 (January 7, 1840), p. 2, col. 5.

51 Ibid., no. 11577 (January 31, 1840), p. 3, col. 3.

52 *The* [New York] *Morning Herald,* vol. V, no. 233 (February 17, 1840), p. 1, col. 3.

53 *The* [Boston] *Daily Evening Transcript,* vol. XI, no. 2949 (March 7, 1840), p. 2, col. 2.

54 Ibid., no. 2952 (March 11, 1840), p. 2, col. 3.

55 Ibid., no. 2957 (March 17, 1840), p. 2, col. 3.

56 Ibid., no. 2963 (March 24, 1840), p. 2, col. 2.

57 Ibid., no. 2967 (March 28, 1840), p. 2, col. 3.

58 Ibid., no. 2972 (April 4, 1840), p. 2, col. 1.

59 Ibid., no. 2980 (April 14, 1840), p. 3, col. 2.

60 Quoted by Mrs. D. T. Davis in "The Daguerreotype in America," *McClure's Magazine,* vol. VIII, no. 1 (November 1896), p. 10.

61 Ibid., pp. 10-11.

62 Hale's Journal, April 15, 1840, quoted by Newhall in *Daguerreotype in America,* p. 30.

63 Quoted by Davis in "The Daguerreotype in America," *McClure's Magazine,* p. 12.

64 Newhall, *Daguerreotype in America,* Plate 3, p. 31.

65 T. S. Arthur, "American Characteristics: The Daguerreotypist," *Godey's Lady's Book,* vol. XXXVIII (May 1849), p. 352.

66 Quoted by Newhall in *Daguerreotype in America,* p. 33.

67 Ibid.

68 Perez M. Batchelder, manuscript letter to Isaac W. Baker, Sonora, Calif., March 21, 1853, in the collection of the late Frederick S. Baker and Mrs. Pine Lea (Baker's grandchildren), Berkeley, Calif.

69 Isaac W. Baker, note added to manuscript letter to him by Perez M. Batchelder, Sonora, Calif., September 2, 1853, Baker-Lea Collection.

70 Ibid.

71 Rudolf Schiller, *Early Photography in St. Louis* (St. Louis: W. Schiller & Co., n.d.), [p. 1].

72 *The Daguerreotype: A Magazine of Foreign Literature and Science . . . ,* vol. I (1847) [p. 4].

73 Ibid., [p. 5]. 74 Ibid.

75 Ibid., p. 8. 76 Ibid., p. 7. 77 Ibid., pp. [5]-6.

78 Mrs. Frances S. Osgood, "Daguerreotype Pictures: Taken on New Year's Day," *Graham's Lady's and Gentleman's Magazine,* vol. XXIII (1843), pp. 255-57. A further example of this type of character vignette occurs in "The Daguerreotype" by Mrs. E. Wellmont in

Gleason's Pictorial Drawing-Room Companion, vol. II, no. 22 (May 29, 1852), p. 343.

79 Joseph G. Baldwin, letter to George B. Saunders, Philadelphia, June 12, 1848, reprinted in "Joseph Glover Baldwin Reports on the Whig National Convention of 1848," edited by Malcolm C. McMillan, *Journal of Southern History,* vol. XXV (1959), p. 373. I am grateful to Henry Clay Black for bringing this material to my attention.

80 "Rhymes and Chimes" from *Elton's Songs and Melodies for the Multitude* reprinted in *American Issues: The Social Record* (Fourth Edition), edited by Merle Curti et al. (New York: J. B. Lippincott Company, 1960), p. 396.

81 Francis Parkman, Jr., *The California and Oregon Trail* (New York: George P. Putnam, 1849), p. 149.

82 Ibid., Foreword.

CHAPTER 4

1 Quoted by Samuel Irenaeus Prime in *The Life of Samuel F. B. Morse* (New York: D. Appleton and Company, 1875), p. 401.

2 John William Draper, "Remarks on the Daguerreotype," *The American Repertory,* vol. I, no. 6 (July 1840) [p. 401].

3 W. H. Goode, "The Daguerreotype and its Applications," *The American Journal of Science and Arts,* vol. XL, no. 1 (1841), p. 144.

4 John William Draper, Memoir XXV, "On Microscopic Photography," *Scientific Memoirs: Being Experimental to a Knowledge of Radiant Energy* (New York: Harper & Brothers, 1878), p. 338.

5 Ibid. 6 Ibid., p. 339.

7 Donald Fleming, *John William Draper and the Religion of Science* (Philadelphia: University of Pennsylvania Press, 1950), p. 41.

8 Draper, *Scientific Memoirs,* p. 340.

9 Draper, "Remarks on the Daguerreotype," *American Repertory,* p. 402.

10 The *Philadelphia Public Ledger,* December 30, 1843, quoted by Beaumont Newhall in *The Daguerreotype in America,* p. 95.

11 Frank R. Fraprie, "Photography for Personal Adornment," *American Photography,* vol. XXXVIII, no. 1 (January 1944), pp. 9-10.

12 The [London] *Athenaeum,* no. 617 (August 24, 1839), p. 637, col. 2.

13 Ibid. I am grateful to Dr. Ira Goldberg, former research assistant, Department of Analytical Chemistry, University of Minnesota, for advice in treating this material.

14 Ibid.

15 M. A. Root, *The Camera and the Pencil* (Philadelphia: J. B. Lippincott & Co., 1864), pp. 339-40.

16 Fleming, *John William Draper,* pp. 38-39.

17 Ibid., p. 39.

18 John William Draper, *A Textbook on Chemistry for the Use of Schools and Colleges* (New York: Harper & Brothers, 1846), p. 92.

19 Robert Taft, *Photography and the American Scene: A Social History, 1839-1889* (New York: Dover Publications, Inc., 1964), pp. 20-21.

20 *Prospectus of Santa Clara College* (San Francisco: O'Meara & Painter, Printers, 1857), p. 4.

21 Draper, "Remarks on the Daguerreotype," *American Repertory,* p. 402.

22 Ibid.

23 Draper, Memoir XIV, "Note on Lunar Photography," *Scientific Memoirs,* p. 213.

24 Daniel Norman, "Development of Astronomical Photography," *Osiris,* vol. V (1938), p. 561.

25 The Rome Observatory activities are reported in *Niles' National Register,* vol. LXIV, no. 1651 (May 20, 1843), p. 182, cols. 2-3; *Annual of Scientific Discovery* [1850], edited by David A. Wells and George Bliss, Jr. (Boston: Gould & Lincoln, 1868), p, 141; and *The Photographic Art-Journal,* vol. II, no. 2 (August 1851), p. 73. Verification of the primacy of stellar photography claimed in these reports has not appeared up to this time. There is also some question whether the process employed was truly photographic.

26 *Annual of Scientific Discovery* [1850], p. 141.

27 [Samuel Dwight Humphrey], "Lunar Daguerreotypes," *The Daguerreian Journal,* vol. I, no. 1 (November 1, 1850), p. 14. (This magazine was later renamed *Humphrey's Journal.*)

28 *Annual of Scientific Discovery* [1850], p. 142.

29 Ibid.

30 *Daguerreian Journal,* vol. I, no. 1 (November 1, 1850), p. 14.

31 Ibid. 32 Ibid.

33 Beaumont Newhall, *The Daguerreotype in America* (New York: Duell, Sloan & Pearce, 1961), p. 92.

34 *Daguerreian Journal,* vol. II, no. 4 (July 1, 1851), p. 114.

35 J. A. Whipple, "Preparing Plates by Steam," *Photographic Art-Journal,* vol. III, no. 5 (May 1852), p. 271.

36 Newhall, *Daguerreotype in America,* pp. 93-94; and Norman, "Development of Astronomical Photography," *Osiris,* p. 562.

37 Quoted by John Werge in *The Evolution of Photography* (London: Piper & Carter, 1890), pp. 197-98.

38 Ibid., p. 198.

39 Quoted in *Edward Weston: Photographer,* edited by Nancy Newhall (Rochester, N.Y.: Aperture, Inc. [1964]), p. 22.

40 *Daguerreian Journal,* vol. II, no. 6 (August 1, 1851), p. 179.

41 *Photographic Art-Journal,* vol. II, no. 2 (August 1851), p. 95.

42 Horace Greeley, *Glances at Europe: in a Series of Letters from Great Britain, France, Italy, Switzerland, &c., During the Summer of 1851* (New York: Dewitt & Davenport, 1851), p. 26.

43 *Annual of Scientific Discovery* [1851], p. 148.

44 Edward Hitchcock, *The Religion of Geology and its Related Sciences* (Boston: Phillips, Sampson, and Company, 1851), p. 410.

45 Ibid., p. 418. 46 Ibid., pp. 418-19.

47 Ibid., p. 425. 48 Ibid., p. 426. 49 Ibid.

50 Ibid., pp. 442-43.

51 Walt Whitman, *Pictures: An Unpublished Poem,* with Introduction and Notes by Emory Holloway (New York: The June House, 1927), pp. 10 [13].

52 Ibid., p. 14. 53 Ibid., pp. 14-17.

54 "The Daguerreolite," *The* [Cincinnati] *Daily Chronicle,* vol. I, no. 38 (January 17, 1840), p. 2, col. 1.

55 George Alfred Townsend, "Brady, the Grand Old Man of American Photography," *The* [New York] *World* (April 12, 1891), p. 26, cols. 5-7.

56 G. P. Bond quoted, with comment, by Norman, "Development of Astronomical Photography," *Osiris,* p. 563.

57 Ibid.

58 Ibid., pp. 564-65; and Newhall, *Daguerreotype in America,* p. 92.

59 Ibid. (both sources). Newhall reproduces the woodcut from *Moore's Rural New Yorker* on p. 93.

60 *American Repertory,* vol. I, no. 4 (May 1840), p. 304.

61 Edmund Burke Delabarre, "Recent History of Dighton Rock," *Transactions 1917-1919* (Boston: The Colonial Society of Massachusetts, 1920), vol. XX, pp. 379-80.

62 Ibid., pp. 381-82. The plate presented to the Massachusetts Historical Society evidently no longer exists. Correspondence with the librarian indicates that it was probably thrown out along with other old photographic materials by mistake.

63 Victor Wolfgang von Hagen, *Maya Explorer: John Lloyd Stephens and the Lost Cities of Central America and Yucatan* (Norman, Okla.: University of Oklahoma Press, 1947), p. 206.

64 John Lloyd Stephens, *Incidents of Travel in Yucatan* (Norman, Okla.: University of Oklahoma Press, 1962 [original edition 1843]), vol. II, pp. 108-09.

65 Ibid., pp. 113-14. 66 Ibid. 67 Ibid., p. 65.

68 U.S. 27th Cong., 3rd sess., House of Representatives, Executive Document No. 31, p. 2.

69 Josephine Cobb, "Reference Service Report," unpublished typescript (Washington, D.C.: National Archives and Records Service), March 31, 1965. I am particularly grateful to Miss Cobb for her personal help in this research.

70 U.S. 27th Cong., 3rd sess., House Executive Document No. 31, p. 4.

71 Ibid., pp. 8-9. 72 Ibid., p. 9. 73 Ibid.

74 Ralph Waldo Emerson, "Nature," *The Selected Writings of Ralph Waldo Emerson,* edited by Brooks Atkinson (New York: Modern Library, 1950), p. 5.

75 Cobb, "Reference Service Report," March 31, 1965.

76 Ibid., April 2, 1965.

77 Charles Preuss, *Exploring with Fremont. . .,* translated and edited by Erwin G. and Elisabeth K. Gudde (Norman, Okla.: University of Oklahoma Press, 1958), p. 32.

78 Ibid., p. 35. 79 Ibid., p. 38.

80 Jessie Benton Fremont, "Some Account of the Plates," *Memoirs of My Life* by John Charles Fremont (Chicago: Belford, Clarke & Company, 1887), vol. I, p. xv.

81 S. N. Carvalho, *Incidents of Travel and Adventure in the Far West; with Col. Fremont's Last Expedition Across the Rocky Mountains . . .* (New York: Derby & Jackson, 1857), p. 24.

82 Ibid., pp. 30-31. 83 Ibid., p. 31.

84 Ibid., pp. 82-83. 85 Ibid., pp. 20-21.

86 Ibid., p. 33. 87 Ibid., p. 64. 88 Ibid., p. 67.

89 *Guide to the Special Collections of Prints & Photographs in the Library of Congress* compiled by Paul Vanderbilt (Washington, D.C.: Reference Department, Library of Congress, 1955), p. 18.

90 Carvalho, *Incidents of Travel and Adventure,* p. 67.

91 Fremont, "Some Account of the Plates," *Memoirs of My Life,* pp. xv-xvi.

92 Ibid., p. xvi.

93 "Letter of J. C. Fremont to the Editors of the National Intelligencer" (June 13, 1854), U.S. 33rd Cong., 1st sess., Senate Miscellaneous Document No. 67, p. 3.

94 [Isaac I. Stevens, U.S. War Department] *Reports of Explorations and Surveys, to Ascertain the Most Practicable and Economical Route for a Railroad from the Mississippi River to the Pacific Ocean,* U.S. 36th Cong., 1st sess., Senate Executive Document (Washington, D.C.: Thomas H. Ford, Printer, 1860), vol. XII, book I, p. 87.

95 Ibid., pp. 103-04.

96 Francis L. Hawks, *Narrative of the Expedition of an American Squadron to the China Seas and Japan, Performed in the Years 1852, 1853, and 1854, Under the Command of Commodore M. C. Perry, United States Navy, by Order of the Government of the United States* (Washington, D.C.: A. O. P. Nicholson, Printer, 1856), vol. I, p. 154.

97 Ibid., p. 194.

98 M. C. Perry, letter to the Secretary of the Navy, quoted by Cobb in "Reference Service Report," March 25, 1965.

99 J. C. Fremont, "Letter," U.S. 33rd Cong., 1st sess., Senate Miscellaneous Document No. 67, p. 7.

100 Hawks, *Narrative of the Expedition of an American Squadron to the China Seas and Japan,* vol. I, p. 289.

101 Ibid., p. 355. 102 Ibid., pp. 463-64.

103 Beaumont Newhall and Robert Doty, "The Value of Photography to the Artist, 1839," *Image,* vol. XI, no. 6 (1962), p. [25].

104 U.S. 36th Cong., 1st sess., House of Representatives Report No. 208, p. [1].

105 Ibid.

106 Joe D. Thomas, "Photographic Archives," *American Archivist,* vol. XXI, no. 4 (October 1958), p. 420.

107 *The Philadelphia Public Ledger* (November 30, 1841), quoted by Harris B. Tuttle, Sr. in "History of Photography in Law Enforcement," *Fingerprint and Identification Magazine,* vol. XLIII, no. 4 (October 1961), p. 4.

108 Andre A. Moenssens, "The Origin of Legal Photography," *Fingerprint and Identification Magazine,* vol. XLIII, no. 7 (January 1962), cover and pp. 5, 13.

109 Tuttle, "History of Photography," *Fingerprint and Identification Magazine,* pp. 15-16.

110 Ibid., p. 7. 111 Ibid., p. 5.

112 *Humphrey's Journal,* vol. V, no. 13 (October 15, 1853), p. 207.

113 Ibid. 114 Ibid., no. 22 (March 1, 1854), p. 352.

115 Joseph G. Baldwin, *The Flush Times of Alabama and Mississippi* (New York: Hill and Wang—American Century Series, 1964 [original edition 1853]), p. 84.

116 Ibid., pp. 85-86. 117 Ibid., p. 86.

118 Ibid., p. 87. 119 Ibid., p. 88.

120 Quoted by Taft in *Photography and the American Scene*, pp. 415-16.

121 *Daguerreian Journal*, vol. I, no. 10 (April 1, 1851), pp. 305-06.

CHAPTER 5

1 Quoted by Samuel Irenaeus Prime in *The Life of Samuel F. B. Morse* (New York: D. Appleton and Company, 1875), p. 104.

2 Alice Van Leer Carrick, *Shades of Our Ancestors* (Boston: Little, Brown, and Company, 1928), p. 13.

3 Robert Taft, *Photography and the American Scene*, p. 39.

4 James F. Ryder, *Voigtlander and I in Pursuit of Shadow Catching* (Cleveland: The Cleveland Printing & Publishing Co., 1902), p. 14.

5 Ibid., p. 15. 6 Ibid., p. 20.

7 Beaumont Newhall, *The Daguerreotype in America* (New York: Duell, Sloan & Pearce, 1961), pp. 36-37.

8 Ibid., p. 37.

9 Ralph Waldo Emerson, "Self-Reliance," *The Selected Writings of Ralph Waldo Emerson*, edited by Brooks Atkinson (New York: Modern Library, 1950), p. 162.

10 Nathaniel Hawthorne, *The House of the Seven Gables* (New York: The New American Library—a Signet Classic, 1961, original edition 1851), p. 156.

11 Ibid. 12 Ibid., pp. 156-57. 13 Ibid., p. 157.

14 Ibid. 15 Ibid., p. 80.

16 Emerson, "Self-Reliance," *Selected Writings*, pp. 147-48.

17 Hawthorne, *House of the Seven Gables*, p. 85.

18 Ibid., pp. 160-61.

19 Clay Perry, "Yankee Genius," *The Hartford Courant Magazine* (January 2, 1949), p. 7.

20 Anson Clark, "Philosophical Experiments with Electricity," a poster in the Historical Room of the Public Library, Stockbridge, Mass.

21 Anson Clark, "Daguerreotype Portraits," a broadside in the Historical Room of the Public Library, Stockbridge, Mass.

22 *The National Cyclopaedia of American Biography* (New York: James T. White & Company, 1907), vol. V, p. 218.

23 Gabriel Harrison, "Reality, in a Dream," *Photographic and Fine Art Journal*, vol. IX, no. 1 (January 1856), p. 27. (I am especially grateful to Nathan Lyons for bringing Harrison to my attention.)

24 Ibid.

25 Gabriel Harrison, letter on the Anthony Prize competition, *Photographic Art-Journal*, vol. IV, no. 3 (September 1852), p. 151.

26 *Photographic and Fine Art Journal*, vol. VII, no. 1 (January, 1854), pp. 6, 9.

27 Ibid., p. 8.

28 Ansel Adams, *The Print: Contact Printing and Enlarging* (New York: Morgan & Morgan, Inc., 1950), p. 2.

29 *Photographic and Fine Art Journal*, vol. VII, no. 1 (January 1854), p. 8.

30 Gabriel Harrison, "Lights and Shadows of Daguerrean Life: No. Two," *Photographic Art-Journal*, vol. I, no. 4 (April 1851), p. 232.

31 Gabriel Harrison, "Brooklyn Art-Union," *Photographic Art-Journal*, vol. II, no. 5 (November 1851), p. 295.

32 The [Matamoros, Mexico] *Republic of Rio Grande and Friend of the People*, vol. I, no. 4 (June 16, 1846), p. 2.

33 The [Matamoros, Mexico] *American Flag*, vol. I, no. 44 (October 24, 1846), p. 3. (This was the same paper as the *Republic of Rio Grande and Friend of the People* under a new masthead.)

34 *The Portland Oregonian* (May 7, 1853) quoted by Theodosia Teel Goodman, in "Early Oregon Daguerreotypers and Portrait Photographers," *Oregon Historical Quarterly*, vol. XLIX, no. 1 (March 1948), p. 32.

35 *American Flag*, vol. I, no. 56 (December 5, 1846), p. 4.

36 Ibid., vol. I, no. 60 (December 19, 1846), p. 3.

37 Newhall, *Daguerreotype in America*, p. 69.

38 Ibid., p. 70. 39 Ibid.

40 Taft, *Photography and the American Scene*, pp. 65-66.

41 Perez M. Batchelder, manuscript letter to Isaac W. Baker, Sonora, Calif., September 2, 1853, in the collection of the late Frederick S. Baker and Mrs. Pine Lea (Baker's grandchildren), Berkeley, Calif.

42 Ibid.

43 Robert Bartlett Haas, "William Herman Rulofson, Pioneer Daguerreotypist and Photographic Educator," *California Historical Society Quarterly*, vol. XXXIV, no. 4 (December 1955), p. 293.

44 Newhall, *Daguerreotype in America*, p. 71.

45 John W. Bear, *The Life and Travels of John W. Bear, "The Buckeye Blacksmith"* (Baltimore: D. Binswanger & Co., 1873), pp. 151-52.

46 Frederick Jackson Turner, *The Frontier in American History* [1893], partially reprinted in *American Issues: The Social Record* (Fourth Edition), edited by Merle Curti et al. (New York: J. B. Lippincott Company, 1960), pp. 670-71.

47 Newhall, *Daguerreotype in America*, p. 68.

48 Ryder, *Voigtlander and I*, p. 28.

49 Ibid., p. 29. 50 Ibid., p. 30. 51 Ibid., pp. 30, 32.

52 Ibid., p. 33. 53 Ibid., p. 55. 54 Ibid., pp. 55, 58.

55 Ibid., p. 58. 56 Ibid., pp. 69-70.

57 Ibid., pp. 111-12.

58 Quoted by Newhall in *Daguerreotype in America*, p. 71.

59 Sam F. Simpson, "Daguerreotyping on the Mississippi," *Photographic and Fine Art Journal*, vol. VIII, no. 8 (August 1855), p. 252.

60 Ibid. 61 Ibid. 62 Ibid.

63 [Robert H. Vance?], Preface to *Catalogue of Daguerreotype Panoramic Views in California*, by R. H. Vance (New York: Barker, Godwin & Company, Printers, 1851). (The only known copy is in the New York Public Library.)

64 *Daguerreian Journal*, vol. II, no. 12 (November 1, 1851), p. 37.

65 *Photographic Art-Journal*, vol. II, no. 4 (October 1851), pp. 252-53.

66 Ibid., p. 253. 67 Ibid. 68 Ibid.

69 Edward Weston, "What is Photographic Beauty?" *Camera Craft*, vol. XLVI (1939), p. 254, quoted in *Photographers on Photography*, edited by Nathan

Lyons (Englewood Cliffs, N.J.: Prentice-Hall., 1966), p. 154.

70 Beaumont Newhall, "The Daguerreotype and the Painter," *Magazine of Art*, vol. XLII, no. 7 (November 1949), pp. 249-51.

71 *Photographic Art-Journal*, vol. II, no. 4 (October 1851), p. 253.

72 John Francis McDermott, "Gold Rush Movies," *California Historical Society Quarterly*, vol. XXXIII, no. 1 (March 1954), pp. 29-30.

73 John Ross Dix, *Amusing and Thrilling Adventures of a California Artist, While Daguerreotyping a Continent* (Boston: published for the author, 1854).

74 Ibid., p. 35. 75 Ibid., p. 36. 76 Ibid., pp. 20-21.

77 Walt Whitman, "Preface to 'Leaves of Grass,'" reprinted in *American Issues: The Social Record* (Fourth Edition), edited by Merle Curti et al. (New York: J. B. Lippincott Company, 1960), pp. 319-21, passim.

78 [James Russell Lowell], "Longfellow's *Kavanagh*: Nationalism in Literature," *The North American Review*, vol. LXIX, no. 144 (July 1849), p. 198.

79 Dix, *Amusing and Thrilling Adventures*, p. 22.

80 The [Oregon City] *Spectator* (September 23, 1851) quoted by Theodosia Teel Goodman in "Early Oregon Daguerreotypers and Portrait Photographers," *Oregon Historical Quarterly*, vol. XLIX, no. 1 (March 1948), p. 35.

81 Dix, *Amusing and Thrilling Adventures*, p. 24.

82 *Harper's New Monthly Magazine*, vol. VII, no. 42 (November 1853), p. 851.

83 Ibid.

84 Dix, *Amusing and Thrilling Adventures*, p. 42.

85 Ibid., p. 43. 86 Ibid., p. 45. 87 Ibid., p. 46.

88 Ibid. 89 Ibid. 90 Ibid., p. 50. 91 Ibid., p. 47.

92 *New York Herald* (April 15, 1854), advertisement, p. 6, col. 5.

CHAPTER 6

1 Quoted in "Gold Rush Panoramas: San Francisco —1850 to 1853," *Sea Letter* [of the San Francisco Maritime Museum], vol. II, nos. 2 and 3—double issue (October 1964), p. 1.

2 Beaumont Newhall, *The Daguerreotype in America* (New York: Duell, Sloan & Pearce, 1961), p. 125.

3 *Putnam's Monthly, A Magazine of Literature, Science and Art*, vol. I, no. 2 (February 1853), p. 121.

4 *Humphrey's Journal*, vol. V, no. 19 (January 15, 1854), p. 303.

5 Ibid.

6 Ibid., vol. VII, no. 6 (July 15, 1855), p. 11.

7 Ibid. 8 Ibid., p. 12. 9 Ibid., p. 5.

10 Ibid., no. 20 (February 15, 1856), p. 8.

11 *Photographic and Fine Art Journal*, vol. VII, no. 1 (January 1854), pp. 9-10.

12 "The 'Arkansaw Traveler' Daguerreotyped," *Photographic and Fine Art Journal*, vol. VII, no. 2 (November 1854), p. 325. (The authorship of the article is given on p. 352.)

13 Ibid. 14 Ibid. 15 Ibid.

16 M. A. Root, *The Camera and the Pencil* (Philadelphia: J. B. Lippincott and Company, 1864), p. 89.

17 *Photographic and Fine Art Journal*, vol. VII, no. 2 (November 1854), p. 326.

18 John Werge, *The Evolution of Photography* (London: Piper & Carter, 1890), pp. 143-44.

19 Ibid.

20 Reproduced by Robert Taft in *Photography and the American Scene: A Social History, 1839-1889* (New York: Dover Publications, Inc., 1969), p. 51.

21 Samuel C. Busey, M.D., "Early History of Daguerreotypy in the City of Washington," *Records of the [District of] Columbia Historical Society*, vol. III (1900), p. 85.

22 Quoted by Robert Taft in "John Plumbe," *American Photography*, vol. XXX, no. 1 (January 1936), p. 8.

23 Taft, *Photography and the American Scene*, pp. 50-51. (Taft reproduces a Plumbeotype of the U.S. Capitol.)

24 Quoted by Busey in "Early History of Daguerreotypy," *Records of the Columbia Historical Society*, vol. III (1900), p. 86.

25 Taft, *Photography and the American Scene*, p. 53.

26 *Memoirs of John Quincy Adams*, edited by Charles Francis Adams (Philadelphia: J. B. Lippincott & Co., 1876), vol. XII, p. 8.

27 *Humphrey's Journal*, vol. I, no. 1 (April 15, 1852), p. 12.

28 Ibid.

29 *Memoirs*, Adams, vol. XI, p. 401.

30 Ibid., p. 430.

31 The Brady picture is reproduced fairly well in *Image of America*, a catalog of an exhibition held at the Library of Congress (Washington: Library of Congress, 1957), p. 21.

32 *Memoirs*, Adams, vol. XI, p. 352.

33 Newhall, *Daguerreotype in America*, p. 80.

34 *The Papers of Willie Person Mangum*, edited by Henry Thomas Shanks (Raleigh, N.C.: State Department of Archives and History, 1953), vol. III (1839-43), p. 173.

35 Root, *The Camera and the Pencil*, pp. 154-55.

36 George Alfred Townsend, "Brady, the Grand Old Man of American Photography," *The [New York] World* (April 12, 1891), p. 26, cols. 5-7.

37 Ibid. 38 Ibid.

39 Taft, *Photography and the American Scene*, p. 57.

40 U.S. 41st Cong., 3rd sess., House of Representatives Report No. 46, p. [1].

41 Gabriel Harrison, "Lights and Shadows of Daguerrean Life," No. 2, *Photographic Art-Journal*, vol. I, no. 4 (April 1851), p. 231.

42 Ibid., pp. 231-32.

43 *Photographic Art-Journal*, vol. I, no. 1 (January 1851), p. 63.

44 U.S. 41st Cong., 3rd sess., House of Representatives Report No. 46, pp. [1]-2.

45 *World* (April 12, 1891), p. 26, cols. 5-7.

46 Henri Herz, *Mes Voyages en Amerique*, reprinted in translation in *This Was America*, edited by Oscar Handlin (New York: Harper & Row, 1964), p. 192. (I am especially grateful to Ronald Letnes for bringing this material to my attention.)

CHAPTER 7

1 Albert S. Southworth, "An Address to the National Photographic Association of the United States,"

The Philadelphia Photographer, vol. VIII, no. 94 (October 1871), p. 320.

2 Ibid. 3 Ibid., pp. 320-21.

4 Henry David Thoreau, *Walden; or, Life in the Woods* (New York: Holt, Rinehart and Winston, 1961), p. 162.

5 Ralph Waldo Emerson, "Nature," *The Selected Writings of Ralph Waldo Emerson,* edited by Brooks Atkinson (New York: Modern Library, 1950), p. 6.

6 Southworth, "An Address," p. 321.

7 Ibid.

8 *Edward Weston: Photographer,* edited by Nancy Newhall (Rochester, N.Y.: Aperture, Inc. [1964]), p. 39.

9 Southworth, "An Address," p. 322.

10 Mathew Brady, letter to Samuel Morse, February 15, 1855, quoted by Beaumont Newhall in *The Daguerreotype in America* (New York: Duell, Sloan & Pearce, 1961), p. 83. The original is in the Morse papers of the Library of Congress.

11 Ibid.

12 Gabriel Harrison, letter to editor, *Photographic Art-Journal,* vol. I, no. 1 (January 1851), p. 64.

13 Ibid. 14 Ibid. 15 Ibid. 16 Ibid.

17 M. A. Root, *The Camera and the Pencil* (Philadelphia: J. B. Lippincott & Co., 1864), p. xv.

18 Ibid. 19 Ibid., p. 28. 20 Ibid., p. 27. 21 Ibid.

22 Ibid., pp. 19-20. 23 Ibid., p. 19. 24 Ibid., p. 25.

25 Rembrandt Peale, "Portraiture," *The Crayon,* vol. IV (1857), p. 44.

26 *Samuel F. B. Morse; His Letters and Journals,* edited by Edward Lind Morse (Boston: Houghton Mifflin Company, 1914), vol. II, p. 144.

27 Emerson, "Self-Reliance," *Selected Writings,* p. 146.

28 Root, *The Camera and the Pencil,* p. 24.

29 *Photographic Art-Journal,* vol. II, no. 2 (August 1851), p. 100.

30 Ibid. 31 Ibid.

32 Helmut Gernsheim, *Creative Photography: Aesthetic Trends 1839-1960* (Boston: Boston Book and Art Shop, 1962), p. 96.

33 Quoted by Beaumont Newhall in "Delacroix and Photography," *Magazine of Art,* vol. XLV, no. 7 (November 1952), p. 300. (Additional material and pictures on this subject are to be found in "The Art of Delacroix and the Camera's Eye" by F. A. Trapp, *Apollo,* vol. LXXXIII, no. 50 (April 1966), pp. 278-88.)

34 Ibid.

35 *Photographic Art-Journal,* vol. II, no. 2 (August 1851), p. 100.

36 Ibid.

37 *The Crayon,* vol. VI, part 12 (December 1859), p. 377.

38 Ibid.

39 Root, *The Camera and the Pencil,* p. 24.

40 *The Writings of Henry David Thoreau: Journal,* edited by Bradford Torrey (Boston: Houghton Mifflin Company, Walden Edition, 1906), vol. I, p. 189.

41 Ibid. 42 Ibid.

43 *Journals of Ralph Waldo Emerson,* edited by Edward Waldo Emerson and Waldo Emerson Forbes (Boston: Houghton Mifflin Company, 1912), vol. VI, p. 87.

44 Ibid., p. 111. 45 Ibid., vol. VIII, pp. 98-99.

46 *The Heart of Emerson's Journals,* edited by Bliss Perry (Boston: Houghton Mifflin Company, 1926), p. 331.

47 *Photographic Art-Journal,* vol. III, no. 3 (March 1852), p. 196.

48 John Werge, *The Evolution of Photography* (London: Piper & Carter, 1890), p. 54.

49 *American Journal of Photography,* New Series, vol. II, no. 5 (August 1, 1859), p. 74.

50 Horace Greeley, *Glances at Europe* (New York: Dewitt & Davenport, 1851), p. 26.

51 *American Journal of Photography,* New Series, vol. I, no. 7 (September 1, 1858), p. 111.

52 Ibid. 53 Ibid., p. 112. 54 Ibid. 55 Ibid., p. 113.

56 Root, *The Camera and the Pencil,* p. 24.

CHAPTER 8

1 Robert Taft, *Photography and the American Scene: A Social History, 1839-1889* (New York: Dover Publications, Inc., 1964), pp. 60-61.

2 Beaumont Newhall, *The Daguerreotype in America* (New York: Duell, Sloan & Pearce, 1961), p. 37.

3 Ibid., p. 34.

4 Taft, *Photography and the American Scene,* pp. 63, 76.

5 Ibid., pp. 78-80.

6 *Leading Pursuits and Leading Men: A Treatise on the Principal Trades and Manufactures of the United States (United States Mercantile Guide),* edited by Edwin T. Freedley (Philadelphia: Edward Young, 1856), p. 447.

7 T. S. Arthur, "American Characteristics: The Daguerreotypist," *Godey's Lady's Book,* vol. XXXVIII (May 1849), p. 352.

8 Translated in *Photographic Art-Journal,* vol. III, no. 1 (January 1852), p. 22.

9 *Photographic Art-Journal,* vol. III, no. 5 (May 1852), p. 320.

10 Translated in *The Knickerbocker,* vol. XLII (August 1853), p. 137.

11 *Gleason's Pictorial Drawing-Room Companion,* vol. VI, no. 13 (April 1, 1854), p. 208.

12 *Humphrey's Journal,* vol. IV, no. 16 (December 1, 1852), pp. 250-51.

13 Ibid., no. 20 (February 1, 1853), pp. 315-16.

14 Ibid., vol. V, no. 5 (June 15, 1853), pp. 73-74.

15 Translated in *Photographic Art-Journal,* vol. III, no. 1 (January 1852), p. 22.

16 M. A. Root, *The Camera and the Pencil* (Philadelphia: J. B. Lippincott & Co., 1864), p. 46.

17 Ibid., p. 47. 18 Ibid.

19 Ibid., pp. 47-48. 20 Ibid., p. 48.

21 *Godey's Lady's Book,* vol. XXXVIII (May 1849), p. 355.

22 Abraham Bogardus, "The Lost Art of the Daguerreotype," *The Century Magazine,* vol. LXVIII, no. 1 (May 1904), p. 91.

23 Ibid.

24 *Photographic and Fine Art Journal,* vol. VII, no. 12 (December 1854), p. 359.

25 The *Knickerbocker,* vol. XLII (August 1853), p. 141.

26 *Littell's Living Age,* vol. IX, no. 110 (June 20, 1846), p. 552.

27 Ibid. 28 Ibid.

29 Mark Twain, *Life on the Mississippi* (Boston: James R. Osgood and Company—Subscription [First] Edition, 1883), pp. 404-05.

30 *Exhibition of the Works of Industry of All Nations, 1851: Reports by the Juries on the Subjects in the Thirty Classes into Which the Exhibition was Divided* [Class X] (London: William Clowes & Sons, 1853), p. 276.

31 Ibid., p. 277.

32 James Glaisher, "Philosophical Instruments and Processes, as Represented by the Great Exposition," Lecture IX, *Lectures on the Progress of Arts and Science, Resulting from the Great Exposition in London* (New York: A. S. Barnes & Co., 1856), p. 282.

33 *Godey's Lady's Book*, vol. XXXVIII (May, 1849), p. 353.

34 Quoted in *Humphrey's Journal*, vol. VI, no. 13 (October 15, 1854), p. 207.

35 Ibid. 36 Ibid. 37 Ibid.

38 *Journals of Ralph Waldo Emerson*, edited by Edward Waldo Emerson and Waldo Emerson Forbes (Boston: Houghton Mifflin Company, 1912), vol. VI (1841-44), p. 111.

39 Ibid., p. 101.

40 Bogardus, "Lost Art of the Daguerreotype," *Century Magazine*, vol. XXVIII, no. 1 (May 1904), p. 91.

41 Ibid.

42 Quoted by Newhall in *Daguerreotype in America*, p. 77.

43 N. Parker Willis, *The Convalescent* (New York: Charles Scribner, 1859), p. 285.

44 Ibid., p. 286.

45 Rembrandt Peale, "Portraiture," *The Crayon*, vol. IV (1857), p. 45.

46 *Godey's Lady's Book*, vol. XXXVIII (May 1849), p. 355.

47 *Letters of Emily Dickinson*, edited by Mabel Loomis Todd (New York: Harper & Brothers, 1931), p. 276.

48 *Barnes v. Ingalls*, 39 Alabama 193 (1863), pp. 78-79.

49 *Photographic News* (October 18, 1861), p. 500; quoted by Helmut Gernsheim in *Lewis Carroll: Photographer* (New York: Chanticleer Press Inc., 1950), p. 6.

50 Newhall gives their development extensive discussion in *Daguerreotype in America*, pp. 129-33.

51 *Photographic and Fine Art Journal*, vol. VIII, no. 1 (January 1855), p. 19.

52 Ibid., vol. VII, no. 3 (March 1854), p. 88.

53 *New York Sun* and *New York Tribune* quoted by Michael Gross in "The 'Wet' and the 'Dry,'" *Photo-Era*, vol. XLII (January 1919), p. 13.

54 *The Story of an Old Album* compiled by Kate B. Carter (Salt Lake City: Daughters of Utah Pioneers, 1947), p. 106.

55 *Humphrey's Journal*, vol. V, no. 19 (January 15, 1854), p. 297.

56 Clarence S. Jackson, *Pageant of the Pioneers: The Veritable Art of William H. Jackson* (Minden, Nebr.: the Harold Warp Pioneer Village, 1958), p. 5.

57 *Photographic Art-Journal*, vol. I, no. 2 (February 1851), p. 126.

58 *Photographic and Fine Art Journal*, vol. VIII, no. 1 (January 1855), p. 19.

59 "The First Daguerreotype Made in Indiana," *The Indianapolis Sunday Star* (November 3, 1907).

60 *Wilson's Photographic Magazine*, vol. XXVIII, no. 407 (December 5, 1891), p. 705.

61 "Daguerreotypes on Tombstones," *Hutchings' California Magazine*, vol. I, no. 11 (May 1857), p. 519.

62 *Godey's Lady's Book*, vol. XXXVIII (May 1849), p. 354.

63 *Daguerreian Journal*, vol. I, no. 5 (January 15, 1851), p. 149.

64 *American Journal of Photography* (New Series), vol. I, no. 1 (June 1, 1858), p. 9.

65 Ibid.

66 *Humphrey's Journal*, vol. V, no. 19 (January 15, 1854), p. 302.

67 *Photographic and Fine Art Journal*, vol. VIII, no. 3 (March 1855), p. 80.

68 *The Berkshire Eagle*, clipping in the unpublished notebooks of Anson Clark in the Historical Room of the Public Library, Stockbridge, Mass.

69 "The Inconstant Daguerreotype," *Harper's New Monthly Magazine*, vol. X, no. 60 (May 1855), p. 823.

70 Ibid.

71 Dion Boucicault, *The Octoroon*, reprinted in *Representative American Plays*, edited with an introduction and notes by Arthur Hobson Quinn (New York: the Century Company, 1917), p. 442.

72 Ibid., p. 453.

73 *New-York Weekly Tribune* (September 18, 1841), p. 8, col. 5.

74 *The* [Boston] *Weekly Symbol and Odd Fellows' Magazine* (January 1, 1848), p. 2, col. 7.

75 Quoted by John Ross Dix in *Amusing and Thrilling Adventures of a California Artist . . .* , (Boston: published for the author, 1854), p. 39.

76 *The* [New York] *World* (April 12, 1891), p. 26, cols. 5-7.

77 "The Daguerreolite," *The* [Cincinnati] *Daily Chronicle* (January 17, 1840), p. 2, col. 1.

78 *Humphrey's Journal*, vol. VI, no. 13 (October 15, 1854), p. 207.

79 *Godey's Lady's Book*, vol. XXXVIII (May 1849), p. 352.

CHAPTER 9

1 Horace Greeley, *Glances at Europe . . .* (New York: Dewitt & Davenport, 1851), p. 26.

2 Ibid.

3 Quoted by John Ross Dix in *Amusing and Thrilling Adventures . . .* (Boston: published for the author, 1854), p. 47.

4 Gabriel Harrison, "Lights and Shadows of Daguerreian Life," No. 2, *Photographic Art-Journal*, vol. I, no. 4 (April 1851), p. 231.

5 Quoted by Beaumont Newhall in *The Daguerreotype in America* (New York: Duell, Sloan & Pearce, 1961), p. 83.

6 M. A. Root, *The Camera and the Pencil* (Philadelphia: J. B. Lippincott & Co., 1864), p. xv.

7 U.S. 41st Cong., 3rd sess., House of Representatives Report No. 46, p. 2.

8 Quoted by James D. Horan in *Mathew Brady: Historian with a Camera* (New York: Crown Publishers, Inc., 1955), p. 33.

9 U.S. 41st Cong., 3rd sess., House of Representatives Report No. 46, p. [1].

10 Root, *The Camera and the Pencil*, p. 27.

11 Nathaniel Hawthorne, *The House of the Seven Gables* (New York: The New Modern Library, 1961), p. 85.

12 Edward Hitchcock, *Religion of Geology* ... (Boston: Phillips, Sampson, and Company, 1851), p. 426.

13 S. N. Carvalho, *Incidents of Travel and Adventure in the Far West* (New York: Derby & Jackson, 1857), p. 83.

14 John A. Kouwenhoven, *Made in America* . . . (Garden City, N.Y.: Doubleday & Company, Inc., 1962), p. 176.

15 Edward Vischer (translated by Ruth Frey Axe), "A Trip to the Mining Regions in the Spring of 1859," *California Historical Society Quarterly*, vol. IX, no. 3 (September 1932), p. 229.

16 James F. Ryder, *Voigtlander and I* ... (Cleveland: Cleveland Printing & Publishing Co., 1902), p. 16.

17 Ibid., p. xi.

18 Robert Taft, *Photography and the American Scene* ... (New York: Dover Publications, Inc., 1964), p. 16.

19 *The* [New York] *Evening Post*, No. 11534 (December 10, 1839), p. 2, col. 2.

20 Henry David Thoreau, *The Writings of Henry David Thoreau: Journal*, edited by Bradford Torrey, vol. I, p. 189.

21 Albert S. Southworth, "An Address ...," *The Philadelphia Photographer*, vol. VIII, no. 94 (October 1871), p. 322.

22 A. H. Griffith, "Introduction" in Ryder's *Voigtlander and I*, p. ix.

INDEX

275

PLATES

Since many original daguerreotypes carry the marks of age, the images given here are sometimes spotted, tarnished, or physically damaged. Rather than falsify reality by trying to retouch the copies, it appeared best to present the images as they are. Aside from some tinting and coloring, daguerreotype surfaces were so delicate as to prohibit tampering; it has seemed proper to respect the nature of the originals, although some subjects have been emphasized by reducing blank areas at the edges of pictures.

Daguerreotype plate sizes were never truly standardized, since many operators chose to cut their own, even though commercial materials were widely available. In general, sizes indicated in the plate captions approximately fit the following scale, in inches:

Imperial plate	larger than 6½ by 8½
Whole plate	6½ by 8½
Half plate	4½ by 5½
Quarter plate	3¼ by 4¼
Sixth plate	2¾ by 3¼
Ninth plate	2 by 2½

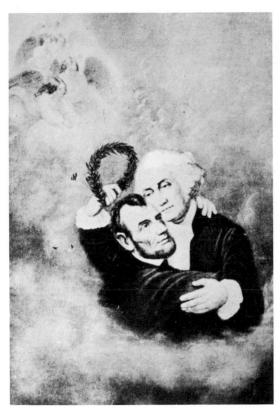

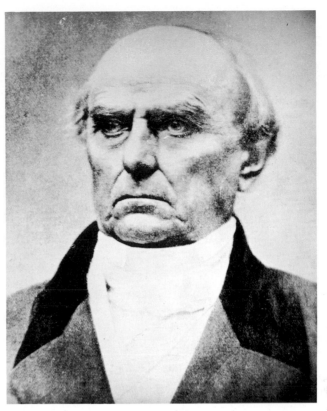

1 Washington and Lincoln (Apotheosis). Photographer unknown, 1865. Carte-de-visite. Collection of the late F. E. Seaton.

2 Daniel Webster. By Southworth and Hawes, 1850. Reproduced from *McClure's Magazine* (November 1896).

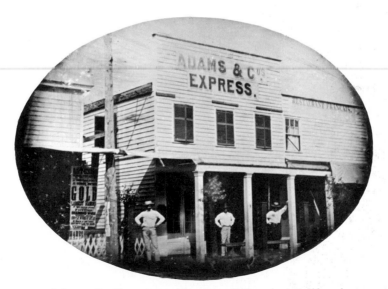

3 Adams & Company Express Office in California. Maker unknown, about 1855. Half plate. Collection of the Bancroft Library, Berkeley, Calif. Reproduced by permission of The Director.

4 Profile of Ann Wellstood at age 31. Made by the Automatic Drawer in London, April 1821, and photographed in 1857 by Meade Brothers, New York. Collection of the late F. E. Seaton.

5 John Sartain. Engraving by Sartain from daguerreotype by Marcus A. Root, Philadelphia. Reproduced from Root's *The Camera and the Pencil*.

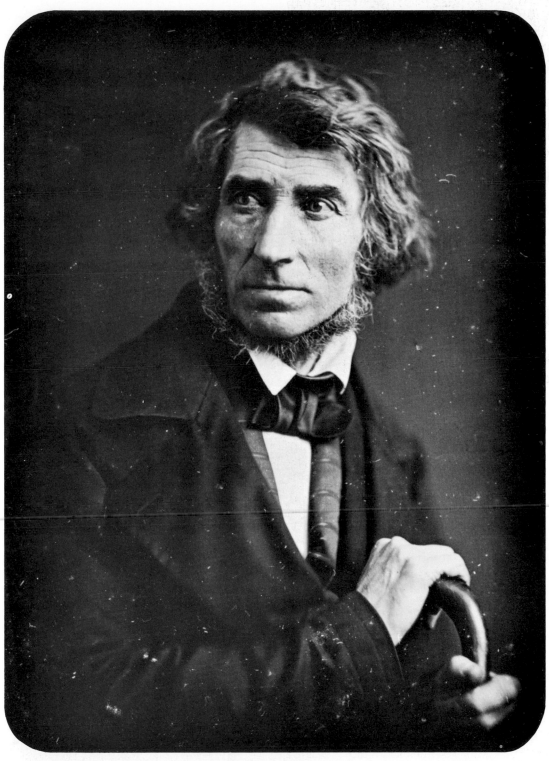

6 Asher B. Durand, American painter. Maker unknown, about 1855. Half plate.
Collection of The New-York Historical Society, New York.

PLATE 6 281

7 Woodcut based on 1839 daguerreotype of Miss Morse and a friend made by Samuel F. B. Morse. Reproduced from Root's *The Camera and the Pencil*.

8 Dorothy Catherine Draper. By John William Draper, 1840. From a collotype in the collection of the Chandler Chemical Museum of Columbia University, New York.

9 Boston. By Samuel Bemis, winter of 1840-41. Whole plate. Collection of the George Eastman House, Rochester, N.Y.

10 King's Chapel Burying Ground, Boston. By Samuel Bemis, winter of 1840-41. Whole plate. Collection of the George Eastman House, Rochester, N.Y.

11 King's Chapel Burying Ground, Boston. By Samuel Bemis, winter of 1840-41. Whole plate. Collection of the George Eastman House, Rochester, N.Y.

12 Crawford Notch, N.H. By Samuel Bemis, probably summer of 1840. Whole plate. Collection of the George Eastman House, Rochester, N.Y.

13 Crawford Notch, N.H. By Samuel Bemis, probably summer of 1840. Whole plate (detail). Collection of the George Eastman House, Rochester, N.Y.

14 Tree in farm meadow, probably near Crawford Notch, N.H. By Samuel Bemis, probably summer of 1840. Whole plate. Collection of the George Eastman House, Rochester, N.Y.

PLATES 12-14

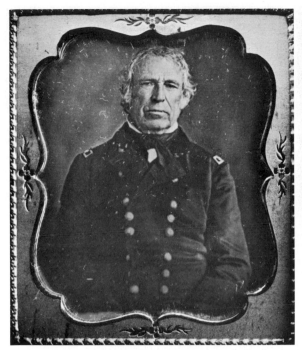

15 Zachary Taylor (1784-1850), twelfth President of the United States. By Southworth and Hawes, about 1848. Sixth plate. Collection of the Metropolitan Museum of Art, New York. (Gift of I. N. P. Stokes and the Hawes family.)

16 Girl with portrait of George Washington. By Southworth and Hawes, about 1852. Whole plate. Collection of the Metropolitan Museum of Art, New York.

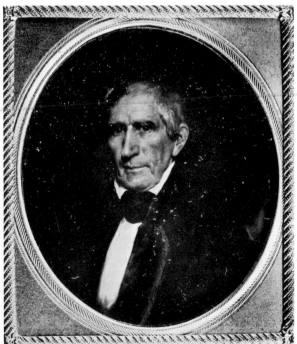

17 Andrew Jackson (1767-1845), seventh President of the United States. Probably by Dan Adams, 1845. Sixth plate. Collection of the George Eastman House, Rochester, N.Y.

18 William Henry Harrison (1773-1841), ninth President of the United States. By Southworth, probably 1841. Sixth plate. Collection of the Metropolitan Museum of Art, New York. Gift of I. N. P. Stokes and the Hawes family.)

19 Unknown man. Maker unknown, 1850. Ninth plate cut for a locket. Collection of Richard Rudisill, Albuquerque.

20 The first photograph of the solar spectrum. By John William Draper, New York, July 27, 1842. Quarter plate. Collection of the Science Museum, London.

21 Multiple exposure of the moon (notes indicate exposure times). By Samuel Dwight Humphrey, Canandaigua, N.Y., September 1, 1849. Sixth plate. Collection of the Harvard College Observatory, Cambridge, Mass.

22 John Adams Whipple (1822-91), Boston daguerreotypist. Lithograph by F. D'Avignon, New York, from the *Photographic Art-Journal*.

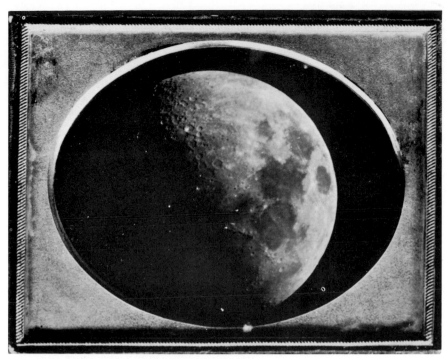

23 The moon. By John Adams Whipple, 1850-51. Half plate. Collection of the Science Museum, London.

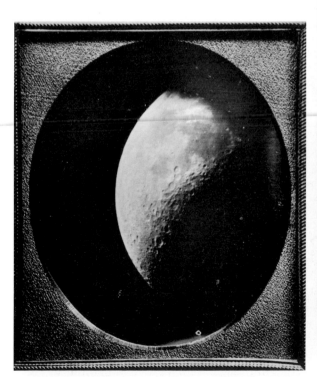

24 The moon. By John Adams Whipple, 1850-51. Quarter plate. Collection of the Science Museum, London.

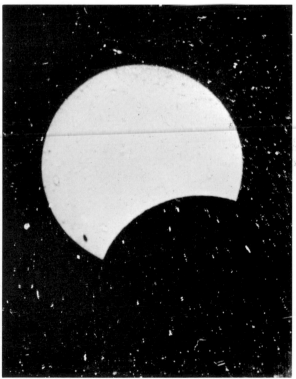

25 Partial eclipse of the sun (detail). By John Adams Whipple, July 28, 1851. Collection of the Harvard College Observatory, Cambridge, Mass.

26 Stone Tower at Newport, R.I. By Gabriel Harrison for Martin M. Lawrence, 1850. Quarter plate. Collection of The New-York Historical Society, New York.

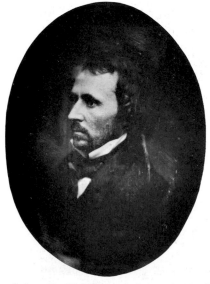

27 John C. Fremont (1813-90). Probably by Mathew Brady, about 1850. Imperial plate. Collection of the Oakland Museum, Oakland, Calif.

28 Plains Indian village. Possibly by Solomon Carvalho, 1853. Whole plate (detail). Collection of the Library of Congress, Washington, D.C.

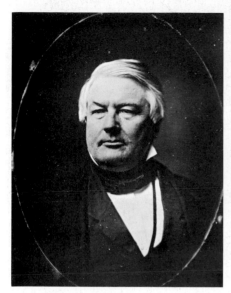

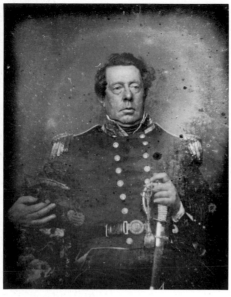

29 Millard Fillmore (1800-74), thir-
teenth President of the United
States. Probably by Edward Anthony,
about 1852. Collection of the Chi-
cago Historical Society, Chicago.

30 Commodore Matthew C. Perry
(1794-1858). Maker unknown, about
1855. Half plate. Collection of The
New-York Historical Society, New
York.

31 Temple at Tumai, Lew Chew. Lithograph by Ackerman, New York, from a
drawing by William Heine and Eliphalet Brown, Jr. From the *Narrative of the
Expedition of an American Squadron to the China Seas and Japan....*

32 Chief Magistrate of Napha, Lew Chew. Lithography by P. S. Duval & Co., Philadelphia, from a daguerreotype by Eliphalet Brown, Jr., 1853. From the *Narrative of the Expedition.* . . .

33 The Regent of Lew Chew. Lithograph by Ackerman, New York, from a daguerreotype by Eliphalet Brown, Jr., 1853. From the *Narrative of the Expedition.* . . .

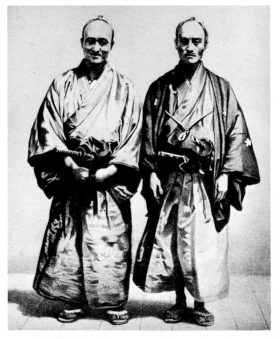

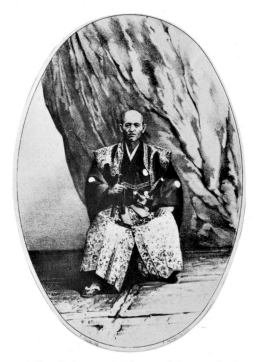

34 Chief interpreter Moryamo Yenoski and interpreter Tako Juro. Lithograph by Sinclair, Philadelphia, from a daguerreotype by Eliphalet Brown, Jr., 1853. From the *Narrative of the Expedition.* . . .

35 The Prince of Idzu. Lithograph by Sinclair, Philadelphia, from a daguerreotype by Eliphalet Brown, Jr., 1854. From the *Narrative of the Expedition.* . . .

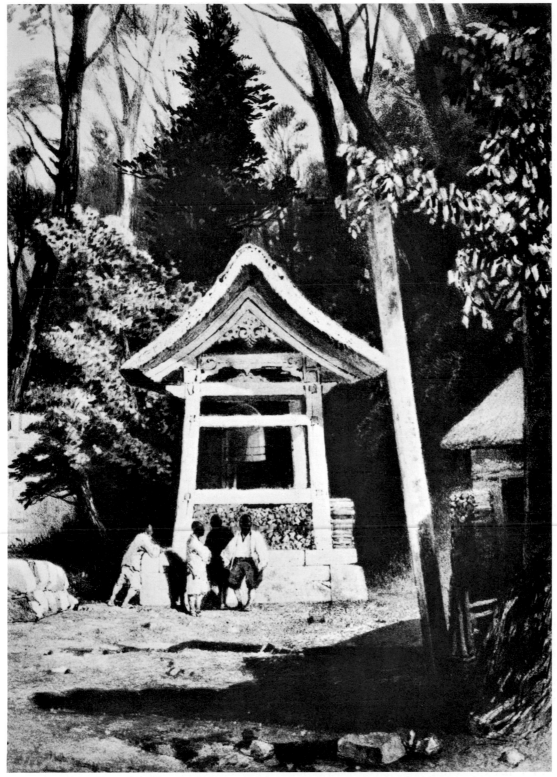

36 Bell-House at Simoda. Lithograph by Sarony, New York, from a daguerreotype
by Eliphalet Brown, Jr., 1854. From the *Narrative of the Expedition. . . .*

PLATE 36 *291*

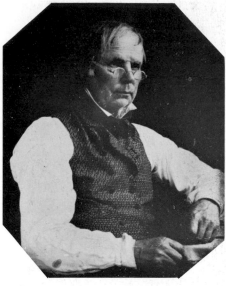

37 Probably Anson Clark (1783-1847), daguer-reotypist. By Anson Clark, about 1842-45. Sixth plate. Collection of the Historical Room of the Stockbridge Library Association, Stockbridge, Mass.

38 Possibly Edwin H. Clark, son of Anson Clark. By Anson Clark, about 1842. Sixth plate. Collection of the Historical Room of the Stockbridge Library Association, Stockbridge, Mass.

39 Almira Marshall, descendant of Chief Justice John Marshall. By Anson Clark, about 1845. Quarter plate. Collection of the Historical Room of the Stockbridge Library Association, Stockbridge, Mass.

40 Unidentified child. By Anson Clark, about 1842-45. Quarter plate. Collection of the Historical Room of the Stockbridge Library Association, Stockbridge, Mass.

41 West Stockbridge, Mass., 1841-42. By Anson Clark. Whole plate. Collection of the Historical Room of the Stockbridge Library Association, Stockbridge, Mass.

42 "Past, Present, and Future." By Gabriel Harrison, 1851. From a crystallotype copy in the *Photographic Art-Journal*. Location of original unknown.

43 "The Infant Saviour Bearing the Cross" (posed by George Washington Harrison). By Gabriel Harrison, 1853. Whole plate. Collection of the George Eastman House, Rochester, N.Y.

44 The Anthony Prize pitcher and goblets. From
The Photographic and Fine Art-Journal (1854).

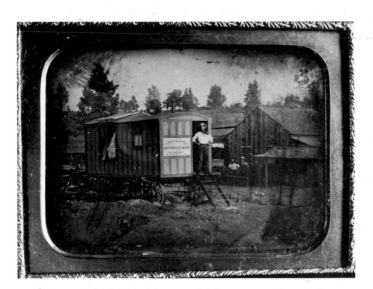

45 Perez M. Batchelder and his Daguerrian Saloon,
Vallecito, Calif. By Isaac W. Baker, summer of 1853.
Quarter plate. Collection of the Oakland Museum,
Oakland, Calif.

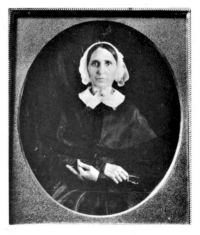

46 Amanda McBriggs (1794-1884). By
D. B. and J. McBriggs, operators of a
New England traveling wagon, 1852.
Sixth plate. Labhard Collection of the
University of New Mexico Art Muse-
um, Albuquerque.

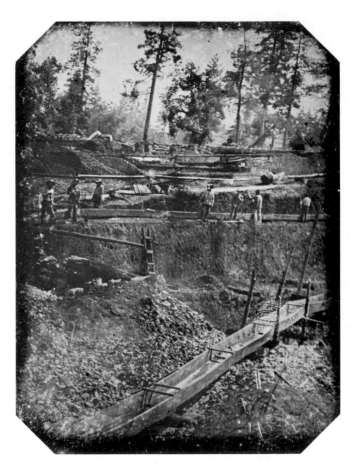

47 Miners with sluice and cut bank, near Vallecito, Calif. By Isaac W. Baker, about August 1853. Quarter plate. Collection of the Oakland Museum, Oakland, Calif.

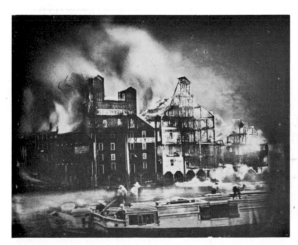

48 Fire in the Ames Mills, Oswego, N.Y. By George N. Barnard, 1853. Collection of the George Eastman House, Rochester, N.Y.

49 James Wilson Marshall, discoverer of gold, and Sutter's Sawmill, Coloma, Calif. Probably by Robert H. Vance, about 1852. Reproduced from a copy by C. E. Watkins in the collection of the Society of California Pioneers, San Francisco.

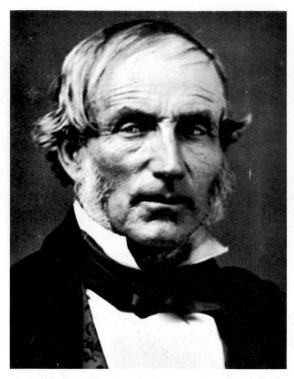

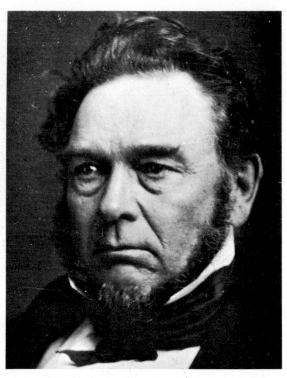

50 Captain William Anthony Richardson (?-1856), leading California pioneer. By Robert H. Vance, about 1854. Half plate (detail). Collection of the California State Library, Sacramento.

51 Unknown man. By William Shew, about 1852. Whole plate (detail). Collection of the Bancroft Library, Berkeley, Calif. Reproduced by permission of The Director.

52 Kearney Street between Sacramento and California streets (looking north), San Francisco. By William Shew, 1852. Whole plate. Collection of the Bancroft Library, Berkeley, Calif. Reproduced by permission of The Director.

53 Smith and Porter's Coffee House and Hotel, Sacramento and Sansome streets, San Francisco. By Shaw and Johnson, about 1850. Whole plate. Collection of the Bancroft Library, Berkeley, Calif. Reproduced by permission of The Director.

54 The Jones party daguerreotyping at Steeple Rocks, 1851. Drawing from the Jones Expedition. Reproduced from *The California Historical Society Quarterly*.

55 Salt Lake City in 1851. Drawing by Alonzo Chappell from a daguerreotype of the Jones Expedition. Reproduced from *The California Historical Society Quarterly*.

56 Placer mining near Hangtown, Calif. (tall man on the right with light suspenders is William Pickett, a relative of Confederate General Pickett). By William Shew, about 1851. Half plate. Collection of the Bancroft Library, Berkeley, Calif. Reproduced by permission of The Director.

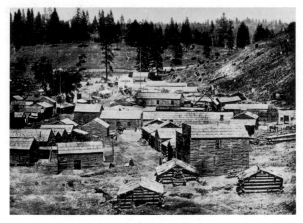

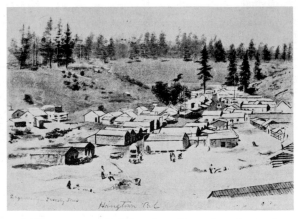

57 Hangtown, Calif. about 1851. Maker unknown. Reproduced from *Pictorial History of California,* edited by Owen C. Coy (Berkeley: University of California Extension Division), 1925. Location of original unknown.

58 Hangtown, Calif., 1851. Drawing from the Jones Expedition. Reproduced from *The California Historical Society Quarterly.*

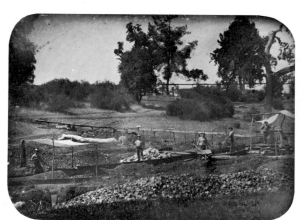

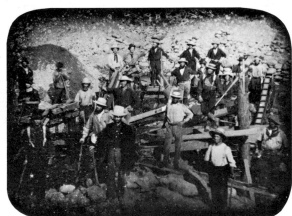

59 Mining scene in California. Maker unknown, about 1851-52. Half plate. Collection of the Oakland Museum, Oakland, Calif.

60 Miners and diggings, California. Maker unknown, about 1851-52. Half plate. Collection of the California State Library, Sacramento.

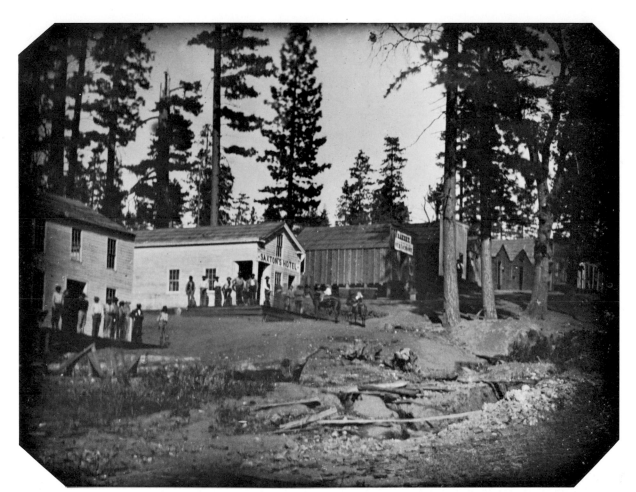

61 Unidentified California mining town. Maker unknown, about 1851-52. Half plate. Labhard Collection of the University of New Mexico Art Museum, Albuquerque.

62 Banking House of James King of William, San Francisco. Maker unknown, about 1855. Whole plate. Collection of the Wells Fargo Bank History Room, San Francisco.

63 Bank of Orleans and stores, New Orleans. Maker unknown, about 1843-45. Sixth plate. Collection of Robert Bretz, Rochester, N.Y.

64 New Orleans. Maker unknown, about 1852. Collection of Prof. Erich Stenger, Photomuseum, Agfa-Gevaert, Leverkusen, Germany.

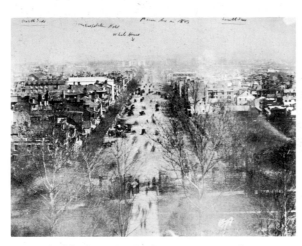

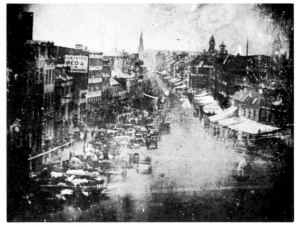

65 Washington, D.C., in 1843. Wet-plate copy of a daguerreotype from the Gallery of Mathew Brady. Collection of the Library of Congress, Washington, D.C.

66 Probably a street in Baltimore. Probably by Henry Fitz, Jr., about 1842-45. History of Photography Collection, Smithsonian Institution, Washington, D.C.

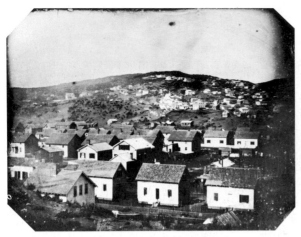

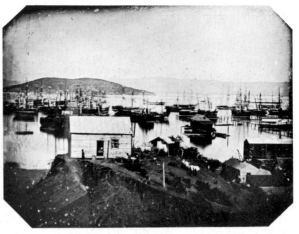

67 Section from a panorama of San Francisco from Rincon Point. Maker unknown, about 1852. Whole plate. Collection of the California Historical Society, San Francisco.

68 Section from a panorama of San Francisco from Rincon Point. Maker unknown, about 1852. Whole plate. Collection of the California Historical Society, San Francisco.

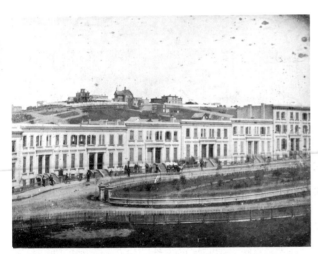

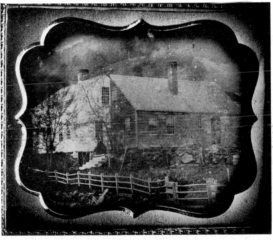

69 South Park, San Francisco, between Second and Third streets. Maker unknown, about 1852-54. Imperial plate. Collection of the Oakland Museum, Oakland, Calif.

70 Home of early settlers, Hangtown, Calif. Maker unknown, about 1855. Sixth plate. Collection of the Bancroft Library, Berkeley, Calif. Reproduced by permission of The Director.

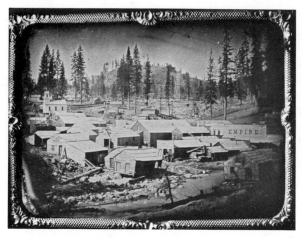

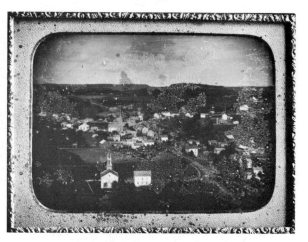

71 Nevada City, Calif. Maker unknown, 1852. Quarter plate. Collection of the California State Library, Sacramento.

72 Nevada City, Calif. Maker unknown, about 1854-55. Quarter plate. Collection of the Society of California Pioneers, San Francisco.

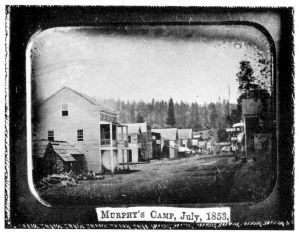

MURPHY'S CAMP, July, 1853.

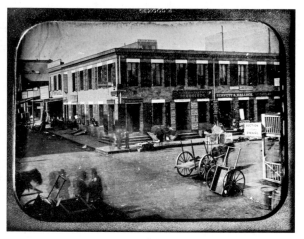

73 Murphy's Camp, Calif. By Isaac W. Baker, July 1853. Quarter plate. Collection of the Oakland Museum, Oakland, Calif.

74 Montgomery and Clay streets, San Francisco. By Fred Coombs, about 1850. Half plate. Collection of the George Eastman House, Rochester, N.Y.

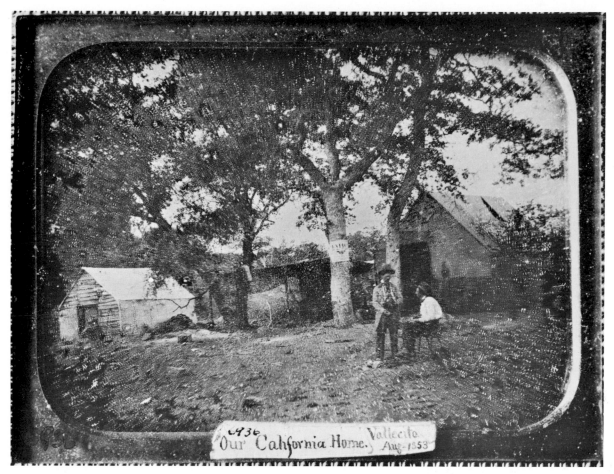

75 "Our California Home" at Vallecito, Calif. Benjamin Franklin Cushing (seated) and his brother. Possibly by Isaac W. Baker or Perez M. Batchelder, August 1853. Half plate. Collection of the California Department of Parks and Recreation, Sutter's Fort State Historical Park, Sacramento.

76 River town with sawmill (detail). Maker unknown, about 1850. Collection of the George Eastman House, Rochester, N.Y.

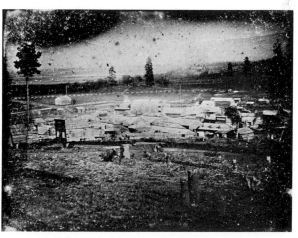

77 Jacksonville, Oregon. By Peter Britt, about 1854-55. Half plate. Collection of the Society of California Pioneers, San Francisco.

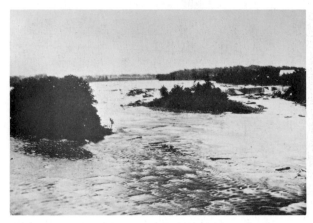

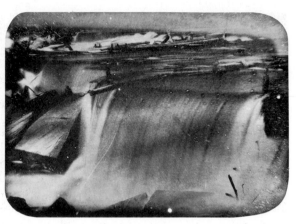

78 St. Anthony Falls on the Mississippi River (looking east). By Alexander Hesler, August 1851. Reproduced from *Minneapolis Album* by E. A. Bromely (1890). Location of original unknown.

79 St. Anthony Falls (looking west). By Joel Emmons Whitney, July 1852. Whole plate. Collection of the Minnesota Historical Society, St. Paul.

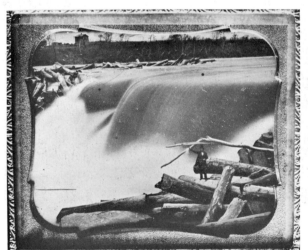

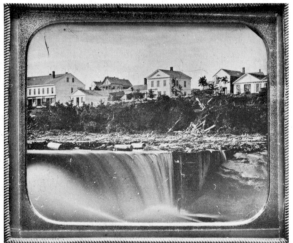

80 St. Anthony Falls (looking west). Maker unknown. Sixth plate. Collection of the Minnesota Historical Society, St. Paul.

81 St. Anthony Falls (looking east) and St. Anthony (now part of Minneapolis), Minn. Maker unknown, about 1852. Sixth plate. Collection of the Minnesota Historical Society, St. Paul.

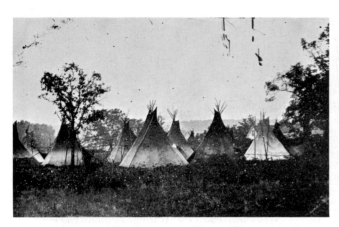

82 Minneapolis, Minn. Indian village on the site of Bridge Square and house of Col. John Stevens. Maker unknown, 1854. Half plate. Collection of the Minnesota Historical Society, St. Paul.

83 St. Anthony Falls (looking west) and bridge over secondary branch of the Mississippi River. Maker unknown, about 1854. Quarter plate. Collection of the Minnesota Historical Society, St. Paul.

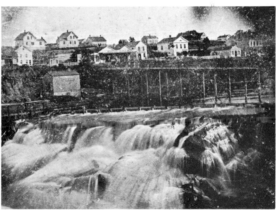

84 First bridge across the Mississippi River. Opened July 4, 1855, at Minneapolis, Minn. Maker unknown, 1855-56. Collection of the Minnesota Historical Society, St. Paul.

85 St. Anthony Falls (looking east—reversed image) and St. Anthony, Minn. Maker unknown, about 1855. Half plate. Collection of the Minnesota Historical Society, St. Paul.

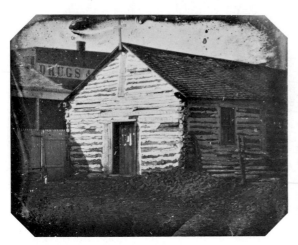

86 Founding chapel of St. Paul, Minn., built by Fr. Lucien Galtier in 1841. Maker unknown, 1854. Sixth plate. Collection of the Catholic Historical Society of St. Paul (gift of Mrs. J. J. Hill).

87 Fort Snelling, Minn. Maker unknown, about 1850. Half plate. Collection of the Minnesota Historical Society, St. Paul.

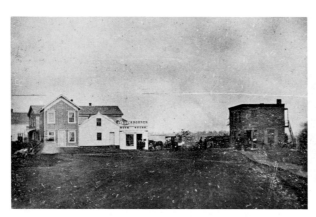

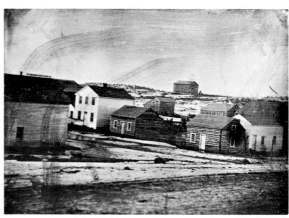

88 Le Duc House and Book Store, Wabasha and Second streets, St. Paul, Minn. Maker unknown, about 1855. Half plate. Collection of the Minnesota Historical Society, St. Paul.

89 Saint Paul, Minn. Maker unknown, 1851. Quarter plate. Collection of the Minnesota Historical Society, St. Paul.

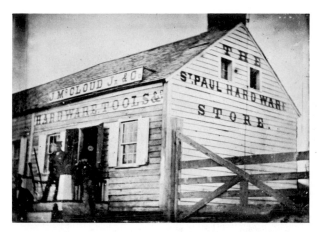

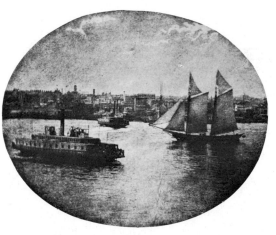

90 Hardware Store of J. McCloud, Jr., St. Paul, Minn. Maker unknown, about 1851. Quarter plate. Collection of the Minnesota Historical Society, St. Paul.

92 New York in 1854. By John Werge. Reproduced from a collotype in Werge's *The Evolution of Photography* (1890). Location of original unknown.

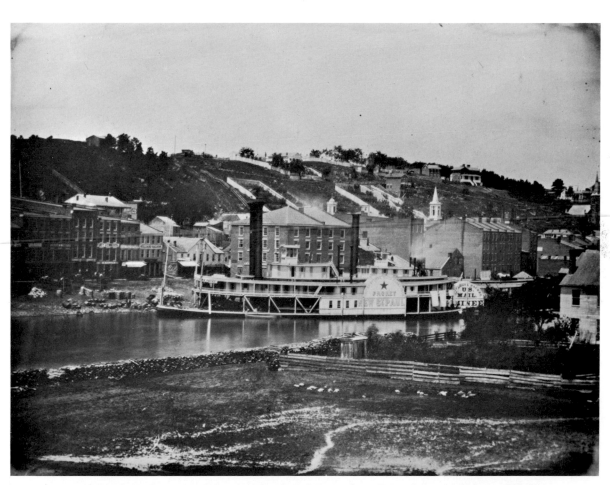

91 U.S. Mail Passenger *New St. Paul* and Steamboat *Nominee* at Galena, Ill. By Alexander Hesler, probably 1851-52. Collection of the Chicago Historical Society, Chicago.

93 "Driving a Bargain." By Alexander Hesler, about 1856. Reproduced from a crystallotype copy in *The Photographic and Fine Art-Journal*. Copy courtesy of the George Eastman House, Rochester, N.Y. Location of original unknown.

94 "The Young Bachelor's Sunday Morning." By J. T. Harrison, Oshkosh, Wis., 1857. Reproduced from a crystallotype copy by C. Farand in *The Photographic and Fine Art-Journal*. Location of original unknown.

95 "The Woodsawyer's Nooning." By George N. Barnard, Oswego, N.Y., 1853. Reproduced from a crystallotype copy in *The Photographic and Fine Art-Journal*. Copy courtesy of the George Eastman House, Rochester, N.Y. Location of original unknown.

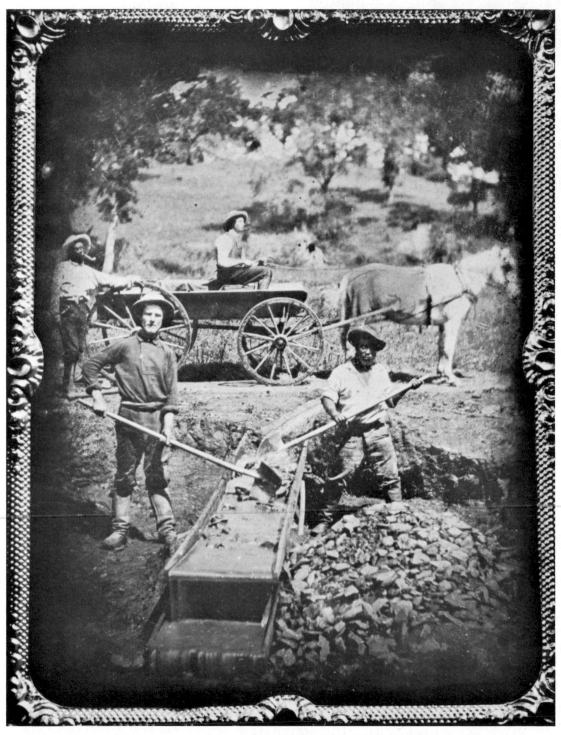

96 Miners with sluice box and wagon, Spanish Flat, Calif. Maker unknown, 1852. Quarter plate. Collection of the California State Library, Sacramento.

PLATE 96 *309*

97 Placer mining scene on the American River in California. By George H. Johnson, 1851. Half plate. Collection of the California Department of Parks and Recreation, Sutter's Fort State Historical Park, Sacramento.

98 Hydraulic mining, Michigan Bluff, Calif. Maker unknown, about 1855. Copy courtesy of the California Historical Society, San Francisco. Location of original unknown.

99 "Free State Battery," Topeka, Kan. (detail). Maker unknown, summer of 1856. Collection of the Kansas State Historical Society, Topeka.

100 Express wagon. Maker unknown. Sixth plate. Collection of the George Eastman House, Rochester, N.Y.

101 Francis and I. P. Hill, millers, sharpening a millstone inside the Island Mills, St. Anthony, Minn. Maker unknown, about 1858. Reproduced from a copy photograph in the collection of Wells Eastman, Wayzata, Minn. Location of original unknown.

102 Shepherd with flock of sheep. Maker unknown, about 1850. Sixth plate. Collection of The New-York Historical Society, New York.

103 Men moving a steam boiler(?). Maker unknown, about 1855. Half plate. Collection of the Society of California Pioneers, San Francisco.

104 Stream dammed and diverted to a water wheel, with group of men, probably Indians. Maker unknown, about 1850. Half plate. Collection of the Society of California Pioneers, San Francisco.

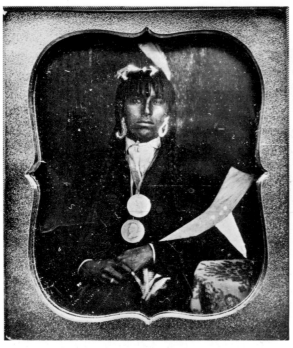

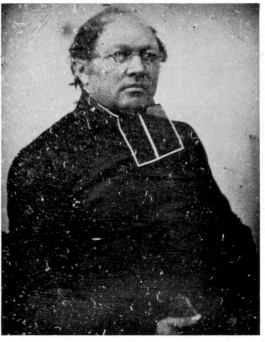

105 Chief Hole-in-the-Day, with war axe and peace medals (head ornaments and axe have been accented with gold paint). Maker unknown, about 1850. Sixth plate. Collection of the Minnesota Historical Society, St. Paul.

106 Joseph Cretin, appointed first Roman Catholic bishop of the diocese of St. Paul, Minn., in 1850. Maker unknown, about 1851-52. Sixth plate. Collection of the Catholic Historical Society of St. Paul.

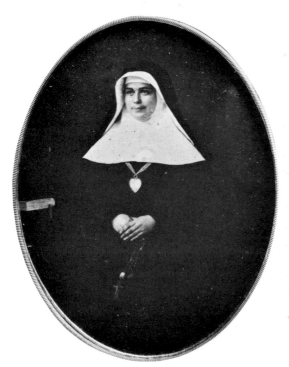

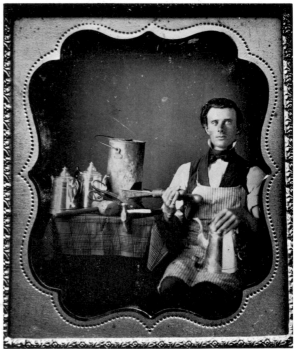

107 Unidentified nun. Maker unknown, about 1850. Quarter plate. Collection of the George Eastman House, Rochester, N.Y.

108 Toleware maker. Maker unknown, about 1850. Sixth plate. Collection of the Bancroft Library, Berkeley, Calif. Reproduced by permission of The Director.

109 Stable groom and trotting horse. Maker unknown, about 1850. Sixth plate. Labhard Collection of the University of New Mexico Art Museum, Albuquerque.

110 Henry Daniel Cogswell, D.D.S. (1818-1900), with dental tools and tooth. Probably the first dentist in California to use chloroform in oral surgery. Maker unknown, about 1850. Sixth plate. Formerly collection of the late Mrs. Theodore J. Labhard, San Francisco. Present location unknown.

111 Soldier with sword. Maker unknown, about 1848. Quarter plate. Collection of the late F. E. Seaton.

112 Reverend Beekman. By Meade Brothers, New York, about 1850. Half plate. Collection of The New-York Historical Society, New York.

113 Alfred Marshall Mayer with chemical equipment, Baltimore, 1856. Probably by Frank Blackwell Mayer. Collection of A. Hyatt Mayor, New York.

114 Valentine Denzer, circus artist. Maker unknown, about 1850. Sixth plate. Collection of the George Eastman House, Rochester, N.Y.

115 Surveyor with transit. Maker unknown, about 1850. Sixth plate. Collection of the George Eastman House, Rochester, N.Y.

116 Aaron D. Crane and a 400-day clock he built. Maker unknown, about 1850. Sixth plate. Collection of The New-York Historical Society, New York.

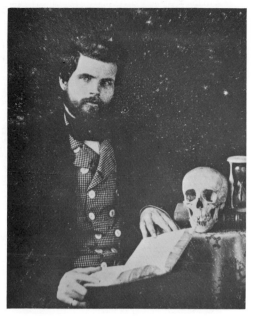

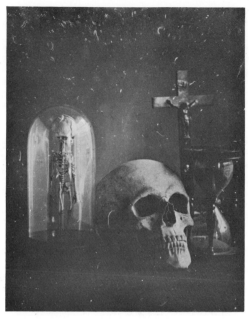

117 Dr. William S. Forwood, physician and historian. Maker unknown, February 1857. From the William S. Forwood Papers in the Southern Historical Collection of the University of North Carolina Library, Chapel Hill.

118 Still life of skull, skeleton, crucifix, and hourglass. By Dubosq, Paris, about 1852-54. Sixth plate from stereo pair. Collection of the George Eastman House, Rochester, N.Y.

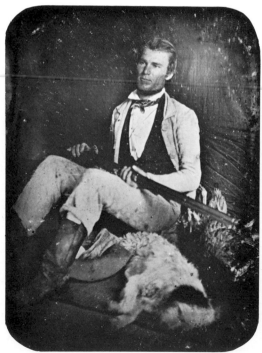

119 Turkey hunter with shotgun, turkey, and dog. Maker unknown, about 1850. Quarter plate. Collection of Robert Bretz, Rochester, N.Y.

121 Lacemaker (Mary R. Young, wife of David K. Hoffman of Lebanon, N.J.). Maker unknown, about 1850. Sixth plate. Collection of the Minnesota Historical Society, St. Paul.

122 Reverend James S. Cannon. By Haas, New York, about 1850. Half plate. Collection of The New-York Historical Society, New York.

124 French or Algerian street scene. Maker unknown, about 1842-45. Sixth plate. Collection of the George Eastman House, Rochester, N.Y.

125 Street scene with brick duplex house. Maker unknown, about 1850. Whole plate. Collection of the George Eastman House, Rochester, N.Y.

PLATE 125

317

126 Sarah Griswold Morse, second wife of Samuel Morse, and Susan Walker Morse, Morse's daughter, playing chess on the porch of "Locust Grove," Morse's country home at Poughkeepsie, N.Y. By Samuel Morse, about 1848. Sixth plate. Collection of The New-York Historical Society, New York.

127 Possibly a French gypsy caravan. Maker unknown, about 1842-45. Sixth plate. Collection of the George Eastman House, Rochester, N.Y.

128 Lynch's Slave Market, St. Louis, Mo. By Thomas W. Easterly. Collection of the Missouri Historical Society, St. Louis.

129 Everett Bailey with sled. Maker unknown, about 1850. Sixth plate. Collection of the Minnesota Historical Society, St. Paul.

PLATE 129 319

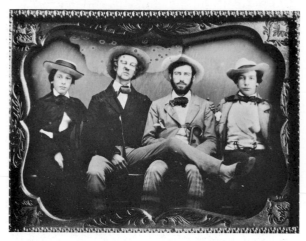

130 Thurlow Weed Whittlesey and friends. Maker unknown, about 1850. Quarter plate. Collection of the Rochester Historical Society, Rochester, N.Y.

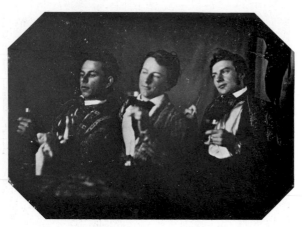

131 Kenyon College boys. Maker unknown, about 1845. Quarter plate. Collection of the Minnesota Historical Society, St. Paul.

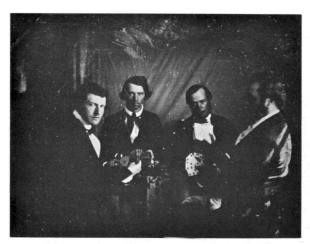

132 Men playing cards. Maker unknown, about 1845-48 Quarter plate. Collection of the George Eastman House, Rochester, N.Y.

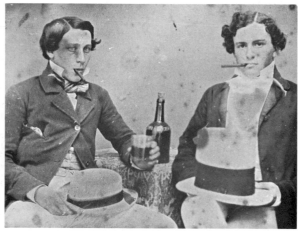

133 John Caldwell and James Sawyer. Maker unknown, about 1850. Quarter plate. Collection of the Rochester Historical Society, Rochester, N.Y.

134 Men boxing, posed in a studio. Maker unknown, about 1850. Quarter plate. Labhard Collection of the University of New Mexico Art Museum, Albuquerque.

135 Couple sitting in a parlor. By Southworth and Hawes, about 1855. Quarter plate (detail—half of a stereo pair). Collection of the Metropolitan Museum of Art, New York.

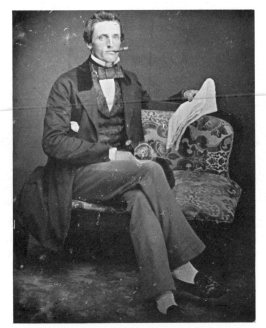

137 Butterfly collector. Maker unknown, about 1850. Sixth plate. Collection of the George Eastman House, Rochester, N.Y.

136 Man in slippers with cigar and newspaper. Maker unknown, about 1856-58. Sixth plate. Labhard Collection of the University of New Mexico Art Museum, Albuquerque.

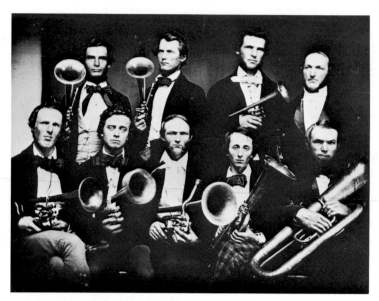

138 Brass ensemble. Maker unknown, about 1850. Half plate. Collection of the George Eastman House, Rochester, N.Y.

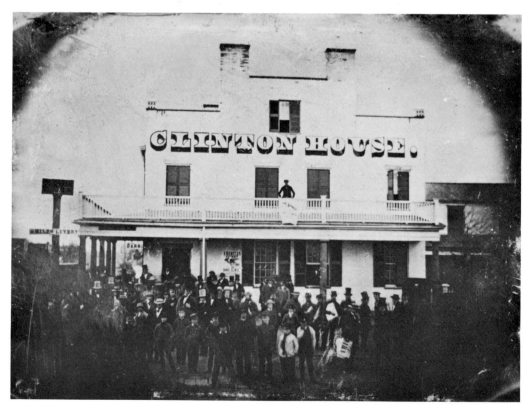

139 Political rally for the American Ticket, at the Clinton House, St. Louis, Mo. Maker unknown, about 1855. Collection of Dale Walden, Boise, Idaho.

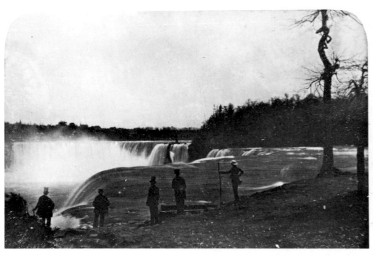

140 Niagara Falls. By Southworth and Hawes, about 1849. Whole plate. Collection of the George Eastman House, Rochester, N.Y.

141 Niagara Falls in winter. By Southworth and Hawes, about 1856. Whole plate (from the Grand Parlor Stereoscope). Collection of the George Eastman House, Rochester, N.Y.

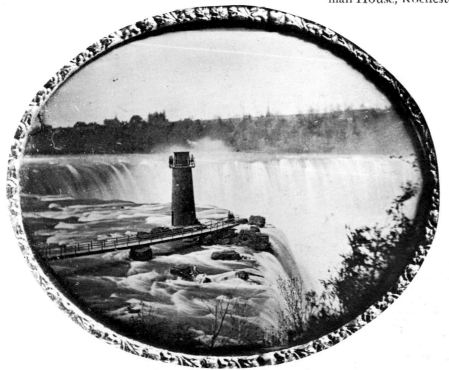

142 Terrapin Tower and Horseshoe Falls of the Niagara. Maker unknown, about 1850. Sixth plate. Collection of the George Eastman House, Rochester, N.Y.

143 Mr. Avery trapped on a log above Niagara Falls. By Platt Babbitt, 1854. Quarter plate. The Gernsheim Collection of the University of Texas, Austin.

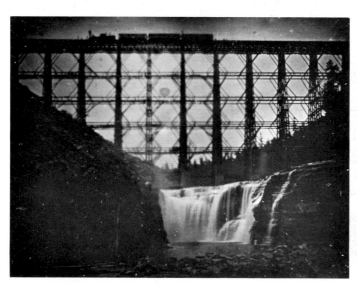

144 Wooden railroad trestle above a waterfall on the Genesee River at Portageville (now Letchworth Park), N.Y. Maker unknown, about 1845-48. Quarter plate. Collection of the George Eastman House, Rochester, N.Y.

145 Railroad bridge and Niagara Falls. By Southworth and Hawes, about 1856. Whole plate (from the Grand Parlor Stereoscope). Collection of the George Eastman House, Rochester, N.Y.

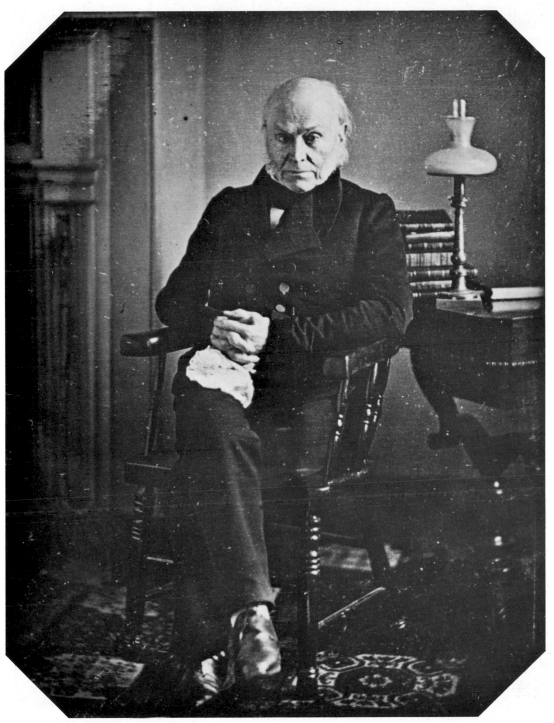

146 John Quincy Adams (1767-1848), sixth President of the United States. By Southworth and Hawes, about 1845. Half plate. Collection of the Metropolitan Museum of Art, New York. (Gift of I. N. P. Stokes and the Hawes family.)

PLATE 146

325

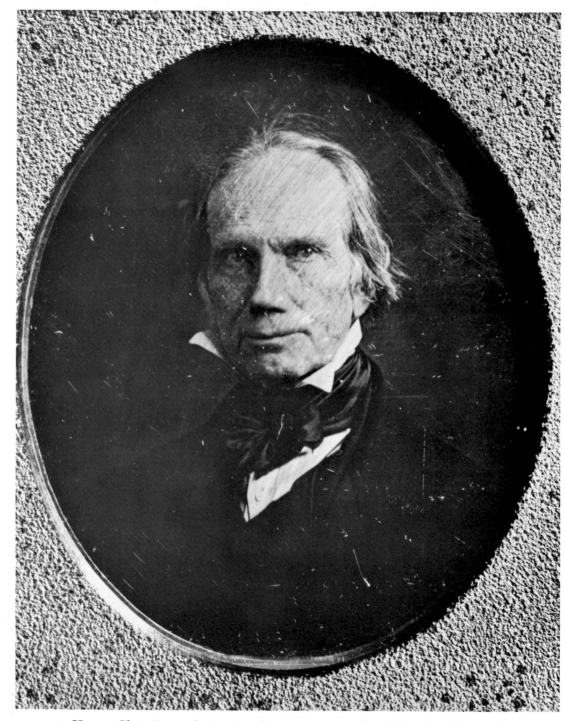

147 Henry Clay (1777-1852), American statesman. Probably by Marcus Root, Philadelphia, 1848. Sixth plate. Collection of Richard Rudisill, Albuquerque.

PLATE 147

148 President Zachary Taylor and his cabinet. By Mathew Brady, 1849. Whole plate. Collection of the Library of Congress, Washington, D.C.

149 Girl adoring a bust of Washington. By Gabriel Harrison, about 1853. Whole plate. Collection of the George Eastman House, Rochester, N.Y.

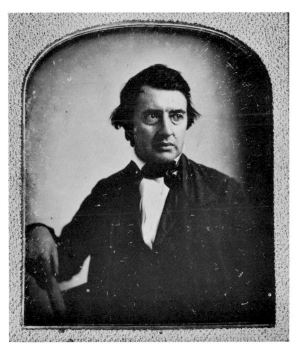

150 Albert Sands Southworth (1811-94), Boston daguerreotypist. By Josiah J. Hawes, about 1845. Sixth plate. Collection of the Metropolitan Museum of Art, New York. (Gift of I. N. P. Stokes and the Hawes family.)

151 Josiah Johnson Hawes (1808-1901), Boston daguerreotypist. By Albert S. Southworth, about 1845. Quarter plate. Collection of the Metropolitan Museum of Art, New York. (Gift of I. N. P. Stokes and the Hawes family.)

152 Unidentified woman. By South-
worth and Hawes, about 1850. Sixth
plate. Collection of the George East-
man House, Rochester, N.Y.

153 Unidentified woman. By South-
worth and Hawes, about 1850. Sixth
plate. Collection of the George East-
man House, Rochester, N.Y.

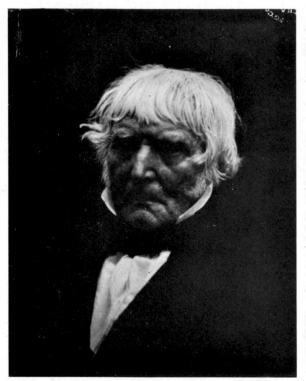

154 Elderly man. By Southworth and Hawes,
about 1850. Sixth plate. Collection of the
George Eastman House, Rochester, N.Y.

155 Lady with lace cap and ties. By South-
worth and Hawes, about 1850. Whole plate.
Collection of the George Eastman House,
Rochester, N.Y.

156 Man with disorderly hair. By Southworth and Hawes, about 1850. Whole plate. Collection of the George Eastman House, Rochester, N.Y.

157 Woman with hands crossed. By Southworth and Hawes, about 1850. Whole plate. Collection of the George Eastman House, Rochester, N.Y.

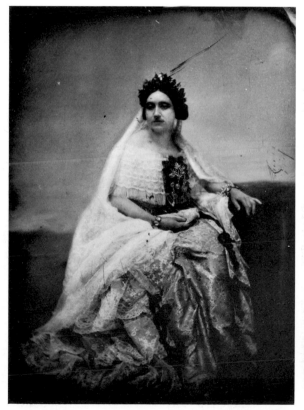

158 Woman in costume. By Southworth and Hawes, about 1850. Whole plate. Collection of the George Eastman House, Rochester, N.Y.

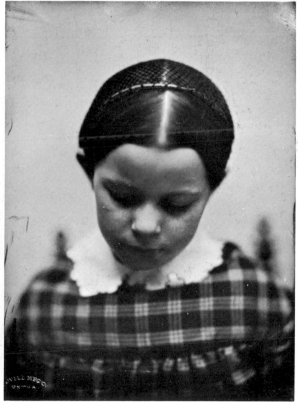

159 Girl with face down. By Southworth and Hawes, about 1850. Sixth plate. Collection of the George Eastman House, Rochester, N.Y.

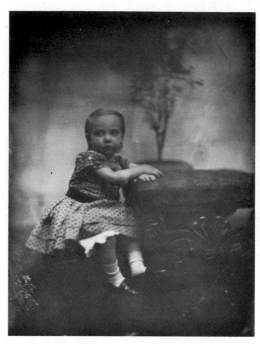

160 Small child with table and potted plant. By Southworth and Hawes, about 1850. Whole plate. Collection of the George Eastman House, Rochester, N.Y.

161 Little girl in sunlight. By Southworth and Hawes, about 1850. Sixth plate. Collection of the George Eastman House, Rochester, N.Y.

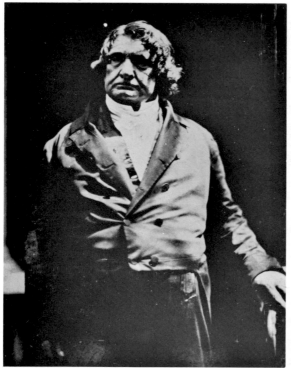

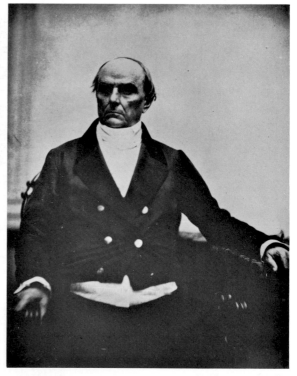

162 Lemuel Shaw, Chief Justice of Massachusetts. By Southworth and Hawes, 1851. Whole plate. Collection of the Metropolitan Museum of Art, New York.

163 Daniel Webster. By Southworth and Hawes, 1850. Whole plate. Collection of the Metropolitan Museum of Art, New York. (Gift of I. N. P. Stokes and the Hawes family.)

164 Lola Montez. By Southworth and Hawes, 1851. Whole plate. Collection of the Metropolitan Museum of Art, New York. (Gift of I. N. P. Stokes and the Hawes family.)

165 Harriet Beecher Stowe (1811-96), American author. By Southworth and Hawes, about 1850. Quarter plate. Collection of the Metropolitan Museum of Art, New York. (Gift of I. N. P. Stokes and the Hawes family.)

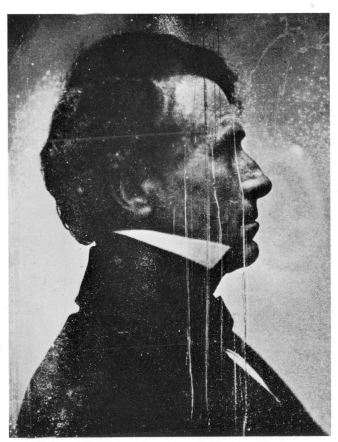

166 Franklin Pierce (1804-69), fourteenth President of the United States. By Southworth and Hawes, about 1855. Half plate. Collection of the George Eastman House, Rochester, N.Y.

167 French nude study. Maker unknown, about 1845. Sixth plate. Collection of the George Eastman House, Rochester, N.Y.

168 Unidentified man with bare chest. By Southworth and Hawes, about 1850. Half plate. Collection of the George Eastman House, Rochester, N.Y.

169 Nude women, possibly Central American Indians. Maker and origin unknown. Quarter plate. Collection of the George Eastman House, Rochester, N.Y.

170 Ellsworth Eliot. By Jeremiah Gurney, about 1852. Quarter plate. Collection of Richard Rudisill, Albuquerque.

171 Eliza R. Snow, Mormon writer and poet, wife of Brigham Young. Probably by Marsena Cannon, about 1853. Sixth plate. Collection of the Office of the Church Historian, Church of Jesus Christ of Latter-Day Saints, Salt Lake City.

172 Francis Le Baron. Maker unknown, about 1850. Quarter plate. Collection of the California Department of Parks and Recreation, Sutter's Fort State Historical Park, Sacramento.

173 Margaret Aurelia Dewing. Maker unknown, 1848. Quarter plate. Collection of Richard Rudisill, Albuquerque.

174 **Old** lady with lace cap and figured shawl. Maker unknown, about 1850. Sixth plate. Collection of Richard Rudisill, Albuquerque.

175 Young man. Maker unknown,
about 1852. Ninth plate.
Collection of the late F. E. Seaton.

176 Child in plaid coat. Maker unknown,
about 1845. Quarter plate. Collection of the
George Eastman House, Rochester, N.Y.

177 Girl in white dress (solarized image). Maker unknown, about 1850. Sixth plate. Collection of the late F. E. Seaton.

178 Sheldon Nichols's mother. By Sheldon Nichols, about 1850. Sixth plate. Collection of the Bancroft Library, Berkeley, Calif. Reproduced by permission of The Director.

179 Man leaning head on hand. Maker unknown, about 1850. Sixth plate. Collection of the late F. E. Seaton.

180 Young man with books (*Travels and Adventures of Celebrated Travelers*). Maker unknown, about 1850. Sixth plate. Labhard Collection of the University of New Mexico Art Museum, Albuquerque.

181 Woman with guitar and rolled music. Maker unknown, about 1850. Half plate. Collection of the George Eastman House, Rochester, N.Y.

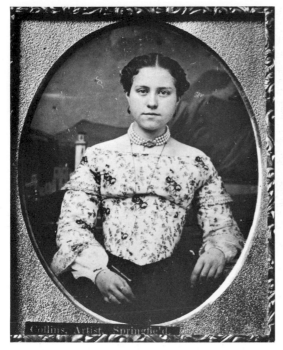

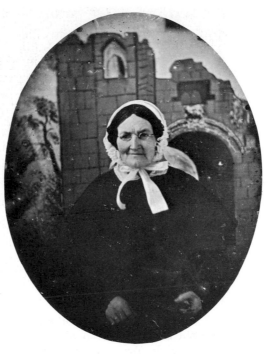

182 Unidentified woman with painted back-
drop. By Collins, about 1850. Ninth plate.
Collection of Richard Rudisill, Albuquer-
que.

183 Elderly woman with painted backdrop.
Maker unknown, about 1850. Half plate.
Labhard Collection of the University of
New Mexico Art Museum, Albuquerque.

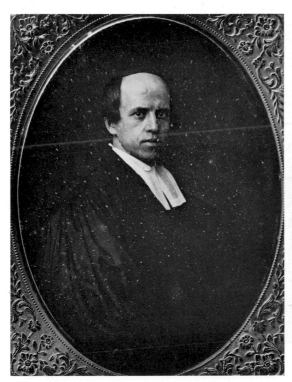

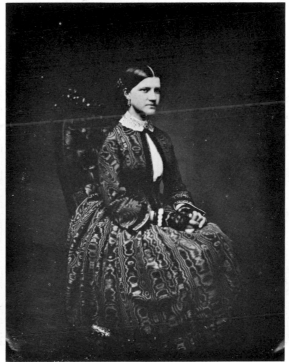

184 Possibly Reverend Joseph Newton Mul-
ford. Maker unknown, about 1850. Half plate.
Collection of The New-York Historical Society,
New York.

185 Mrs. Peter Thomson. By Mathew Brady,
about 1850. Half plate. Collection of the
California Department of Parks and Recrea-
tion, Sutter's Fort State Historical Park, Sacra-
mento.

186 William Cullen Bryant (1794-1878), American poet and journalist. By Mathew Brady, about 1850. Whole plate. Collection of the Library of Congress, Washington, D.C.

187 Emily Dickinson (1830-86), American poet. Maker unknown, 1847-48. Sixth plate. Collection of the Amherst College Library, Amherst, Mass.

188 Elijah Coffin. By W. H. White, 1848. Sixth plate. Collection of the George Eastman House, Rochester, N.Y.

189 Mrs. Elijah Coffin. By W. H. White, 1848. Sixth plate. Collection of the George Eastman House, Rochester, N.Y.

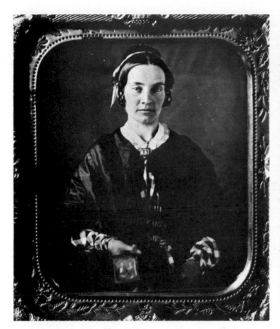

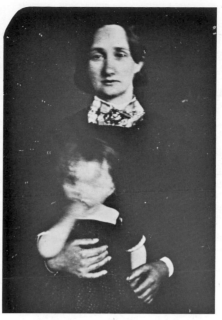

190 Woman holding daguerreotype. Maker unknown, about 1850. Sixth plate. Collection of the George Eastman House, Rochester, N.Y.

191 Mrs. John H. Stevens and daughter Mary Elizabeth, the first white child born in Minneapolis. Maker unknown, about 1852. Sixth plate. Collection of the Minnesota Historical Society, St. Paul.

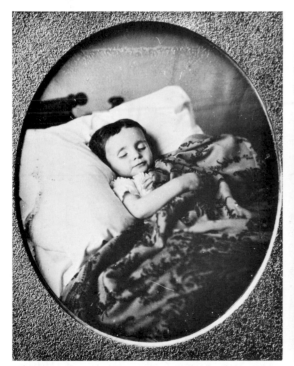

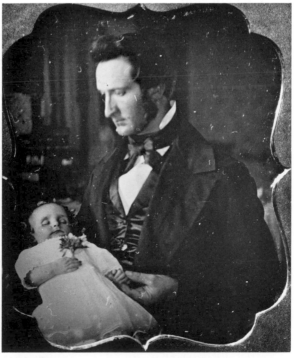

192 Dead child. Maker unknown, about 1850. Sixth plate. Collection of Richard Rudisill, Albuquerque.

193 Man with dead child. Maker unknown, about 1850. Sixth plate. Formerly collection of the late Mrs. Theodore J. Labhard, San Francisco. Present location unknown.

194 Dead woman. By Southworth and Hawes, about 1850. Sixth plate. Collection of the George Eastman House, Rochester, N.Y.

195 Joseph Cretin, first Roman Catholic bishop of the diocese of St. Paul, died February 22, 1857. Maker unknown, 1857. Sixth plate. Collection of the Catholic Historical Society of St. Paul.

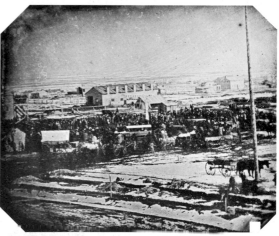

196 Grave of Robert Barnard of Poughkeepsie, N.Y. Died San Francisico, Calif., 1855. By J. M. Ford, 1855. Half plate. Collection of The New-York Historical Society, New York.

197 Ground-breaking ceremonies for the Mormon Temple, Salt Lake City, February 14, 1853. Probably by Marsena Cannon. Sixth plate. Collection of the Office of the Church Historian, Church of Jesus Christ of Latter-Day Saints, Salt Lake City.

198 Young woman with crossed eyes. Maker unknown, about 1850. Half plate. Labhard Collection of the University of New Mexico Art Museum, Albuquerque.

199 Man with defective hand. Maker unknown, about 1850. Sixth plate. Collection of Wayne R. Lazorik, Albuquerque.

200 Fire engine built in 1830 by Henry M. Ludlum in New York City. Maker unknown, about 1850. Quarter plate. Collection of The New-York Historical Society, New York.

201 Mining machine. Maker unknown, about 1850. Quarter plate. Collection of the Society of California Pioneers, San Francisco.

202 Dolley Madison (1768-1849), wife of President James Madison. By Mathew Brady, probably 1848. Collection of the Library of Congress, Washington, D.C.